60.

innovators

shaping our creative future

With over 500 illustrations

Thames & Hudson

60.

contents

1–5.
interiors & exteriors

julie lasky

on innovation
martha schwartz

/16

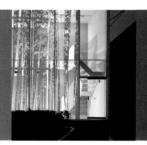

1.
cao|perrot /26
Creators of multi-sensory outdoor spaces that challenge us to re-imagine the garden

2.
petra blaisse /30
Interior and exterior spaces that blend and collapse divisions between inside and out

3.
lang/baumann /34
Artistic duo who turn art inside out – and invite you to stay the night

4.
klein dytham /40
All-seeing outsiders who blend nature, artifice and commerce in the Japanese cityscape

5.
ab rogers /44
Interiors that weave a world of sensations appealing to nose, ear, skin and eye

6–10.
street world

tristan manco

on innovation
blek le rat

/48

6.
darius & downey /58
Artist-adventurers whose street sculptures and installations bring wit and life to our urban spaces

7.
invader /62
Colourful retro-geek mosaics take over the world, one installation at a time

8.
swoon /66
Spectacular artistic journey from intricate poster cut-outs to floating performance art

9.
jr /70
Young photographer whose giant poster portraits defy stereotypes and touch communities

10.
blu /76
Prolific image-maker of extraordinary skill and imagination

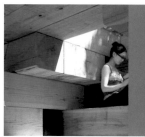
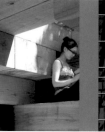

60.
contents

60.
contents

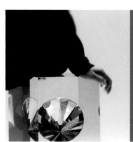

60.
introduction

Innovation is not new. It cannot be claimed as the exclusive purview of the digital age, the space age or even the industrial revolution. Innovation has been part of our world as long as humans have had problems to solve, communities to organize, tools to make work more efficiently and ideas to give form to. Of course, the naming of this impulse to rethink or improve on our lives came later. The word 'innovation' came into use in English around the time 'New Worlds' were being 'discovered' and the English language itself was being transformed by one of the greatest linguistic innovators of all time. Fast forward from the era of Shakespeare to the beginning of the third millennium CE, and a world ever more fully immersed in the digisphere. We have become acclimatized to the heady mutability of language, technology and information. Innovation is a byword for progress. But it wasn't always so.

To establish a sense of how the idea of innovation has developed over the past few hundred years, from the Western perspective, the word's etymology offers some insights. Derived from the Latin *novare*, to make new, the word entered the English and French languages in the sixteenth century. From the beginning, 'innovation' suggested not so much the creation of new things or ideas but renewal from inside existing traditions or modes of doing things, an agent of change from within. In its early use the word appears largely in the context of political and religious matters, and what is most striking is that its associations were almost entirely negative – heretical, even. Writing in 1651, in

the aftermath of the English Civil War, political philosopher Thomas Hobbes was emphatic: 'There are many who supposing themselves wiser than others, endeavour to innovate, and divers innovators innovate in various ways, which is a mere distraction and civil war.' The message is clear: the 'new' was something to be resisted, if not feared.

Change came with the Enlightenment, the period in which many of the most fundamental concepts defining humanity's relationship with the world – across science, religion and politics – were examined afresh. So too in this era did innovation begin to assume the positive associations we recognize today. To be sure, there were original thinkers and makers who changed the course of history before the advent of the modern age – St Benedict, Leonardo da Vinci, Copernicus, Gutenberg, Galileo, to name just a few – but genuine innovators frequently fell foul of the entrenched conservatism of religious and political authorities. It was only in the latter part of the 1700s, with the arrival of the Age of Reason, that the idea of innovation *per se* finally began to shake off its pejorative aura in a world that was learning to welcome reassessment, reinvention and renewal.

Today, at the dawn of the digital age, we have entered another new era – one in which technological advances, geopolitics and ecological concerns (and, more recently, economic collapse) have given rise to widespread reassessment and reinvention, and with them the promise of renewal. This book is the result of a quest to discover genuine innovation across a wide spectrum of commercial and artistic activities. It represents an unprecedented collaboration. Twelve established practitioners and critics – each innovative in his or her own right – were invited to propose five innovators from across their realm of expertise. Their overviews are complemented by a more personal perspective on innovation from a seminal contributor to each field. Every editor made his or her selection of innovators independently, and what emerges is a fascinating insight into current creativity, as well as plenty of sharp clues about the directions in which we should be moving towards the future.

In approaching this subject, it is useful to consider the reflections of American philosopher Warren Steinkrauss, who in a 1982 essay explored the connection between art and innovation. Asking 'whether the concept of innovation is of any real meaning or use in coming to an understanding of human artistic achievement', he proposed five types of artistic

Intriguing new models for *creative collaboration* and *dissemination* that blur the boundaries between *art* and *commerce*, the *virtual* and *material*, are appearing in the worlds of popular media, advertising, gaming and design.

innovation: the exploitation of new techniques or materials deriving from technology (exemplified by Modernist architecture); the inclusion of 'incidental novelties' or doing something new with something old (Victor Hugo's experiments with shaped poetry); the application of self-imposed rules for creation (Alexander Pope's heroic couplets, Arnold Schoenberg's tone rows, Jackson Pollock's drip technique); radical departure from tradition (Alexander Calder's use of movement in sculpture, Isadora Duncan's modern dance); and finally a creative advance within a tradition of such magnitude that it transcends the four previous categories.

Steinkrauss's thoughts are worth bearing in mind as one considers the work of these sixty very different innovators. For here, too, an intriguing set of overlapping perceptions and preoccupations begins to emerge.

Reinventing the art of commerce

In 1934 Joseph Schumpeter's *Theory of Economic Development* advanced a definition of economic innovation in the world of consumers and markets. His principles include the introduction of new goods, new modes of production, opening up new markets, the acquisition of new materials and new organization. 'Innovation is the outcome of continuous struggle in historical time between individual entrepreneurs, advocating novel solutions to particular problems, and social inertia.'

These principles are still at play today more than seven decades later. Many of our featured innovators use highly creative – occasionally

almost subversive – means to bridge the worlds of art and commerce. Fully comprehending the power of a free distribution network offered by the internet, they embrace the possibilities offered by a new form of commercial exchange. After all, if and when the day comes where we no longer have 'hard' media, digital transmission via the internet may be the only form of distribution in many fields. Intriguing new models for creative collaboration and dissemination that blur the boundaries between art and commerce, the virtual and material, are appearing in the worlds of popular media, advertising, gaming and design. 42 Entertainment's 'immersive entertainment' turns passive consumers into active participants of extraordinarily elaborate multi-platform marketing campaigns; Radiohead's free music downloads and user-led online experiences point to a far closer relationship between artist and fan in the future; while Area/Code's gaming experiences jump seamlessly between real-world and virtual-world play.

Multi-disciplinarity

A number of the innovators presented here operate at the margins of their chosen discipline, incorporate other forms of creative output and work across boundaries. Indeed many could represent more than one creative field. Of course artists have always traversed media and disciplines, but today's ready accessibility of flexible digital tools, combined with a curiosity and openness to artistic cross-fertilization, has made multi-disciplinarity the norm. For example, Manuel Raeder applies his skills as graphic designer to furniture; Oron Catts applies a product-design background to biotechnology in order to create art; Nick Knight pursues still photography, video and 3D imaging as well as exploring ways of enabling online user-interaction to contribute to his creative process; Moritz Waldemeyer applies his expertise in electronic engineering to interactive furniture and kinetic fashion.

World-changing

With its potential for reaching a global audience, the internet has empowered those with a desire to confront authority, expose hypocrisy and engage others in the issues of the day. Many of our featured innovators, like their Enlightenment forebears, challenge politicians, taste-makers and the news media, and provoke us to reconsider our

values and lifestyles. The preoccupation with preserving democracy, freedom and social equality comes through, for example, in the online activism of the Yes Men, the large-format photographic portraiture of street artist JR, or the drawings of Michael Patterson-Carver.

While some innovators seek to question the top-down bias of authority, others focus on harnessing the power of communities or interest groups, mobilizing to create grassroots networks that are greater than the sum of their parts. Whatever its inspiration, such activism can tap into the extraordinary connectedness of the digisphere to generate vigorous new forms of collective enterprise. From Cameron Sinclair's humanizing architecture for impoverished communities to UrbanLab's 'eco-boulevards' that posit a radically localized new approach to the management of urban services; from Hilary Cottam's networking strategies for the improvement of social welfare to Rob Hopkins' Transition Towns movement for local sustainability – each is finding a way to exploit homegrown wisdom and connections for the greater good of their own communities, while often at the same time providing models, inspiration and advice to others half-way across the planet.

Humanizing the digisphere

With more information available to us now than any human can comprehend within several lifetimes, and exponentially more every day, our desire to describe and explain the world remains unquenchable. There is a need to extract meaning from the infosphere; to reframe it on a human scale and relate it to our emotions and personal experiences. Many of these innovators, in very different ways, gather information and reinvest it with graphic and narrative meaning. Carlo Ratti mines mobile-phone data to describe and map our collective emotional responses to events; Jonathan Harris creates digital installations and web-based projects that restore the human dimension to the online experience. Others are finding ways to humanize our interactions with technology – for example, through interfaces that respond to gesture, movement or voice commands.

All together now

The internet has made virtual communities a part of our everyday lives, whether through social networking (FaceBook, Twitter), blogging,

The *future* of *innovation* is no longer in the hands of the scientist, artist or designer working alone in lab, loft or studio…. It is a *creative, collective, humanist* enterprise.

collaborative information resources (Wikipedia), or the millions of super-specialized interest groups that can exchange ideas across vast distances. Real-world hierarchies everywhere are being shattered as the digital realm enables more and more voices to be heard. And yet, until comparatively recently, the creative talent – the artist, designer, architect – has worked largely alone or with a group of close associates. But this is changing, as Paola Antonelli concludes in the final section. We have entered an age of mass creative collaboration. This is expressed in the open-source phenomenon, which promotes sharing and remote cooperation in order to make digital resources – software and skills – available for free to all. Or the growing practice of crowdsourcing: opening up a task – product-testing, problem-solving, data-processing or indeed design – to the online community. The internet makes it possible for people of every conceivable location and agenda to join together in a common purpose, whether commercial, artistic or philanthropic. The future of innovation is no longer in the hands of the scientist, artist or designer working alone in lab, loft or studio. Nor is it the preserve of R&D teams working for the forces of commerce. It is a creative, collective, humanist enterprise that seeks to find new solutions to the problems of our planet and its future. That is reason enough to celebrate innovation at this extraordinary moment in history.

Lucas Dietrich General Editor

1–5.

cao|perrot

petra blaisse

lang/baumann

klein dytham

ab rogers

interiors & exteriors

julie lasky

introduction
julie lasky

Editor of *Change Observer*, an online magazine about design and social innovation, and former editor-in-chief of *i-D* magazine

The designer of interior or exterior landscapes is a visionary by default. Unlike architecture, which is built to endure, or industrial design, which is produced in mass multiples, or graphic design, which is embedded in printing plates or computer code and therefore can be cloned indefinitely, indoor and outdoor environments take on a life that eludes the designer's grasp. No matter how carefully an arrangement is planned and executed, it is bound to be thrown into disarray the moment bodies occupy the space. The designer of such settings – practising what the New York Museum of Modern Art curator Peter Reed has described as 'an art of horizontal surfaces and systems, impermanence and change' – must consider a host of unknowns. How will the materials stand up to uncertain use? How will the composition of elements survive the impulse to rearrange them? The project is always a work in progress. The designer's task is to imagine how it will unfold.

Interior and exterior landscapes of course have more in common than merely a condition of entropy. Both types of environments sheathe, soften, ornament and provide context for the architecture that defines them. As with painting or sculpture, their effect depends on the compositional relationship between solid and void. Circulation paths are carved out of areas laden with furniture or plants. Mirrors of glass or liquid reflect backdrops of wall or sky. Carpets are woven in fibre or sprout from grass. The very distinction between inside and outside, which Modernist architects sought to undermine with their oversize windows and transparent building walls, has been further demolished by technologies that bring nature into climate-controlled interior spaces while domesticating the world outdoors.

It isn't just designers who assault the boundary between internal and external space; artists, too, have been *merging* and *recombining* these environments to *challenge* conventional ways of thinking about community and privacy.

Despite the kinship between interior and exterior landscapes, however, few designers are proficient in both specialities. More common are interior designers and architects who import tropes of the street or garden, and landscape designers who borrow themes from indoors to blend nature and artifice. And it isn't just designers who assault the boundary between internal and external space; artists, too, have been merging and recombining these environments to challenge conventional ways of thinking about community and privacy.

The five designers or studios featured in this chapter represent remarkable inventiveness across these professional categories. Petra Blaisse is the rare designer who works on both sides of the building envelope. The name of her Amsterdam-based firm, Inside Outside, announces her ambidexterity, but the dualism is constantly being eroded. Whether Blaisse is draping yards of floral interior textiles or specifying a garden with a strong graphic pattern, she is absorbed in colour, contrast and flux. Architectural walls aren't barriers in her practice, but trellis-like structures that support, and indeed are inseparable from, animated, mutating life – greenery, or curtains vitalized by a breeze, or shadows, or the steady flush of a sunset. Her landscapes are creations that cross thresholds, gently unfolding through time and space.

Blaisse – who, among other accomplishments, has designed some of the world's most astonishing theatre curtains – reminds us that landscapes are not things but contexts. They set the stage for drama. While the detached beholder can appreciate an attractive scene, a landscape's true power lies in the way that it fosters activity. Andy Cao and Xavier Perrot, who head Cao|Perrot Studio, from Los Angeles

and Paris respectively, typify the landscape designer who furnishes the outdoors with domestic materials and comforts – in their case, polished-glass pebbles, intimate shelters, chandeliers and floral arrangements that are unapologetically contrived. 'It doesn't matter if it's mineral or vegetable, inside or outside, it can all be a garden,' Perrot says.

Years before the sustainability movement caught fire, Cao and Perrot were squeezing luminous effects out of cheap, recycled materials such as panels of fused glass medicine bottles. Their landscapes are not so much panoramas as volumes packed with sensory experiences; homemade incense floats on the air and light bounces off the surface of water or filters through strands of woven nylon. Their designs stimulate a response, if only the dislodging of memories and emotions.

London-based Ab Rogers similarly designs environments that are complex sensory apparatuses. He specializes in shops, restaurants and museum exhibitions – interiors whose focal points are commercial products or art. But although one might expect such items to drive all other landscape elements into the background, Rogers breaks open the envelope to create a sensation of space that is as compelling as the contents. Walls and ceilings might be mirrored or womb-red or painted with clouds or curved into pods. They might even have movable parts. Visitors feel literally at sea, yet without being alienated from the objects surrounding them. Speaking to an Australian journalist about his approach to designing museum exhibitions, Rogers could have been describing his interiors in general: 'Rather than creating a minimal plinth, and sticking your icon, your hero worship on the plinth, we try to create an environment that is as challenging as the object itself, so it becomes a totality….'

It's not unusual for architects and designers to sound like urban planners from time to time. Their allusions to 'main streets' and 'squares' in the layout of large offices, for instance, speak to the dominance of landscape as a metaphor for interiors. In the work of the architectural firm Klein Dytham, however, the urban streetscape plays a more potent aesthetic role than, say, a corridor running along a row of cubicles. Graffiti, billboards, winking lights, tiny buildings-within-buildings, industrial architecture and surprising bursts of nature are referenced in the studio's projects, inside and out – from an advertising agency's bowling-alley-inspired boulevards and hut-like conference rooms to the giant flowing illustration that covers two exterior walls and several windows of a hair salon. These motifs are perfectly suited to their sites in the electric, stylish and dense city of Tokyo, where Klein Dytham is

All of the innovators in this chapter have swapped the traditional tools of their trade for a Möbius strip, in which *spectator* and *spectacle*, inside and outside, *natural* and *artificial*, nature and culture form one seamless entity.

located. The projects offer up pieces of the panorama into which they also fit, like fractals of eccentricity.

Landscapes furnish artists not just with inspiration and settings but also materials. Robert Smithson, Niki de Saint Phalle, Walter De Maria and Michael Heizer are just a few names associated with manipulated geological formations and gardens that turn the earth into a canvas. Sabina Lang and Daniel Baumann of Lang/Baumann (or L/B), based in Burgdorf, Switzerland, graft art onto nature; they've striped buildings and highways with colourful ribbons of paint that have some qualities of plant life (vibrancy, flowing continuity, the ability to soften urbanism) but are rigorously constructed.

The detachment of those geometries is indicative of L/B's interest in design as a counterpoint to art – one that refines and provides context for creative expression, much as the built environment rationalizes and controls the natural landscape.

As artists they have made a theme of functionality (or its absence) by erecting a high-dive board in a pool-less patch of Swiss countryside, stretching a soccer field over the length of a barge, and decorating a working bar in Cape Town. As they've moved closer to the designer's role, their projects have become more intricate, culminating recently in *Hotel Everland*, a mobile one-room lodging that offered generous views from its perch atop cultural institutions in Leipzig and Paris until it moved to its final home at L/B's studio in early 2009. *Everland* admitted art lovers by day and paying guests by night, pushing its creators into the jobs of hotel proprietors. 'It always was much more work for us than expected because [Everland] is a hybrid, really a piece of art on the

edge,' said Lang. 'If we hadn't put our finger on this point over and over, it could have easily slipped to "the other side".'

Everland's occupants were expected to feel the same sense of slippage, housed within a meticulously designed shell with multiple comforts, enjoying a god's-eye perspective of the city while leaving their fingerprints on art, spectator and spectacle rolled up in one. L/B, like all of the innovators in this chapter, have swapped the traditional tools of their trade for a Möbius strip, in which spectator and spectacle, inside and outside, natural and artificial, nature and culture form one seamless entity.

Through her lively and occasionally controversial urban designs and landscape architecture since the late 1970s, Martha Schwartz has consistently questioned our relationship with the built environment and offered revolutionary ideas for improving it.

on innovation
martha schwartz

We are all obliged to <u>make</u> a <u>contribution</u> towards the well-being and advancement of future generations. *I believe that we, as humans, have the capacity to evolve mentally, ethically and spiritually* – something that does seem to set us apart from all other animals that inhabit the earth. <u>We</u> <u>can</u> <u>improve</u> <u>our</u> <u>inner</u> <u>selves</u> <u>and</u> <u>thereby</u> <u>make</u> a <u>world</u> a <u>kinder</u> <u>and</u> <u>gentler</u> <u>place</u>. We can evolve the way we think about the universe, about our *fellow human beings* and about ourselves as individuals. We can come to appreciate our differences and <u>use</u> <u>these</u> <u>differences</u> <u>to</u> <u>advance</u> <u>our</u> <u>thinking</u>. As an optimist, I believe that if we are all looking for knowledge and understanding, we *can* create new and better futures.

Innovators are the human bridge that connects the past and present to the future. They explore what can be as opposed

to protecting the 'tried and true', relying on common 'wisdom',
or sticking to safe, culturally approved ways of thinking.
<u>Innovators</u> <u>question</u>, <u>debunk</u> <u>and</u> <u>upset</u> <u>the</u> <u>status</u> <u>quo</u>.
They may be unpopular: we humans are a risk-averse
bunch and need communal approbation. Innovators
often occupy the 'lunatic fringe' of society (that's
why the fringes are so much more interesting
than the middle!).

Innovators frequently venture forth without
knowing why they do so or where they are going.
They often cannot control the urge to *test the norm*
and invent a 'new' and better way: it is stamped into
their DNA. They may be rejected and even reviled.
Certainly, they are rarely driven by the goal of
making money – <u>often</u> <u>innovators</u> <u>are</u> <u>the</u> <u>ones</u>
<u>who</u> <u>do</u> <u>not</u> <u>reap</u> <u>benefits</u>; <u>instead</u> <u>the</u> <u>profits</u> <u>are</u>
<u>claimed</u> <u>by</u> <u>those</u> <u>who</u> <u>follow</u> <u>and</u> <u>clean</u> <u>up</u> <u>new</u> <u>ideas</u>
<u>to</u> <u>make</u> <u>them</u> <u>'saleable'</u> <u>or</u> <u>palatable</u>. *Sometimes, at least*
in times past, innovators were burned at the stake or forced to
drink poisons. But thanks to innovators – people who
are not content just to fit in but feel they have to kick
the tyres, question and create a new and better way –
we are able to inch towards a better, brighter, more
informed and, I believe, enlightened future.

1.

cao|perrot

Creators of multi-sensory outdoor spaces that challenge us to re-imagine the garden

Like other 'Avant Gardeners', Andy Cao and Xavier Perrot propose that we reconsider the definition of a garden. Might it not be fields of colourful glass pieces that crunch underfoot like gravel? Or an incense-scented pavilion shaped like an oversize Vietnamese lantern floating in a pond? Or an open-air structure topped with a grid of hand-knitted nylon mats and surrounded by a gossamer fence of monofilament?

Cao, an artist trained as a landscape architect who emigrated from Vietnam to the US as a child, and Perrot, a landscape designer raised in Brittany and currently residing in Paris, met in 2001 at a garden festival in Chaumont-sur-Loire, France. Cao was already known for the *Glass Garden* he installed on his Los Angeles property in 1998, a re-imagining in heaps of recycled glass, bamboo, and blossoms of the salt farms and rice terraces he recalled from his youth. They discovered a common interest in the emotional reactions provoked by the use of unexpected materials in a landscape.

Several Cao|Perrot Studio projects have also referred to Vietnam. *The Lullaby Garden*, designed for a 2004 garden festival in Sonoma, California, was roofed with 200 square mats knitted by 60 Vietnamese artisans and featured polished coconut shells as well as a fence of woven translucent fishing line; the sound

of Vietnamese lullabies floated through the installation. But although Perrot insists 'Brittany is not as iconic as Vietnam,' his own roots are apparent in the partnership's emphasis on poetic shifts in light and mood, especially in the context of water. Cao and Perrot both grew up near the sea, and that ambiance is highlighted in their frequent use of reflections as well as in their competition-winning plan for the 600-acre Guangming Central Park in Shenzhen, China, offering a man-made lake with an integrated floating swimming pool and a transparent bridge that creates the sensation of walking on water.

Indeed, much of their work seems to address the lightness of materials and their interaction with light, so as to create a place for dreaming. A house in Los Angeles designed by the British architect John Pawson and landscaped by Cao appears suspended in a bamboo forest. Airy clouds of gypsophila (otherwise known as baby's breath) are heaped like a floral cumulus in a Miami lake. A vast crystal-studded wire-mesh cloud for the courtyard of a private residence in Malibu turns into a chandelier at night.

Just as the partners are drawn to water, they're attracted to the limpid, reflective, sparkling and fluid qualities of glass. The material has become a trademark ever since

Cao deposited 45 tonnes of it in his backyard. Or glass appears in the form of panels made from fused recycled medicine bottles, a material the partners are working to bring to market. Fishing line, another favourite, likewise shimmers and changes opacity under different light and aspects. In 2003, the designers wrapped sunset-coloured threads of monofilament around steel armatures fabricated by the architect William Massie. The three 'cocoons' were exhibited by San Francisco Bay, facing the Golden Gate Bridge. Recent installations include a tree made out of steel and 20,000 mother-of-pearl shells for Laurent-Perrier at the Tuileries Garden, Paris.

So what is a garden? In essence, Perrot says, 'it can be about anything, as long as it evokes emotions, reactions'. Cultural or personal memories may be stirred, but the intensity of the response depends on multiple and perhaps even contradictory stimuli. The partners enjoy mixing East and West – Southeast Asian lanterns and Mediterranean citrus perfume, Chinese cricket cages and California swimming pools – and they revel in such paradoxes as cacti floating on water. 'You look at such projects twice,' Perrot says. '"What was that?" you wonder. That's the language of dreams and imagination.'

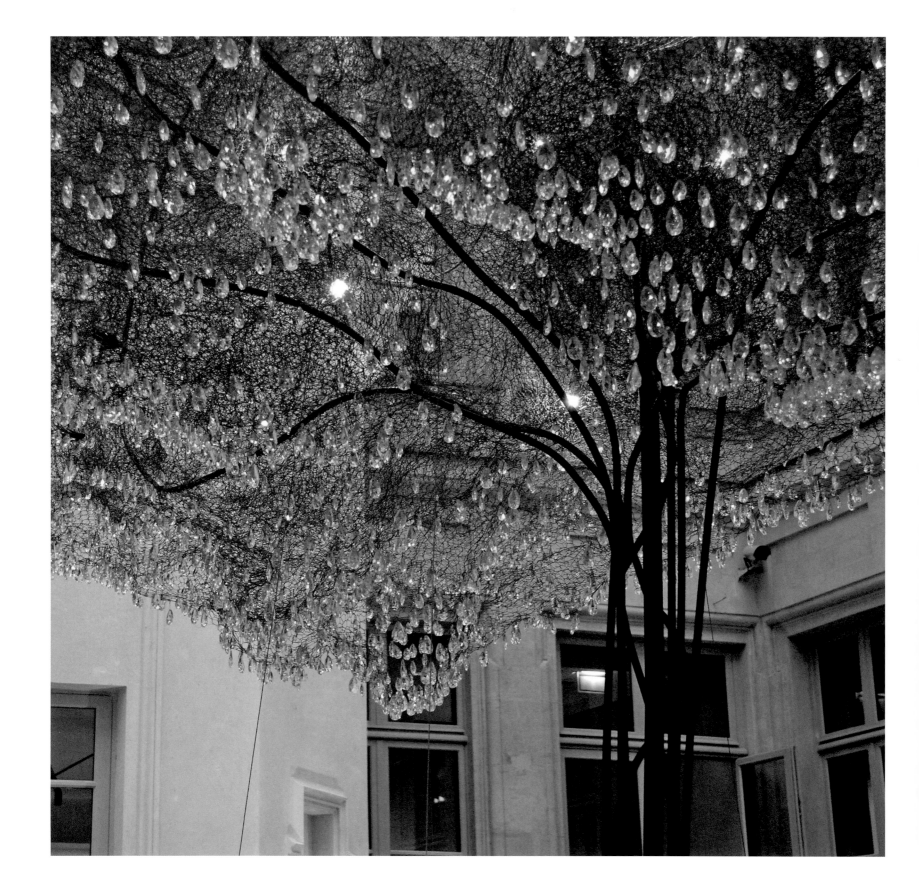

Cloud Chandelier, 2008
KENZO headquarters, Paris
This intricate, sparkling installation is constructed
of steel, wire mesh and 3,500 cut crystals. Its
vaporous and constantly shifting shape evokes
the traditional Japanese *wabi-sabi* aesthetic, which
embraces the beauty of imperfections.

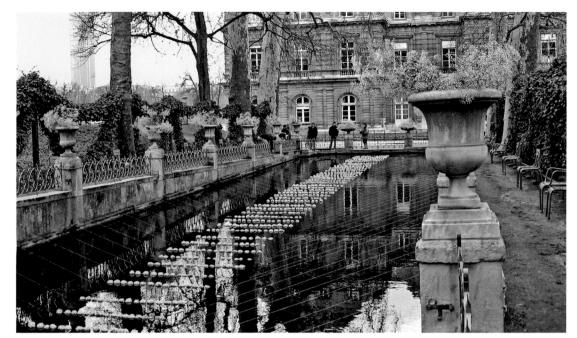

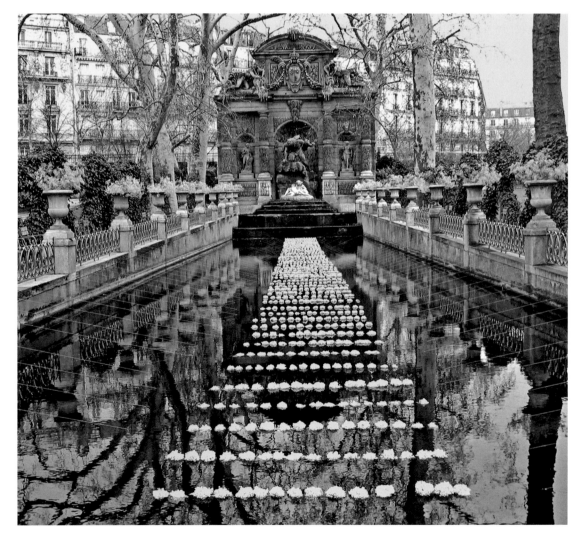

Left and below left
L'Allée des Amoureux, 2002
Medici Fountain, Luxembourg Gardens, Paris
This temporary installation in the seventeenth-century Medici Fountain was sponsored by the French Senate to celebrate the winter-blooming mimosa flower. Clear monofilament lines were used to float a path of the vibrant yellow blossoms across the water, with bouquets of white gypsophila arranged in the surrounding urns.

This page and opposite right
Red Box, 2002
Courtyard of the American Academy in Rome
While on a fellowship in Rome, Cao and Perrot
turned their studio and the courtyard of the
American Academy into an installation inspired by
the city's art and history. Visitors followed paths of
brightly-coloured recycled glass pebbles around the
courtyard and through a grass-covered doorway,
entering a grass-floored red room whose walls were
studded with candle-niches and hung with panels
made from fused recycled medicine bottles. Inside the
space, fragrant coils of Vietnamese incense, a Roman
masseuse and music by composer Derek Bermel
evoked the sensuality of ancient Rome.

2.
petra blaisse

Interior and exterior spaces that blend and collapse divisions between inside and out

Petra Blaisse calls her Amsterdam-based design firm Inside Outside. Inside, Blaisse is famous for her use of textiles: curtains that carve space, muffle sound, filter light, rise to reveal a theatrical stage or a domestic view, or provide a vibrant burst of colour. Outside, she transforms landscapes with greenery that buckles up from dense urban patches in Beijing, Riga or the Netherlands. She's dotted a desert plaza in Qatar with circular imprints of native plants staged to grow to different heights, and she's strewn mirrors on the lawn of Italy's Villa Manin museum and provided visitors with parasols lined in reflective material so that the green world shimmers on silver and is turned into a dizzying, boundary-less prospect.

Often, the realms of inside and outside blend into one another, as in Blaisse's design for the Music Theatre Enschede (2008). A 150-metre-long, 12-metre-high wall that zigzags through the building is papered with a large-scale, mutating floral pattern and hung with panels of brush-like material that filter sound as if they were leaves clustered on branches. A stage curtain in cherry red is hung with long pleats; when the curtain rises, the pleats move to reveal inserts of black-and-white honeysuckle fabric.

Blaisse's medium is change. Rigorous, bony architecture becomes flexible as it showcases shifts in light, movement and seasons. Layers of floral-printed voile and pink cotton velour draped over the circular glass walls of the Haaksbergen Villa in the Netherlands (2005–8) reveal patterns that grow more intense as daylight recedes. Even the dust that's collected on her flamboyant stage curtain for London's Hackney Empire Theatre (2000–5) adds a meaningful patina. In Blaisse's hands, the delicate matter of fabric finishes and garden plantings, traditionally afterthoughts to a building, become equal partners. 'What interests me is the whole biology of things; seasons, climate,' she says. As much as design, her work is 'about process, narrative, and what comes out of that in combination with architecture.'

The integration of soft, fluid, solid, unyielding, natural and inorganic is largely a product of Blaisse's own partnership with her architect-collaborators. Her long association with Rem Koolhaas's OMA studio has yielded, among other works, the giant knitted sock that camouflaged the audio equipment in New York's Prada Epicenter shop (2001); the three interior gardens of the McCormick Tribune Campus Center at Chicago's Illinois Institute of Technology (1998–2004); the vast foliage-themed carpets echoing the native species planted outside of Seattle's Central Library (2000–5), and new landscapes for Beijing's CCTV Building and, eventually, Shanghai's Stock Exchange.

If any one project demonstrates the integral contribution of Blaisse's work, she says, it's the eleven massive curtains designed for OMA's Casa da Música complex in Porto, Portugal (1999–2004) – textiles that cast lacy veils against glass, disappear into recessed walls, or offer strategically placed apertures for observing underground rehearsal rooms.

For Blaisse, seemingly, all the world really is a stage. Her curtains and landscapes frame not just the routines and improvisations of daily life but the hourly spectacle of changing pattern, colour and perspective.

Opposite and overleaf
Garden Carpet, the 'Living Room',
Seattle Central Library, 2004
Injection print on 100% polyamide pile fibre
The library's transparent façade is surrounded by native tree species, grass and perennial fields that slope, fold and overlap as planes of differing greens. Inside, these green fields transform into 'Garden Carpets' printed with large-scale plant patterns.

Below
Auditiorium curtain for Seattle Central Library, 2004
Acoustically absorbent plissé printed Trevira CS and
acoustically reflecting flat PVC with bear-fur print.

Below and bottom
**Garden Carpet, the 'Living Room',
Seattle Central Library, 2004**
Injection print on 100% polyamide pile fibre

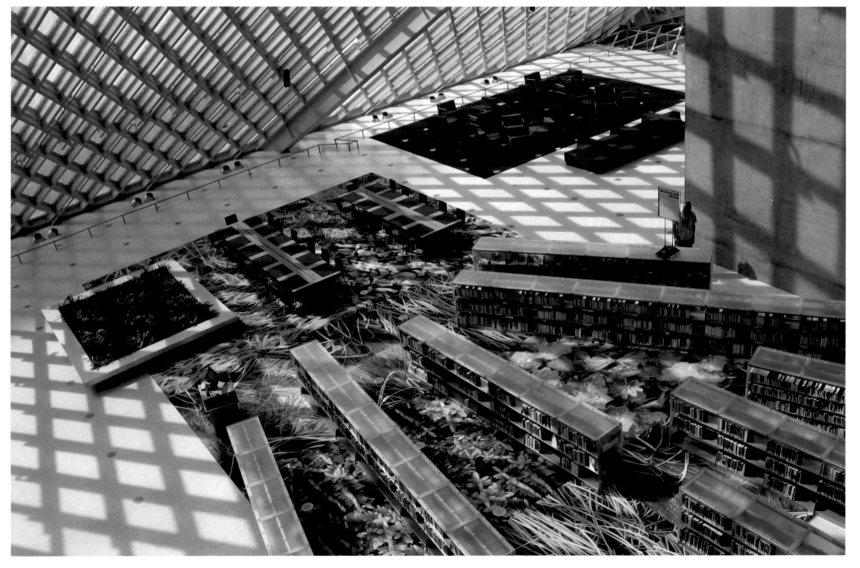

'Art wall', for Enschede's Music Theatre,
the Netherlands, 2008
Vinyl wallpaper with digital print and inlaid
brush panels, 12 x 150 m (40 x 500 ft)

Cooling and darkening curtain for private house,
Haaksbergen, the Netherlands, 2008
Bright pink velvet curtains lined with voile digitally
printed with a pattern of green grasses.

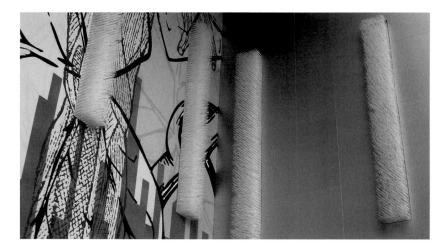

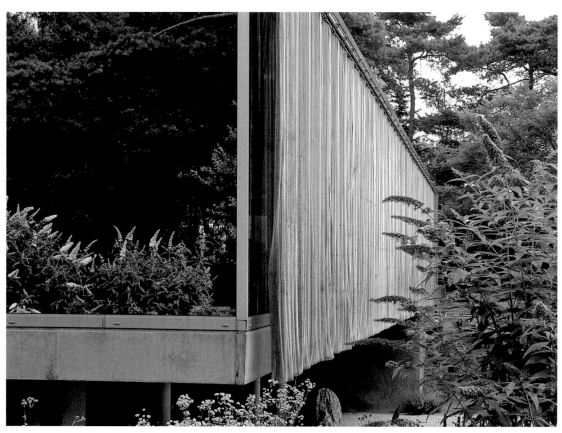

Above and right
Exterior curtain for Villa Holten, the Netherlands, 1995
Stainless steel spiral mesh and black Trevira CS voile.
To screen the fully glazed façade of this private house,
an exterior metal mesh curtain was installed, lined
with black voile and hung from an ingenious system
of scissor-like carriers running on rails that allows it
to fold and unfold at the touch of a switch. Despite the
curtain's solid exterior appearance, it is transparent
from the inside (right).

3.
lang/baumann

Artistic duo who turn art inside out – and invite you to stay the night

The world's most elite hotel opened in Switzerland to the kind of press a mere Hilton might envy. Its popularity was replicated in Germany and France, and then its developers decided to shut it down. Sabina Lang and Daniel Baumann weren't hoteliers. And although they had designed every detail of the establishment, from the retro-futuristic, blue-hued interiors to the online reservations system, they weren't designers either. They were artists known as Lang/Baumann, or L/B, and they were probing the boundary between public and private space. Their *Hotel Everland* made its first appearance lakeside at the Swiss Expo.02 in 2002, before migrating to the roof of the Museum of Contemporary Art in Leipzig and later to the top of Paris's Palais de Tokyo. Visitors who managed to get through to the reservations system to book the hotel's sole room may not have realized they were occupying a three-dimensional critique of voyeurism. But for 333 euros (444 on weekends), they had a comfortable bed and – at least in the hotel's last days of public occupancy – a spectacular view of the Eiffel Tower. The structure currently sits on the roof of the artists' studio in Burgdorf, Switzerland.

Since 1991, when they began their collaboration, L/B have dismantled the traditional art-gallery divide between observer and spectacle, as well as between public and private and between art and design. The viewer's participation with an environment is fundamental to their work. Their *Beautiful Lounge* (2003), an installation in Cape Town that doubled as a functioning cocktail lounge, was a sybarite's haven in purple and green, with wall-to-wall-to-ceiling carpets and a round, rose-coloured bar. (L/B's attachment to 1970s disco style is frequently represented in circular shapes. The couple have apparently never met a right angle they liked.)

Not that all of their artwork invites literal action. For *Dynamo Kyiv* (2001), they drew swirls in chalk on a Ukrainian soccer field, evoking the structural underpinnings of a species of football that exists only in an alternative universe. For *Spielfeld #2* (2004), they floated a soccer field in the improbable setting of a Hamburg canal. In such cases participation is no more than irresistibly imagined.

L/B's *Beautiful* series of wall paintings break through the public/private divide by introducing abstract scenery into interiors. These bright, fat parallel lines are descendants of the panoramic wallpapers that enlivened homes in centuries past, with oversize motifs lending not just colour and intensity but also spatial distortions and illusions.

As for their inflatable *Comfort* series, which began as precarious sculptures that viewers were encouraged to sit on and grew into billowing tubes snaking through lines of cars or bulging out of windows, these forms suggest invasions by an alien creature. Or are they life-support systems for inanimate buildings and autos? Lang described them as 'pieces interacting with the architecture and sort of finding their comfort in the space.' The reason they got so big, she went on, was that 'we really liked the fact that they appear so powerful and change a situation totally, but they remain just nothing – just air.'

Spielfeld #3, 2008
Epoxy paint, metal, lacquer 5.8 x 13 m (19 x 43 ft)
Part of the exhibition 'Balls and Brains' in Helmhaus, Zurich, this reimagined soccer field was used for frequent tournaments during the show, which was staged to coincide with the Euro 2008 Football Championship in Switzerland.

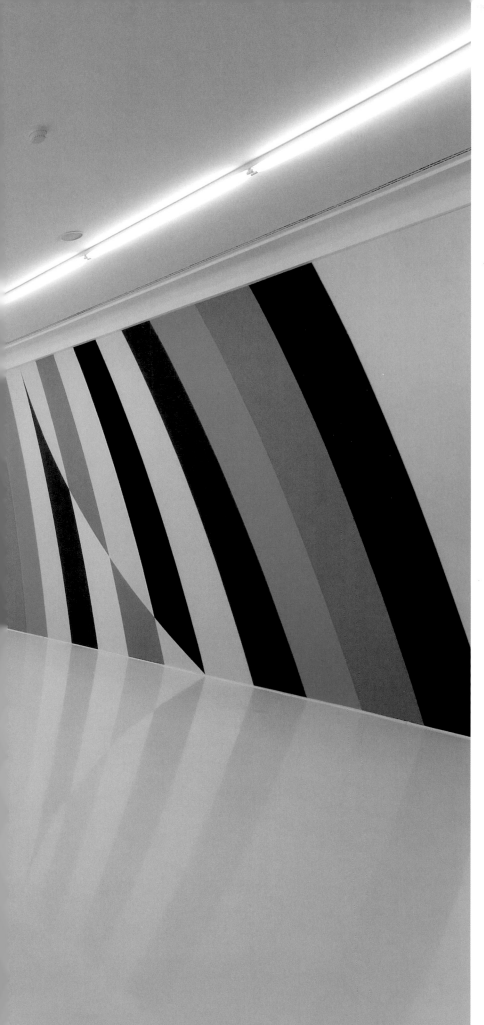

Beautiful Walls #14, 2005
Wall painting, 60 x 4.2 m (197 ft x 7 ft 9 in.)
In this installation for the 'Malereiräume' exhibition
held at the Helmhaus in Zurich, the windows of the
space were covered and a single continuous mural
painted on the surrounding walls.

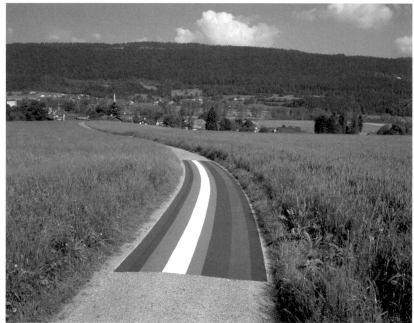

Above
Street Painting #1, 2003
Road-marking paint, 2 x 20 m (6 ft 5 in. x 65 ft 6 in.)
For the open-air exhibition 'Art en Plein Air' in
Môtiers, Switzerland, L/B painted bright, colourful
stripes on a downhill track that marked the end of
the visitors' tour. It was impossible not to walk on the
painting, as if stepping on a carpet rolled out across the
landscape. The work remained after the show ended.

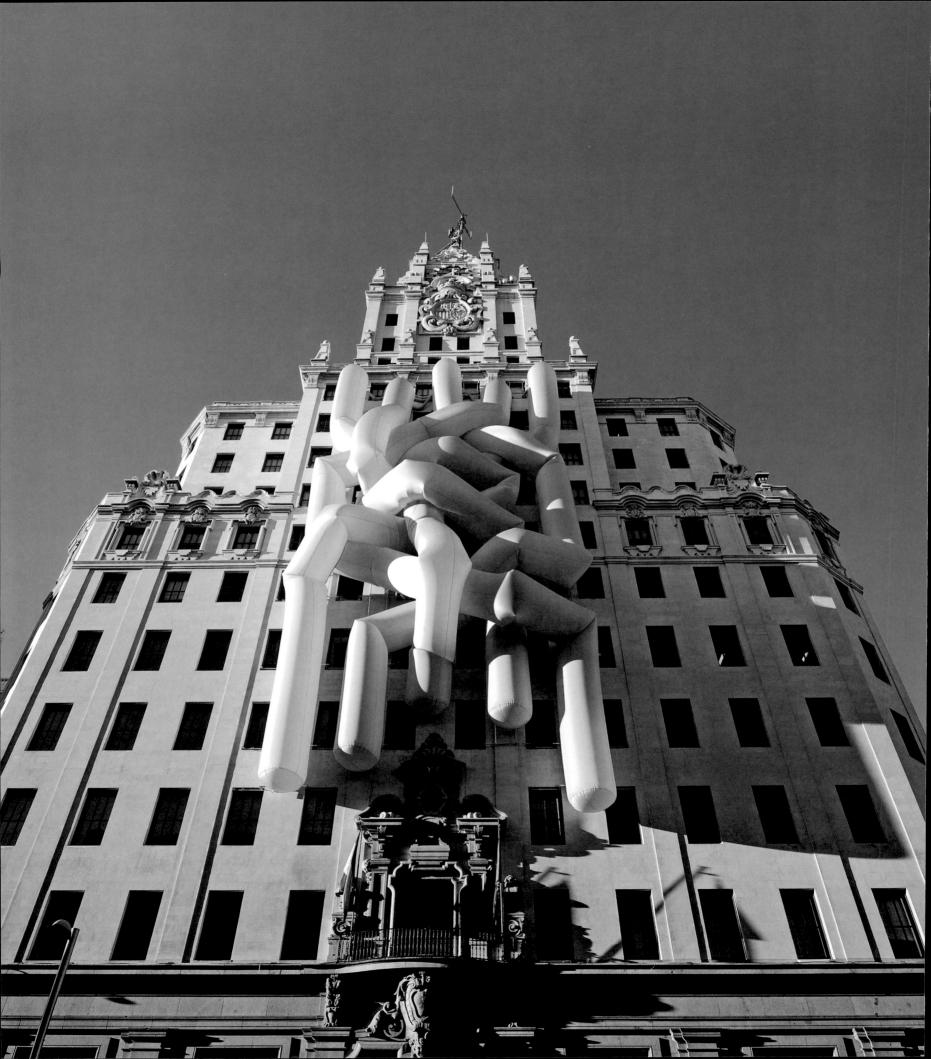

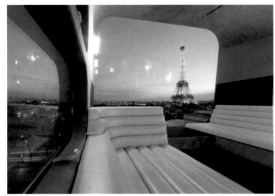

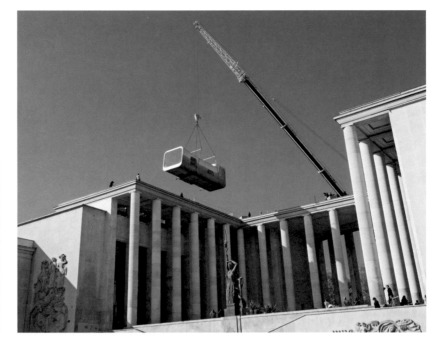

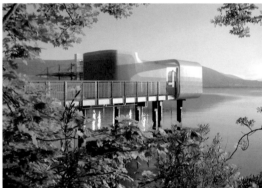

Opposite
Comfort #6, 2008
Polyester-foil tubes, ventilator
c. 14 x 36 x 5 m (46 x 118 x 16 ft)
Installed on the façade of the Fundación
Telefónica, Madrid, as part of the exhibition
'La Noche en Blanco', five golden-coloured
inflated tubes cross each other chaotically
before becoming untangled and ending in their
original vertical position, parallel to each other.

Hotel Everland, 2002
Mobile one-room hotel
12 x 4.5 x 4.5 m (39 x 15 x 15 ft)
This mobile hotel had just one room and could be
booked for only one night; the guests became part
of the work. It was installed on the roof deck of the
Museum of Contemporary Art, Leipzig (above left);
on stilts in a lake in Yverdon, Switzerland (above right);
and, most recently, on the Palais de Tokyo, Paris, with
views of the Eiffel Tower (top left and top right).

4.
klein dytham

All-seeing outsiders who blend nature, artifice and commerce in the Japanese cityscape

Modern design owes much to Japan, not least the intimate relationship between interior and exterior, a necessity in a densely populated country where life flows constantly onto the street. The Japanese urban landscape owes much in turn to a pair of Westerners who came for a six-month visit more than twenty years ago and ended up staying. Italian-born Astrid Klein and British Mark Dytham studied architecture at the Royal College of Art before moving to Tokyo in 1988. Their effort to carve a niche in a tradition-bound culture is mirrored in the type of work at which they excel: cheeky buildings and interiors with tiny footprints in oddball settings – projects whose monumental character and charm more than make up for lack of scale.

The talent of Klein Dytham architecture (KDa) lies in pushing the building envelope so that nature, artifice, and commerce are seamlessly blended. A private residence/ hair salon is adorned with a stylish exterior mural that signals the youth and creativity of its occupants (Sin Den, 2007). A clothing store's giant façade of LED pixels pulses in competition with the electric circus of Tokyo's Ginza district (UNIQLO, 2005). The glass walls of an impossibly narrow jewelry shop are stencilled with a grove of bamboo trees like a poster advertisement for Eden (Billboard Building, 2005). A construction screen sprouts thirteen species of live evergreen plants, not just occluding the view of urban development in progress but offering a vertical garden in compensation (Green Green Screen, 2003). An advertising agency is housed in a former bowling alley with a bucolic interior landscape of sloping paths and green-carpet-covered huts (TBWA\ HAKUHODO, 2007). A pod-like wedding chapel is perforated on one side like a lace veil, admitting soft, stippled light; when the ceremony ends, this screen rises up to present the newly married couple to the magnificent natural setting (Leaf Chapel, 2004).

'Stealth' is one of KDa's favourite words. It describes the effect of reflected light on the stainless-steel wedding reception space (2006) installed near their Leaf Chapel, which makes the building appear to dissolve among the surrounding trees. Or the 20-metre (65-foot) cantilevered black tube that juts into the site of their Undercover Lab (2007), a combination fashion studio, showroom and office scrunched into a minuscule Tokyo lot.

KDa have an eye for idiosyncrasy that meshes with Tokyo's antic culture while offering something new. 'Because we're outsiders, we see things in Japan that the Japanese don't see,' Dytham explained in a 2007 interview for *Dwell* magazine. 'In a taxi in Japan, I see the driver's white gloves, the lace covers, some kind of funny lights, flowers, a printer for the receipt, two or three machines that have to do with the cost, a satellite navigation system. And then in the back there will be a novel, just in case you want to read, some wet tissues, sweets, all this stuff. A Japanese person gets in there and sees nothing....'

KDa have also invented PechaKucha Night, the presentation format in which architects and designers are invited to comment on twenty slides for up to twenty seconds each. Born in 2003 at SuperDeluxe, an event space co-founded by the studio in Tokyo's Roppongi district, this model of concise, live presentation of creative work has spread virally to over two hundred cities across the world, tapping into a desire for an informal setting in which designers can meet, network and show their work in public. PechaKucha (a Japanese expression that roughly translates as 'chit chat') yields a streaming wall of creative inspiration that could be classified as a landscape in its own right – never mind the heckling.

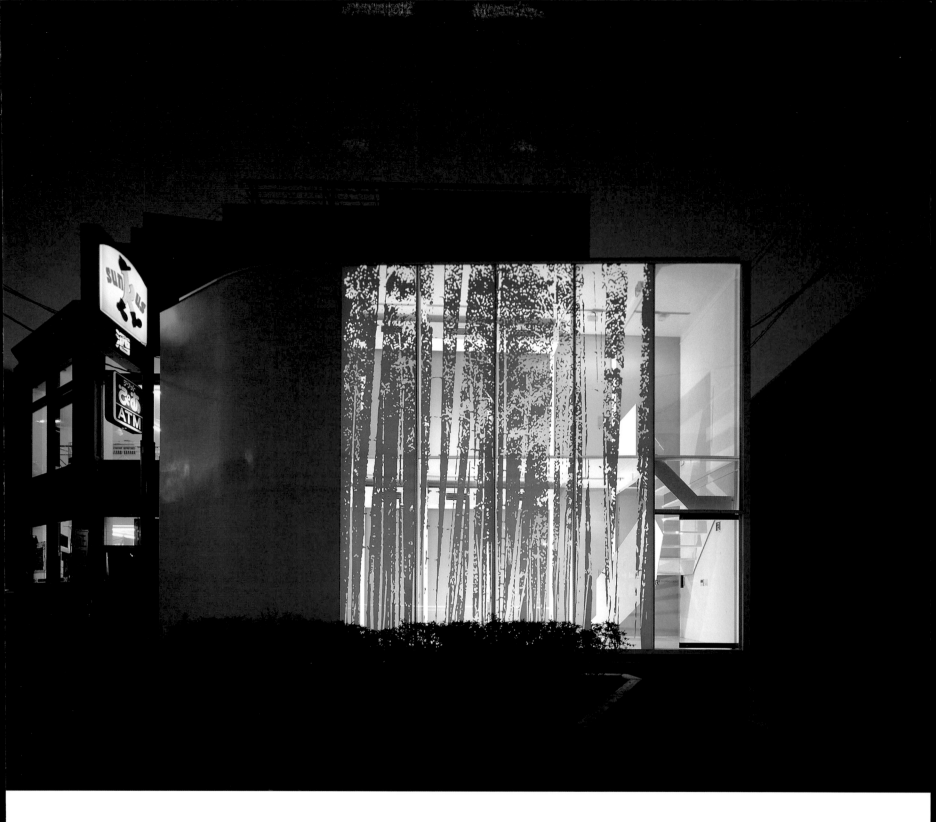

Billboard Building, 2005

Commissioned to design the building and façade
for a tiny jewelry store facing a main road, KDa
decided to 'let it be what it so obviously wanted to
be – an inhabitable billboard'. A bamboo grove was
stencilled on the glass front, and the back interior
wall painted bright green. By day the stencil functions
as a sunshade, casting dappled forest shadows over
the building's interior hallways; at night it becomes a
green bamboo plantation shining out upon the city:
a glowing 'billboard' advertising the tranquillity of
the natural world.

KDa have an eye for *idiosyncrasy* that meshes with Tokyo's *antic* culture while offering something new.

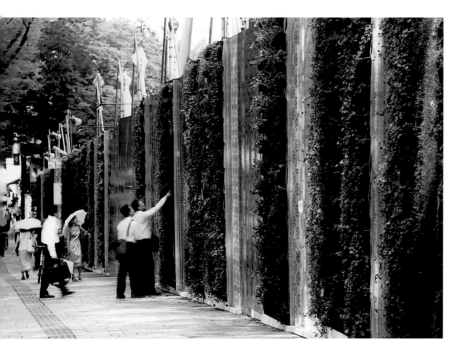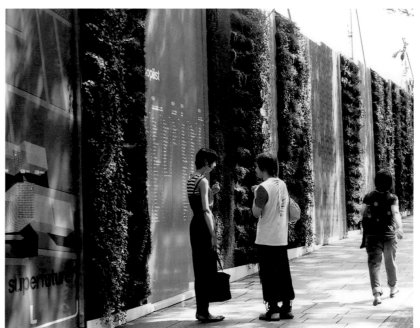

Green Green Screen, 2003
This lush, dynamic installation turned a functional construction screen into an urban garden, alternating vertical plantings of thirteen varieties of trailing evergreen plants with green graphic panels. Running almost the full length of Tokyo's central promenade, the screen hid the building site of Tadao Ando's large mixed-use development and remained in place for three years.

UNIQLO Ginza store façade, Tokyo, 2005
This façade is made up of a matrix of 1,000 illuminated cells, which can be programmed to produce chunky Tetris-style patterns. The heavily pixelated 'electro-retro' appearance contrasts with the elaborate hi-resolution LED façades of the luxury-brand flagship stores in the Ginza shopping district, reflecting UNIQLO's emphasis on simple, casual clothing.

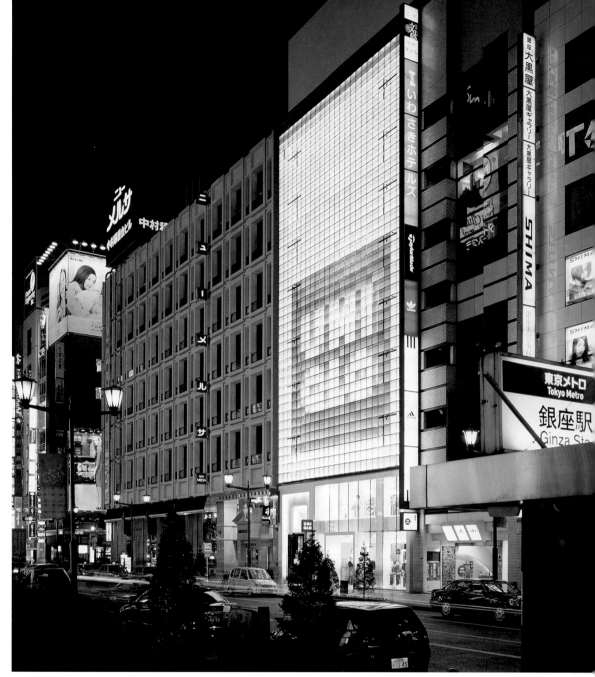

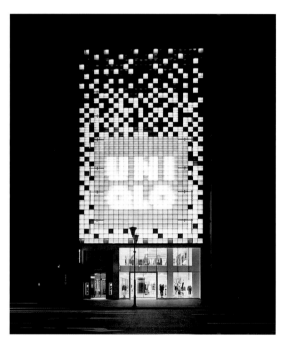

5.
ab rogers

Interiors that weave a world of sensations appealing to nose, ear, skin and eye

Ab Rogers received his first formal design training as a cabinet-maker – but he received his first design training as the son and stepson of three architects. He left school at fifteen to be an apprentice cabinet-maker and spent a decade pursuing the immaculate craft of making pieces fit together. At one point, he also ran off to sea for a year. Then, in his late twenties, Rogers went back to school, studying industrial design at the Royal College of Art. Today, his London-based multi-disciplinary studio, Ab Rogers Design (ARD), produces commercial and residential interiors and museum exhibitions, including the 2008 retrospective at the Centre Pompidou of work by his father, the Pritzker Prize-winning architect Richard Rogers.

Though ARD interiors are diverse, they have two things in common: they are wholly absorbing environments filled with unexpected twists and perspectives, and they are elegantly constructed machines for experience. The cabinet-maker lives on.

Rogers's concept for the Emperor Moth clothing boutique in London's Mayfair district is a three-dimensional mosaic of mirrors reflecting the vibrant colours of the Russian designer Katia Gomiashvili's fashion line. The design features subtle nautical references. A hot pink horizon line provides some orientation, but the mirrored planes disrupt the boundary between walls and ceiling, much as the ocean-going eye finds water and sky dissolving into a continuous mass. 'The [poured resin] floor is a pool of colour inspired by the sky, sea and air to be a calming element within the chaos,' Rogers stated when the shop opened in 2006. 'Mirrors can act as camouflage, reflecting and continuing what is around them, portholes into the world around us, maybe even the universe.'

A world resonating in a nutshell also describes Rogers's experimental makeover for Little Chef, the UK's half-century-old roadside restaurant chain. The Popham branch opened in January 2009 as a hotbed of nostalgia for 1950s diner culture (banquettes, tiles, bright red vinyl upholstery) while celebrating contemporary advances in technology and cuisine. (Under the direction of the celebrity chef Heston Blumenthal, the menu features braised ox cheeks and mussels in cream and wine.) And just as Rogers used mirrors to visually expand Emperor Moth's interiors to infinity, he tiled Little Chef's ceiling with an irrepressible blue sky.

Throughout his practice he's resisted a single drumbeat of impact in favour of weaving a fugue of sensations. True, along with his former partner Shona Kitchen, he designed a sleek, shiny red Comme des Garçons shop in Paris with moving benches (2001). And true, they outfitted Michel Guillon's electric blue optical shop in London with display cases that opened and closed mechanically (2004). But both projects transcended gimmickry. As curator and critic Lucy Bullivant wrote in a 2004 article, 'ARD excels in [an] indeterminate sphere, a place not virtual but dynamic.'

Like a few of his contemporaries – the Muji creative director Kenya Hara and the interior and product designer Ilse Crawford spring to mind – Rogers pushes for design that appeals to nose, ear and skin as well as eye. 'The norm is to create slick commercial objects which save on labour and are produced in dull, conservative colours,' Rogers has noted. 'These objects do not smell. They are cold to the touch. They have no taste. Their sounds are hard.' His is a futurist's approach to a richly sensed, deeply inhabited present.

Emperor Moth boutique, Mayfair, London, 2006
Luxury sportswear label Emperor Moth was launched by young Russian designer Katia Gomiashvili. For the brand's Mayfair boutique, Ab Rogers introduced a 3D mosaic of mirrors that echoes and intensifies the vibrant colours of Gomiashvili's designs.

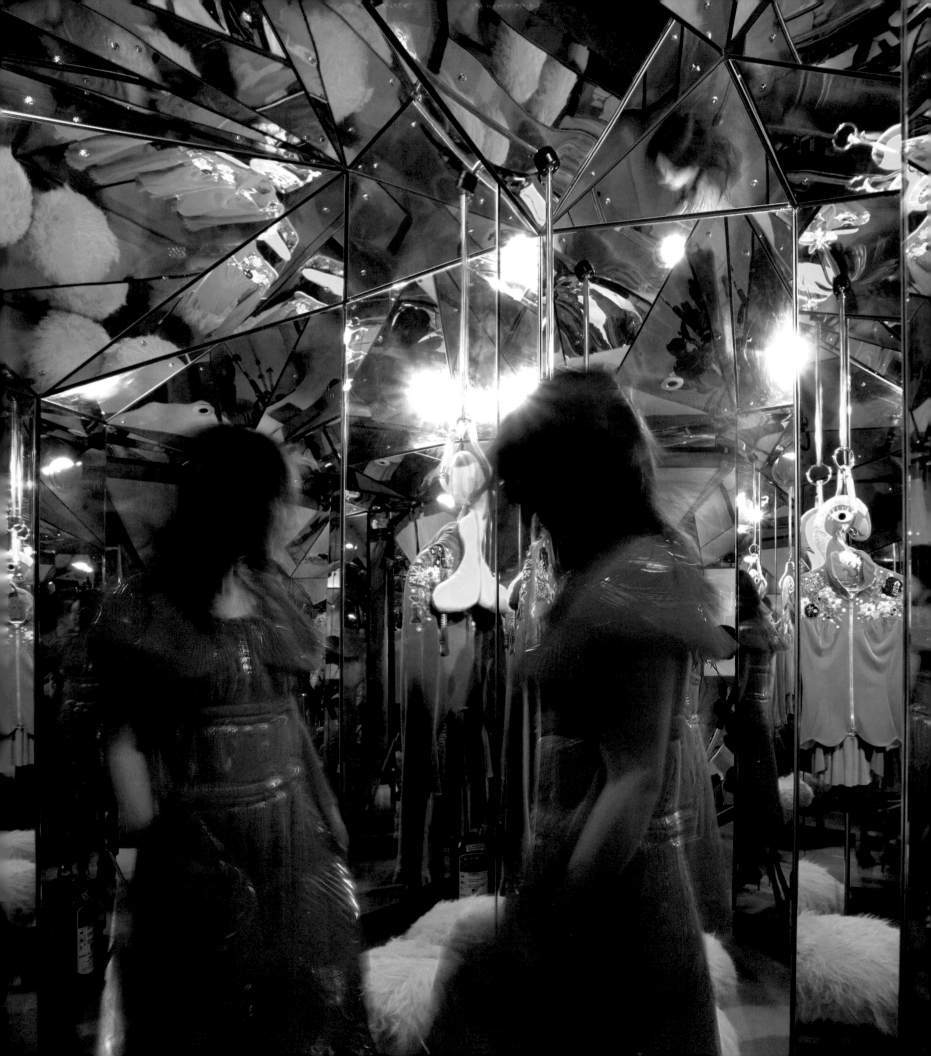

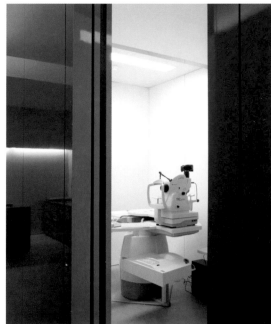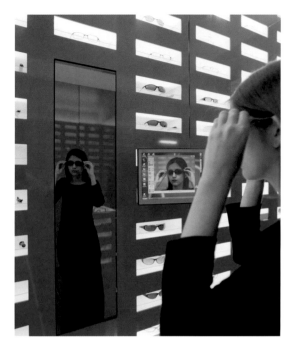

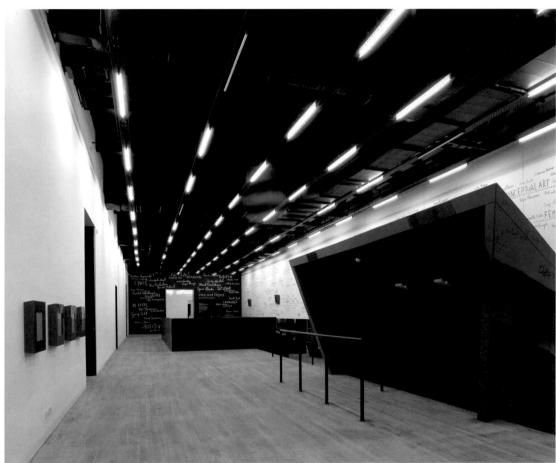

Top row, this page and opposite
Michel Guillon, London, 2003
The optician's store on the Kings Road features a 14-metre (46-ft) blue wall containing 462 compartments, each displaying a pair of spectacles against a brilliant white background. Integrated within the wall is a kinetic installation which, as if by magic, pushes individual spectacles forward and quickly retracts them, making the store almost appear to be alive.

Above and opposite centre row
Tate Modern, Level 3 and 5 concourses, London, 2006
To coincide with the first complete rehang of the Tate Modern's collection, ARD redeveloped the museum's Level 3 and 5 concourses, grounding the interior around a set of angular structures, with a hand-drawn timeline of art history connecting the two levels. The dominant red colour reflects the simple, vibrant palette of much Modernist and contemporary art.

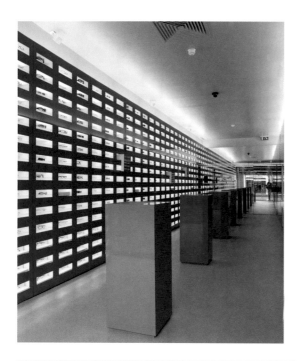

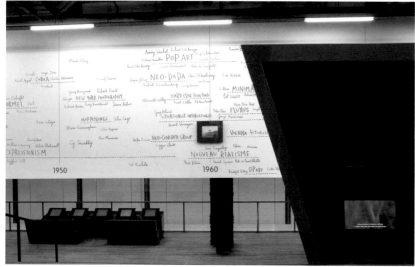

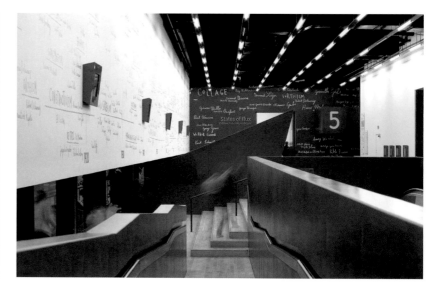

Above and right
Comme des Garçons, Paris, 2001
ARD created a simple, striking identity for the
Japanese fashion brand's flagship store near the
rue du Faubourg Saint-Honoré. Reflective walls of
red fibreglass dominate the interior, while ARD's
signature kinetic elements feature prominently:
a motion sensor in the outer courtyard opens red
aluminium sliding entrance doors to the store.
Inside, red fibreglass cubes skate back and forth
across the floor, seemingly of their own volition.

street world

tristan manco

introduction

tristan manco

Graphic designer, art director, lecturer and author of multiple books on street art and graffiti

What makes street art exciting? How did it come to be so important today? Street art and graffiti, once minority subcultures, are making increasing impact on the mainstream, becoming an influential force in the visual arts and beyond. This despite the fact that we live in a world of global digital communications and high-tech entertainment. Millions of us are hooked up to the internet, TV and computer games. And yet simple spray paint, stencils or posters on a neighbourhood wall have resoundingly captured our imagination. Internet sites, books and magazines devoted to street art and graffiti proliferate. British street art icon Banksy regularly makes front-page news. How did this happen?

Since their rebirth in the late 1990s, the street art and graffiti scenes have become bolder, wilder and more imaginative forms of artistic communication. They represent an independent voice in our city spaces, a refreshing alternative to conventional media and sterile urban planning. Graffiti and street art are often described as the planet's biggest art movement. Wherever you are in the world, someone will be painting a wall, or adding some kind of visual communication to his or her environment. The result is a textural build-up of layers, words, images and symbols across our cities. Although made by many individuals, graffiti and its culture are experienced by the viewer as a collaborative display. Artists are inspired to add their mark to urban spaces, to interact with other street artists and dream up new ideas and imagery. The genre has become an evolving visual language that slowly changes as individuals create new styles and approaches. To select just five artists to represent the most innovative street art is therefore a daunting challenge. Innovation is the lifeblood of the culture. For every artist whose work

has won recognition, there are many less celebrated artists who have also contributed. Those showcased here stand out as individuals, but at the same time they embody the collective spirit of street art.

Perceptions and definitions of street art and graffiti vary widely. Historically the term 'Street Art' was first used in the 1970s and 1980s to describe the work of artists who were creating art in public spaces, particularly in New York. Artists such as John Fekner, Jenny Holzer and Barbara Kruger explored ways of engaging with the public on a political or conceptual level using media such as stencils, billboards, LED signs and sculpture. On an architectural scale, American artist Gordon Matta-Clark was becoming famous for his 'building cuts', in which he removed entire sections from abandoned buildings as if slicing right through them. At the same time graffiti writers such as Dondi, Lee Quinones, Crash and Daze developed a whole subculture and visual language based on illegal painting, from quick tags to typographic masterpieces on subway trains and walls. In those days the two arenas were entirely distinct; this time around, as we ride a second wave of street and graffiti art, the differentiation has blurred.

The boom in graffiti and street art in the late 1980s spread across the world but was gradually succeeded by a creative lull. As walls became choked with generic graffiti, artists needed to find ways to stand out. The mid-to-late 1990s was a period of slow evolution as key figures such as Barry McGee, Cost and Revs, Espo, Os Gemeos and Banksy began to perfect their style and change the way artists approached graffiti. From San Francisco, Barry McGee revolutionized the use of figurative characters and made many innovations in the gallery context. New York graffiti writers Cost and Revs branched out into street art territory using stickers and posters as well as starting a trend for using rollers to paint giant letters and slogans on the roofs of buildings. Also from New York, Stephen Powers aka 'ESPO' brought a vernacular sign-writing influence to the scene and had a huge impact with his top-to-bottom letters painted on storefront shutters. São Paulo's finest, the Os Gemeos twins, brought a touch of magic with their unique character-based art and giant murals, while the UK's Banksy revived stencil graffiti and created his own brand of guerrilla art.

While graffiti was being revolutionized by new techniques, stickers, posters and stencils were appearing more widely on the streets, signalling a street art revival. One of the most influential street artists from this time was LA-based Shepard Fairey, whose famous 'Obey' poster and sticker campaign used the language of advertising, propaganda and

graphic design to parody the authoritarian tone of the communications that fill our public spaces. Many more artists from this period were doing all kinds of work, from mural painting to street sculpture to billboard liberation. By the end of the 1990s they had turned the streets into a hotbed of creative activity. It was from this new wave that the innovators featured in this chapter emerged.

Artists come to graffiti and street art from all kinds of starting points and find their own reasons for continuing to make it. A street artist might also be a fine artist or graphic designer, a campaigner, or all of these. His or her work may engage with other visual arts disciplines such as art and architecture, or it may address political or social issues. The artists featured here have taken diverse paths and have used the street to communicate in different ways.

American artists Leon Reid IV and Brad Downey (aka Darius & Downey) create carefully crafted street art and installations that often use humour to reclaim and re-humanize our urban environments. New York paste-up and installation artist Swoon focuses in her work on the human presence in the urban environment. French 'photograffeur' JR interacts with communities, telling their stories through photographic-based street art. Also from Paris, the artist Invader works on a global canvas, exploring the physical make-up of our cities and commenting on our modern world through his viral game play. Italian artist Blu focuses on the aesthetics of surface and scale through his gigantic figurative painting, which fills entire façades of buildings.

For all their differences, these artists share certain key qualities. Most important is a talent for communication. Successful street artists are those that can genuinely connect with an audience. There is no formula for this. It could be achieved by making something beautiful or surprising, whether an image, installation or message. Street art is typically created in a generous spirit, to be shared by everyone. If the work is thoughtful, engaging and of high quality, the public will be left wanting to share it, talk about it and discover more by the same artist.

Equally important is an understanding of the street. The artist needs to experience a city, to be interested in how it functions and how it is inhabited. Placement is everything in street art. How a work looks on a particular surface and how it communicates in a particular space are essential dimensions of the art. When choosing a location an artist must consider who will see the work and in what context, and how long it's likely to last. For anyone producing illegal graffiti, success depends on understanding how it will be perceived by the public at large and

Successful street artists are those that can genuinely *connect* with an audience. Street art is typically created in a *generous spirit*, to be shared by everyone.

also by the graffiti community. The city walls create their own checks and balances. If you go over someone else's work you can expect repercussions. If you copy another person's style or idea you can't expect high regard. And if a wall becomes too covered in graffiti it may end up being 'buffed' (cleaned), so the fun is over for everyone.

If an artist's work is regularly seen and appreciated, gradually he or she may gain recognition and fans. With that comes a certain amount of responsibility and a two-way communication. The artists in this chapter have all had a positive reception to their work and at the same time have found additional ways to communicate with their audience, whether through books, websites or interviews. On one level this is simply good PR, but the artist's vision is also an important element of their work. For art is in essence a dialogue between maker and viewer. The more interaction the public can have with the work and its maker, the more that dialogue can develop.

While on the one hand street art and graffiti are some of the freest forms of art and communication, the genre can also be restricting since it is circumscribed by a number of preconditions. The work needs to be created in public space and almost by definition be created illegally. For some artists these conditions are perfect, but it is not surprising that many artists branch out into other areas: for example, Blu's animations, JR's documentary film work, Swoon's sculptures and Darius & Downey's officially sanctioned public art as well as a film and a book. Street work may remain at the heart of an artist's practice, or it may be a stepping-off point into other areas that can rejuvenate his or her whole output.

As an art form, street art exists solely in the public domain, but its practitioners are frequently adept at working in other contexts. Many street artists have adapted their work successfully and in original ways to gallery or museum spaces. How they adjust themselves to commercial and institutional settings varies widely. Some enjoy creating artworks for sale, while others find this troublesome, preferring still to sidestep the buyer/seller relationship of the art market. Blu, for instance, avoids making exhibition work on canvas, preferring instead to exhibit and sell only pages from his sketchbooks. These are working drawings, not originally intended for commercial distribution.

Away from the street, the physical context of the art is also changed. JR has exhibited photographs of his street campaigns both inside and directly outside museums and institutions. Swoon has taken advantage of the controlled space of the gallery to make elaborate sculptural installations that would have been impractical on the street.

The changed perception of their art when transferred to a commercial environment can work to the detriment of street and graffiti artists. Since street art is free, when an artist sells work in another medium it is sometimes looked upon as a 'souvenir' of the original work rather than an artwork in its own right. In some cases it can be true that an artist's work is more exciting when it's free and outside. But street artists can often also bring an intuitive energy to their off-street work.

Another paradox in the commercialization of street art and graffiti is the pitfall of success. Some success is a good thing – too much can be the opposite. Street art is often an alternative or even subversive voice, speaking out against injustice or mainstream culture; to profit greatly from such work can seem hypocritical. To avoid this, a number of artists including Swoon and Banksy have made charitable donations and instigated projects for the public good.

If success and publicity are among street art's current problems, then these are the kind of problems many other art forms would be happy to have. As an artistic movement it has the kind of inclusiveness and popularity that museums and cultural institutions can only dream of. As a culture that thrives on fresh ideas and maverick spirit, the world of street art is a rich source of inspiration for practitioners in other artistic fields, from illustration and graphic design to fine art. A great deal of art created on the street, outside of established commercial, institutional or legal frameworks, has an immediacy and excitement that is hard to find in any other creative field.

Blek le Rat was one of the earliest graffiti artists in Europe, and the first to work with stencils. He began stencilling his iconic silhouette of a rat on the walls of Paris at the beginning of the 1980s, and his subsequent work using stencils, posters and stickers has profoundly influenced today's generation of street artists.

on innovation
blek le rat

Inspiration is the magic moment between activity and inactivity. I've often found these moments of inspiration when I'm on the road, driving, in the middle of a long car journey, perhaps when I'm having a conversation with the person next to me. *Suddenly an inspiration will come to me*, stimulated by the exchange of ideas, by intense interaction and by forgetting myself. Ideas become clearer and images present themselves and emerge in my mind. They come to me so strongly at such moments that their execution becomes inevitable.

I've never believed that things can actually be invented. Everything exists already and everything has been done and redone. Pure invention doesn't exist; rather we try to improve or redo what already exists, but in our own ways, with our own backgrounds

and education, by arranging things and making them understandable to people in the present day. Millions of Christs on the cross have been painted by so many artists over the last two thousand years, but no two Christs are alike. *Each artist leaves his own mark, and brings his own sensibility to the image. Either you like an artist's sensibility or you don't, but in any case the invention and creativity are only a personal appreciation of our physical and intellectual environment.* Pure invention and creation can only come from the divine.

Innovation is part of the creative process. I've tried to make use of all the things I've done since the day I was born to innovate in the artistic domain in which I've chosen to express myself. Everyone in the history of art should try to form part of a link in the chain of creative evolution.

6.
darius & downey

Artist-adventurers whose street sculptures and installations bring wit and life to our urban spaces

The worlds of graffiti, street art and public art sometimes cross over. In the work of American artists Leon Reid IV (aka Darius) and Brad Downey (aka Downey) they have become an adventure playground of possibilities. Both in partnership and as individuals, these street artists have woven an increasingly original path to engage with the urban environment and its inhabitants. Wherever they have found conventions they have mercilessly punctured them. Whether it is the codes that structure our cities or the conformities of art practice, they have found ingenious ways to draw attention to the rules by craftily breaking them.

The pair first began working together in 2000, after meeting as students in Brooklyn. Leon was a graffiti artist who had been painting as 'VERBS' since 1995. Brad was making a film about Leon's alternative artistic education and in the process was inspired to make his own street art and graffiti in partnership with Leon.

Influenced by New York artists such as ESPO, they were inspired to make graffiti in original ways. Leon gave up painting VERBS and instead began to paint slogans using rollers, keeping things fresh and friendly with phrases such as 'Who Farted' in range of the Ohio River's notorious stench. Together they continued in this vein, painting simple slogans on a giant scale on the tops of buildings or beside the highway rather than competing in the style wars of classic graffiti writing. They wanted to accentuate the positive, challenging graffiti's negative reputation with work that was fun and accessible.

Over the next five years Brad and Leon spurred each other on to invent ever more innovative ways to make their mark. During a stay in Atlanta, Brad began to see the potential of small, subversive interventions in public space: a slightly altered sign, some additional road paint or a poster could be just enough to subtly change the reading of the landscape. Meanwhile in Cincinnati Leon was installing affirming messages in impoverished neighbourhoods: 'Read', 'You Caan Do It' or 'Don't Let Go'. Gradually their work became more ambitious and sculptural with a series of highly specific street installations, as they learned their craft through observation, trial and error.

Throughout their collaboration they documented their activities alongside others who inspired them such as Swoon, Shepard Fairey, Giant and fellow street sculptor JJ Veronis. The final result was the film *Public Discourse*, released in 2003, an exploration of illegal street art directed by Brad Downey with Quenell Jones as cinematographer. The film and later the groundbreaking book *The Adventures of Darius & Downey and Other True Tales of Street Art*, narrated by Ed Zipco, communicated the Darius & Downey mission. The book and film gave away almost all of their secrets – including their practice of donning disguise and posing as construction workers – while describing their successes, failures and epiphanies along the way.

In 2005 the Darius & Downey partnership came to an end as they found themselves living and working in different parts of the world, but both have gone on to ever greater success. In New York, Leon Reid IV has been working within the public art system, which has given him the opportunity to create much larger works. Brad Downey lives in Berlin. He continues to work partly in covert street art and to make short films, but also finds ways to make larger works with permission.

Public art has a reputation for being staid and some street art can be rather predictable but Darius & Downey point to how exciting both can be. In their work, both legal and illegal, as partners and as individuals, their energy, exploration and sense of fun have created a new benchmark for street art and public art alike.

David vs Goliath, 2006
Leon Reid IV, Brad Downey (Darius & Downey)
New York, duration two days

The Tree, 2005
Brad Downey
London, duration two weeks

A Father's Duty, 2003
Brad Downey
London, duration: father figure six days;
sign four months

Top
Love is a Two-Way Street, 2007
Leon Reid IV (Darius)
São Paulo, commissioned by S.E.S.C., São Paulo

Above
True Yank, 2009
Leon Reid IV (Darius)
Manchester, commissioned by Urbis Manchester

Cannons, 2008
Brad Downey
Berlin

CCTV Sacrifice, 2008
Brad Downey
Berlin

7.
invader

Colourful retro-geek mosaics take over the world, one installation at a time

Space Invaders n. a classic arcade game originating in 1978. Alien invaders formed from clusters of pixels battle to destroy earth's buildings brick by brick.

Space Invader n. artist of French origin who since around 1998 has been invading cities with characters inspired by retro arcade games.

There are now two common definitions for the term Space Invader, both with a cult following. One is a retro gaming experience, the other is a larger game played out in real-life cities across the world.

Invader, as he prefers to be known, originally set out with a modest invasion plan of Paris. On street corners, dotted high and low, he began to cement ceramic tiles in mosaic representations of the classic space invader icon. Each coloured tile represents a pixel. Small, unobtrusive and yet eye-catching, these additions to the city's fabric were an instant hit with Parisian residents. The public had a new game: spotting Invader's advancing forces.

Unlike the pixel-shooting arcade game, these invaders came in peace. There was a quiet subversion to the whole plan. Although the mosaics were illegally placed, something about their considered positioning and their materials didn't feel like vandalism. It was not all plain sailing, however; sometimes building owners and passers-by became suspicious and installations had to be hastily aborted. Once up, though, many of these benevolent invaders have survived a surprisingly long time.

In the hands of lesser mortals, this brilliantly simple idea might have been short-lived and local, but Invader had a master plan. He soon recognized the need to launch the project on a planetary scale, and very quickly became a globetrotter. The process of invading took on new dimensions; it became an observation of our cities, how we inhabit them, and how the urban landscape changes over time. Almost like an alien scout, studying the planet for signs of life, Invader's meticulous documentation began to look like a real invasion feasibility study. As he creates his installations, each one is photographed, catalogued with a number and marked on a map. Once completed, he produces a printed invasion map detailing the location of each mosaic, which people can then visit. Playing himself at his own game, he has also devised a scoring system, awarding each installed Space Invader between 10 and 50 points.

Over a ten-year period, city after city has succumbed to this friendly invasion, from Melbourne, Mombasa and Tokyo to London, Kathmandu and Los Angeles. No two mosaics are the same and each city's atmosphere has been influenced and subtly changed by the installations. In Paris some Space Invaders mimic the blue colour of old-fashion street signs; in Barcelona they are camouflaged to look like the city's old stone. In each setting they inevitably add to the archaeological layers of urban history.

More recently Invader has diversified his repertoire to create work for the gallery context. In what he calls his 'RubikCubist' pieces, he employs another famous 1980s game to nostalgic and emotive effect: dozens of Rubik's Cubes arranged to recreate iconic images in pastiche digital style. The Space Invader and the Rubik's Cube date from an era not so far back, yet already remote enough to invoke nostalgia. Invader's retro-geek images are a reminder of simpler times, but they also signal the beginning of the digital age that we have entered and from which we can never return. In a world of instant digital communications, Invader has slowly spread his viral message by hand, sometimes three or four mosaics a week. The global invasion continues…

Space Invader #10 of Varanasi, India, 2007

There are now two common definitions for the term *Space Invader*, both with a *cult following*. One is a retro gaming experience, the other is a larger game played out in real-life cities across the world.

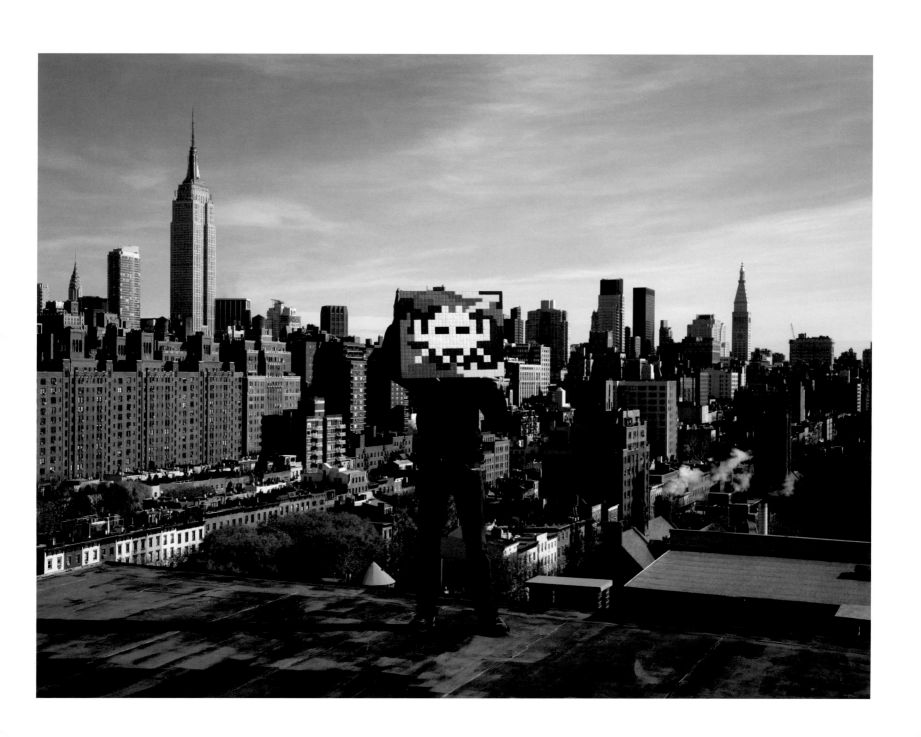

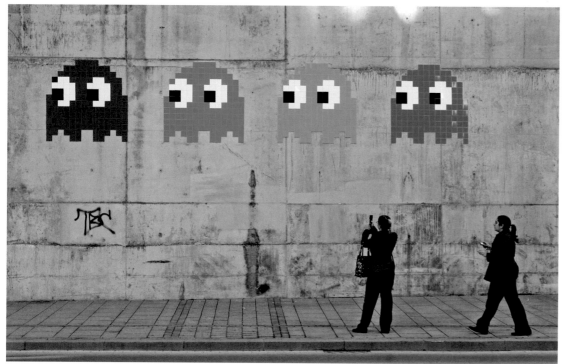

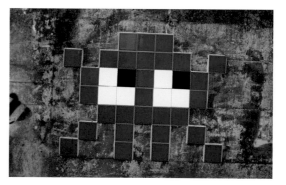

Top
Space Invader #88 of NYC, 2007

Opposite
Invader in New York, 2007

Above
Space Invader #23 of Bilbao, 2007

Top
Space Invader #10 of Côte d'Azur, 2006

Above
Space Invader #22 of Bilbao, 2007

8.

swoon

Spectacular artistic journey from intricate poster cut-outs to floating performance art

A defining quality of street art is engagement with the public. Swoon is a Brooklyn-based artist who exemplifies this ethos with admirable passion and flair. She made her first forays into street art in 1999 and developed her signature wheat-pasted cut-out figures over the next few years. Having initially enjoyed the process of adding to the chaotic surface layers of New York, she became excited by the interaction of strangers with her work. People were drawn to her characters, to the intricate detail and craft of her pieces and to the imaginary narratives they evoked. This fostered in her a greater sense of her audience and of the value of public and performance art. That would one day lead to the founding of a community arts centre, travelling with a theatre group on a riverboat and more…

The cityscape is a big influence on Swoon. Its architectural structure, its constantly shifting surfaces and its role as a backdrop to day-to-day human stories have all helped shape her work. At first her life-size portrait prints were of friends and family. But as she reflected on how her images seemed to populate the city, her focus shifted to anonymous, everyday folk – construction workers, a bicycle courier, children playing. Often printed using woodcut or linocut, she wove such figures into drawings of city scenes, so that each would be formed by fragments of images within images and merge with adjacent posters and other ephemera. The cut-out shaped allowed the texture and colour of the urban backdrop to show through.

Made of paper, often hand-cut to fine filigree, her work is subject to an inevitable cycle of decay, but she celebrates this as part of the process. Exposed to the elements, to people and to new layers of posters, it is ever changing, like the city itself. In time, the paper rots, curls, rips, gets covered in dirt and then is gone.

By 2005, Swoon's work was gaining wider recognition. Although she kept her own identity under wraps, she became a key communicator for a scene that often did not communicate itself well. Projects in places such as Cuba and Berlin gave her new perspectives and led to further invitations to exhibit. While still a consistent champion of street art, she accepted some carefully selected opportunities with institutions and galleries. The resulting work remained influenced by outdoor spaces: sculptural, theatrical installations that play with shadows and layers.

With commercial success came the freedom to take her work on the road…or, to be precise, down the Mississippi River. In the summer of 2006, a plan was hatched to build a raft in New York, recycling wood used in her last gallery show, then reassemble it on the banks of the Mississippi. The floating structure would travel on towards New Orleans, docking at towns along the way to present workshops and performances. Dubbed *The Miss Rockaway Armada*, this project comprised an assembled crew of thirty carpenters, welders, artists and performers, who together provided enough collective skill and goodwill to bring it off.

The communal creativity of the venture and the participation of the public were just as important to Swoon as any aesthetic result. The message was clear: cultural and artistic activities don't need a commercial or institutional rubber stamp of approval. In the autumn of 2008, a second flotilla was launched, this time along the Hudson River, made up of seven boats and the work of seventy-five collaborators directed by Swoon. Titled *Swimming Cities of Switchback Sea*, it too aimed to be part-exhibition and part-living performance on a floating sculptural city. Its final destination, appropriately, was New York – the metropolis where this ongoing artistic journey began.

'Hua-Hua', or 'Sewing Lady', *Swimming Cities of Switchback Sea* (detail), 2008
Installation at Deitch Projects, Long Island City, Queens, New York

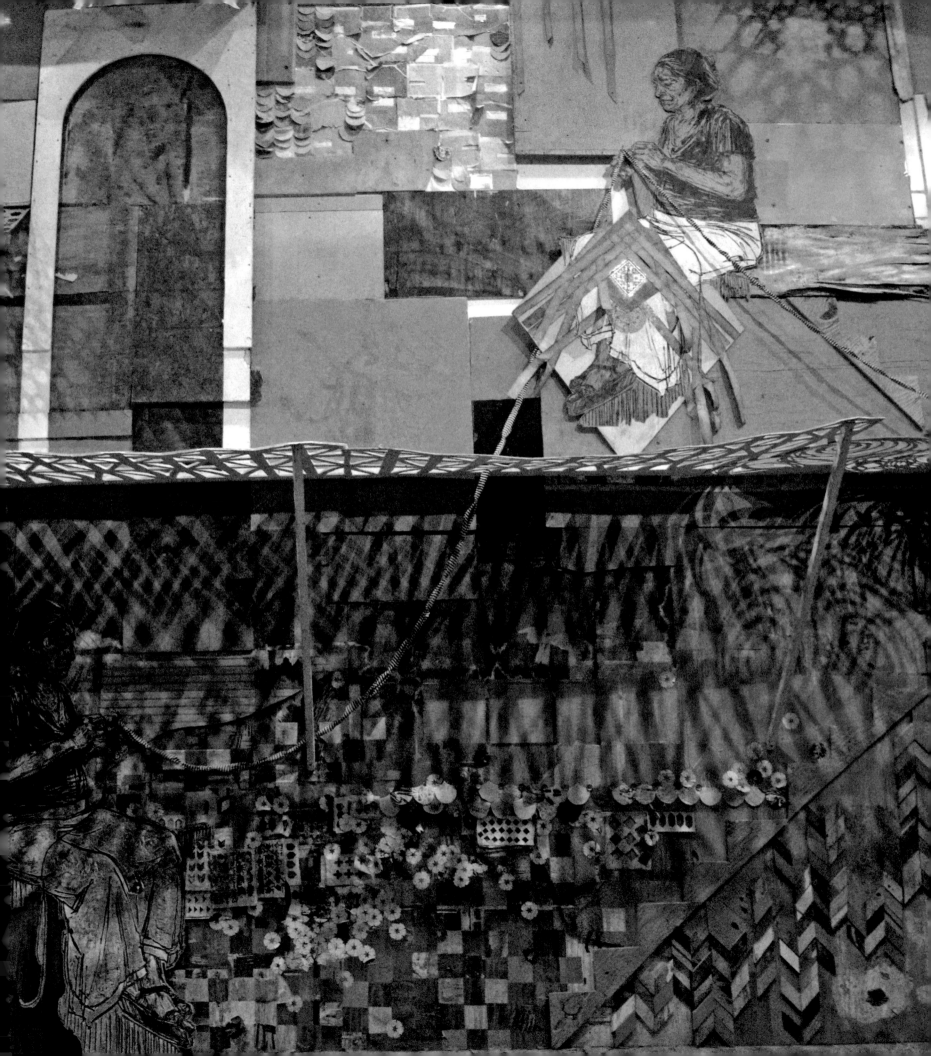

Portrait of Sylvia Elena (detail), 2008
Installation at Yerba Buena Center for the Arts,
San Francisco, California
Cut paper and found wood

Zahra, 2007
Paste-up on the separation barrier between Israel and
the West Bank, Bethlehem

Helena
Street paste-up. Block print with spray paint on paper

Bethlehem Boys, 2006
Block print and drawing in progress in the studio

Swimming Cities of Switchback Sea (detail), 2008
Installation at Deitch Projects, Long Island City,
Queens, New York

La Boca del Lobo, 2006
Swoon in collaboration with Alison Corrie
and Polina Soloveichik
Installation at Black Floor Gallery, Philadelphia

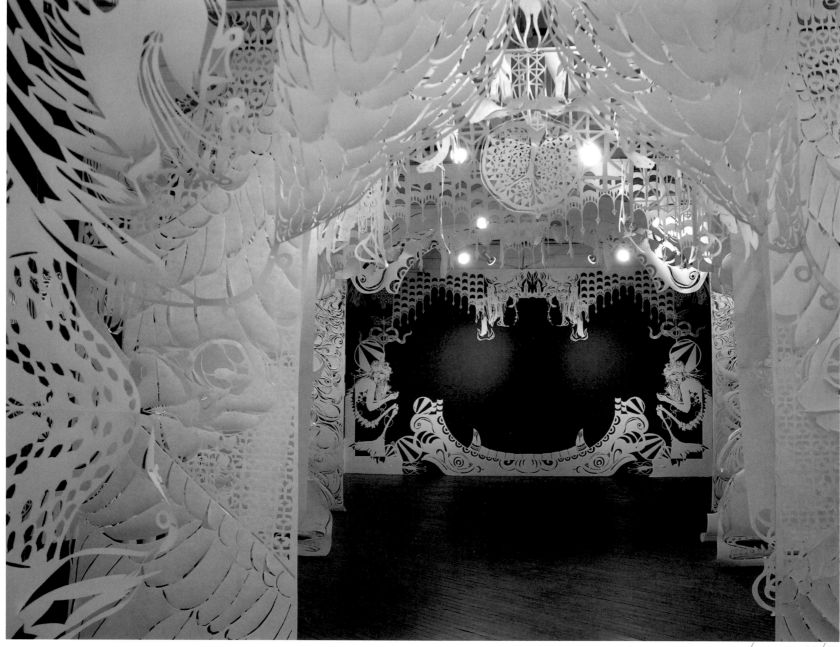

9.

jr

Young photographer whose giant poster portraits defy stereotypes and touch communities

Provocative yet sympathetic, the work of Parisian photographer JR has made headlines around the world. The streets are his galleries where he pastes giant blow-ups of his own photographs. These images, usually portraits of ordinary people, speak about the lives of others, celebrating both differences and similarities and exposing social realities.

His audience is caught by surprise; passers-by stumble on the work as they turn a corner somewhere in the city. Captivated by an enormous portrait, they are transported from their own thoughts to stop and look, to point or maybe share with a friend. Perhaps to wonder how these images came to be and what they are saying. Who are these people?

Just 25 in 2009, JR has already had an extraordinary career. A key turning point for him came when he found a camera on the Paris Metro in around 2001. He was a young graffiti writer at the time and with camera in hand he began to document that scene. His subjects were communities of graffiti artists, B-boys and musicians, people he knew or was passionate about. Gradually he started to bring his photographic work to the street, with his now trademark super-size photocopied posters.

In 2004 he began the first installment of his celebrated *28 mm* project. Under the title

Portrait of a Generation he photographed young people living in the troubled Parisian suburbs of Montfermeil and Clichy-sous-Bois. With widespread unemployment and high immigrant populations, these *banlieues* were forgotten places receiving little government support. By embedding himself within the community, he was able to get his subjects to express themselves freely. His simple head-on portraits let their postures tell a story. Some of his sitters grimace and strike arrogant poses, seemingly to confirm 'ghetto' stereotypes. For the outsider, the distinction between ironic posturing and genuine hostility is ambiguous.

The project gained momentum after riots ignited in Clichy-sous-Bois in October 2005 and spread to other suburbs. JR interviewed his subjects to get their impression of events and started pasting posters of his photographs within the city of Paris. The campaign soon gained attention. These huge images of aggressive-looking youths played on the anxieties of a city in fear of its multi-racial suburbs. Were these the barbarians at the door or were they just kids cheekily playing to the camera?

Seeking out parallels to Paris's divided communities, JR next ventured to the Middle East to find out why Palestinians and Israelis couldn't live together. He and his companions

were struck by the fact that despite religious differences there were many similarities between peoples living apart yet in close proximity. Using his 28 mm wide-angle-lens camera, JR took portraits of individuals from different communities who had the same jobs: taxi drivers, teachers, security guards and holy men. Adept at catching his subjects off guard, he photographed them laughing and making faces. The resulting images were pasted on buildings on both sides of the wall separating Israel from the West Bank.

The portraits highlighted the common humanity between the communities and led to some extraordinary outcomes. Among his subjects were three holy men: an imam, a rabbi and a priest, whose portraits he famously pasted side by side. The men subsequently became friends and when an exhibition of the project was shown in Geneva, the imam and the rabbi came to support the show.

28 mm: Women, 2008
Stairs in the *favela* Morro da Providência,
Rio de Janeiro
In 2007, in collaboration with Médecins sans Frontières and a film crew, JR set out to photograph women in conflict zones around the world and tell their stories. He has since taken his *Women* project to Kenya, Sudan, Sierra Leone, Liberia and Brazil.

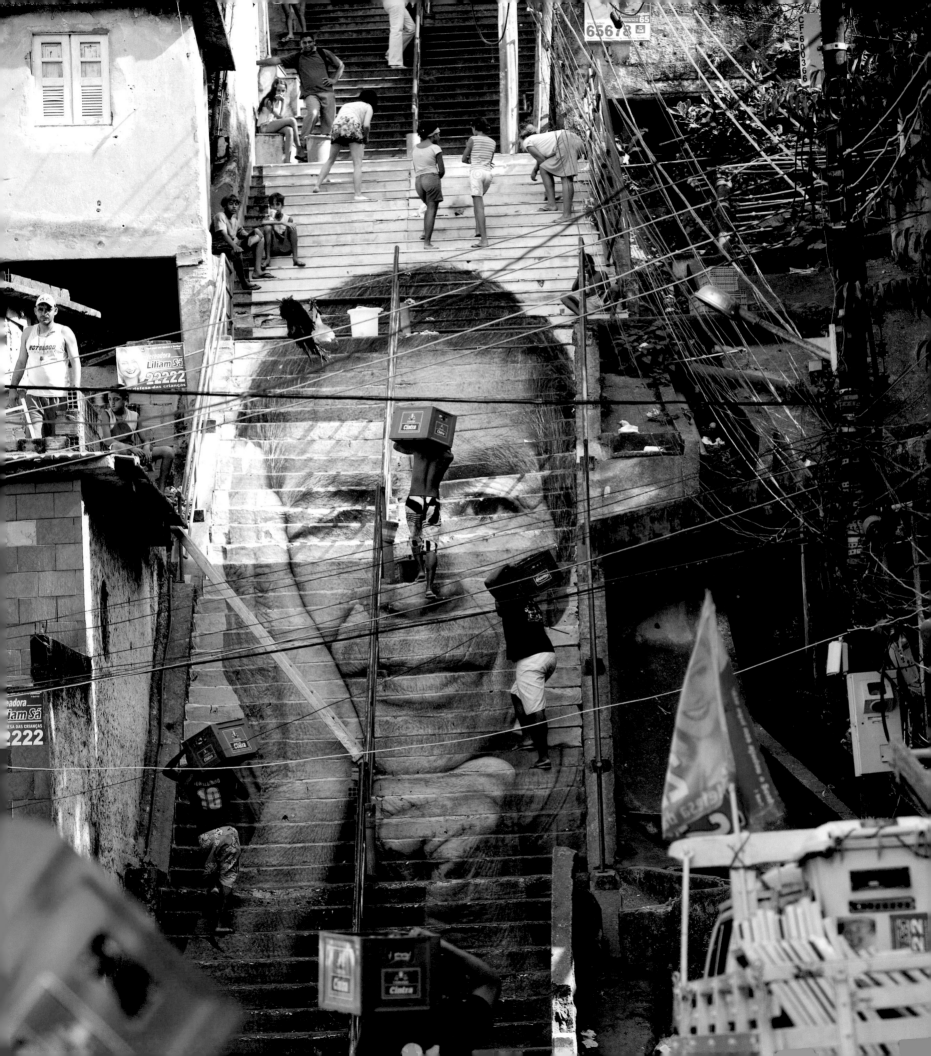

Poster mural in Herbrand Street, London, 2008
JR's portraits are initially shot with a 28 mm camera, then displayed on walls, and finally re-photographed and enlarged as giant photocopies. This four-storey poster of a young boy attracted both outrage and admiration from local residents when it appeared overnight in a conservation area in Bloomsbury.

Los Surcos de la Ciudad (The Grooves of the City), 2008
Marino Saura Oton, Cartagena, Spain
JR photographed Cartagena's oldest inhabitants and pasted their portraits on various new and decaying structures in the town.

28 mm: Women, 2008
Manette Street, London

28 mm: Women, 2008
Bus in Bo City, Sierra Leone

28 mm: Portrait of a Generation, 2006
Cleaning off the exhibition in Paris

Ladj Ly by JR, 2008
Exhibition on Tate Modern north front, London

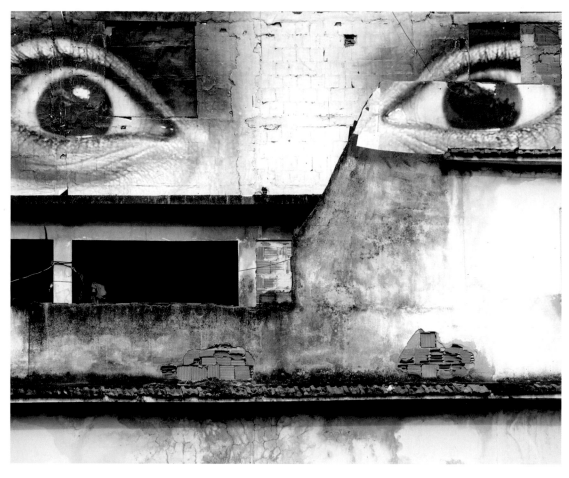

28 mm: Women, 2008 (detail)
Favela Morro da Providência, Rio de Janeiro

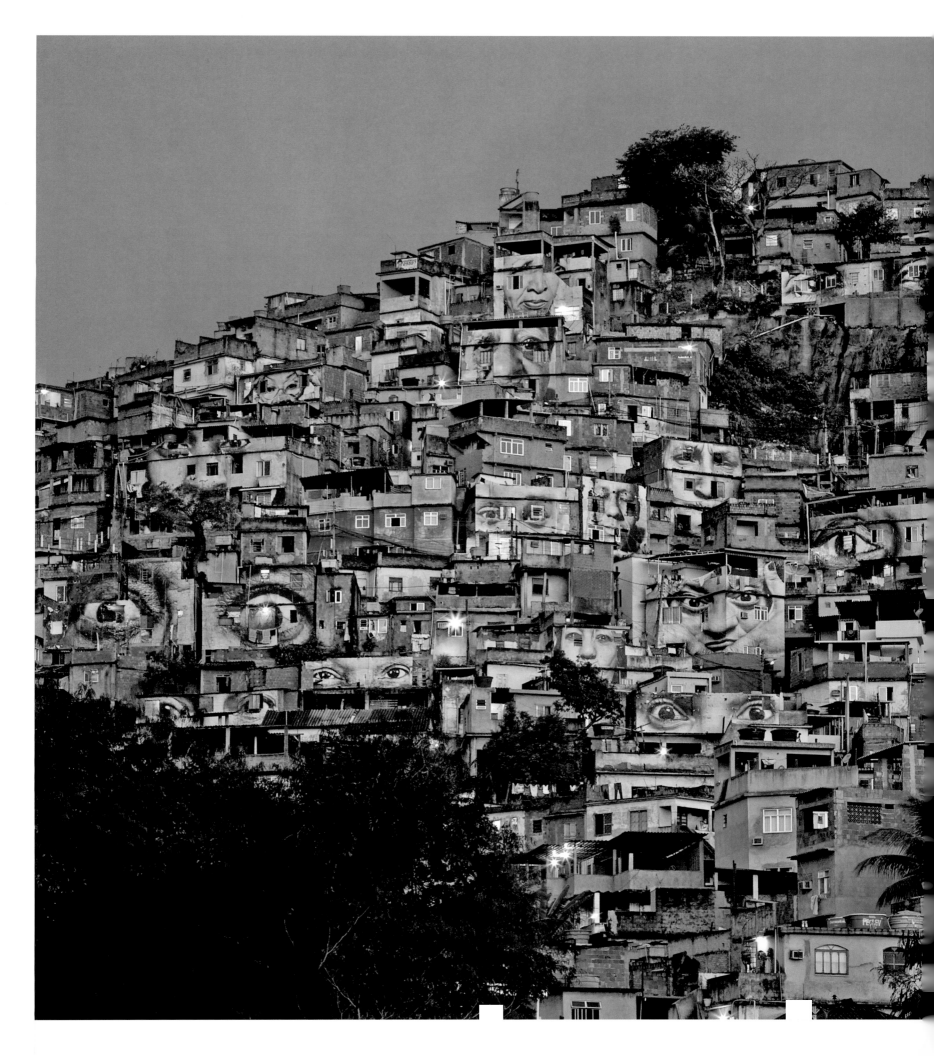

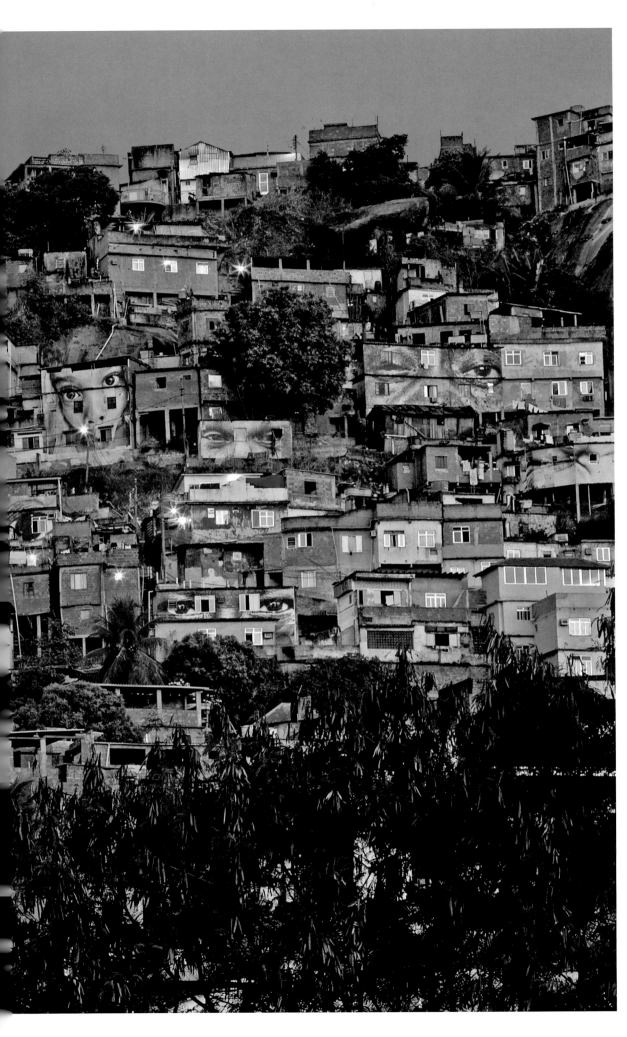

28 mm: Women, 2008
Favela Morro da Providência, Rio de Janeiro
In the *favelas* of Rio, where so many men have been lost to crime and violence, women are central to society. They are matriarchs who hold family and community together. In Morro da Providência JR posted photos of the impressive women he met on façades across the entire *favela*. The result was spectacular: all across the hillside, the women's giant eyes looked down protectively upon their neighbourhood.

10.

blu

Prolific image-maker of extraordinary skill and imagination

Based in Bologna, the young Italian artist who goes by the name Blu is a rare and visionary talent. Through his awe-inspiring murals and groundbreaking animations, Blu is a conjuror of strange universes, a player of visual games and a sharp social commentator.

He began painting in the streets with friends around 2000. As the pieces got bigger, he shifted his canvas to abandoned buildings and old industrial spaces. While his style developed, so did his appreciation of the act and impact of creating public art. The first thing that strikes about Blu's work is his sense of scale. His wall paintings are colossal, often covering whole buildings, yet they are executed with great sensitivity. He has an extraordinary instinct for composition at such scale, always taking into account the aspect and character of each wall. He uses rollers and brushes attached to long poles, standing on a ladder if one is available or stretching out from a roof or window. This awkward method has become second-nature to him. He sketches with a roller as fluently as if it were a pencil and the building a giant sketchpad.

Drawing is the key to his artistic process, a clear graphic line that flows from sketch to wall painting or animation. He fills sketchbooks constantly; dense with doodles, stories and concepts, these are an ever-expanding library of ideas. His daily observations of life are filtered into images that capture his mood and become the seeds for further explorations. His drawings take on a life of their own, unfolding like origami as his mind meanders and his lines transform into new, unexpected forms and surreal scenarios.

Despite the name, Blu tends to work in monochrome, emphasizing the outline with little or no shading. As in the work of M.C. Escher, this neutrality puts the focus on his playful use of perspectives and details. He thrives on improvisation. While there may be a rough plan for a mural, much of the content or details are created on the spot. He has been known to start one composition and then paint over it with something entirely new.

In 2007 he took this a step further by combining his skills as an animator with his wall paintings. The result was the animated film *Muto*, which tracks a mutating painting as it walks and slithers across the walls of two cities, Buenos Aires and Baden. Using stop motion animation, each frame was painted and photographed, then painted over to provide the next frame in the sequence. The camera pans as the action moves from wall to wall, and passers-by are caught momentarily in shot as the film progresses. The extraordinary result is a play of shadowy metamorphosing forms in a slowly changing time and space.

Although Blu's work can be playful and absurd, behind the quirky humour there are often deeper themes, in particular the darker sides of humans' behaviour towards each other and the planet. There is also a metaphysical dimension to his images: human figures are dissected and abstracted as if to explore our spiritual make-up. If Hieronymus Bosch were alive today he would find a kindred spirit in this artist, whose images run the full gamut from beauty to grotesque.

Blu's programme of work each year is ever more ambitious. Invitations to travel have presented opportunities to take his art to different settings, from Nicaragua to Bethlehem's separation barrier between Israel and the West Bank. Meeting people, discovering and sharing experiences all filter into the works he paints on the street and propel him forward on his extraordinary artistic journey.

Painting on the separation barrier between Israel and the West Bank, Bethlehem, December 2007

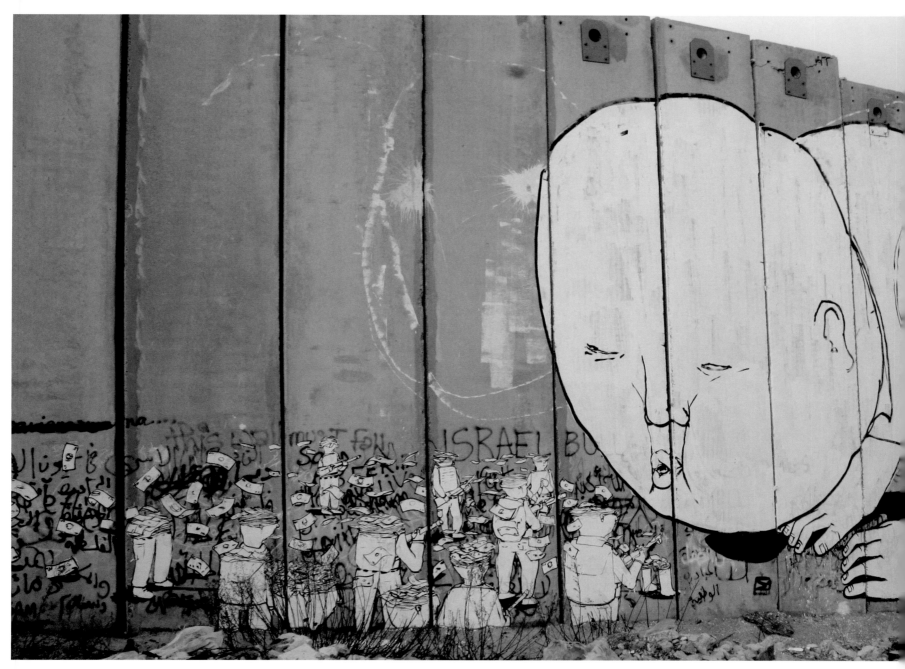

The young Italian artist Blu is a *conjuror* of *strange* universes, a player of visual *games* and a *sharp* social commentator.

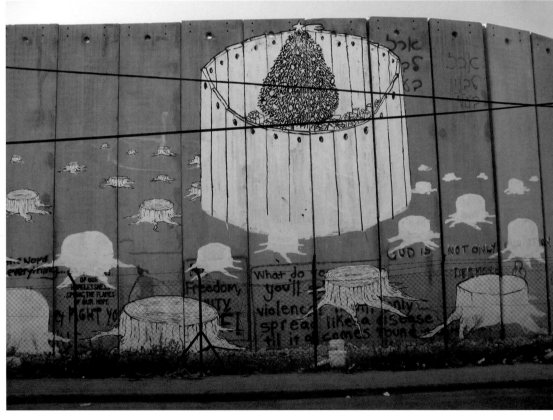

Images painted on the separation barrier between Israel and the West Bank, Bethlehem, December 2007

11–15.

[sou fujimoto](#)

[alejandro](#) [aravena](#)

[urbanlab](#)

[carlo](#) [ratti](#)

[turenscape](#)

built world

cecil balmond

introduction

cecil balmond

Internationally renowned designer,
structural engineer and author, and
Deputy Chairman of the engineering
firm Ove Arup and Partners Ltd

At the beginning there is a source, and from the origin a causal chain runs. This is the model for most of our thinking and decision-making today. But it is changing, as we see that linear extrapolation leads to predictions that don't hold true in science; and repetitive modular thinking, inherited from a past age, does not excite us any more in a fast-changing world.

The idea of flux, known so well to us in our everyday lives, is also informing today's design. The power of the computer allows a greater complexity in finding solutions, and we no longer think of one answer but of outcomes – there is an understanding that changing circumstances require 'local' problem-solving. We find that if the problem is tackled in small areas of concern, then somehow sympathetic responses arise elsewhere and from the overlapping points in this series of 'localities' a trend or result emerges. The method permits simultaneity and allows *time* to run through the process. The new thinking is 'time full', not 'timeless'.

This radical change of paradigm throws out prescriptive methods and allows improvisation. And that improvisation breaks with straight-line modes of thinking: it admits 'jumps'.

Separate disciplines can invade one another; architecture can merge with landscape, and country with city. Bringing the countryside to the city is a green mission that grows apace, and nature's cycles of replenishment and seasonal fluctuation give rise to imaginative architectural/landscape solutions, such as those of Kongjian Yu and Turenscape. Nowadays, such a jump between contexts and disciplines is more closely wedded than before to technology; the design imagination is intimately bound up with the realm of digital processing. The speed,

accuracy and multi-stranded possibilities of software promote a new, more complex kind of speculation. The simplistic world of the past, divided into separate classifications by compartment thinking, has begun to dissolve as more fluid concepts gain ground.

The outcomes of this new way of thinking are proposals that have a high degree of irreducible complexity – they cannot be pulled apart or simply analysed. The problem space is seen as holistic. This brings richness to the solutions we find – for example, in the small house designed by Fujimoto where the module is a rotating space-axis, taking the eye in every direction, yet controlled in increments of perception. And there is enjoyment to be found in the facets of such serial unfolding. Function is not clinical and minimal, but layered and baroque.

All the innovators in this chapter embrace the shifts of the new paradigm; they embrace the meaning of technology today as the power of the digital. The virtual maps created by Carlo Ratti and his MIT research lab afford new levels of comprehension between the digital and the concrete worlds, which will lead to more informed realities for city planning based on flux patterns of data use.

This paradigm explores a new aesthetic of layers and networks. The result is a humanism based on the richness of patterns, in the best sense of that word, as an organizing and directing force. In architecture we leave behind the object of a building and enter a more fractal-like dimension, experiencing the in-betweenness of its elements and its internal compiled sequences. In planning we subvert top-down thinking. We may become vulnerable to fate, but we attempt to give chance a chance. Algorithmic methods help us to do this. The field is rich, and the possibilities for innovation never more fruitful.

Sketching was once the most immediate way for designers to explore their intuition. People were sceptical of what computers could add to our creative armoury. But now, an emerging symbiotic relationship with the computer helps us realize that, because of the way the computer can create information and detail, we can push our own intuitions further than we ever imagined. A primed intuition fuels innovation. The larger the range of options explored in new configurations, the more creative and fundamental will be the insight. Plotting a course through this new world means rethinking the way we see things. Innovators have to approach problems differently; finding a new angle is the key.

And here lies the challenge for those who create buildings, landscapes and cities. For the most part, the traditionalists continue to resist the potential of a digital process; there is something about computers and

their mechanical nature that repels some designers, who wish to cut out what they perceive as having been created by a machine. The education handed down from the Beaux Arts period has made architecture a discipline less open to change than, say, engineering or biology. Architects struggle to embrace digital advances. But the young are being groomed in schools of design where a new kind of thinking is beginning to emerge, one that is about coding bespoke answers in a sympathetic field of like answers. The digital is no longer a mere tool for analysis, but a companion for exploring synthesis.

The binary code zero-one runs through every aspect of our world. Those who embrace it – with all its layers of transpositions and quirks, with its increasing power and intelligence – are those who will impact the future. The digital process and its flexibility will re-evaluate the world. Bottom-up thinking that effects change at local level will transform how we think and formulate ideas, not as part of a linear method but as a complex mesh that includes optimization techniques.

The fittest will survive. Mistakes can happen because the bottom-up approach is an evolutionary process, and if left unchecked it could lead to freaks and monsters; but it can also lead to amazing achievements. We need to find organizational methods that will allow us to catch errors and yet to tolerate certain mistakes which could be instrumental in releasing creativity.

We begin to see the workings of a 'localized' approach in the recent phenomenon of micro-credit for poor communities. One million loans of a few hundred rupees empower people to help themselves, to build homes and businesses in ways that a one-hundred-million-rupee government initiative never could. In a related way, Alejandro Aravena's Chilean social housing schemes upturn the cost-driven hierarchy that historically pushed poor people to the outskirts of cities. By spending more on land and building only half of each house, allowing the owners to finish it when they can and to their own liking, Aravena brings the disenfranchised in from the margins. He has changed the parameters of how we view a social challenge and transformed them in a way that could never be done in the conventional linear paradigm. His inspiration has overcome social and political hurdles to enable him to progress his role as an architect while benefiting those who will use the buildings he creates.

There is a different problem in our cities where the environment is concerned. Architects and city planners are unduly preoccupied with what is often described as 'green architecture' – giant schemes of tower

A new *humanism* puts the *little, local, life-giving* things first. As modern technology enhances our speed of thinking, it leads to more *sophisticated solutions*; we now have the power to put *more creativity* and a *new aesthetic* into the built world.

blocks for First World countries that seek one-fix solutions, such as putting grass on their roofs. But we need to find a way to put 'nature' into the city and the 'city' back into nature more imaginatively. To some extent, on a micro-scale, we are learning from nature's template for survival, through innovations such as motion-sensitive lighting and façade systems that respond to differing intensities of sunlight. But we need to go further, utilizing computer-design optimization as an architectural tool, to understand patterns of building use through algorithms that synthesize a building's performance with its locality, its energy output and its use. Learning from the cyclic and evolutionary patterns of nature and our human interactions with them, and synthesizing these with our urban environment, leads to an ethos I call 'big City big Nature'.

With its suggestions for 'eco-boulevards', UrbanLab proposes a new kind of city street scheme that could replace our municipal and urban utility grids with specific local conditions designed with an understanding of how to generate energy and recycle waste at street level. If such 'local' ideas work, we no longer need systems that create their own 'waste' by collecting everything in a hierarchy of mains branching to one point and then discharging back, across miles, to outfalls.

Just as Le Corbusier's philosophies and designs for a machine-inspired tectonic transformed the way architects viewed the possibility of built components in the 1920s, so the potential offered by intelligent software brings forth new compositional techniques today. But there is one major difference. While Le Corbusier's architectural thinking influenced the

way we designed buildings, the Modernism that grew out of the period denied local human intervention. The system, not humanism, governed. The social ideals that it espoused – open spaces, utopian societies, prescribed efficient interaction – have ultimately become part of the top-down world that is now deemed a failure and a disastrous social experiment.

What subverts this is the admittance of complex patterns into the realm of the solution. Something in this method resonates with us – a new humanism that puts the little, local, life-giving things first, rather than the Big Plan. A many-stranded response is possible. As modern technology enhances our speed of thinking, it leads to more sophisticated solutions; as we open up to innovations facilitated by such methods, we now have the power to put more creativity and a new aesthetic into the built world.

The innovators of today need technology, just as others did, but they must learn to give back, to enchant and to delight us.

Architect, designer and educator, Greg Lynn
was one of the first, some twenty years ago,
to embrace the advanced powers of higher
mathematics and computer processing to create
new ideas about architectural space and practice.

on innovation

greg lynn

In general, innovation involves a cocktail of disruptive technology, historical awareness and perspicacity in more or less equal parts. In any design field the focus becomes more specific where these factors are filtered through a creative medium such as drawing, model building, material testing and some form of pre-visualization. It would be difficult to make a case that the Chicago steel frame buildings of Burnham and Root were as innovative as either the *pilotis* of Le Corbusier, where columns floated free of a structural frame, or Louis Sullivan's department store façades, where steel, terracotta and glass formed a new skin for shopping in the city. In the cases of Le Corbusier and Sullivan the steel frame was the technical third of a mixture that included a transformation of historical types – the orthogonal

frame and unexpressed structure respectively – and a new mode of spatial and formal expression.

Today, one finds more technical invention than historical awareness, and perspicacity is in short supply. This might be what makes the moment we are living in special, and it might be why there is so little innovation in design despite a plethora of technical inventiveness.

In order to innovate one must be aware of the creative milieu of the present through which a multiplicity of historical vectors pass. Innovation is a consequence of the degree to which one can bend these historical trajectories into new territories.

11.
sou fujimoto

Creating in-between spaces that suggest new possibilities for how we might live

Space is one of the defining elements of architecture, the foil to structure, in that if the two work in harmony a building is wonderful. In this sense, the quest to redefine different types of spaces, and the way that we think about them, is an important undertaking. Sou Fujimoto is an architect who is attempting to do just that. Born in Japan in 1971, he formed his practice in Tokyo in 2000 and is already widely regarded as a leading light in the international architectural field.

Fujimoto designs what he describes as 'a sort of primitive situation that relates to the human cave habitation but at the same time something new for the future'. Dubbing it 'Primitive Future', he sees this cave space as a place people need to explore, and within which they establish their own comfort. In recognizing the complexities of twenty-first-century living, Fujimoto approaches this primitive realm – the basic human need to keep the elements out – in an unconventional way. Specifically, he considers the degrees of integration between people as a basis for the subdivision of space, which he achieves by creating modularity in a fascinating way.

Fujimoto's Final Wooden House is a perfect example. Built from stacked wooden blocks, it forms a module that can be read from the exterior as a single space. Inside, there are interlinked zones that promote the re-examination of the surroundings. He achieves this by using a single material – wood – and blurring the conventional ideas of floors, walls and ceilings. The floor levels are relative; people reinterpret the spatiality according to where they are in the volume.

In conventional architectural practice, if modularity is used to subdivide the spaces, this is reflected in the surfaces that become the form – the module and its volume are the same thing. Fujimoto upturns this notion so that our reading of the outside and the experience of the inside are confounded.

Although Final Wooden House, like many of Fujimoto's works, can appear simple on one level, it also looks complex due to its geometric form. Beyond redefining our ideas of space, Fujimoto also seeks to strengthen the ties to our collective experience of space, using what appear to be vernacular forms on the exterior that then create entirely unexpected spaces inside. The N House, for instance, is essentially a simple box house. But Fujimoto creates an outdoor space that feels like an interior and an indoor space that feels like the outdoors. It is an architecture that is clever and enchanting, and entirely practical.

Fujimoto creates in-between spaces. Through these deceptive, basic, yet richly complex structures, his work offers new possibilities for how we live and interact with our buildings and their surroundings.

Final Wooden House, Kumamoto, Japan, 2008
Fujimoto's aim was to make an 'ultimate wooden architecture' that would recreate the harmony of the primitive conditions that existed before architecture. In this house, there is no clear distinction between the wall, the chair and the ceiling. 'Rather than just a new architecture, this is a new origin, a new existence.'

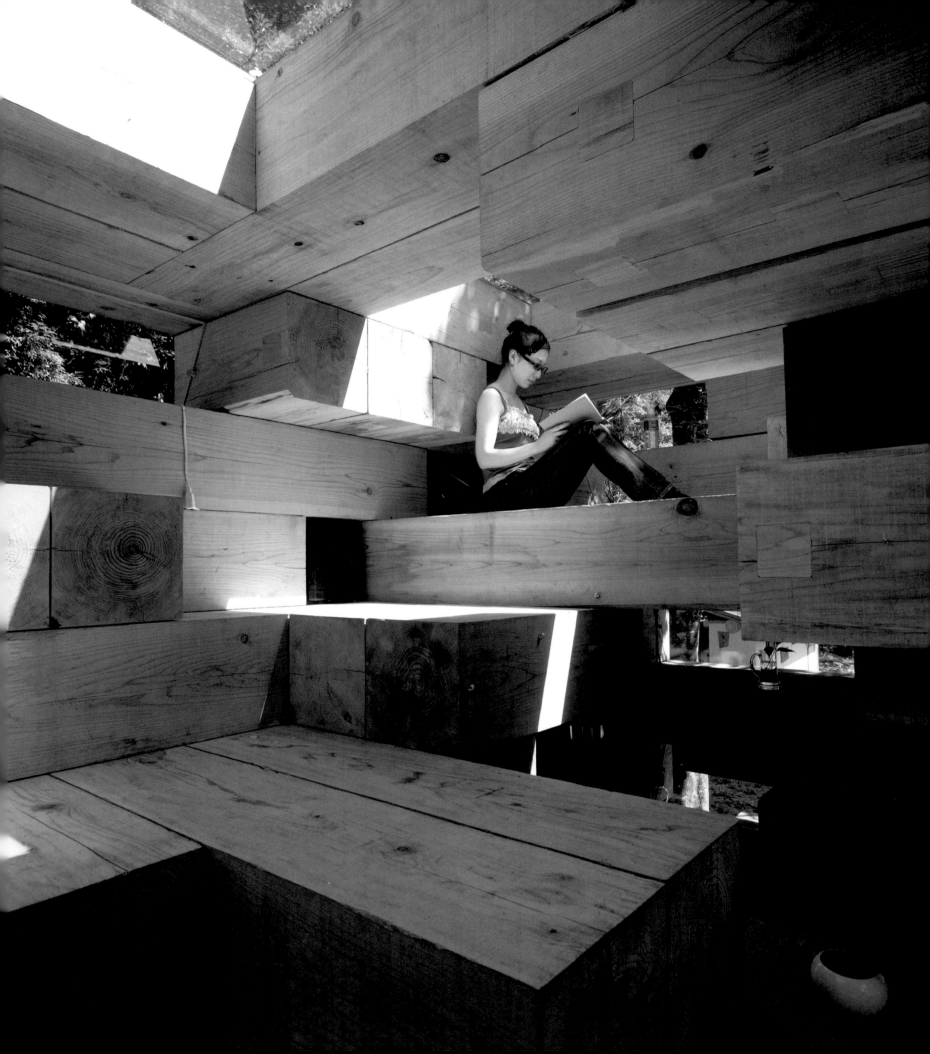

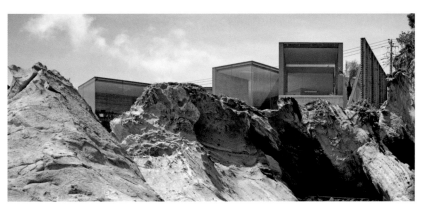

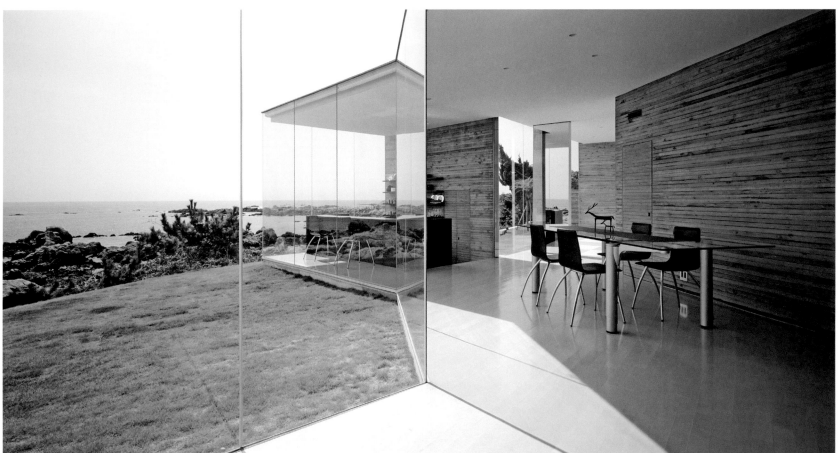

House O, Chiba, Japan, 2007
The design for this weekend house, situated on a rocky stretch facing the Pacific Ocean, was imagined like the branches of a tree. It forms one continuous room that incorporates every part of the living space. Each area offers a different relationship to the water. Fujimoto likens the experience to 'a walking trail along a coast – one could happen by a panoramic view, sometimes feel the ocean at [one's] back or find the ocean through a small gap'.

7/2 House, Hokkaido, Japan, 2006
The building, composed of seven 'house' shapes, is actually two small separate houses. The use of the 'house' shapes allows different spaces to be created within each dwelling, for example M-shaped or N-shaped rooms. Each house contains two bedrooms and living spaces.

12.
alejandro aravena

Social housing visionary who has inspired the global architectural community

The architecture of current times often focuses entirely on style and image-making. As part of a culture of celebrity and instant success, architecture can be subsumed by fashion; in a time of excess, self-satisfaction leads to hubris and seeks sensation. Corporate demand also fuels a mass market for excessive façades and statement architecture. But the substrate from which architecture emerges is mixed with political and social need.

In our age's preoccupation with the image, or 'icon', the fundamental concerns of the architecture profession can be forgotten, and imagination lost through a false sense of scale. Alejandro Aravena, executive director of Chilean 'do-tank' Elemental, has looked to a neglected area for inspiration: social housing, a global phenomenon that is the architectural profession's most pressing concern.

Although Aravena has designed several works of architecture in Chile that could be classified as 'icons' – his Siamese Towers for the Universidad Católica de Santiago (2005), for example – it is his work with Elemental on low-income housing that has attracted the interest of the world's design and business communities (the CEO of COPEC, the Chilean oil company, is on Elemental's board). The firm's ambitions are clearly set out: 'To think, design and build better

neighborhoods, housing and the necessary urban infrastructure to promote social development and overcome the circle of poverty and inequity of our cities.' In order to realize this, 'projects must be built under the same market and policy conditions as any other', and rather than seeking all-in-one, fixed solutions, the firm takes a longer-term view of design that 'guarantees incremental value'.

Until recently, social housing has been a largely urban problem, but Aravena and Elemental's startling proposals to create 'half-houses' in remote areas of Chile have spurned the assumption that social housing must consist of cramped, run-down buildings on the edges of cities. Aravena creates small properties, approximately 70 square metres (753 square feet), that are situated on more expensive land, thus creating better opportunities for the inhabitants, rather than ghettoizing them. Because of the higher land cost, there is less money for construction, so Aravena's ingenious solution is to build half the house, allowing the owners to fill in the remaining half over time. In addition to encouraging people to personalize their homes – further humanizing what are often seen as inhumane social spaces – Aravena holds intensive workshops in order to develop an understanding of the community in which

he works, and employs modern prefabrication methods and sustainable materials to achieve what then becomes genuine collective housing. Indeed, Aravena's architecture could create a viable and enduring strategy for the development of more inclusive social housing around the world.

Siamese Towers, Universidad Católica de Santiago, Chile, 2005
Alejandro Aravena's iconic design for the technology building at Santiago's Universidad Católica comprises an outer skin made of glass and an inner building of fibre cement, which together are energy-efficient yet weather-resistant. The space between the two towers acts as a chimney, drawing hot air circulating between the glass and cement up and out of the building.

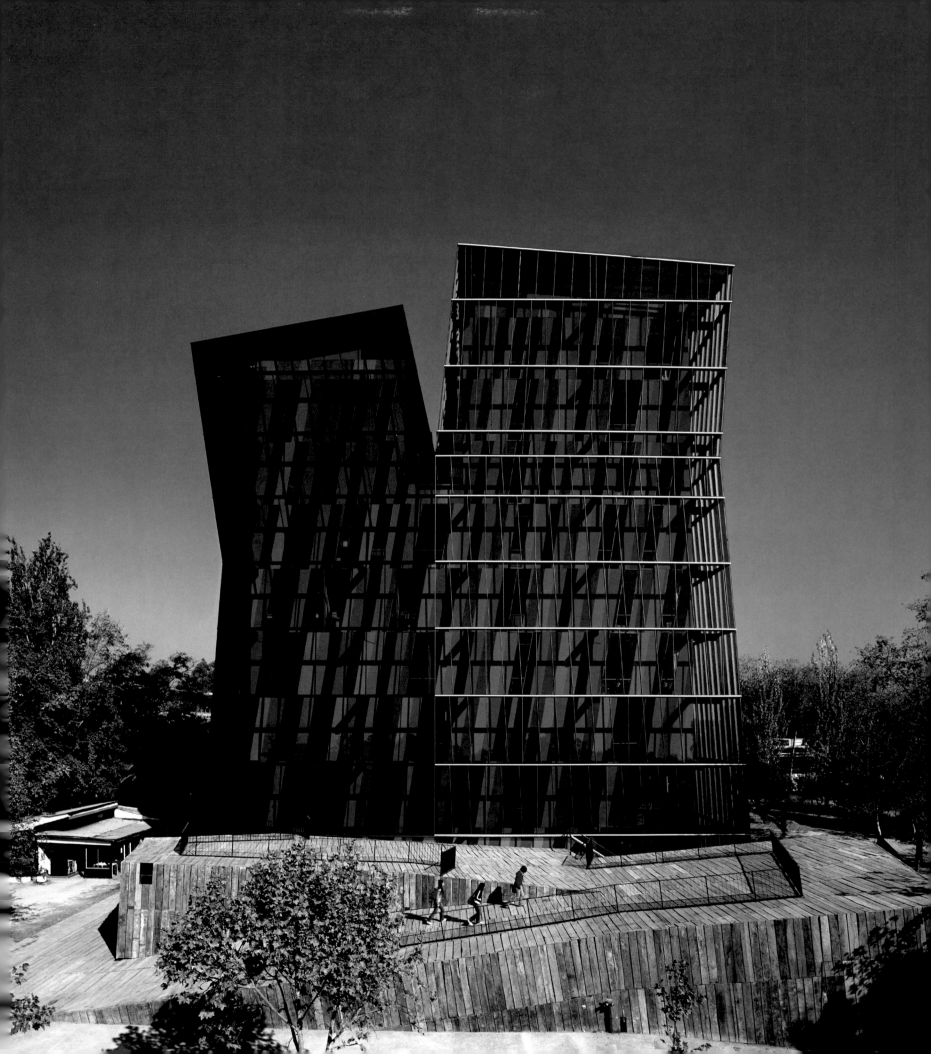

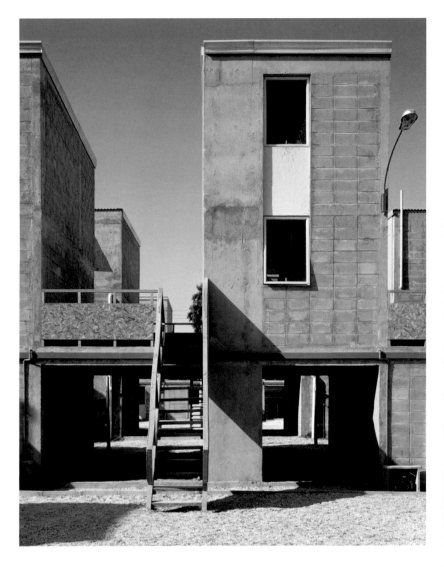

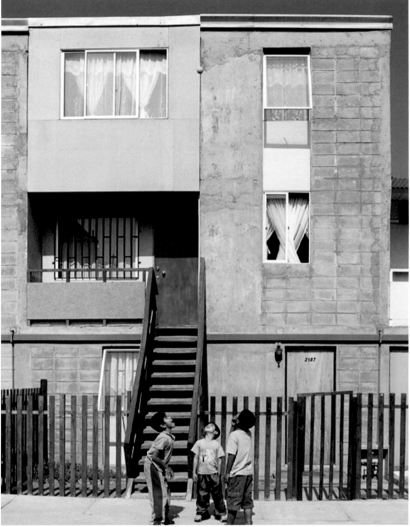

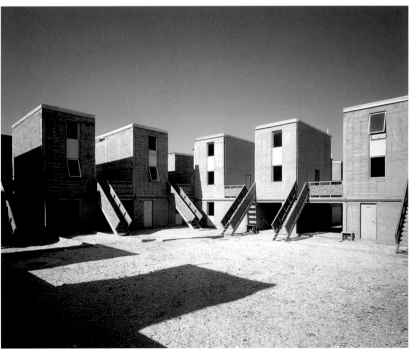

93 Houses Complex, Iquique, Chile, 2005
Aravena's groundbreaking designs with 'do-tank'
Elemental have revolutionized conceptions of social
housing. The initial 36 m² (387 sq. ft) structure
(above) is expanded by the occupants to 70 m² (753
sq. ft.; top right). In this way construction costs
are reduced and each space is personalized and,
therefore, humanized. There are approximately
twenty houses in each courtyard (right).

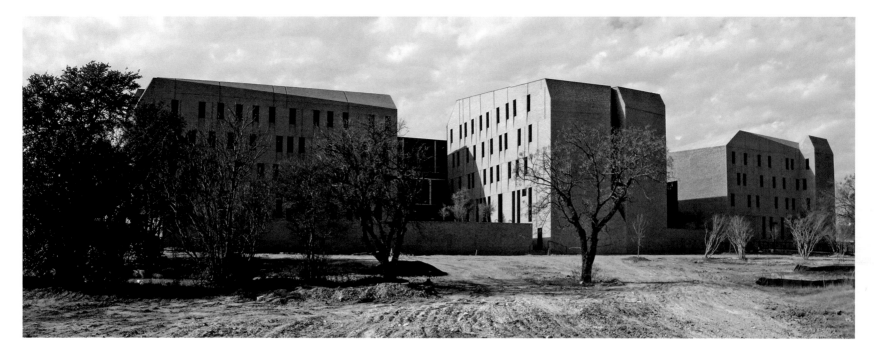

**Halls of residence, St Edward's University,
Texas, 2008**
Inspired by the work of Alvar Aalto and Louis Kahn,
here Aravena also refers to the design of monasteries,
buildings which, like halls of residence, are focused
on the relationship between repetitive cells and large
spaces, and are made for 'feeding the body and the
soul and digesting'. Aravena's design is structured
so that each room has a view and natural light. Its
external form was carefully integrated into that of
older campus buildings.

13.
urbanlab

Localized, renewable, sustainable: a radical new approach to urban water management

The city is addicted to growth and density. Everything flows from success, one district prospering at the expense of another. A vital city is alive with contradictions and local 'ghettos' of wealth or poverty. Demographics can change in just a few blocks, or across the boundary walls of a gated community.

The infrastructure of a city has long been conceived as a hierarchy of street to grid to collective artery to exit point. This applies equally to traffic as to storm water drainage and other utility distributions. In today's city, however, continually changing patterns of urban settlement and expansion have created a gap between conception and reality. In Chicago, for example, storm water is collected from the grid, taken to a point outside the city, treated, and then discharged back across the city in huge sewers to Lake Michigan. This represents a wasteful to-and-fro on a huge scale.

Chicago architecture studio UrbanLab posits a radical new approach: in its Growing Water project, conceived for the City of the Future competition, the street itself is active in the collection of water and managing its utilities. The project's starting point is the prediction that in our near future water will be 'the new oil' – valuable, scarce and the cause of conflict. At present 20 per cent of the world's fresh

water and 95 per cent of the United States' fresh water is in the Great Lakes. In 2003, one billion gallons of lake water were consumed in Chicago, with less than one per cent of that water being replenished.

The aim of the project is to enable Chicago to 'grow' its own water by creating a series of 'eco-boulevards'. These would supplement Chicago's existing 'Emerald Necklace' of green parks and boulevards that connect in a ring around the city. Each eco-boulevard would be porous, collecting its run-off and draining it into absorbent surfaces. All waste water would be cleaned naturally by micro-organisms, small invertebrates (such as snails), fish and plants. Areas of wetland, prairie and forest would filter storm water. Treated water could be harvested or returned to the great lakes. The system is powered by renewable sources, including solar and wind energy stations as well as underground geothermal energy. According to Martin Felsen and Sarah Dunn, UrbanLab's principals, these 'eco-boulevards will function as a giant "living machine"'. Ultimately, the eco-boulevards could create a closed water loop within Chicago, so that all the water consumed from Lake Michigan is re-used, treated and, along with filtered rain water, returned to the lake in a self-sustaining cycle.

This visionary approach to urban water management upturns the established hierarchies of national and regional grids, favouring instead a highly localized system closely attuned to local resources and conditions. The physics draws upon the most advanced technologies we have to promote sustainable cycles of water use.

UrbanLab's scheme is currently only a proposal, but its importance as a working model for cities around the world earned it the prestigious $100,000 Latrobe Prize, awarded by the American Institute of Architects, which will fund further research and testing. If UrbanLab's vision prevails, universal centralized patterns for urban infrastructure will give way to more local approaches. Cities and buildings around the world could be transformed.

Growing Water, 2006
UrbanLab's proposal is to transform Chicago's existing networks of parks and boulevards into public spaces that are also 'eco-boulevards', running alongside high-density live and work spaces. This 'living system', composed of wetlands, prairies, forests and swamps, could capture, treat and purify all of the city's waste water and rainfall.

Growing Water, 2006
The hybrid infrastructural landscapes simultaneously contain walkways, bio-walkways, bicycle ways, waterways, roadways, public transport-ways and renewable energy-ways.

The project's starting point is the prediction that in our near future *water* will be *'the new oil'* – valuable, scarce and the cause of conflict.

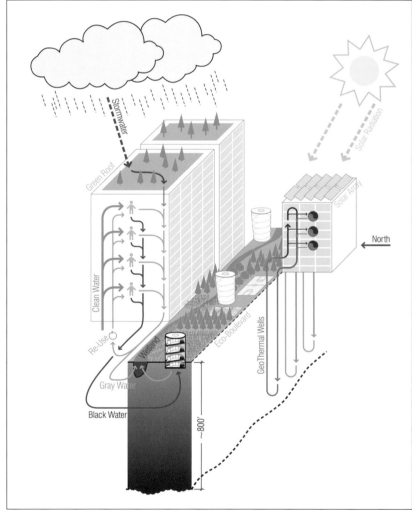

Growing Water, 2006
Water on the west side of the Sub-Continental Divide, shown in red, naturally flows into the Great Lakes. Eco-boulevards, shown in green, would harness this natural process, facilitating a self-sustaining water loop within the city.

Growing Water, 2006
Eco-boulevards 'grow' clean water using micro-organisms, invertebrates, fish and plants. The system is powered by solar and wind energy stations as well as underground geothermal energy.

14.
carlo ratti

Using virtual mapping of data flows to create a powerful new understanding of urban dynamics

Based in Turin, Italy, and the Massachusetts Institute of Technology (MIT) in Boston, architect and information designer Carlo Ratti asks a basic question: 'How can our built environment adapt to our changing needs?' Put another way: 'How can we develop a mode of urban planning and architecture that evolves over time with the city?' While there is much information to be gathered on human consumption, transportation and energy needs, Ratti and his SENSEable City Laboratory at MIT take a distinctive approach, using the data flows generated by the proliferation of sensors and hand-held, always-on mobile devices. The visualizations that Ratti creates from this information are powerful tools for understanding our urban dynamics and connections, on both a local and a global scale. Ultimately, Ratti's research is compelling because it proposes new ways of harnessing technology to change the built environment, and gives rise to the notion that data is vital and has a life of its own. Ratti's interpretation of this abstract information leads to surprising points of departure for contemporary space-makers.

One recent example is NYTE (New York Talk Exchange). On the basis that 'telecommunications such as the internet and the telephone bind people across space by eviscerating the constraints of distance', Ratti and his team map volumes of long-distance calls and internet-protocol data between New York and other cities around the world. By looking at the real-time data and analysing activities by time of day and even neighbourhood, Ratti's visualizations of these digital communications begin to suggest new, dynamic forms of 'buildings' across space.

How might this affect a sense of 3D space when making plans? Globalization can be seen in trade figures, but visual maps of actual data flow are more concrete and comprehensible. Tracked information can offer live insights into social patterns, revealing a new kind of geography with its own demographics and 'power' patterns that are linked to trade and the extensions of personal domains. A virtual map of 'land mass' can take form. The maps generated by Ratti and his team of researchers provide us with a sense of ourselves in a dynamic, interconnected planet and can establish the groundwork for a better understanding of urban patterns and needs.

Even Ratti's more 'conventional' architecture projects are conceived at the interface of the digital and the concrete. A built metaphor for his data research is the Digital Water Pavilion for the 2008 Expo in Zaragoza, Spain – an interactive structure made of digitally controlled liquid curtains, it is a world of fractal water that disappears and reappears within a tectonic. The mechanics of 12 hydraulic pistons, 120 metres (394 feet) of water walls and 3,000 electromagnetic valves lie behind a structure in which spaces are flexible, changing and responsive, just as our cities – and their flows of people, information and communication – must be in the future.

Los Ojos del Mundo (The World's Eyes), 2008
Spain is one of the most visited countries in the world. But what do the millions of tourists see? Where do they travel to? And where do they come from? The SENSEable City project *Los Ojos del Mundo* uses data-mining techniques to analyse digital photos posted on the internet by tourists, allowing an insight into the intensity of tourist flows and quantifying the attractiveness of locations throughout the country.

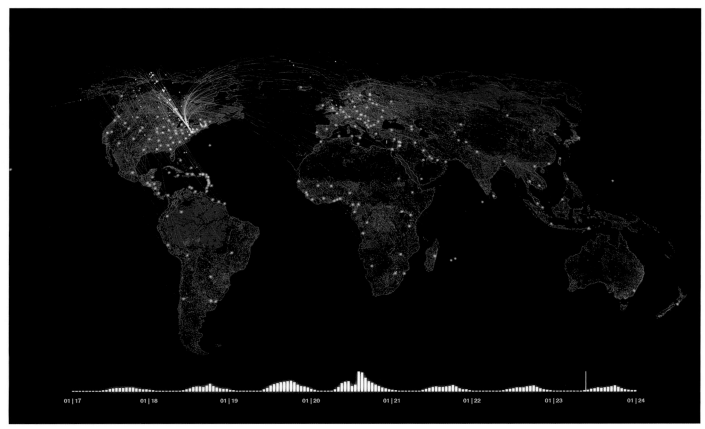

Top left and right
Obama, One People: the City and the Country, 2009
Through an analysis of AT&T's call volumes, Ratti is able to illustrate the emotional flow of the Presidential Inauguration in Washington, DC. Each pixel in the City vizualization rises and turns red as call activity increases. The Country includes a map of the US, where states with strong increases in call activity light up and move forward. Timelines at the bottom show overall calls in the Washington area.

Above
Obama, One People: the World, 2009
The World reveals the international nature of Inauguration Day, depicting the variations in call activity between Washington, DC, and other US states and foreign cities – 138 different nations in total, over half of all the countries in the world. The main international callers were from Canada, Great Britain, France and Puerto Rico, which registered a five-fold increase in call activity.

The 3,000 electromagnetic valves that control the
water walls can be opened and closed to form a
curtain of falling water with gaps at specified points.
The result is an architecture that is fluid both literally
and figuratively – a place where spaces are flexible,
changing and responsive, and walls and doors can
disappear and reappear.

15.
<u>turenscape</u>

Landscape design that preserves ancient patterns of nature in a dramatically expanding urban setting

There seem to be no limits to the insatiable expansion of our urban spaces. The growth patterns of a steadier, more organic demand have long been forgotten. The call for more and more leads to bankruptcy in design, and development that has no vigour in its assumptions or execution. Suddenly, approaches from the past appear innovative and offer much-needed relief. They show how success evolves in the same way as nature, building on patterns of growth by moving forward but also looking back. Tradition has always been a spur for innovation, and the concepts of nature an inspiration.

Landscape architecture, using modern technology, can restore these beliefs. In the practice of the Beijing-based Kongjian Yu and his firm Turenscape – the Chinese word *turen*, 'natives of earth', derives from *tu* ('earth') and *ren* ('man') – the nature in our midst is an old prescription, but in our increasingly hasty urbanization, innovation in planning and architecture must be seen as an 'art of survival'. In Yu's words, 'Armed with modern technology, Turen observes the phenomena up in the sky and the patterns down on the earth; follow the natural and social processes so that man, nature and the spirits can be understood as one and designed as one.'

Yu draws on traditional planting techniques to deal with contemporary design issues in some of the most rapidly developing urban environments in the world. Cultivation techniques and cyclic patterns are embedded in the land, and Turenscape draws on these natural palimpsests – for example, in their beautiful and quietly stated design for the university campus in Shenyang, set amid a fully functional rice paddy and system of irrigation, alongside other native crops. The presence of this working landscape 'draws both students and faculty into the dialogue of sustainable development and food production'.

Perhaps Turenscape's most iconic project is the Red Ribbon – recognized by several publications as a 'modern architectural wonder' – at the Tanghe River Park in Qinhuangdao, Hebei Province. Here, as in so many Chinese cities, native vegetation and biodiversity were threatened by the city's rapid outward expansion. Yu and his team created a single calligraphic sweep of an idea: a 'red ribbon' of steel that incorporates seating, lighting and a display of plant life. By 'integrating ecological principles with modern art', the new park preserves the natural surroundings and secures their appreciation for generations to come.

In promoting the symbiosis of natural vegetation, traditional agricultural concerns and land use, in one of the most dynamic building environments on the planet, Yu's approach to the landscape and to our urban condition is destined to be an enduring lesson for all those who seek to green our cities.

Opposite and overleaf
The Red Ribbon, Tanghe River Park, Qinhuangdao City, Hebei Province, China, 2008
The ribbon is designed to protect the ecology of the site, which is situated in an area of rapid urban development, by allowing people to use it as a park. Turenscape developed a minimalist design that responded to urban tastes and pressures by integrating ecological principles with modern art.

Below and right
**The Red Ribbon, Tanghe River Park,
Qinhuangdao City, Hebei Province, China, 2008**
Turenscape's minimalist intervention has transformed
the natural landscape into a social space.

Below and right
**The Red Ribbon, Tanghe River Park,
Qinhuangdao City, Hebei Province, China, 2008**
Turenscape's minimalist intervention has transformed
the natural landscape into a social space.

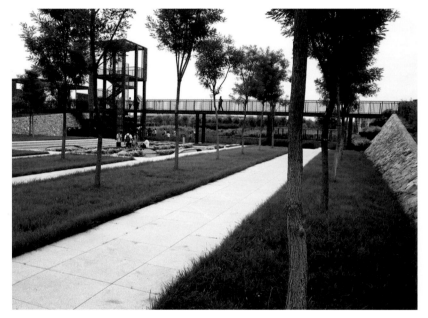

Opposite, and above left and right
Qiaoyuan Park, Tianjin City, Tianjin, China, 2006
The site of Qiaoyuan Park was originally fishponds
and wetlands located in the industrial city of Tianjin.
Turenscape responded to the natural and cultural
characteristics of the site by 'sampling' plants and
minerals and creating 'cells' within the landscape
that echo their wider context.

Top
Cloud Pavilion, Tanghe River Park,
Qinhuangdao City, Hebei Province, China, 2008
Four pavilions in the shape of clouds are distributed
along the Red Ribbon, providing protection from
the weather, meeting points and a visual focus.

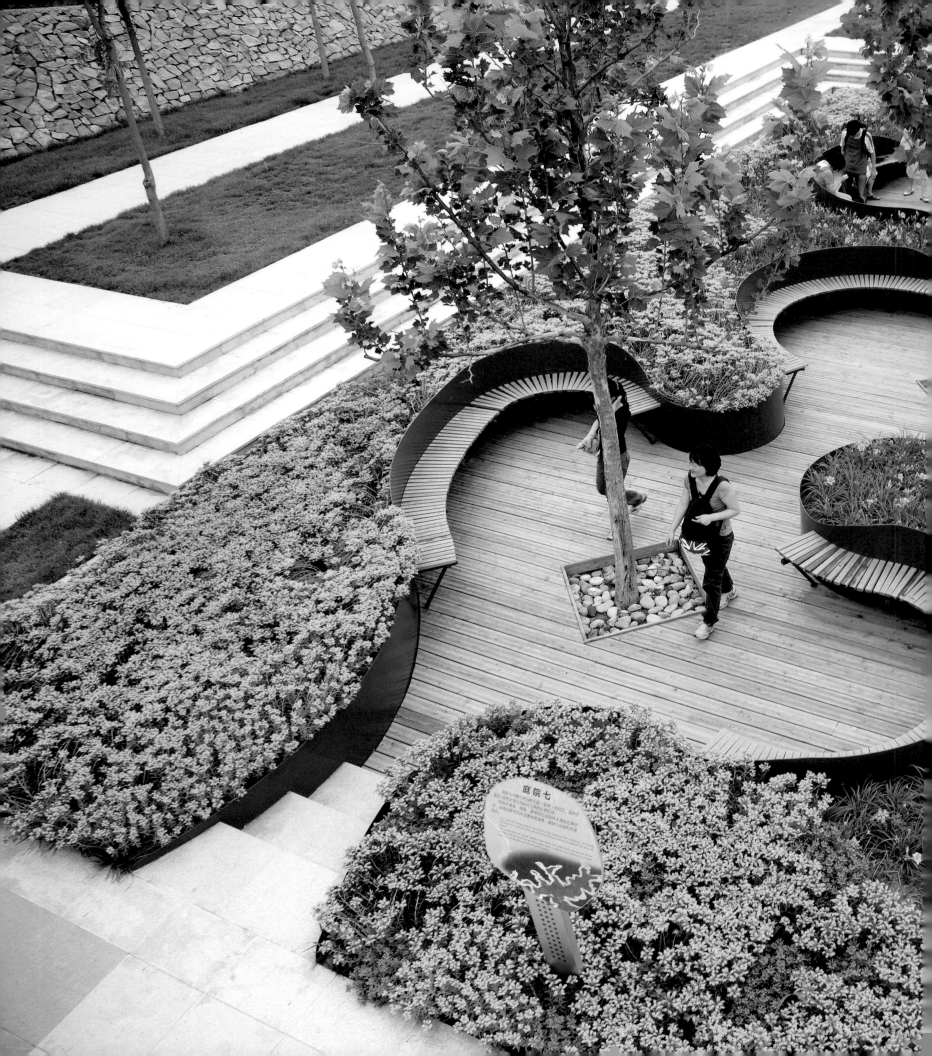

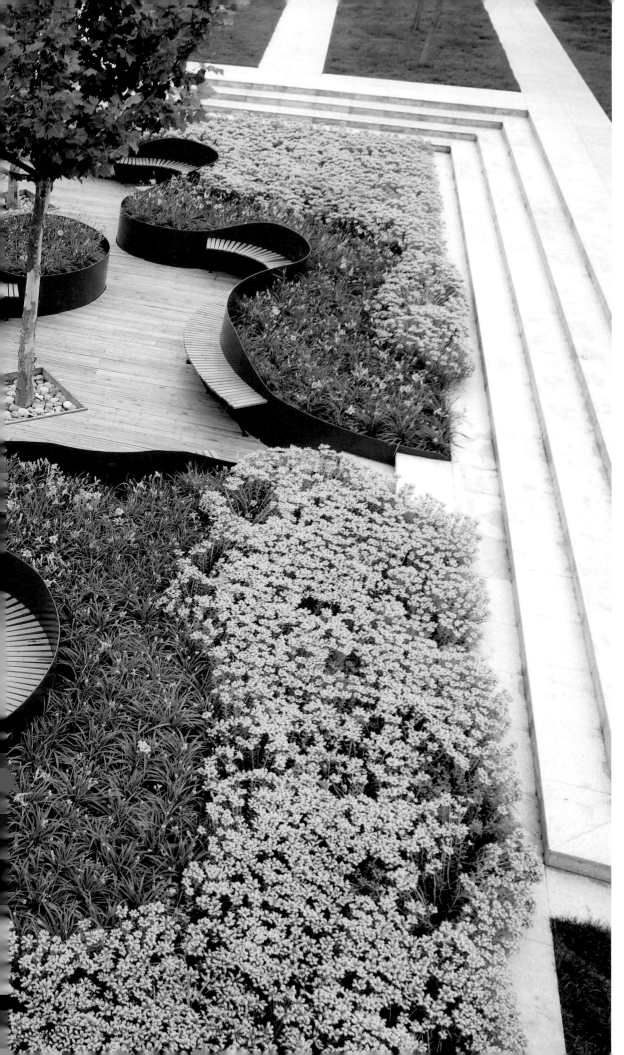

Qiaoyuan Park, Tianjin City, Tianjin, China, 2006
Turenscape's aim was to make a space for the urban
public while preserving the natural wetlands. By
balancing development and the natural landscape in
this way, the future of the wetlands is assured.

16–20.
justin francis
cameron sinclair
rob hopkins
william mcdonough
janine benyus

green world

alastair fuad-luke

introduction
alastair fuad-luke

Sustainable design consultant and author

To be 'green' is to pursue a way of living, working, playing and consuming that can be sustained indefinitely. It encapsulates the concept of 'sustainable development' first articulated by the World Commission on Environment and Development (WCED, also known as the Brundtland Commission) in 1987 and later by the International Union for Conservation of Nature (IUCN) in 1991. The IUCN stated that sustainable development is a commitment to 'improving the quality of human life while living within the carrying capacity of supporting ecosystems'. Others would argue that this remains a fundamentally anthropocentric concept that doesn't guarantee which *other* living species are entitled to survive in the future. Whether we hold an anthropocentric or deeper green 'biocentric' view of what we are trying to sustain, this variance in the definitions of sustainable development mirrors diverse attitudes to what 'green' actually means for us as individuals. As consumers we range from 'dark green' (highly committed to self-made, local, organic, Fair Trade and eco-efficient products and services) through 'mid green' to 'light green' (occasional purchase or use of such products and services). And there are still plenty of recalcitrant 'browns', from light to dark, the latter never giving any consideration to the environmental or social consequences of their consumption. 'Green' is a relative concept open to many different interpretations.

In the developed countries of the 'West' or 'Global North', even a citizen of 'dark green' disposition on average still has an ecological footprint (the amount of biologically productive land and natural resources consumed per capita) several times that of an average Indian or Chinese citizen. For even if this 'green citizen' is careful to minimize

his or her own ecological footprint, the transport, energy and food infrastructure of developed nations is inherently very demanding of nature's services and resources. In fact most developed countries are currently in ecological deficit: they maintain the quality of life of their inhabitants by importing vast amounts of resources and relying on nature's 'services' from other countries, for example the stabilizing effect that tropical rainforests have on global atmospheric conditions.

Any attempt to become more 'green' therefore must factor in local, regional and global resource use and depletion. Green World innovation treads lightly, promotes equity of resource use, encourages bio-regional solutions suited to local and regional ecosystems or biomes, and is readily adaptable to future needs. Green design or innovation takes into account both present and future environmental and social load, delivering higher rates of eco-efficiency and encouraging specific ethical and social objectives. Wherever possible, it enables and empowers people rather than perpetuating their status as passive consumers reliant on external suppliers and systems.

One of the most important challenges the world faces is the energy demand of a growing human population coupled with a rise in per capita energy consumption. This double whammy means that the world is increasingly energy hungry just at a time when half of the planet's oil reserves have already been consumed. This is the phenomenon of 'peak oil'. Over the next fifty years or so we will urgently have to find replacements for the fossil fuel energy that drives the entire global economy, underpinning the ceaseless flow of materials, goods, information and people. Furthermore, we know that the carbon dioxide output of this oil-dependent economy is raising average global temperatures towards a point where ice-cap melting, rapid sea-level rise and desertification will, literally, change the bio-capacity of our planet. The message is clear. We need to forge new relationships with the energy sources that give us life.

Rising global temperatures also mean that large parts of the world will begin to experience severe water shortages in the next 20–25 years. Water conservation and recycling will become imperative. Agricultural systems that currently depend on lots of water will need to reduce their demand by shifting from monoculture to polyculture at the same time as shifting from high energy inputs (oil, fertilizer, pesticide) to low inputs, and from high mechanization to new labour systems that draw upon human and renewable power. Climate change will also bring more extreme weather and increase the incidence of natural as well as man-

Eco-efficient technologies alone will not deliver our Green World. We shouldn't hope that tinkering with *genetic modifications, nanotechnologies* or *super-performance materials* will deliver us from ecological chaos.

made disasters. The ensuing movement of human populations will place significant demands on existing housing stock and create a need for more temporary and permanent shelter.

We are all bound by the flux and flows of natural, human, social, financial, manufactured and political capital. Truly sustainable innovation makes responsible choices about all these diverse capitals both today and in the long term. Any activity or industrial process that destroys capital, or makes that capital inaccessible, or shares it unequally within and between generations, forecloses options for the future. Our challenge is to find ways to nurture all these capitals to ensure present and future sustainability. To prevent further depletion of the planet's resources (fossil fuels, minerals, timber, fertile soil) we have to seek new ways of manufacturing – ways that rely on local bio-capacity and mineral wealth; that are ultra energy-efficient; and that prioritize local over global supply and trade.

Eco-efficient technologies alone will not deliver our Green World. We shouldn't hope that tinkering with genetic modifications, nanotechnologies or super-performance materials will deliver us from ecological chaos. New technology needs to be accompanied by the societal, political and commercial will to change. We have to find new ways of living and new models of enterprise that will restore harmony with our planet and its vital living systems – systems upon which we all ultimately depend. The Green World innovators featured here are not looking to reinvent the whole world, rather they are seeking to reuse and adapt what is already here – to smartly recombine existing resources, technologies and systems while concurrently developing new low-impact, eco-sensitive technologies that take inspiration from nature's own expertise.

Environmentally aware designers, scientists and entrepreneurs working in the realm of technology all share a consummate respect for nature's materials, patterns, mechanisms and energy flows. Many of the guiding rules they apply in their work reflect nature's own intelligent principles. William McDonough thinks deeply about the life cycle of the components of his designed products, buildings and systems. His vision of the 'Next Industrial Revolution' is encapsulated in the phrase 'cradle to cradle'. Instead of cradle-to-grave products, dumped in landfill at the end of their life, McDonough and his colleague Michael Braungart propose a system in which industrial products are subject to cradle-to-cradle cycles under which their biological and technological ingredients follow separate cycles of use, recycling and reuse. The ultimate result could be to eliminate the immense waste, pollution and resource depletion of our current global manufacturing system.

Nature's technology is revered and celebrated by Janine Benyus, an advocate of biomimicry – the science and art of emulating nature's best biological ideas to solve human problems. Through projects such as asknature.org and n100best.org (Nature's 100 Best Innovations), she and her colleagues are dedicated to educating and inspiring as wide an audience as possible. Their goal is to facilitate a new collaboration between scientific and creative industries that will spur a radical reinvention of products, processes and ways of living while increasing respect for and conservation of biodiversity.

Architects and designers contributing to the Open Architecture Network operated by Cameron Sinclair's Architecture for Humanity seek to use appropriate materials sourced from the bio-region where a proposed building is located. They strive to employ eco-efficient methods of cooling and heating using affordable technologies and passive systems. And they take account of traditional technologies that have been refined over hundreds of years to reflect the culture and environment of a particular location.

Transition to more sustainable ways of living and working will require considerable societal change. But just as we are all implicated in the problems, so we can all contribute to the solutions. Sinclair has engaged the skills of thousands of architects and designers in the complex problem-solving required to provide homes and shelter for the world's poor and displaced. He has achieved this by bringing together different actors and stakeholders, by offering challenges and competitions, and by suggesting that the future of today's 6.7 billion humans can in part be provided by 100 million design solutions – *your* design solutions.

Justin Francis is working to redefine leisure travel as 'Responsible Travel': a model of tourism that encourages sustainable development while conserving both local cultural heritage and the environment. He uses the transparency and networking possibilities of the internet to encourage travellers to share their experiences, to connect them with local hosts around the world, and to expose the destructive practices of established operators in the industry. This theme of collaboration and participation is also echoed by the emerging Transition Town Network, co-founded by Rob Hopkins, which aims to empower people to develop their own local, community-based strategies to prepare for 'energy descent' as fossil fuels become scarcer over the next fifty years.

Sinclair, Francis and Hopkins are each in their way facilitating local capacity-building from which innovation can spring, and harnessing the power of social networks, real and virtual, to co-create. These strategies are producing a quiet revolution: grassroots innovation that manifests itself in material changes as well as simultaneously regenerating human and social capital and enriching life.

If there is an overriding message to draw from diverse Green World innovation it is the importance of the widest possible participation in decision-making, whereby citizens and professionals across a broad spectrum of disciplines come together to pool their expertise; communities and societies are empowered to realize their own potential; and businesses, politicians, scientists, designers and citizens come together to enact long-lasting solutions that expand life's options now and in the future. Such solutions will regenerate damaged ecosystems and heal disrupted communities; they will make use of renewable energy, respect nature's cycles, and be efficient, non-polluting and equitable.

Design theorist John Wood advocates the idea of 'attainable utopias'. He urges us to begin by envisioning the world we would like to create for our children…and their children…and their children…. We must dare to dream beyond what we believe to be attainable. The innovators featured in these pages have not only dreamed of a different future, but are making it happen. They offer abundant hope and inspiration to all of us to re-energize our individual and collective creativity in order to secure the future of the planet and all its riches, including humankind.

Professor of Industrial Design at the Politecnico di Milano, Ezio Manzini has focused on sustainability and social innovation in everyday life throughout his career, making him one of the most respected thinkers of our time.

on innovation

ezio manzini

Amidst the complexity of contemporary society it is possible to identify promising models of innovation that represent both solutions to current problems and meaningful steps towards the creation of a sustainable future. These models can be found across a variety of fields: from the *ecological reorientation of production processes* to the construction of an *active welfare system*, from the empowerment of diffuse *micro-enterprises* to the establishment of *sustainable development programmes* among local communities.

Many of these examples have a *common denominator:* they have been conceived and implemented primarily by their participants, who have drawn upon their own direct knowledge, experience and capabilities. That is, they are the results of successful processes of social innovation.

Spontaneous by nature, social innovation cannot be planned. Nevertheless, the invention of new ways of living and producing becomes more likely in circumstances where creativity and design thinking are diffused and where local institutions have a collaborative and tolerant attitude; that is, where there is a <u>favourable</u> <u>environment</u>. At the same time, they are more likely to spread and become robust when they are empowered by specific sets of products, services and communications; that is, when appropriate *enabling solutions* are in place.

<u>Favourable</u> <u>environments</u> and <u>enabling</u> <u>solutions</u> both require *articulated co-design processes:* collaborative networks in which final users, local institutions, service providers and product manufacturers are all actively involved. In this *participation* lies the greatest promise of a different future.

16.
justin francis

Eco-entrepreneur using online connectivity and transparency to redefine tourism from top to bottom

Cheap air travel and better transport infrastructures make the dream of visiting distant destinations an affordable reality for many citizens in the West. This same connectivity also makes us witness to vastly unequal income distribution and resource use across the globe. And we are increasingly aware of how our travels contribute to climate change. So the question travellers and holidaymakers are asking themselves is where and how can I take a break that I can enjoy without the guilt? Better still, how can I make sure that my travel will directly benefit local people and their economy?

Justin Francis sought to answer these questions with Responsible Travel, a new type of travel agency that he co-founded in 2001 with Harold Goodwin, Director of the International Centre for Responsible Tourism at Leeds Metropolitan University, UK. Francis's previous experience at global advertising agency J. Walter Thompson and ethical retailer the Body Shop convinced him that it was possible to reinvent the idea of travel from top to bottom. 'I wanted to give people a different choice in travel … a new category of travel that would be understood like "organic food" and "FairTrade" products.' Responsible travel encourages sustainable economic development while conserving both local cultural heritage and the environment.

It 'reconnects the guest [or tourist] with the host, bringing their lives and stories together.' 'Responsible tourism is about more authentic experiences and it is about "deep" enjoyment.' Above all, Francis seeks to encourage celebration of 'local distinctiveness'.

The Responsible Travel website is a one-stop shop that today brings together over 270 operators and hundreds of villas, lodges, B&Bs, small hotels and specialist tours. But Francis is more than a travel agent. His mission is to inspire consumers and reshape the tourism industry. He wants to see destinations, tour operators and the industry in general begin to compete around the agenda of responsible travel, not price or visitor numbers. In 2004 he launched the Responsible Tourism Awards to celebrate the achievements of those committed to this new vision. By 2008 they were attracting nearly 2,000 entries. Responsible Travel also encourages travellers to share their experiences and has published over 3,000 independent reviews. This spirit of openness and participation was boosted by the launch of a further initiative, iknowagreatplace.com, which invites travellers worldwide to log their recommendations, photos and diaries.

Greening tourism means challenging the culture from within. The days of the

tourism industry marketing a destination as 'underdeveloped', exploiting it for a few years and then moving on are over. Online networking is empowering travellers to share information that can impact the profile of even the most powerful companies. In 2007, in collaboration with the British *Daily Telegraph*, Responsible Travel audited a range of mainstream, luxury and adventure tour operators alongside cruise companies, airlines, ferry services and car hire companies, using publicly available information. Such transparency is ever more important. Francis believes that tourism is undergoing a welcome process of democratization fuelled by real travellers' experiences and by proactive operators and local communities. His company is more than just a catalyst in this process. 'Responsible Travel' is a brand that signifies a new way of travelling, and represents a vitally important sector for the future of the global tourism industry.

Paperbark Camp, Jervis Bay, Australia
This camping resort features elevated tents designed for minimum impact on the surrounding bushland, and offering the perfect base from which to explore the unspoilt beaches and Booderee National Park nearby.

Below and bottom
Kapawi Ecolodge and Reserve
Located in the Pastaza province in Ecuador, in
the heart of the Amazon region, the resort works
closely with the local Achuar Indians, whose
culture informs the architecture, food and activities,
including hiking, canoeing, birdwatching and visits
to nearby villages.

Below and opposite, below left
From Here 2 Timbuktu
Offering expeditions across West Africa and the
Sahara with emphasis on the journey and the African
communities that host the trips. Below: the remote
oasis of Tada Makat, Mali, reached by camel trek.
Opposite below left: Tuareg nomads at the Festival
in the Desert, Essakane, Mali, 2007.

Responsible Travel 'reconnects the guest with the host, bringing their lives and stories together.' *Justin Francis*

Above and top left
Paperbark Camp, Jervis Bay, Australia
The resort aims to provide a unique and genuine Australian bush experience that is ecologically sustainable.

17.
cameron sinclair

Architect who has inspired thousands of design professionals to volunteer their skills for humanity

The Bartlett School of Architecture, University College London, is renowned for producing inventive, experimental and exploratory architects. So it is no surprise to see that its graduates include British-born Cameron Sinclair, who co-founded Architecture for Humanity (AfH) with his partner Kate Stohr in 1999.

AfH is a not-for-profit organization based in San Francisco that focuses on creating architectural solutions for people hit by natural or man-made crises. With a strong sustainable and ethical agenda, AfH works closely with communities in the global South and North, using architecture as a catalyst for encouraging social entrepreneurship and community-building. In less than a decade, it has become a global player in providing and coordinating professional design services to community groups, NGOs, funding bodies, social entrepreneurs and other not-for-profit organizations.

AfH's innovative strategy is to act as a conduit, a network and a resource for designers and architects worldwide, and it does this by using web technologies to make architectural design available as open source. In 2007 AfH launched the Open Architecture Network (OAN). This hosts details of over 1,220 projects and is supported by over 13,500 members including architects, designers, landscape architects, structural and civil engineers and more. Its open-source designs can be modified, improved and customized to local needs by other designers from around the world. 'We can have architects from America, Finland and Tanzania working on the same project on a collaborative basis', enthuses Sinclair. 'Most importantly, the mechanism is totally transparent. When it doesn't work everyone can see; equally, when it is successful, everyone can share the lessons.' This is invaluable to funders, stakeholders and final users. It also helps exceed the typical *c.* 35 per cent 'success' rate of projects undertaken by NGOs and relief organizations. 'AfH is a nimble but strong tug boat compared to the NGO supertankers.'

In 2005, natural disaster in the form of Hurricane Katrina brought demand for AfH's services nearer to home. Experience acquired overseas was applied to the US$2 million Biloxi Model Home Program, set up to provide design services and financial assistance for the reconstruction of homes in Biloxi, Mississippi. The practice model enabled each family to work one-on-one with architects and design professionals, giving them access to the necessary expertise to design a new home that would be affordable, sustainable and would meet tough new building standards for hurricane-prone areas. The output drawings were made available as open source, and the whole project was financed by a 'forgivable loan' system tied to a community bank with a rolling fund. In terms of contract management, this rewrote the book, enabling successful designs to be replicated and the lives of 700 families to be positively improved.

'The architect is no longer the caped crusader,' says Sinclair, 'he/she is a co-collaborator, a liaison person and guide. Architecture of the ego is no longer relevant, it is now about "shared understanding".' Hundreds of architects continue to sign up each month to donate design services, confirming his conviction that: 'There is a pendulum swing towards more humane architecture.'

AfH also runs the annual Open Architecture Challenge, a competition to find empowering humanitarian solutions through architectural design. The 2009 challenge was to design schools for the children of the future. 'By 2035', observes Sinclair, 'there will be more than two billion people worldwide between the ages of 12 and 24. Ten million classrooms are needed globally.' The ability of AfH and the OAN to generate and circulate ideas will make a major difference in this and many other fields in the decades to come.

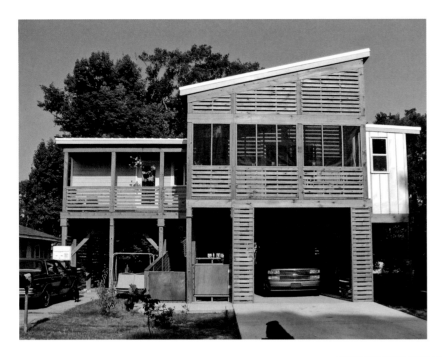

Biloxi Model Home Program, launched in 2005
East Biloxi, Mississippi, USA
Four different examples of sustainable, storm-resistant
housing designed by AfH architects for families left
homeless after Hurricane Katrina.

Mobile Health Clinic for sub-Saharan Africa, 2002–5
Nicholas Gilliland and Gaston Tolila of LILA Design
Winner of an AfH competition to design a mobile
HIV/AIDS clinic, this was picked from entries
submitted by over 530 teams from 51 countries.
The clinic consists of two parts: one or two earthen
'granaries' built by the community before the arrival
of the clinic, and a tent-like mobile component, which
arrives by truck with the medical team. An awning of
local African textiles gives protection from the sun.

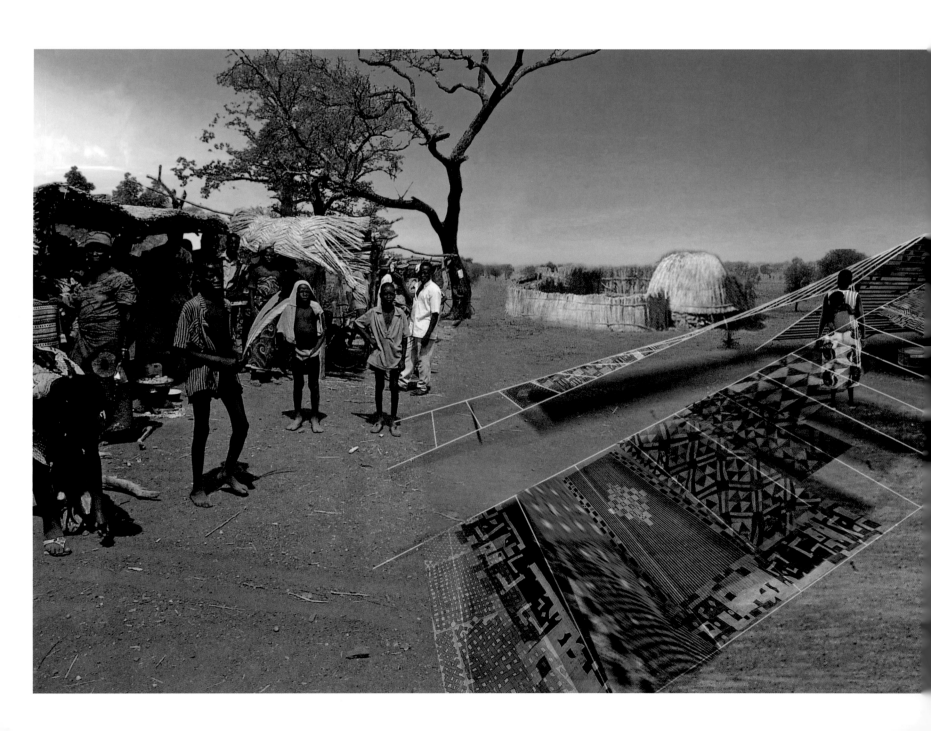

Mobile Health Clinic for sub-Saharan Africa, 2002–5
Nicholas Gilliland and Gaston Tolila of LILA Design

Architecture for Humanity's strategy is to act as a *conduit*, a *network* and a *resource* for designers and architects worldwide, by using *web technologies* to make architectural design available as *open source*.

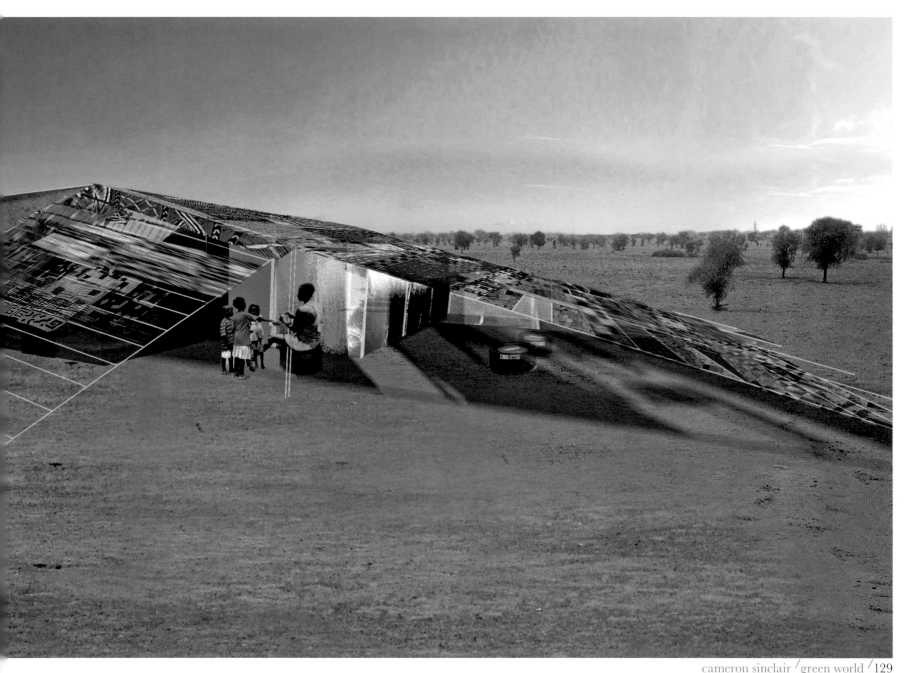

18.
rob hopkins

Eco-campaigner encouraging people to prepare for a future without oil, one community at a time

Rob Hopkins qualified as an environmental and quality resource manager at the University of West of England, Bristol, UK, and followed this period of study with a short but life-changing course on permaculture – locally sustainable agriculture that mimics the relationships found in natural ecologies. By 2001 he had established the first permanent full-time permaculture course in Ireland, at Kinsale Further Education College. During 2002–4 he built the first cob house to be constructed in Ireland for over a hundred years. These projects kindled the interest of a wider community and in 2005 Hopkins organized the 'Fuelling the Future' conference with Catherine Dunne and Louise Rooney. This led directly to the development of the Kinsale Energy Descent Action Plan of 2005, believed to be the first attempt by a local community to create a year-by-year action plan for its transition to a low-energy future to meet the impending twin challenges of 'peak oil' and climate change. It was also the seed of the 'Transition Town' (TT) movement.

Hopkins continued to nurture the concept after returning to his home town of Totnes in southwest England, and by 2007 a movement was launched, co-founded by Hopkins with Ben Brangwyn. TT Totnes quickly captured the imagination of this eclectic West Country town, with its ancient history, medieval street layout and colourful community. The movement launched its own currency, the Totnes Pound, to encourage local purchasing. Imaginative initiatives ranged from Seedy Sunday (a seed exchange to encourage people to take up gardening) to World Café dialogues and business resource swapshops. The most recent initiative is Gardenshare, a scheme devised to bypass the 300-name waiting list for council allotment plots. Hopkins describes Gardenshare as a kind of 'dating agency' bringing garden owners together with those who want to garden, and providing a rental agreement and certification process. But as he points out, 'TTs catalyse and support but don't "run" projects – they are all self-organized and intiated. That's why the whole Transition Network is still run by two and a half people!'

A core belief of the movement is that local people can and must work together to build resilience for the time when communities will have to 'power down' – when the decline of oil and the reality of climate change mean that reducing dependence on fossil fuels and cutting emissions of greenhouse gases, particularly carbon dioxide, become urgent priorities. Key to developing this resilience is participation to encourage creative solutions from all, with open decision-making, and a re-focusing on ideas and the practicalities of localization. 'We can mainstream this approach if we take away the "blame culture" and focus on positive solutions. We need "heads, hearts and hands",' says Hopkins. The goal is to inspire everyone to take part in redesigning now and, in doing so, to design the future.

Hopkins gathered the experiences of TT Totnes into a practical guide to setting up a Transition Town. Published in 2008, *The Transition Handbook* is a clarion call to local communities of all kinds, empowering them to begin the transition to a lower-energy life. In summer 2008 the book was number five in the list of most popular reading among UK Members of Parliament. Hopkins believes this reflects politicians' recognition that the Transition Network has a level of energy that today's conventional political movements lack.

The remarkable growth of the TT movement, which is sweeping across the USA and elsewhere, reveals a latent enthusiasm among individuals and communities to reconfigure their lives at a local level. It represents a refreshing paradigm shift and a force for change driven not by government or business but by community will. It may well herald the emergence of a new generation of what Hopkins calls 'producer-consumers'. Will you be one of them?

The Totnes Pound

Transition Town Totnes, the first TT movement, launched its own currency to encourage local purchasing. The Totnes Pound (above) has a value of £1 and is accepted in over 70 shops in the town. Local currencies were routinely issued by banks in centuries past. This 1810 'Totnes Union Bank' note (top) was an inspiration behind the project.

A core belief is that local people can and must work together to *build resilience* for the time when communities will have to 'power down', *reducing dependence* on *fossil fuels* and *cutting emissions* of greenhouse gases.

Top
TT Totnes 'Garden tour'
David Heath, son of George Heath who until 1980 ran an extensive market garden in the centre of Totnes, shows a tour group where his father's gardens used to be. It is now a car park.

Above
TT Brixton 'Great Unleashing', 2008
The event featured a cake decorated with the names of other Transition initiatives.

Top
TT Totnes, planting walnut trees
The trees were planted both as an awareness-raising strategy and a long-term food-security measure.

Above
The Transition Timeline
The Timeline is a tool used by Transition groups to invite people to contribute ideas for moving away from oil dependency in their communities.

Above
Transition Cities Conference, Nottingham, 2008
A participant gives a presentation on peak oil and gas.

Opposite
Photovoltaic bicycle shed
Dyfi Eco-Park, Machynlleth, Wales

TT Totnes, planting walnut trees
Hybrid walnuts and chestnuts may be one of the staple crops of the future: they can produce as much carbohydrate and protein per hectare as organically grown grains.

TT Brixton 'Great Unleashing', 2008
An idea-gathering wall encouraged all participants at the launch event to contribute suggestions for reducing the oil dependency of this London district.

Transition BS3 information stall, South Bristol
The group has managed to convince the local council to give them two areas of land for food production.

19.
william mcdonough

Architect and environmentalist with a far-reaching vision for a successful sustainable future

In September 2008 William McDonough made the prestigious *Vanity Fair* 'New Establishment' list, just behind Apple designer Jonathan Ive. This recognition testifies to the huge impact he has made on industrialists, urban planners, architects, designers and academics worldwide with his vision of sustainable architecture and design. As the founding principal of William McDonough + Partners, an architecture and community design practice based in Charlottesville, Virginia, McDonough is involved in projects across the globe. The practice's portfolio is defined by its mission to create structures that use renewable energy, produce zero waste and encourage new natural habitats.

The root of McDonough's design philosophy is a belief that development has to be – and can be – within nature's limits. Cities of the future, he believes, must seek to offer a 'safe, healthy, just world, [with] clean air, soil and power, that is elegantly enjoyed'. Long before the idea of sustainability had attained the profile it has today, McDonough and chemist Michael Braungart were commissioned by the City of Hannover to develop a systematic definition of sustainable design ahead of the 2000 World's Fair. This was published as *The Hannover Principles: Design for Sustainability* (1992). These principles call for equity, co-existence and interdependence between humans and the natural world; consideration of the social and spiritual aspects of buildings and products; integration of natural energy flows; elimination of waste; sharing of knowledge; and acceptance of the limitations of design.

McDonough has held a series of academic positions, notably as Dean of the School of Architecture at the University of Virginia, and later Edward E. Elson Professor of Architecture. He also teamed up with Michael Braungart to found the product design and development firm McDonough Braungart Design Chemistry (MBDC), which developed the world's first totally sustainable modern textile, Climatex® LifeCycle™. This is made of wool and ramie using safe dyes and clean technology processes, making it durable yet compostable at end-of-life.

Braungart and McDonough's influential 2002 book *Cradle to Cradle* set out a vision for a new industrial revolution that would eliminate the immense waste, pollution and resource depletion of the present global industrial system. They describe a world of interdependent natural and human systems in which the elements of products circulate, like nutrients, in a continuous regenerative cycle: organic parts are composted after use; high-tech and synthetic parts are recovered and remanufactured. Cradle-to-cradle strategies have been implemented by multinational manufacturers including The Gap, Nike, Herman Miller and Ford. MBDC's Cradle to Cradle™ Certification programme now provides an independent system for evaluating the environmental credentials of everything from office seating to building systems.

McDonough is also a key advocate of bringing systemic, holistic thinking to the planning and execution of new development in China. He is a co-founder of the China–US Center for Sustainable Development, a not-for-profit organization that encourages collaboration between business, government, education and third-sector organizations. Master-planning for Liuzhou in Guangxi Zhuang Autonomous Region reveals a design strategy to maximize social engagement by walking and exercise, and to use a whole ecosystem approach to water use.

Through these many different avenues, McDonough continues to be a global leader in the search for an equitable, sustainable and economically and environmentally viable future for humankind.

Ecourban 22, 2008
Poblenou district, Barcelona
This ambitious, mixed-use urban renewal project combines sustainable architecture with high design.

Park 20|20
Beukenhorst Zuid, Hoofddorp, the Netherlands
Park 20|20 represents a new model for the sustainable design of working environments, reducing energy use by orienting buildings to optimize daylight and shading, integrating a storm-water management system, and encouraging biodiversity via green roofs and regenerative landscaping.

Isola building
Porta Nuova redevelopment, Milan
This office building for developer Hines Italia will incorporate renewable energy in a number of ways, including photovoltaics and ground source thermal capture, in combination with a high-performance building envelope.

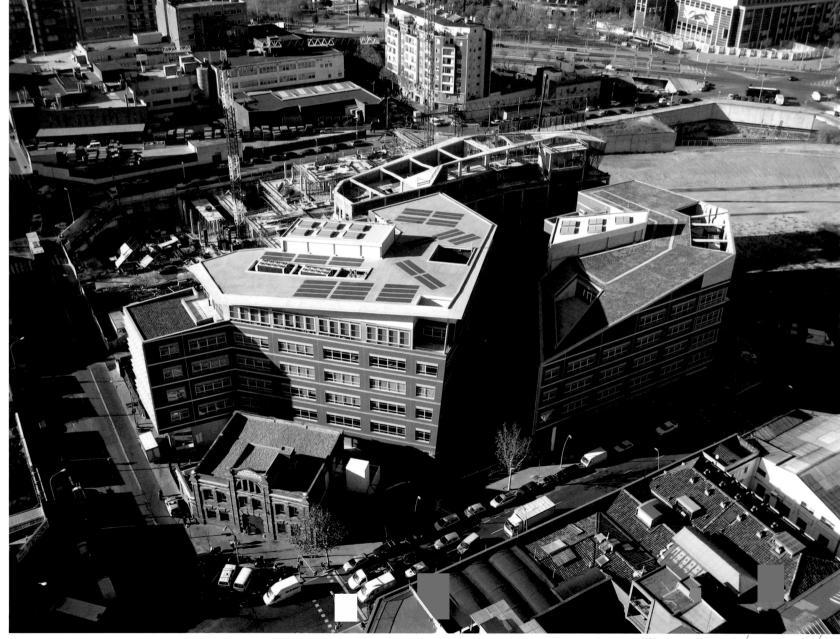

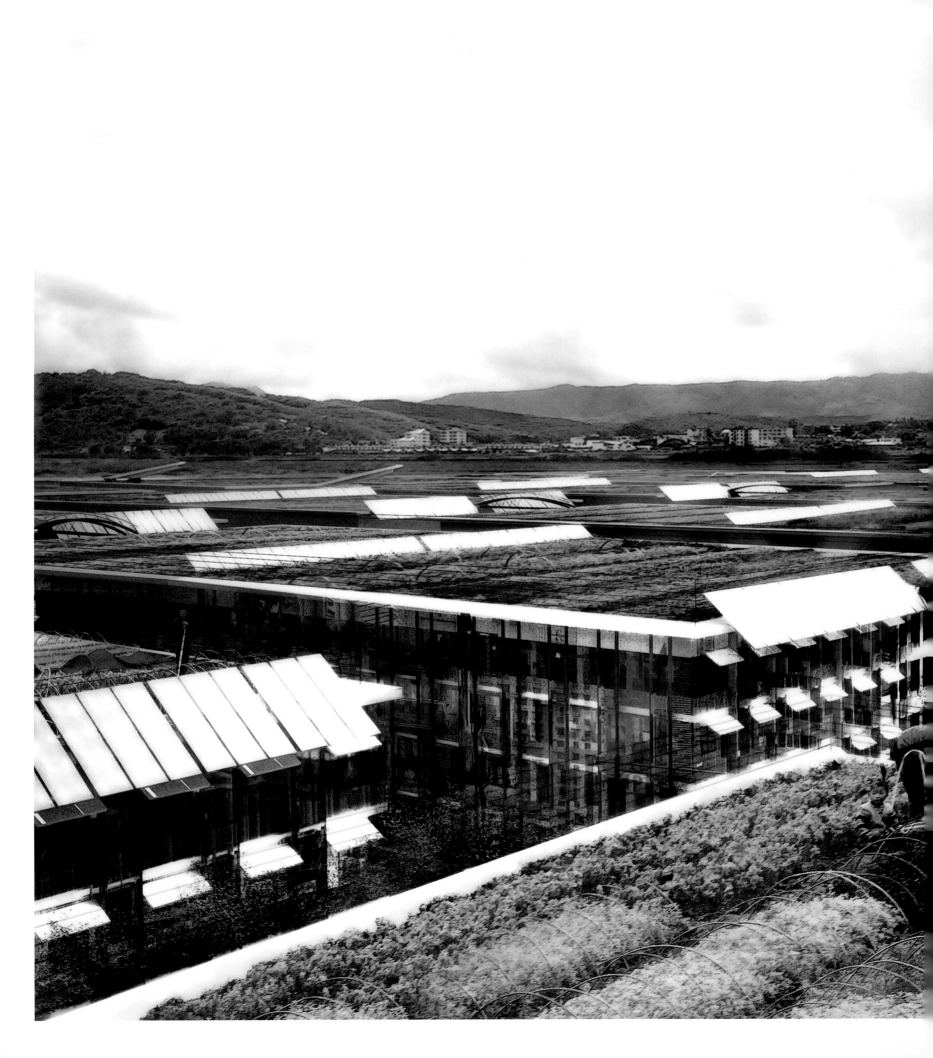

Urban rooftop farming concept
Scheme inspired by the scale of China's
urban migration and the shortage of arable
land for food production.

20.
janine benyus

Pioneering advocate of biomimicry: design innovation inspired by the natural world

Nature's designs have been honed over 3.8 billion years to cope with slowly evolving, or occasionally cataclysmic, changes in the planet's incredible history. No wonder then that humankind has always been inspired by the aesthetics, mechanisms, structures and sheer ingenuity of nature's solutions.

Biomimicry (also known as biomimetics or bionics) is an approach to design, engineering and architecture that seeks to emulate the proven strategies and mechanisms of nature. In her 1997 landmark book of the same name, biomimicry consultant and philanthropist Janine Benyus described biomimicry simply as 'innovation inspired by nature'. Her treatise alerted designers, scientists and innovators worldwide to the latent potential of nature as a source of knowledge for the development of new technologies. Nature's ability to manufacture materials at ambient temperatures using locally available resources makes humanity's 'heat, beat and treat' modes of synthesizing materials look hugely clumsy. Nature's armoury of material technologies includes life-friendly manufacturing processes that don't poison or deplete the environment. Nature produces an ordered hierarchy of structures and is brilliant at self-assembly and templating to form formidably complex materials and composites.

In 1998 Benyus co-founded the Biomimicry Guild with Dayna Baumeister. This consultancy, based in Montana, USA, works with brands such as Nike, General Electric and Interface to encourage out-of-the-box thinking through exploration of nature's solutions. This is often achieved by field trips to rainforests or other biomes to make first-hand observations. Nature's concepts are then transposed and blended to meet technological challenges. Benyus also founded the not-for-profit Biomimicry Institute which encourages dissemination of knowledge.

Benyus regards herself as a natural history writer, whose goal is to 'direct people's gaze to the natural world; to look outside, to look in a different way.' In 2008 she co-authored *Nature's 100 Best* with Gunter Pauli, setting out a top one hundred natural technologies and detailing their potential to inspire man-made innovations. The book highlights a wide range of precious organisms and habitats that are repositories of amazing knowledge, some of them threatened by humanity's voracious appetite for resources.

A host of projects in progress hint at the depth of Benyus' holistic bio-philosophy and also the potential for biomimetic theory and practice. AskNature – www.asknature.org – is a free, open-source, online database demonstrating nature's genius for design solutions. It is set to revolutionize how the scientific and creative industries collaborate and inspire each other. 'We've found 25 or so "life design principles" and over 2,100 strategies deployed by nature,' Benyus said, 'but realized that life function and biological information needed organizing to improve its usefulness to a wider community.'

Benyus is also working with HOK Architects to develop new ways to measure the services provided by ecosystems. 'Our cities should be functionally indistinguishable from the rest of the natural world. Even if they look very different from rainforests, they should function like one. Future "place-making" will be learning about how to create the capacity for life, it will be "regenerative place-making".'

A passionate advocate for and on behalf of nature, Benyus believes that increasing respect for the natural world is essential for tackling the many challenges that confront us today.

Morpho butterfly
asknature.org
Morpho butterflies remain a vibrant blue throughout their lives. The scales on their wings are formed of layers of proteins that refract light, and the colour we see is often due entirely to the play of light and structure rather than the presence of pigments. They were the inspiration for Morphotex® fibres produced by Teijin Fibers Limited of Japan (overleaf).

Morphotex® structural coloured fibres
asknature.org
Morphotex® fibres are produced by Teijin Fibers
Limited of Japan without use of dyes or pigments.
Instead – as in the wing scales of morpho butterflies
(bottom) – the perception of colour is created by the
varying thickness and structure of the fibres. Energy
consumption and industrial waste are reduced
by eliminating the dyeing process.

bioSTREAM

askNature.org

Inspired by the tail-propulsion movements of sharks and tuna (bottom) BioPower Systems' tidal-power conversion system generates electricity from the flow of water. It swivels to realign as the tide changes direction.

bioWAVE and bioBASE
asknature.org

Another of BioPower Systems' hydrodynamic generators was inspired by the swaying movements of bull kelp (*Nereocystis luetkeana*, opposite). The bioBASE mooring device that anchors the blades to the seabed is modelled on the root structure of the bull kelp, exploiting multiple small-gauge bolts that do not require heavy drilling. The technology can also be used to anchor offshore wind turbines.

21–25.

jonathan harris
metahaven
ben fry
manuel raeder
yugo nakamura

graphic design

alice twemlow

introduction

alice twemlow

Chair of the graduate programme in Design
Criticism at the School of Visual Arts, New York

At the sharp edge of contemporary graphic design, where tools and approaches are being tested, media absorbed and territory assimilated, a new type of practice is being forged. This new graphic design practice is organizationally compact (although expandable on demand); its progenitors initiate their own projects and often products; they create their own tools; they use multiple media interchangeably; and, rather than design something finished or static, they often define the parameters for open-ended outcomes that require the participation of users for their realization. Graphic design is no longer only about clarification and communication; its purpose has been significantly broadened by designers' desires to raise questions and provoke debate, and to reflect upon, and subvert, the very nature of communication design itself.

Graphic design's domain has expanded to encompass adjacent practices such as filmmaking, game design, sound design, interactive design, writing and publishing, the production of events, coding and programming, strategy and some aspects of fashion and product design. This expansion is largely due to technological innovations that make these once-specialized and professionally demarcated disciplines more accessible. It is also fuelled by the receptiveness and expectations of audiences who are accustomed to interacting with multiple communications channels, and whose engagement with the output of graphic design practice is increasingly sophisticated.

Where growth was once a more or less given goal for a design firm, today many choose to remain small and flexible. When a complex multi-channel project comes in, the small firm can expand exponentially by

Designers interested in *redefining the graphic design profession* in recent years have been willing to sacrifice paying commissions for the *independence* and *creative freedom* that *self-directed work* allows.

enlisting on a freelance basis the services of a network of specialists in various disciplines or technologies. In this way, the firm keeps its overheads low. When Japanese interactive designer Yugo Nakamura needed to create a television commercial for the clothing retailer UNIQLO, for example, he transformed his small day-to-day team of designers by calling in producers, stylists, editors and music supervisors.

Self-directed projects are key to this new graphic design practice. Rather than waiting for clients to commission interesting new work, designers are initiating and pursuing their own projects. Designers interested in redefining the graphic design profession in recent years have been willing to sacrifice paying commissions for the independence and creative freedom that self-directed work allows. For many, a regular teaching post provides a base salary, which can be supplemented by grants and other types of funding. Often clients will see a designer's self-initiated projects and then commission something similar, in a transaction that blurs the once clear distinction between designer and artist. After seeing designer Jonathan Harris's previous work – which tracks the blogosphere for evidence of people's feelings and correlates this with geography, weather, gender and age – the organizers of MoMA's 2008 'Design and the Elastic Mind' exhibition commissioned Harris to produce an interactive video installation on the theme of how people date online. Dutch design collective Metahaven have recalibrated their entire practice around self-directed work. The issue for them now, as Metahaven member Daniel van der Velden says, is 'how to maintain self-direction when you start getting commissioned for new self-directed work.'

A larger phenomenon is pervading both art and design in which the *participation* of an *audience* is required to complete a particular project.

London-based åbäke operates in many respects as an art collective – both in terms of approach and the context in which the group's work is presented. Its members choreograph performative events that encourage interaction, such as Trattoria, a recurring collaboration with furniture designer Martino Gamper, in which they cook a multi-course meal for an invited audience of about forty people. One of their former students, Alex Bettler, a Swiss designer who works in London, is also interested in exploring the event or performance as a medium: he regularly conducts participatory bread-making workshops, usually in the setting of an art gallery.

For those designers engaged in reframing practice, however, the goal is not simply to move beyond design and to become recognized as artists. Even though they have an established place in the art world, the members of collectives such as åbäke and Metahaven continue to refer to themselves as graphic designers since this gives them the distance they need and protects the status of what they call 'professional amateurship' in which they prefer to operate. There are traditional graphic design elements in such activities as the Trattoria and Bettler's bread workshops – invitations, menus, place cards and the subsequent documentation in print and online. But the focus is not on these artifacts; rather it is on the event they represent and frame, and on establishing the parameters of novel types of social interaction.

This shift of interest away from the design of an object and towards the choreography of a situation, event or performance can be seen as part of a larger phenomenon pervading both art and design in which the participation of an audience is required to complete a particular

project. The designer's role is focused on establishing the parameters of the experience – on determining a system that will then be fulfilled spontaneously, or at least with some degree of randomness, by a group of end users. These open-ended systems create distance between the designer and the object or end product; they might be thought of as designs for making designs. Other designers, adept at coding, may customize or design new software that will 'complete' a project according to a set of principles or algorithms. Many who have developed new software, plugins or fonts for such projects then sell them, or make them available for free via open-source platforms. Ben Fry, in collaboration with Casey Reas, developed Processing, a programming language and environment for images, animation and interactions that is used by everyone from children in their first exploration of computer programming, to other designers, architects, engineers, and scientists. R.E.M., Radiohead, and Modest Mouse have used Processing in their music videos; *Nature*, the *New York Times* and *Seed* have commissioned information graphics using Processing; and the University of Washington used it to create a visualization of a coastal marine ecosystem.

Other designers are developing lines of products such as fonts, digital applications and screensavers, as well as garments, publications and printed matter that they sell either individually through their own websites or collectively through online platforms shared with like-minded designers. Manuel Raeder, best known for his print design for artists and galleries in Berlin, is increasingly intrigued by three-dimensional forms and their potential to represent 'answers' to his 'questions'. His triangle shelving unit, both a seat and a storage device, emerged from his pondering whether a piece of modular furniture could grow into a whole library shelving system. Japanese designer Yugo Nakamura's SCR label is a platform for interactive art, software and video-based projects. Through SCR he sells DropClock, a screensaver in which heavy Helvetica numerals drop into water in mesmerizing slow motion, and Kaze, another screensaver that blows the items on your desktop across the screen to reflect the wind conditions in your particular location. Swiss designer Cornel Windlin distributes his fonts and those of a select group of international designers through his online type boutique Lineto. Recent additions to the site include playful fonts-as-software applications such as Lego Font Creator by Jürg Lehni, and Rubik Maker by Lehni and Windlin using Norm's Sign-Generator. The applications allow users to modify the letterforms within certain constraints, and to export the result as vector data for use in their own work.

In more traditional media such as publications, designers are also exerting authorial power. With the emergence of print-on-demand publishing outfits such as Lulu and the prevalence of independent distribution via PDF, it has become easier for designers to create their own magazines, treatises and books without the need for editors, publishers or distributors. And, since many are interested in writing themselves, they also have less need for collaboration with professional writers. Members of Metahaven, for example, believe that writing is an integral part of graphic design and many of their design projects emerge directly from an essay, lecture text or research paper they have written on topics such as state branding, the post-industrial age or art and politics.

For several years now, designers have engaged in these kinds of entrepreneurial and authorial activities, which have afforded them more independence and more control. As they simultaneously become more interested in socially interactive, open-ended, open-source design in which the designer determines neither what their final product will look like, nor how it will be used and interpreted, so they have to embrace the concomitant loss of control. To some degree, then, as designers turn over responsibility for shaping the final product or experience to the end users – to people having dinner in their improvised Trattoria or those using a software tool or font for their own, unanticipated, ends – an interesting irony arises: increased independence and authorial influence is combined with a relinquishing of control over the end product. This tension is just one of many themes that spur on those in the vanguard of an evolving contemporary graphic design practice.

President of Rhode Island School of Design and author of *The Laws of Simplicity* (2006), John Maeda's graphic and interaction designs have made him one of the most influential designers and spokesmen of the digital age.

on innovation

john maeda

The very nature of innovation requires that one must look *beyond the status quo, defy the limits of 'the box', and risk failure.* My focus has been on the practice of simplicity, bringing humanity to technology and demonstrating that 'new' and 'more' are not always better. People used to desire 'high tech', and some now go the other extreme, shunning technology as they strive to be 'low tech'. I say the best strategy, looking ahead, is simply to become 'less tech'.

Today, I apply this thinking as President of Rhode Island School of Design. As an institution, we are practising new and uncommon (particularly in higher education) methods of open-source administration. This creative leadership model flattens the hierarchy of the traditional organization into a network in which people are encouraged to share their voice.

By implementing technologies that allow us to connect at all levels – tools such as blogs and digital bulletin boards, and gatherings such as open community meetings and morning jogs – a real peer-to-peer incubation happens in which conversations occur, ideas are shared and connections are made. Each strand allows me to lead with principles I believe in – openness, clarity and transparency.

If there's anything we know about business in the twenty-first century, it's that success will be more closely tied to creativity and innovation than ever before. Just as we pursue that here within our own community, I believe it is imperative to teach students to carry it outwards into a world in which the model of the so-called 'starving artist' is shifting to that of the 'artrepreneur'.

We are at a turning point. *Passionate, emotional invention is what is needed to keep today's world thriving.* The new conventional wisdom must embrace the essential nature of critical thinking/making – a values-based, humanitarian, tactile process – and policy makers and employers should recognize that this is something that we can no longer afford to overlook.

21.
jonathan harris

Interaction designer and storyteller who explores the human experience of the web

Brooklyn-based Jonathan Harris represents a new type of visual practitioner who combines in his work elements of computer science, anthropology, reportage and storytelling. He introduces humanity and human emotion to interaction design, a sphere that is more often dominated by technology. He has made projects about desire, happiness, modern mythology, news, anonymity and language, and even documented an Alaskan Eskimo whale hunt.

The Whale Hunt website (thewhalehunt.org), in which Harris records an Alaskan whaling expedition, is indicative of a new preoccupation in graphic design. It was entirely self-initiated and authored. Harris spent nine days living with a family of Inupiat Eskimos in Barrow, Alaska, the northernmost settlement in the United States. He joined the community on their whale-hunting expedition, recorded the experience and then composed the resulting visual data – a sequence of 3,214 photographs taken at five-minute intervals, spanning seven days – into an interactive storytelling platform that can be experienced in multiple ways.

The project takes a new approach to graphic storytelling. The user chooses filters to follow one of many sub-stories embedded within the larger narrative (the story of blood, the story of the captain, the story of the Arctic Ocean, etc.). Each viewer thus creates his or her own experience.

Harris studied computer science at Princeton University, where he developed a program that gathers and clusters similar news articles from distant locations across the web. Upon graduating, in 2004, he was awarded a Fabrica Fellowship from Benetton. At Fabrica, Harris built on his student work and created the award-winning sites 10x10, which surveys news reporting across the world and selects the top 100 words and pictures every hour to create a snapshot of a global moment, and WordCount, an interactive presentation of the 86,800 most frequently used English words, arranged in order of prevalence side by side as one very long sequence that can be tracked and explored.

Harris sought out practical and commercial outlets for his interest in news aggregation. As the first design director of Daylife, a global news service, he created Universe, an exploration of modern mythology which proposes new constellations for the night sky that reflect themes of contemporary life such as the Iraq war or climate change.

The winner of three Webby Awards, Harris has also been recognized by AIGA, Ars Electronica, *Print*, *i-D* magazine and the State of Vermont, has been featured by CNN, the BBC, NPR, Reuters, *Metropolis*, the *New York Times*, *USA Today* and *Wired*, and has been exhibited at the Pompidou Centre, Paris, and the Museum of Modern Art, New York.

In 2006, he was commissioned by Yahoo! to build the world's largest time capsule, which was open for one month online, in ten languages, and whose contents were then projected for three consecutive nights onto the ancient canyon walls of the Jemez Pueblo in New Mexico. Compiling the contributions of 170,857 individuals who used words, pictures, videos, sounds and drawings to express themselves on themes such as Love, Sorrow, Faith and Fun, Harris created a collective digital portrait of the world in 2006 that will be reopened in 2020.

New York's MoMA asked Harris to create a new work for their 2008 show 'Design and the Elastic Mind'. The result, *I Want You to Want Me*, combined Harris's signature interests in interaction design and the human experience of the web in an interactive installation exploring people's search for love and self in the world of online dating.

I Want You to Want Me, 2008
iwantyoutowantme.org
A young child interacts with the touchscreen installation at New York's MoMA.

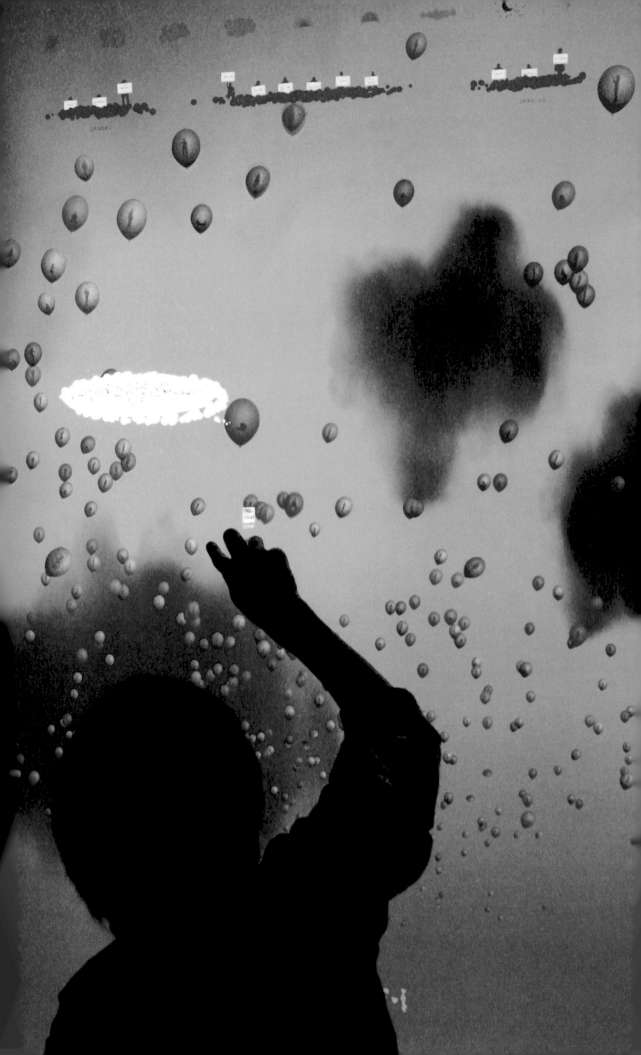

Balloons of Bhutan, 2007
balloonsofbhutan.org
In Bhutan, Harris asked people to define their level of
happiness on a scale of one to ten, and photographed
them holding that number of balloons. He also asked
their greatest wish. Clockwise from top left: 13-year-old
student Sonam Wangmo; 17-year-old student Chimi
Dema; 78-year-old farmer Chencho Doji; and Salamon
Ali, a 37-year-old road worker, with his co-workers.

We Feel Fine, 2006
wefeelfine.org
This project tracks the blogosphere for up-to-the-minute
evidence of human feelings across the world. These
are correlated against location, weather, gender or age,
and the results presented via interactive montages. It is,
Harris says, 'an artwork authored by everyone. We hope
it makes the world seem a little smaller, and helps people
see beauty in the everyday ups and downs of life.'

Left
The Whale Hunt, 2007
thewhalehunt.org
All 3,214 whale hunt images arranged
chronologically, as a pinwheel, each column
representing twenty minutes.

Opposite
The Whale Hunt, 2007
thewhalehunt.org
All 3,214 whale hunt images arranged
chronologically, as a grid.

Above
Images from *The Whale Hunt,* 2007
thewhalehunt.org
Clockwise from top: Simeon Patkotak, the whaling
captain; Jonathan Harris at whaling camp in Barrow,
Alaska; an 11.5-metre (38-foot) Bowhead whale,
weighing about 40 tonnes; the Barrow community
use a block and tackle system to haul a whale onto
the ice; the snowy tarmac at the airport in Barrow,
Alaska; Patkotak's whale, with the captain's share
of *muktak* (blubber) removed; men use a rope to
open the whale's carcass, while Rony extracts the
whale's intestines.

22.

metahaven

Radical collective pursuing self-directed projects at the conceptual forefront of contemporary design

With self-initiated research at the core of their work, the members of Metahaven redefine the role and working methods of a design firm. Vinca Kruk and Daniel van der Velden, both trained as graphic designers, are based in Amsterdam, while architect Gon Zifroni is based in Brussels. They do not depend on client commissions; rather they generate their own lines of inquiry into issues that interest them, including branding and identity, nation states, the monopoly of search engines and globalization. This research then fuels their self-directed design work, lectures and essays.

For the *Sealand Identity Project* – a formative project for the members of Metahaven, begun in 2003 – the designers conceived a visual identity for the Principality of Sealand, a self-proclaimed mini-state situated on a former anti-aircraft tower in the North Sea. This structure was squatted in 1967 by Englishman Roy Bates, and he and his wife proclaimed themselves Prince and Princess of Sealand. In 2000 Sealand began to offer secure, secret data storage and traffic from its servers, turning the fortress into a so-called 'data haven' outside the jurisdiction of established nation states. For this space that is both physical and virtual, Metahaven created an array of logos, symbols, stamps and heraldry. The collective were able to test out their innovative approach to design research in a

project in which there were no client stipulations and which allowed them to pursue explorations of theory, politics, writing and making.

Superstudio, the 1960s Italian architecture collective, is the inspiration for Metahaven's investigative design practice. Like the conceptual architecture firm, whose members criticized Modernist ideals and the established practice of architecture and design, Metahaven offer critiques of their own profession and use the tools of architectural communication such as models, prototypes and essay-writing to develop and convey their ideas. They do not work from a particular studio since, as they point out, living in a post-Fordist, networked era means designers can work from anywhere. Their income comes from a mix of commissioned work – design and writing – and teaching. Kruk teaches at ArtEZ Academy of Arts in Arnhem and, with the rest of the Metahaven team, she is a guest tutor at the Academy of Arts in Valence, France. Van der Velden is a critic at Yale University, a tutor of design at the Sandberg Institute in Amsterdam and an advising researcher at the Jan van Eyck Academie, Maastricht.

Among Metahaven's recent projects is a set of posters for CAPC, Museum of Contemporary Art of Bordeaux. The posters, densely layered and using a vibrant palette of warning-sign

colours, take as their theme borders and the ways they are conceived – for example, by means of political statements or by marketing and brand profiling. The posters were displayed in summer 2008 alongside the city's *boulevard périphérique*, the circular road demarcating the border between the centre and outskirts of town. For the 2008 exhibition 'On Purpose: Design Concepts' at the Arnolfini in Bristol, UK, Metahaven designed a series of three invitations to the show, which was curated by London-based design firm åbäke and examined conceptual design practice and the roles of function and purpose in design. The invites take the form of sheets of postage stamps, the first of which was sent out in advance of the show. The second was sent out six months later and the final one a year later, serving as what Metahaven called 'future echoes' of the first.

Opposite and overleaf
Monopolis – A Europe Game, 2007 model
View from Paris – Créteil
This game is an imaginary reconstruction of the suburbs of Paris grouped around the inner city core. Based on the Monopoly board, it presents a continuous loop around the centre, without ever entering it. The boundary between *banlieues* and *intra muros* city functions as an 'inner border'. The heights of the buildings in the centre correspond to real estate values in different districts of Paris.

Below
Future Echo (Arnolfini), 2008
Offset prints with perforations
Two out of a series of three preview cards for the
2008 exhibition 'On Purpose: Design Concepts'
at the Arnolfini in Bristol, UK. The cards were
conceived as sheets of postage stamps. The first
announced the upcoming show; this was followed
by two subsequent 'echoes', mailed to the same
group of recipients, in spring and autumn 2009.

23.
ben fry

Pioneer of interactive information design in an age of unprecedented data abundance

Ben Fry creates beautiful graphic visualizations which enable us to understand and interpret large amounts of complex information that may be in a state of flux. He designs and programmes his own software tools, which he makes available to other designers as open source, thereby helping both to redefine designers' and students' relationships to their tools of production and to break the design community's dependence on proprietary software.

Designers presenting static information displays such as timetables or maps have traditionally dealt with fixed data sources. As the amount of information increases and its sources become more fluid, designers including Fry are developing a more organic and responsive model of information design that is capable of processing present and future flows of data. Fry refers to this kind of flexible, unfinished design – when he designs parameters but cannot determine what the final outcome will look like – as 'design for a moving target'. Trained as a designer, he finds it hard to let go completely, and consequently much of his work is concerned with exploring and establishing which parts he can control and which he cannot.

Fry received his doctoral degree from the Aesthetics + Computation Group at the MIT Media Laboratory. His research focused on combining aspects of fields such as Computer Science, Statistics and Graphic Design to create new visualization techniques for understanding complex data, especially genetic data. In the process, he has helped evolve the new sub-discipline of Computational Information Design.

When Fry heard about the near-completion of the Human Genome Project, in which biologists identified the 25,000 genes and determined the sequences of the three billion chemical base pairs contained in human DNA, he knew that this was just the kind of complicated data visualization problem, with social relevance, that he would relish. After completing his PhD thesis, he thus spent time developing tools for the visualization of genetic data with Eric Lander at the Eli & Edythe L. Broad Institute of Harvard and MIT.

Projects of similar scale and complexity have occupied Fry ever since. Today he works as a freelance design consultant for firms including Oblong Industries, who developed the gestural interface that features in the movie *Minority Report*. He recently built a working model for an interface in which gestures can be used to sort through a month's traffic-pattern data generated by State of California traffic sensors.

One of Fry's personal missions is to help as many designers as possible become familiar with computation. In his spare time, he and Casey Reas of UCLA maintain Processing, an open-source programming language they developed as students at the MIT Media Lab working with John Maeda. Reas and Fry use the Processing platform to exhibit examples of aesthetically pleasing computational design and to teach the fundamentals of programming. An active online community has coalesced around the project, which has won a Golden Nica from the Prix Ars Electronica, the Muriel Cooper Prize from the Design Management Institute, and was featured in the 2006 Cooper-Hewitt Design Triennial.

In addition to freelance consulting, Fry also teaches – he was the 2006–7 Nierenberg Chair of Design for the Carnegie Mellon School of Design – and his work has illustrated articles in publications such as *Nature*, *New York Magazine* and *Seed*.

Isometric Blocks, 2001
benfry.com/isometricblocks
When comparing the genetic codes (the three billion A, C, G and T letters) of two individuals, changes can be seen every 1,000–3,000 letters. The changes are often inherited in groups, taking on a kind of 'block' structure. This image compares the genetic profile of three different populations using data collected by the International HapMap Project (hapmap.org). It is part of a project that created multiple representations of such data via a single interactive tool.

All Streets, 2008
benfry.com/allstreets

This image is a compilation of all the streets in the
lower 48 United States: 26 million individual road
segments. No other elements – such as geographical
features – have been added, yet they emerge anyway
since roads avoid mountains, and sparse areas convey
low population. The white blocks, says Fry, appear to
be rural routes and unnamed roads, their alignment
to latitudinal and longitudinal boundaries owing to
differences in how adjacent counties identify streets.

manuel raeder

Versatile design talent who brings his genius for reinvention to type, print and product design

Manuel Raeder's work is aesthetically compelling at the same time as being grounded by strong concepts and rich content. Working with just one other designer and a couple of interns from a small studio near Berlin's Alexanderplatz, Raeder takes advantage of the city's famously low overheads to focus on projects that challenge him – projects that emerge from intense collaboration with inspirational clients, mostly galleries, for example Galerie Neu and MD72, and artists such as Mariana Castillo Deball and Nora Schultz.

One of Raeder's most longstanding client-collaborators is the avant-garde luxury fashion label Bless. Known for experimental products such as a visor with a hairpiece attachment, a couture car cover and a hammock made of mink fur, Bless also take an experimental approach to their graphic identity and promotion. After a five-year relationship with Bless founders Desiree Heiss and Ines Kaag, Raeder feels that he knows 'what they are about, and how they work, think and see themselves.' Bless want their seasonal lookbooks to reach an audience beyond the press offices of the fashion world, so Raeder inserts the books like 'parasites' in a range of existing publications. He redesigns the lookbooks to fit each new context, hoping they will 'find a new life of their own' among, for example, the readers of *Pacemaker* in Paris or *Textfield* in LA.

In 2006 Bless orchestrated a novel street event in Berlin's Mulackstrasse. They inserted their wares in other stores and engaged a van to sell coffee and a man with a grill attached to his waist to walk up and down selling bratwurst. Raeder contributed an enigmatic signage system to entice curious passers-by. His sign, a transparent sticker printed with white stripes, was stuck on lamp posts and graffitied walls all over neighbouring streets to form a trail leading people to Mulackstrasse, where they encountered a profusion of the white stripes at a variety of scales. Some filled entire store windows, others stretched across banners. Raeder also tied translucent supermarket bags overprinted with the white stripes to a length of fencing, each bag containing a black-and-white map of the vicinity.' [The signage system] only made sense at its destination, so it did the opposite of what most systems do,' explains Raeder. It also inverted conventional branding wisdom: since the stickers were not explicitly linked to Bless, other stores inserted their own postcards and flyers beneath them.

For Raeder's most recent collaboration with Bless, he took elements of the previous lookbook to create a new photographic textile design, from which Bless designers then created garments. 'Having to think about how my design will be worn on people's bodies is really fun,' he says.

Raeder's interests have taken him beyond the printed page and into the realm of product design. 'These are questions that I want to answer in objects,' he says of his furniture, signage systems and storage devices. A triangular shelving unit that also functions as a seat is the result of Raeder's desire to create a piece of modular furniture that has the potential to grow into a whole library shelving system. Raeder developed *Composite Greetings*, a wood and glass display system for postcards and invitations, because so many of the invitations and postcards he has designed for exhibitions end up either stored in a box or being thrown away. He also makes agendas, which he refers to as 'time storage devices'. Working with a different publisher each year, Raeder reinvents the format annually, often requiring that users complete the piece's design. His 2006 agenda consisted of loose-leaf parts and a hanging system that could be arranged and rearranged. Each copy of his 2009 agenda, *A Cach Cach Porra*, contained a different colour-scale iris print, and users had to tear open every sixth page.

His mission is to define a new, reflexive approach to design. 'I want to make things and objects that provide a new setting for objects, or even invent a totally new economy for them.'

Seven Times Streamlined Font, 2002
Invitation and poster for Mark Bain and James
Beckett's 'Museum of Noise' exhibition at the
Kölnischer Kunstverein, Cologne, 2007
This typeface was created by passing a bitmap (pixel)
font seven times through a vectorizing program. The
computer interprets the corners and gaps created by
pixels as errors, which it corrects into straight lines.

Composite Greetings, 2008
Wood, glass, paper, metal

Raeder has pursued his design interests into the realms of product and furniture design. This wall-mounted display system for postcards and ephemera can be continuously rearranged in new compositions. It is supplied with a selection of limited-edition postcards and several glass sheets; the wooden components are available in various sizes and colours.

Below and opposite (top row and centre)
BLESS Nº 36 Nothingneath, 2008
Offset-printed publication

Raeder generated the concept and design for this lookbook for fashion firm Bless, which was distributed inside the magazine *Paris, LA*.

Triangle, Circle, Square chair, 2009
Wood and paint
This collapsible modular chair also functions
as an expandable book-storage device.

25.
yugo nakamura

Peerless creator of online experiences that are playful, ingenious and sublime

Yugo Nakamura is one of the most highly regarded designers in the interrelated fields of interaction design, interface design and web media. Trained in civil engineering and landscape design, Nakamura brings a satisfying tactility to the digital realm. He creates wonderfully appealing Flash-generated devices and sound to indicate to the user that their selection or action is acknowledged and being responded to. Nakamura was senior art director at the web design company Business Architects Inc. before he founded Tha Ltd, his own design studio in Tokyo.

Visually stunning, almost cinematic in their immersive power, his Flash-driven projects consistently transcend their original context as client commissions and become iconic pieces of work in their own right. His major projects include the online exhibition that accompanied 'Design and the Elastic Mind' at MoMA, New York. The website presents innovative new methods of tagging to enable efficient contextual browsing of the large number of works included in the exhibition. Earlier projects include the award-winning *Ecotonoha* for NEC, in which people all over the globe add messages in the form of leaves to a virtual tree. As the virtual tree grows, NEC plants real trees on Kangaroo Island in Australia. For this project alone

Nakamura won the Cannes Cyber Lions Grand Prix Award, the Clio Awards Grand Prix and a One Show Interactive Gold Pencil.

Nakamura is also responsible for the design direction of the website and other digital content of Japanese clothing brand UNIQLO. This is simultaneously urbane and playful. He also now directs television advertisements for the company, most recently for its Merino Wool campaign, in which the camera traverses an undulating landscape of merino wool garments. The accompanying website introduces a simple interface allowing users to fly up and over the woollen hills and click on floating colour chips to access the catalogue.

Nakamura's working practice is typical of those at the leading edge of contemporary design. All of Nakamura's projects are completed in collaboration with expandable teams of designers, programmers and other specialists; unlike design firms that expand permanently, Nakamura chooses to keep Tha Ltd's studio overheads lean so that he can continue to focus on design and direction rather than management. Tha Ltd also has its own SCR line of digital media products such as DropClock, a screensaver in which heavy Helvetica numerals drop into water in mesmerizing slow motion, and Kaze, another screensaver that

blows the items on your desktop across the screen according to the wind conditions in your particular location.

The initiative that has probably brought Nakamura most international attention is FFFFOUND!, an online image bookmarking service that allows members to post and share their favourite images found on the web. As the site learns more about each user's taste and interests, it responds with recommended images. The site is elegantly minimal and refreshingly peaceful, since there is no place for users and browsers to comment; the images and the source url are left to do the talking.

Motion Logic with Geometric Progression, 2004
YUGOP.com
This is one of the interactive features on Nakamura's signature networked Flash website. Users click and drag to manipulate and reform the constantly moving graphic shapes.

Top and right
'Design and the Elastic Mind' website, 2008
Online exhibition for MoMA, New York
In keeping with the show's emphasis on design
technology, the website uses experimental tagging
methods to aid efficient contextual browsing.

Above
DropClock screensaver, 2008
The time is displayed in Helvetica digits that slowly
plunge into water over the course of each minute,
scattering droplets in random patterns.

Top
HELLO, WORLD! , 2008
softbank.co.jp
A website for the SoftBank telecommunications group
offers an interactive virtual 'park' to explore.

Above
UNIQLO_GRID, 2008
uniqlo.com
Multiple users worldwide can simultaneously
generate, delete or move the UNIQLO logo in this
perpetually running online game.

Right
UT LOOP!, 2008
ut.uniqlo.com
The website for UNIQLO's T-shirt brand
continuously loops in rhythms submitted
by the public.

26–30.
radiohead
42 entertainment
anomaly
the king
sid lee

advertising

tom himpe

introduction

tom himpe

Founding Partner of Ag8,
an independent studio developing
currency for content makers,
media platforms and brands

Advertising anno 2009. Any person working in the industry who happened to have been asleep for the last ten years would have a sobering wake-up call today. True, there are still posters on the walls, billboards at the sides of roads, commercials on our radio waves and television screens and direct mail in our letterboxes. So far, so familiar. It would, however, be hard to overlook how the rise and omnipresence of digital media have transformed and redefined what brand communication can be, and how they have reduced traditional advertising methods to only one of the tools in an ever-growing box.

Brands are increasingly competing with a real-time web of conversations driven by a vocal and savvy audience. Not so long ago, this took place behind closed doors, in living rooms and around water coolers. The internet has both multiplied and amplified these conversations, and has turned them into a global, public platform. This presents brands with both a daunting challenge and an incredible opportunity.

Companies are in the process of accepting (and discovering) that the dynamics of the advertising game have fundamentally changed, and the balance of power has shifted. Rather than simply announcing their latest shiny products and services at regular intervals through pushy media, they now have to earn the right to be welcomed into people's lives, be picked up in their conversations and, essentially, earn the privilege not to be ignored.

The key for contemporary brands keen to stand out from the scattered noise lies in fundamentally rethinking their behaviour. From stimulating co-creativity with their audiences to fostering small-scale

experiments, from embracing collaborations beyond their category to adopting a more humble, supportive attitude, the biggest successes in communication of the last few years have tended to result from a company-wide shift in mindset. Brands such as Burger King and bands such as Radiohead have shown they are able consistently to adapt to the new rules of the game through a range of refreshing initiatives.

Essentially, brands now need to provide communities with social currency that is exchanged among peers. This can take the form of top-quality entertainment, or it can come from products and services that add genuine value to people's lives – that excel in their design, usefulness, inventiveness or quality.

Building up such social currency is all the more challenging in a digital environment that is fast becoming real-time in nature. The internet has enabled a 24/7 conversation, in which attention turns to the now and immediacy has become an important driver. Technology journalist and *Business 2.0* senior writer Om Malik claims that 'the real-time web…is the next logical step in the internet's evolution.' This forces advertisers to act and engage with audiences rather than focusing all their energy on fixing a campaign in stone months before it launches. In an environment of one-day sensations, one-minute hoopla and one-second replies, brands need to develop quicker response mechanisms and adapt to the relentless pace of their audience.

Real-time communication is also affecting how trends are developing and reaching the surface. The JC Report, an insider's guide to the fashion and style market, has observed a so-called 'no-trend trend'. Its authors see the fashion industry shifting away 'from a two-season system toward a more fluid system of a constantly evolving blend of eclectic micro-trends.' The rise of new media is the driving force behind this evolution, as these media 'allow micro-trends to enter the mainstream and evolve into new trends much more rapidly.'

This no-trend trend is equally affecting brand communication. Short, expensive spikes of advertising are being replaced, or at least complemented, with ongoing communication efforts, enabling brands to have a more permanent presence – to live among their audience rather than drop in a few times a year.

Traditional advertising channels have lost their crown as by default the most influential means of communication. The directness and transparency of the web have created equality across a company's activities, from the operations on the factory floor to the sourcing of

In an environment of *one-day* sensations, *one-minute* hoopla and *one-second* replies, brands need to develop quicker response mechanisms and adapt to the relentless pace of their audience.

ingredients, from a flashy new packaging concept to a corporate press release, from the user-friendliness of a product to the interior of the retail environment. There are no more hiding places. The web has led to radical transparency, see-through CEOs and naked brands. It has turned the hierarchy between media channels upside down. The wrong 140 characters on micro-blogging platform Twitter from a company employee can have an impact equivalent to a multi-million-dollar marketing campaign. Every signal from a company, in whatever shape or form, becomes part of an indivisible bundle of messages from which audiences extract their own meaning.

This refreshing equality is creating new opportunities for marketers, who are encouraged to experiment much more freely with how they construct their communications mix and spend their budgets. With more paint and paintbrushes at their disposal (including books, comics, video games, web shorts, feature films, branded spaces and virtual worlds), each brand can develop its own unique palette. And, with today's increasingly multi-tasking, channel-hopping audience, this process becomes very interesting. Rather than splashing one and the same message everywhere, brands can spread different parts of their puzzle across different places at different moments in time, giving the audience the implicit or explicit task of piecing it all together.

This dispersal of elements across multiple delivery channels for the purpose of creating a unified and coordinated entertainment experience is also referred to as 'transmedia storytelling'. It enables campaigns to be more complex and layered, more enigmatic and mysterious, and, most importantly, more interesting and therefore less annoying. Not all

communication from the same entity has to look and feel homogeneous, nor must it always be crystal clear from first impression. This new type of storytelling has been successfully applied by mystery master JJ Abrams (co-creator of the television series *Felicity*, *Alias* and *Lost*, and producer of the films *Cloverfield* and *Star Trek*), and is quickly gaining ground. Henry Jenkins, author of *Convergence Culture: Where Old and New Media Collide* and originator of the term, has stated that 'the key is to produce something that both pulls people together and gives them something to do.' Transmedia storytelling does exactly that, by scattering different parts of a story across platforms and channels, and inviting audiences to create meaning and fill in the gaps.

Such complex and layered transmedia campaigns are often referred to as alternate reality games or ARGs, as pioneered by 42 Entertainment. ARGs construct alternate universes for audiences to engage in, spread across a multitude of physical and digital channels. Rather than turning people into a 'target', they draw them in as active participants, players and explorers. The audience has a sense of ownership over the marketing, since they feel involved in its discovery and dissemination.

If brands with a different attitude and behaviour are rising to the top, the same goes for agencies. Those with a beta mindset – more open, entrepreneurial, collaborative, experimental – are the ones that thrive well in today's murky waters, irrespective of their size. The most innovative players show a readiness and eagerness to embrace a multitude of creative disciplines, and easily hop between them. This has given rise to a new generation of cross-disciplinary companies. Partnerships between games companies, television production companies and web companies are as commonplace as collaborations between architecture firms, product design companies and venture capitalists. One of the innovators in this section, the Montreal-based agency Sid Lee, is a great example of this evolution, having developed a structural partnership with an architecture firm and nurturing a talent pool that stretches across many creative disciplines.

One particular area that has come to the fore is product and service innovation. In a time of overwhelming product parity, the product-centric successes of the last decade (iPod, iPhone, Mini, Senseo, Toyota Prius, PSP, Wii, Kindle, Innocent Drinks) as well as all web 2.0 successes that have gained their status with virtually no advertising dollars, have intensified the race for innovation – both hard long-term and soft short-term innovation.

The internet has created a transparent global distribution market, more easily accessible for a long tail of smaller, artisan entrepreneurs across the world. Although on their own the influence of each is negligible, collectively they are chipping away at the monolithic companies. The chairmen of both Procter & Gamble and Unilever have publicly emphasized the importance (as well as urgency) of innovation in driving their respective brand portfolios. Swedish Unilever chairman Michael Treschow has stated: 'The single most important thing is that we speed up our innovation machine, which means that we bring more highly appreciated products to the consumer so that they say, "Wow, this is really something I would like to have."'

The big challenge in generating this 'wow' effect lies in blending the physical and digital worlds, connecting networked data with physical objects. Today's generation of designers and inventors enrich products and services with storytelling and experiences. Rather than inventing remarkable stories around mediocre products through traditional marketing tricks, marketing needs to become an essential and indistinguishable part of the product development process. This explains why some of the more forward-thinking agencies are becoming heavily involved in the development of companies' core offering, or have even started to apply their brand expertise to the creation of their own products and services. Anomaly is a leading example in this regard.

True innovators have the ability to affect the fundamental dynamics of the industry in which they operate. The five advertising innovators in this chapter are a source of inspiration for what might be around the corner in an industry plagued with questions about the road ahead. They show the way, at least the first few miles. Beyond that, nobody can tell.

CEO and Global Chief Creative Officer of R/GA, Bob Greenberg has been a pioneer in the advertising industry for over three decades, embracing all new forms of technological change to move the industry forward.

on innovation

bob greenberg

<u>We are standing on the edge of a new era in advertising</u>. Technology is driving innovation and expanding the limits of creativity. Marketers are moving beyond messaging to create useful tools that enhance our lives, while the availability of information anytime, anywhere creates fresh possibilities for brand building. Networks and devices are converging to allow wireless, high-speed internet connections from aeroplanes 10,000 metres in the air to subways 10 metres underground. Couple this with cloud computing, which stores all our files in a 'cloud' for immediate access, and the term 'always on' takes on a new level of reality.

We live in a time when we interact every single day with multiple screens — from TVs to computers to mobile devices. Today, there are nearly four billion mobile devices in

operation. That's equal to more than half the world's population. Given this fact, the power of mobility is evident. It offers the unique opportunity for marketers to send smart, *personalized messages* direct to consumers at the moment they are most relevant. The impact of mobility on communications and commerce will rival that of the internet. Video conferencing will also soon reach a tipping point, and not just for businesses: it will redefine face-to-face interactions for everyone.

The explosion of new media and the socialization of the web have fundamentally changed how we communicate. <u>And</u> <u>this</u> <u>change</u> <u>is</u> <u>only</u> <u>the</u> <u>beginning</u>. Innovation in advertising will come from diverse sources, including breakthrough search algorithms, marketing-infused product design and community-based platforms and apps. Regardless of where the innovation comes from, technology will be the cohesive thread that connects us in remarkable ways and makes the world feel infinitely smaller.

26.
radiohead

Rock band personifying the changing relationship between artist and audience in the digital age

Few creators better illustrate the changing relationship between artists and their audience better than the alt-rock band Radiohead. Their ability to reach out directly to fans and their eagerness to embrace modern tools and technology in doing so have made them the pioneering poster child for a new generation of musicians, writers and filmmakers.

Music artists are increasingly viewing conventional labels as an obstacle between them and their fans rather than a connector. Major names including Madonna, Nine Inch Nails and Jamiroquai have all decided to kick out the middlemen and become free agents. But it is Radiohead who have most effectively seized the opportunity represented by the seismic power shift between artist and label (and, by extension, between filmmaker and studio, or between author and book publisher) that has been enabled and powered by the immediacy of the internet. The music industry, plagued by plummeting music CD sales and illegal online file-sharing, is eagerly watching and following Radiohead's experiments as a precursor of things to come.

The English band, who have been operating on their own since the release of 2003's *Hail to the Thief*, are wholeheartedly embracing the principles of sharing and experimenting, both

fundamental ingredients of the web ethos. Rather than relying on the standard promotion and distribution formula, they are continuously exploring new ways to get their music to market and engage directly with their fanbase.

Before their 2007 album *In Rainbows* ever saw the official light of day, Radiohead had already performed many of its songs in public, much aware that they would be immediately bootlegged and spread across the web. A year before the album was actually recorded, the video clips gained popularity on YouTube, in turn inspiring the band to reconsider them in the studio. In an interview with the *New York Times*, frontman Thom Yorke declared: 'it's fantastic. The instant you finish something, you're really excited about it, you're really proud of it, you hope someone's heard it, and then, by God, they have. It's OK because it's on a phone or a video recorder. It's a bogus recording, but the spirit of the song is there, and that's good. At that stage that's all you need to worry about.' It's a clear illustration of how Radiohead have embraced the open-ended, beta mentality of the web in their creative process.

Despite their increasing use of the internet as a promotion and conversation tool, however, the band still believe that the physical release

of an album is quintessential, and have rejected the idea of releasing exclusively on the web. This is regarded as conservative by some, including fellow innovators Nine Inch Nails, who dismissed the *In Rainbows* pay-what-you-like initiative as a 'marketing gimmick'. But the fact remains that Radiohead kick-started a global industry debate that is set to continue for the foreseeable future.

Opposite and overleaf
In Rainbows poster and album artwork, 2007
The results of the audacious *In Rainbows* download experiment – which enabled fans to download the entire album at a price of their choosing – were eagerly awaited by the whole music industry and beyond. The initiative brought Radiohead instantaneous global reach. Although they never divulged specific figures, frontman Thom Yorke claimed that 'it's been a really nice surprise and we've done really well out of it'. Even though it was done as a one-off, the initiative demonstrated the viability of the internet as an avenue for an album-release as well as the feasibility of life without a record label. Bands such as Coldplay and Nine Inch Nails later launched similar initiatives.

House of Cards music video, 2008
The video for *House of Cards*, from the album
In Rainbows, was a technological first, created
using only lasers and scanners but no cameras. In
keeping with their open-source ethos, Radiohead
released the video's data so that developers could
remix it and make their own variations. Google
hosted the interactive video application and
provided an iGoogle gadget for it.

NU_DE _STEM
GUI T AR
ST/EM FOR
REMIX NU/DE
RADIOH EAD
R/ADIOHEA_D
GTR/STM

NU_DE _STEM
DRUM S
ST/EM FOR
REMIX NU/DE
RADIOH EAD
R/ADIOHEA_D
DRM/STM

NU_DE _STEM
BAS S
ST/EM FOR
REMIX NU/DE
RADIOH EAD
R/ADIOHEA_D
BSS/STM

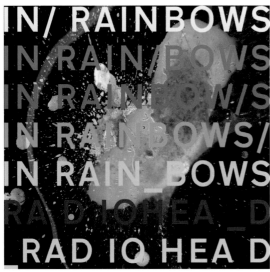

IN/ RAINBOWS
IN RAIN/BOWS
IN RAIN BOW/S
IN RAIN BOWS/
IN RAIN_BOWS
RA D IOHEA _D
RAD IQ HEA D

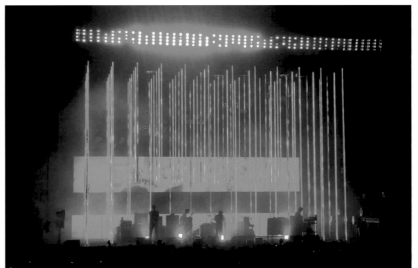

Top row
Nude Remix, 2008
Radiohead organized a remix competition for the singles *Nude* and *Reckoner*. The separate stems from each song (bass, voice, guitar, strings/FX and drums) were made available to buy on iTunes. Fans uploaded remixes on radioheadremix.com and voted for their favourite. The competition resulted in over 2,000 unique remixes, around 1,750,000 track listens and a significant chart showing.

Right
New Year's Eve concert, 2007
Radiohead streamed a free, hour-long concert on New Year's Eve 2007. The video, called *Scotch Mist*, featured performances of every song from the *In Rainbows* album, along with poetry readings and imagery created or selected by the band. The show was available via radiohead.tv as well as Current TV and current.com, and was intended to promote the physical release of their album the following day.

27.
42 entertainment

Immersive entertainment experts creating the world's largest participatory cross-platform experiences

The agency 42 Entertainment is inseparably linked to the expanding marketing phenomenon of alternate reality games (ARGs). A mash-up between advertising, treasure-hunting and role-playing, ARGs immerse an audience in an alternate reality, intricately constructed through a web of experiences and clues spread across television, radio, newspapers, websites, emails, telephone, SMS, voicemail and real-life manifestations. ARGs are defined by intense player involvement with a story that takes place in real time and evolves according to participants' responses.

42 Entertainment was founded in 2003, at a time when social media were still in their infancy and the power of the web was still blossoming. The company's very first project was for Steven Spielberg's film *AI*, after which it quickly established itself as the global leader in the creation and execution of the world's largest participatory and cross-platform entertainment experiences. Since then, 42 Entertainment has created elaborate experiences for the game *Halo 2*, Microsoft, Disney's *Pirates of the Caribbean: Dead Man's Chest*, Xbox, MSN and the film *The Dark Knight*. In 2008, the agency won the Cyber Grand Prix award at the Cannes International Advertising Festival for the ARG devised to launch Nine Inch Nails' album *Year Zero*.

While most traditional marketing hits you right in the face, ARGs tend to start with a subtle whisper – anything from joker cards left in comic book stores for the *Dark Knight* campaign, to a URL flashing at the end of the *Halo 2* trailer, or messages on a T-shirt at a Nine Inch Nails concert. The clues are intentionally covert, giving the audience the sense of having 'discovered' the campaign. This first clue is referred to as the rabbit hole, the opening through which players can enter the alternate world. Because of the connective tissue of the web, only one person has to find the clue for it to spread to a wider audience.

Tangible evidence is vital to create the convincing impression that these alternate worlds are real. For the *Dark Knight* campaign, 42 Entertainment created websites for everything from a cab company to churches to TV stations to the subway in Gotham City. There was even a newspaper that printed four pages of fake stories.

Advertisers' natural hunger for audience reach is solved by creating different levels of engagement for different levels of consumer, ranging from the casual, to the active, to the truly enthusiastic. The latter represent the 'tip of the wedge' audience, who become deeply engaged by providing content of their own to the community. Through the different levels of interaction, combined with the PR effect around these types of campaign, ARGs have the capacity to reach millions.

42 Entertainment has created a body of work that has transcended and transformed what marketing can be and how long its storytelling can extend in time (the *Dark Knight* experience ran for no less than fifteen months prior to the release of the film). Nine Inch Nails frontman Trent Reznor described the *Year Zero* campaign not as marketing but as an extension of the album. Susan Bonds, CEO of 42 Entertainment, is convinced that 'If this qualifies as an art form, we are just scratching the surface of it.' She believes 'we haven't seen everything that is going to come out of using it, but we're starting to get glimpses of the power of these passionate online communities.'

The Dark Knight, Batsignal on Woolworth Building, New York, 2008
In the final days leading up to the release of *The Dark Knight* in July 2008, players were able to show their support by joining an organization called 'Citizens for Batman'. One night, in both Chicago and New York City, players gathered to follow instructions and turn on the 'batsignal'. A few days later, the Joker had the last laugh when he tagged the batsignal, and subsequently all online Gotham websites.

'If this qualifies as an art form, we are just scratching the surface of it… we're starting to get glimpses of the power of these passionate online communities.'
Susan Bonds, CEO of 42 Entertainment

The Dark Knight, Joker dollar, 2007
The initial clue or 'rabbit hole' to find the site whysoserious.com consisted of dollar bills 'tagged' by the Joker – the tag was actually a sticker that easily peeled off. They were used as change and left around the San Diego Convention Center during ComicCon 2007, the world's largest comic book and popular arts convention.

Right above
The Dark Knight, It's all Part of the Plan, London, 2008
Fans in London, São Paulo and ten cities across the US responded to an invitation posted on whysoserious.com to gather at a series of specific locations on 28 April 2008. Some made up their faces to look like the Joker. They followed a treasure-hunt that led them to a newly released trailor for the forthcoming movie *The Dark Knight.*

Right
The Dark Knight, I Believe in Harvey Dent, 2007
In March 2007, Harvey Dent asked the citizens of Gotham to show their support for his run for District Attorney. Dentmobiles travelled across the country to over thirty cities to meet up with players and campaign. Thousands of players participated, bringing more women and mainstream movie-goers into the alternate reality experience.

This ARG celebrated the launch of Microsoft Windows Vista. Forty-eight immersive and visually beautiful puzzles were published on the game's website over the course of a month. Each week they reflected a different theme: time, magic, eras and vanishing. The solutions to these challenging puzzles depended on clues provided by real-world events.

The Vanishing Point, 2007

During the Consumer Electronics Show in Las Vegas in January 2007, 42 Entertainment reprogrammed the Bellagio Fountain show to create a 7–8 storey, 33-metre-wide (110-foot) projection screen to kick off the Vanishing Point, the world's first global puzzle game. The prize for the ultimate winner was a trip into space on Rocketplane.

Project Abraham, 2008

The Project Abraham ARG was created to promote the game *Resistance 2*. It conveyed the origin story of the game's hero Nathan Hale. Live action footage was shot at an abandoned hospital to represent the secret military base where scientific experiments were conducted on soldiers in an Alternate America in 1951. 42 Entertainment also took inspiration from a moment in *Resistance: Fall of Man* when Nathan Hale looks pensively at this old photograph of seven soldiers.

Year Zero, 2007

Year Zero by Nine Inch Nails is a concept album that criticizes the US administration by presenting a dystopian vision of the year 2022, which in the game's plot has been designated 'Year 0' by the US government. One of the early sites in the Year Zero ARG was AnotherVersionoftheTruth.com. When it loaded, viewers encountered a picturesque poster of a fruitful America. Dragging over the image scratched away the surface to reveal a wasteland.

Year Zero, 2007

On 3 March 2007, an Art Is Resistance flyer was distributed in Brixton, London, containing GPS coordinates to a mural painted beneath a bridge. The mural paid homage to both the notorious 1981 Brixton riots and Operation Swamp 0000, another website from Year Zero.

Year Zero, 2007

While websites encouraged participants to submit subversive works of art, with the suggestion that it would somehow be published, secret concerts were organized for fans to meet in real life, such as this one in April 2007 in LA.

28.
anomaly

Hybrid shop reinventing the agency model with entrepreneurial-led remuneration schemes

For an industry that is so dependent on the power and value of ideas, and so eager to win back its seat at the CEO table, it's surprising how *un*creative advertising agencies – and clients, for that matter – have proven over the years in devising new models for remuneration. Although the digital revolution has shifted business practice and changed the role of intermediaries across most brand categories, agencies are still largely earning their fees through time sheets and media spend.

Anomaly was one of the very first to consistently and openly rethink ways in which agencies can receive pay cheques from their clients, or how client–agency relationships can be redefined. Since its heavily publicized launch in 2004, the New York/London-based shop has been closely watched by the industry to see whether it will be able to turn its promise into reality. In its wake, other agencies have adopted elements of the Anomaly philosophy, including the Brooklyn Brothers, London-based AnalogFolk, and Zag, a division of BBH focusing on product invention.

There are, broadly speaking, three types of project within Anomaly. First, there is the standard fee-based business with clients such as Converse and P&G – although fees are never justified on time but on value. Work

for these blue-chip clients includes new product development, strategic innovation, graphic and structural design, and any other form of communication, from advertisements to retail.

A second subset consists of entrepreneurial compensation schemes. These relationships are the ones where Anomaly has some 'skin in the game', motivating the agency to sell as much of the client's product as possible without actually running the business. Clients in this section include EOS, Virgin America and Aliph.

Sharing commercial interests between agency and client creates benefits for both parties, according to Carl Johnson, one of Anomaly's founders. He argues that 'it is more likely that we will over-deliver as our motivation will be to work all day, every day, to drive up our return. That's just human nature…. Also, the impact of a more commercial culture at Anomaly is that we are closer to and more interested in the reality of our clients' business than many, if not, most agencies.' Major clients are starting to follow suit. Coca-Cola has started an industry-wide movement towards a 'value-based' compensation model that promises agencies nothing more than recouped costs if they don't perform, but profit margins as high as 30 per cent if their work hits top targets.

Finally, there are the brands that Anomaly is creating and running with a clear and

significant equity stake. Since agencies are ostensibly the branding experts, it makes sense for them to create their own original products. For each invention or brand, Anomaly creates a separate company with its own operating agreement, shareholders and roles. Anomaly plays a central role in building and managing these businesses and has money invested in each of them. They include By Lauren Luke cosmetics; Avec Eric, a collaboration with chef Eric Ripert; and fashion and music venture i/denti/tee.

Carl Johnson acknowledges that it can be strange for some people to work in an agency environment where there is not always a client for each project. 'There is no client, there is no one to "service", there is only the requirement for leadership of the business. Some people cannot make that transition because the notion of "service" is so ingrained. However, the natural go-getters and entrepreneurs thrive and grow exponentially.'

Although Anomaly's revenue split is still around 65/35 in favour of client fees, the staffing reflects a more even ratio, while the split in 'value' is more like 40/60, taking into account Anomaly's shareholdings in various businesses. Moreover, this value can greatly increase over time, in a way that fees for service never can.

Converse

My Drive Thru was a Converse-commissioned music
track written and performed by a disparate trio of
artists: Pharrell Williams, who produced the song;
up-and-coming R&B artist Santogold; and Julian
Casablancas, lead singer of The Strokes. The song
was released as a free download on the Converse
website as well as distributed to radio stations. The
track had daily downloads in the thousands, received
favourable reviews from music critics and fans, and
most importantly, created buzz for the brand.

Below
i/denti/tee
Launched in December 2008, i/denti/tee is a fashion and music joint venture involving Edun Live, an ethical T-shirt company created by Bono and his wife Ali Hewson; iTunes; Jay-Z's music lawyer; US digital agency Night Agency; and Anomaly, which owns a 30 per cent share. Its first product was a line of T-shirts printed with music lyrics beginning with the letter 'I'. The initial release included 'I love rock 'n' roll' (Joan Jett), 'I still haven't found what I'm looking for' (U2) and 'I'm a hustler baby' (Jay-Z). Each T-shirt purchase included ten free iTunes songs.

Centre row below
Avec Eric
Launched in June 2008, Avec Eric is a new culinary brand created by Michelin-starred chef Eric Ripert and Anomaly, which owns a third. Anomaly is producing content under the Avec Eric brand name, including a television series, a book and a blog. It will also create licensed products. More broadly, the agency's role consists of brand strategy, comms strategy, sponsorship, licensing, design, product innovation, all communications and running the actual business.

Left
By Lauren Luke
Single mum Lauren Luke's unedited make-up tutorials, filmed in her bedroom in South Shields, have built up a huge fan base: her channel is one of the top two YouTube pages in the UK. Launched April 2009, By Lauren Luke is a joint venture to create cosmetics and cross-platform media properties. Company ownership is split three ways between Lauren Luke, Anomaly and product manufacturer Zorbit. Anomaly oversees areas including brand strategy, comms strategy and running the business.

Top row, this page and opposite
Keep a Child Alive
In June 2007 Anomaly partner Johnny Vulkan stood
for four days outside an Apple store in Manhattan to
buy the very first iPhone. He was interviewed by over
100 reporters, all of whom he told his plan to auction
the phone on eBay to raise money for the children's
HIV/AIDS charity Keep a Child Alive. KCA
supporter Spike Lee joined him as the doors opened.
The effort resulted in over twenty million media
impressions, and the iPhone was sold for $100,000.

Above
EOS
This line of women's shaving and skin care products
is currently sold at Target, Shoppers Drug Mart and
drugstore.com. In addition to holding a minority
equity stake in the brand, Anomaly gets a revenue
share for every shaving cream or lip balm sold.
Anomaly is responsible for brand strategy, design,
product innovation and communications.

29.
the king

*Burger King icon and transmedia character,
constantly morphing and adapting to any platform*

Much can be learned about the evolution of advertising by observing how its iconic characters have evolved. Over the decades the industry has spawned a host of recognizable figures, each representing a brand's core values. They range from the Marlboro Man to Ronald McDonald, from the Energizer Bunny to the Pillsbury Doughboy.

Few characters have so radically and consistently adapted to modern times as Burger King's hero, widely known as 'the King'. Originally conceived in the mid-1950s as Burger King's logo, the King's career began in the late 1960s and early 1970s as an animated character in children's advertising, then named 'The Marvelous Magical Burger King'. Burger King's mascot was often to be found performing magic tricks and making balloon animals in the parking lot outside local franchises. This costumed character faded in the late 1980s, but was brought back to life in 2003 under the shortened name of 'the King'. One of the creatives at Burger King's agency Crispin Porter + Bogusky found a vintage, over-sized King head for sale on eBay. The team initially used this as an inspiration for brainstorming, but eventually decided to restore the head and use it in a campaign, after it had been remodelled by a Hollywood effects specialist.

The character has played a central role in many Burger King commercials in the United States. The King, portrayed by an actor with a gargantuan plastic head, bejewelled crown and burgundy robes, typically appears in wholly unexpected places, such as in bed or behind doors and walls, offering people a Burger King product. The edgy, quirky humour employed in these ads quickly earned the King celebrity status and a cult following.

More importantly, the King character has evolved beyond television commercials, unlike most of his peers, and has become a media star in his own right. The King appeared on *The Tonight Show with Jay Leno* and featured in a line of Xbox games. His face started popping up on Burger King cups and bags, and the King masks have been sold during Halloween. He was transformed into a 'Simpsonized' version for the launch of *The Simpsons Movie*, into a retro-futuristic robot for a 2008 commercial and into an animated version in Seth MacFarlane's *Cavalcade of Cartoon Comedy*, where he dramatically flew through the movie screen during the introduction to each clip.

In a time when people jump ever more comfortably across media channels, collecting information and entertainment on their own terms, brands are faced with the challenge of maintaining a coherent creative message while addressing diverse audiences and adapting to multiple channels. The King character has been able to provide that creative coherence for the Burger King brand, adapting seamlessly and flexibly across channels, morphing between digital and real-life versions, hopping from games to the web and from television to physical products. The King exemplifies the way that brands are embracing the splintered and fragmented advertising landscape, while maintaining a grin throughout.

The Return of the King, 2004

After several decades of absence from the advertising
scene, the iconic Burger King character returned in
2004 with a series of absurd commercials described
as 'some of the creepiest fast food ads ever'. In one
of them, titled 'Wake Up with the King', a man wakes
in the morning, rolls over and finds himself face
to face with the King. In the ad – which has some
serious gay overtones – the King comforts the man by
handing him the new Double Croissan'wich.

Bottom
The King and the National Football League, 2005–6
A series of NFL-themed television commercials featured the King going crown-to-helmet with the pros to promote a national sweepstake of codes on BK wrappers.

Below
The Return of the King, 2004
Scenes from a series of commercials for Burger King that marked the revival of the character of the King, first conceived as a logo in the mid-1950s.

Below and centre row
Big Bumpin' and *Pocketbike Racer*, 2006
Burger King partnered with Microsoft to develop a series of three Xbox games featuring familiar characters from the Burger King universe. The games were sold instore, during the holiday season, for $3.99 each with the purchase of a BK Value Meal. According to Microsoft, 2.4 million units were sold during the five-week promotional period.

Bottom
The King and The Simpsons, 2007
In July 2007, the King appeared in several commercials promoting *The Simpsons Movie* as a Simpsons character, complete with four fingers, yellow skin and an overbite. The brand also launched the hugely popular 'Simpsonize Me' online tool, allowing anyone to create their own personal *Simpsons* avatar. The avatars spread widely on the web, from Twitter profiles to Instant Messenger thumbnails.

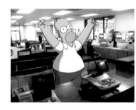

30.
sid lee

Multi-disciplinary agency embracing commercial creativity through an eclectic global talent pool

In 2006, the Montreal-based agency Diesel decided to put an end to confusion with the popular jeans brand and changed its name to the anagram Sid Lee. With the name change came an even more outspoken and radical philosophy about what advertising can and should be. According to agency president Jean-François Bouchard, Sid Lee 'has never believed in the ad-centric model. Actually, we hate it and we are out to destroy it.' While many opportunists in the frantic and highly competitive advertising industry may recite similar mantras, Sid Lee has created the structure and organization to put its beliefs into practice. The fact that the agency was founded by a group of students with no prior track-record in advertising no doubt contributed to the agency's unconventional attitude and approach.

Committed to embracing 'commercial creativity' in its broadest sense, Sid Lee has gathered a global talent pool covering areas including retail architecture, experiential marketing and industrial design. For example, the Canadian shop has forged an alliance with Montreal-based architectural firm Aedifica and has several architects working for Sid Lee Architecture on retail and interior design as well as urban design. This partnership underpins the agency's core belief that retail is an integral part

of the overall brand experience, an area often overlooked despite being a crucial step in the customer's journey towards final purchase.

What distinguishes Sid Lee from much of the industry – multi-billion-dollar holding companies that tend to be structured in silos and separated disciplines – is its inside-out, multi-disciplinary approach. For each specific project, a customized team is assembled comprising diverse creative minds. Depending on the challenge at hand, the agency can tap into a roster of more than 150 artisans including theatre directors, photographers, architects, account handlers, producers, art directors and copywriters.

In order to give a non-commercial outlet to its creative workforce, and to reinforce the notion that commercial creativity can take any shape or form, Sid Lee has created the Sid Lee Collective, which supports employees' personal projects. The collective has already distributed an urban music compilation, landed a photo exhibition in New York, and debuted a new furniture and kitchen collection at the International Contemporary Furniture Fair in New York. The collective's output is on display at Sid Lee's offices in Montreal and in the recently opened Amsterdam branch. Bouchard believes that 'agencies must be a

part of cultural life to be active participants in the creative community. It keeps the creative well full of water. It's very refreshing.' Sid Lee's recruitment strategy is equally ingrained in the creative community. In order to ensure an ongoing inflow of talent, the agency works closely with art schools around the world, and has a partnership with the California-based Art Center College of Design.

Sid Lee is the embodiment of a new agency model, one that embraces the broadest possible spectrum of creativity and is eager to include a maximum of disciplines in its pursuit of a more eclectic mix of expressions for twenty-first-century brands. In an increasingly blurred creative landscape, it has abandoned the old model of distinct disciplines in favour of organic, hybrid teams working and collaborating under the same roof and according to a shared ethos.

adidas, Celebrate Originality, 2009
R'n'B singer Estelle in the 2009 global campaign Celebrate Originality created by Sid Lee for adidas Originals.

adidas, Celebrate Originality house party, 2009
To celebrate sixty years of Sole and Stripes, Sid Lee threw a house party with adidas Originals ambassadors David Beckham, Kevin Garnett, DMC and Missy Elliott to name a few. They all played key roles in the establishment of the 3-Stripes brand.

Above and right
adidas, Atelier retail stores, 2008
One of Sid Lee's first mandates for adidas Originals was to create an entirely new concept for their Atelier retail stores. The concept launched with openings in Berlin and New York to coincide with the adidas Spring/Summer 2008 collection, and was subsequently rolled out in major metropolitan cities worldwide. It was developed in partnership with Aedifica.

Opposite
SUCC, 2008
Sid Lee Collective is a cultural and commercial incubator that allows the agency to push the boundaries of creativity ever further. Tired of meetings that seem never to end and have no specific agenda, Sid Lee Collective came up with SUCC: The Slightly Uncomfortable Chair Collection.

31–35.

miuccia prada
alber elbaz
martin margiela
tom ford
viktor & rolf

fashion

masoud golsorkhi

introduction

masoud golsorkhi

Creative Director of TANK, London

The influence of fashion has extended far beyond the fashion world in recent times. Not only has the industry exploded in scale and geographical reach, but the language of fashion –once an obscure Parisian dialect – is now spoken from São Paulo to Macao. Its terminology and methodology have penetrated fields as diverse as the world of art and the business of manufacturing, from automobiles to vacuum cleaners. No curator from any cultural institution, public or private, would deny the significance of the cycle of fashion trends in their work, nor could a car-maker be blind to the fact that people sooner choose a car for the way it makes them feel about themselves and their image than for its technical performance. Thus has fashion spread wide and penetrated deep into the global psyche and culture.

Innovation defines this industry. Every designer, manufacturer, marketeer or humble window dresser at a department store must innovate or die. In a business that depends on trends, generating constant change is a core business priority. Fashion designers pull down the edifices of their creations biannually and rebuild them from scratch, perhaps more so than in any other creative industry. Imagine an architect who built houses and destroyed them before the paint had dried in order to start over.

The business of fashion concerns much more than clothes design: at its broadest it can be described as the business that generates and/or exploits trends. Its roots predate the industrialization of the manufacture of clothing. Fashion designers in the beginning did not sell clothes, they sold patterns for making clothes, in the days when most people made their own clothes and a few who could afford it used dressmakers.

In a sense, fashion was an early incarnation of the software industry. It was in its interest to sell trend as often as possible. Fashion has always needed the idea of newness as its core raison d'être. Amidst the slow pace of nineteenth-century communication, the biannual fashion season encouraged repeat purchase and thereby renewal. This biannual cycle survives to this day, though in recent times it has been accelerated by pre-collections and mid-season capsule collections, wistfully called 'Cruise' collections, to plug gaps created by the feverish growth in consumer demand and the speeding up of manufacturing and distribution.

Meanwhile, fashion has been transformed from craft-orientated cottage industry to mammoth global business, incorporated and capitalized and organized like any other major business sector. According to the World Trade Organization, fashion is the fourth-largest industry worldwide, with an estimated turnover of US$900 billion. From the tentative start of ready-to-wear business just after the Second World War to the global fashion industry today, the transformation has been massive. Across all price points, from Fast Fashion for the high street as represented by the likes of Top Shop, H&M and Zara to the venerable houses of haute couture that are still going strong – though for how long is anyone's guess – this is an industry that employs millions of people and represents a key economic indicator.

Fashion as a business is constantly being redefined and re-imagined. This was the first industry to disassemble design, manufacture and marketing and scan the globe in search of the cheapest (and sometimes the best) places to realize each part of the process. So an American jeans brand run from the US might subcontract much of its design to a studio in the UK, its sales and marketing would be done in Italy and the manufacture in North Africa or Southeast Asia. Fashion did this before computer and car manufacturers ever caught on. As early as the 1950s a small but successful leather-goods manufacturer from Rome could set up a store in New York and be an instant success thanks to branding communication done on its behalf by a client base of Hollywood stars. The customers queuing in New York had first encountered Gucci as they pored over images of stars relaxing in Cinecittà film studios in Rome, photographed by a new class of journalist-photographer later to become known as the paparazzi.

At the lower price points, high street brands that deliver fashion to the greatest number of people are doing so by being at the forefront of globalized capitalist modes of production in the era of instant communication. Driven as they are by relatively small margins and

While the high street has traditionally copied the *design innovation* of top brands, now designer brands play catch-up with the *business, marketing* and *production innovations* of the Fast Fashion mega brands.

a highly competitive environment, these brands have been at the sharp edge of innovation in the fashion business. Top Shop, H&M and Zara are companies that in their own different ways feed upon and fuel fashion fever in a mass audience. In each case their pioneering business models are profoundly affecting the industry as a whole. Zara, for example, is the master of logistics, shrinking the delivery time of garments from trend to design concept to rail beyond a point anyone could have imagined, at prices and quality unmatchable by competitors. Its latest innovation is to manufacture garments on big factory ships: fabric is picked up in China and finished goods delivered in Europe. This allows Zara to respond faster and more frequently to trends than ever before: what was Fast Fashion last season has become (almost) Instant Fashion now. When the designer brands were still changing their stock twice a year, Zara's offer was reinventing itself every few weeks. Even if Fast Fashion scores lower on originality, quality or design, it ranks higher as pure 'fashion' in the degree to which it embodies the latest trend. While the high street has traditionally copied the design innovation of top brands, now designer brands play catch-up with the business, marketing and production innovations of the Fast Fashion mega brands.

Companies at the other end of the scale of price point and margin have refined the art of branding goods, none more so than Chanel, which historically has been at the forefront of creating worldwide trends, led by its haute couture business and by head designer and media star Karl Lagerfeld. Brand extension started with founder Coco Chanel's preference for sample number 5 out of a batch of fragrances created by her perfumer. Chanel No 5 is still a bestseller today. The aura

around the Chanel trademark, such as only a couturier of truly exceptional pedigree can generate, enables a multitude of licensed products from eyeliners to sunglasses to be sold on the basis that they are touched by the magic of the brand. Even humble and inexpensive products can transmit essential, intangible Chanel-ness. Branded Chanel goods may be sold at a few euros for an eyeliner, many times more for, say, sunglasses, a few thousand euros for an item of ready-to-wear clothing or tens of thousands of euros for a one-off haute couture dress. Yet ironically, each step up the ladder of price is a few steps down the ladder of profit margins. It is no secret that the world's leading fashion brands are sustained by high-margin, low-cost goods and not the low margins earned on the highly priced garments – hence the big marketing and advertising push for accessories such as cosmetics, handbags and sunglasses.

Selling us things we might not need before we have any idea we are going to want them is certainly an art. Fashion, however, is neither pure commerce nor pure art. At its best, fashion exists at a nexus in between. It consists of intangibles like feelings, public mood and complex ideas, as well as the more tangible: technique and craftsmanship and sheer, sharp-elbowed business sense. Products are created sometimes by commercial and sometimes by creative impulses. But fashion that attempts to exist in isolation of either of these camps soon withers and dies. The art of fashion needs the oxygen of commerce to thrive, while the business of fashion would be dull and tiresome without ephemeral inspiration: the ability to make hearts leap and to make the unnecessary irresistible. Fashion business has to be exposed to cultural as well as technological and commercial forces to make it relevant – to give it vitality and social usefulness. Similarly the creative personalities involved in the business often combine several sets of skills and qualities. Karl Lagerfeld has engaged the mass media with a verve, intelligence and playfulness that are arguably unmatched since Andy Warhol. Giorgio Armani would have scaled the summit as a pure businessman even without his design genius and insight into the Zeitgeist. Yohji Yamamoto would be hailed as a great artist whatever canvas he had chosen. Paul Smith would be a god to retailers even if he sold fish. Hussein Chalayan, Vivienne Westwood, John Galliano, Jean Paul Gaultier, Alexander McQueen, Azzedine Alaïa... the list goes on. All rank as highly influential fashion innovators; all have poured multiple talents and unique vision into the contribution that has made them fashion industry legends.

The five fashion innovators presented here represent a highly subjective selection at a snapshot moment in time. This selection is not shaped by any presumption to stand in judgment. Rather, the following pages highlight aspects of the multi-faceted discipline of fashion at this particular juncture. Each profiled designer embodies a unique set of characteristics and an innovative approach that not only makes them leaders in their field but illustrates how the fashion business is developing, changing and addressing the challenges of our time. To be good at fashion is to be good at several things at once, from showmanship and the ability to work a crowd to the skill of pure design to the process of inquiry and experimentation in the craft and technical aspects of working with fabric around the contours of the human form. Also to be celebrated are the skills of branding: storytelling, presentation, responding to and reflecting the culture at large. This selection of leading creatives is brought together as a way of capturing the 'now'. They represent some of the many facets that join up to create the fashion industry in its dazzling, glittering complexity and subtlety.

Paul Smith's modern, innovative and broad-minded approach to classic cuts and materials have made him one of the most consistently successful international designers of the past two decades.

on innovation

paul smith

Design is about new ideas, and new ideas come from innovation, so it's vital that we innovate. Anyone who wants to earn a living from creativity and design must work very hard to discipline him- or herself not to imitate but to find new ideas. This is one reason why *innovation in the fashion world is such a challenge:* as with many design disciplines, almost everything has been done before in some form. The job of design is to create new ideas that people want to buy, and to keep buyers loyal, which means constantly striving to move ideas around so that they don't appear to be retrospective.

At the beginning of my career, my own creativity and innovation were more laboured, but after a few collections I found a rhythm and a way for my mind to take in what it sees naturally, all the time, and to use this to

spark new ideas. *You can find inspiration in almost anything, even if total originality is obviously very difficult.* By training my mind to draw ideas from practically anything – a conversation, a one-off experience or more obvious sources such as art, architecture or film – I find that new design ideas often arise from inspirations not directly linked with my work.

We must stop being *obsessed by what others are doing* and be more confident in our own abilities and the way each of us thinks individually. By pushing ourselves, original ideas will come.

31.
miuccia prada

Setting the fashion agenda through unparalleled creativity and ceaseless experimentation

'Miuccia Prada is the Coco Chanel of our time'. That audacious statement was made to me by the chief designer of a major French fashion house, the quintessential Parisian establishment. An assistant at another great fashion brand told me how her boss, the creative director, who had been designing a collection for a Paris show for many months, scrapped it all and remade an entirely new collection in four days after seeing Prada's collection in Milan. Clearly, Miuccia Prada not only commands the considerable respect and attention of her peers, but right now she sets the agenda.

Miuccia Prada is influential like no other designer in our time. But this was not always the case. She might have been born into the fashion business, but she has achieved fashion greatness through her own work and in incremental stages. She is the youngest granddaughter of Mario Prada, who began selling imported and locally made leather goods and luggage to Milanese bourgeois in 1911. A child of the 1960s and of sturdy Milanese bourgeois stock herself, she has no formal training in fashion. She studied for a PhD in political science and spent five years with a mime troupe. Her personal interest in fashion developed later into a professional concern, and is arguably still developing. More than any other designer, she justifiably uses the

word experiment to describe what she does. Perhaps her lack of formal training means that she is permanently at school – permanently seeking, curious and never quite satisfied. In fact this ceaseless craving for change and total transformation from season to season is the only constant in her output. Her mission, she says, is 'being deeply involved in the present and reflecting it in my work'. She is in touch with the essence of fashion, which is about the now – the moment as it is lived. It is hard to describe what the 'classic Prada' look is, and although the company has made a fortune with several ranges such as its black industrial-grade-nylon handbags and other staples, the transformative quality of Prada is nevertheless quite distinct.

Maybe this is the reason why her collections have become younger, braver and more dangerous the older she has got. Her revamping of the Miu Miu business recently to reflect her personality and her mood is a case in point. Prada is the last fashion business of its scale where the principal creative force is also a partner and a business driver. The output of the company often resembles that of a cultural institution more than a business, occasionally at some expense to the business. Sometimes it seems that she is anxious to get away from the pigeonhole of fashion designer: 'actually fashion

at the moment is an incredible instrument of communication with many different people all over the world and I enjoy it more than before. It is also an instrument of knowledge.' She is a spontaneous designer who makes multiple points of contact across several aspects of culture at once rather than referring to them in the formulaic way that so many others do. Not chastened nor challenged by the increase in the number of domains that fashion has to relate to, she seems if anything invigorated. Life was simpler and fashion a much smaller palette for Coco Chanel. 'Today designers have to deal with a much enlarged world, [of] races, cultures and religions', she says. Complexity, speed and diversity are all favourite propellants for Miuccia Prada's uniquely creative jetpack.

Prada advertising campaign,
Autumn/Winter 2000

Prada advertising campaign,
Autumn/Winter 1998

Prada advertising campaign,
Spring/Summer 2006

Prada advertising campaign,
Autumn/Winter 2004

32.
alber elbaz

Designer of clothes with emotional pull and pathos that have earned a passionate following

While other designers make women look great, Alber Elbaz has the gift of making them feel great. Elbaz, a Moroccan-born Israeli, creates clothes invested with an emotional charge that inspires an almost hysterical response in his fans, making his fashion shows feel more like evangelical church services than catwalk presentations.

Other fashion designers tend to adopt the role of the dictator in matters of taste, but Elbaz is at pains to do otherwise. He is masterful in the way that he injects a measure of humility into his collections, and the ease with which he positions himself as the woman's co-conspirator in pursuit of glamour. As he often puts it, 'Beauty must come from within – feel beautiful and you are beautiful.'

The depth of passion generated by Elbaz's work at Lanvin, where he has been in charge since 2001, is clear to see – just look at the critical and commercial success he has brought to a relatively small fashion house. This emotional pull is intrinsic to Elbaz's designs, which are always understated and womanly, never overtly sexy or showy. The seams are often left to fray naturally, while structure and pattern may be fiendishly clever but are always minimal. Similarly, Lanvin stores and their window displays have the feel of a dishevelled palace, with the decor and setting left artfully unfinished. They are often dressed by Elbaz himself.

His clothes never overpower the wearer. Other designers may make clothes that wear the woman, but at Lanvin, the woman always wears the clothes. Elbaz makes no inflated claims for the power of clothes: 'If it's edible, it's food; if it's wearable, it's fashion.' A sense of grand and elevated conviviality, allied to a solid grounding in and mastery of haute couture techniques, is what makes his clothes so appealing and so successful on the body. The accessories that accompanied his Spring/Summer 2007 collection were inspired by a story he had read of how, when Tsar Nicholas II and his family were executed by their Communist captors, the women survived the firing squad's first volley of shots because they were wearing the family jewels beneath their garments. 'They were saved by diamonds,' says Elbaz. Here is a man who knows how to wield the power of pathos as well as a pair of scissors.

Lanvin Fall 2003
Scarlet pleated ribbon dress with strips of tulle and bateau neckline. Knee length with ribbon-tied waistline.

Alber Elbaz creates clothes invested with an *emotional charge* that inspires an almost hysterical response in his fans, making his fashion shows feel more like *evangelical church services* than catwalk presentations.

Above left
Lanvin Spring 2009 Ready-To-Wear
Orange silk one-shouldered draped dress, worn with nude pointed court shoes.

Above right
Lanvin Summer 2004 Ready-To-Wear
Emerald green satin twisted plunge-neckline dress, worn with black leather court shoes.

Left
Lanvin Spring 2007 Ready-To-Wear
Charcoal grey pleated mini dress with a canary yellow neck piece, worn with black leather crossed T-bar shoes.

Above
Lanvin Spring 2006 Ready-To-Wear
Gold silk draped dress with folded fabric
breastplate, worn with peep-toe court shoes.

Right
Lanvin Winter 2007 Ready-To-Wear
Cerise shift dress with oversized sleeves and
shoulders, worn with fuchsia patent court shoes.

33.
martin margiela

Enigmatic and iconoclastic fashion outsider who is every fashion insider's hero

Recently celebrating twenty years at the helm of his eponymous label, Martin Margiela is an enigmatic personality. The Belgian designer rejects wholesale almost every convention and orthodoxy prevalent in the industry. He shuns fashion's fame factory to the extent of refusing to have his photograph published, give interviews or even put his name or logo on clothes of his design. The label doesn't say Martin Margiela but instead is a simple number printed on a piece of fabric tacked at four corners. Ironically, of course, the clothes tags work as a very effective form of branding: no logo as the ultimate logo. And what might appear at first to be a gimmick in fact points to his singular obsession: detail. Those numbers represent a cataloguing process. They signify the collection that the piece belongs to and its place within it.

Margiela never meets journalists face to face – there is even a rumour that he doesn't exist (he does) – but he will answer written questions. He tells me that: 'In our method, details are unquestionably one of our obsessions. Some are visible and others are less obvious.' His comments reflect a passionate engagement with the craft of making clothes. Every detail, whether functional (for example seams or fastenings) or ornamental (shoulder pads) is deconstructed and reconsidered from scratch. These elements become ideas that collide, coincide or conspire to create clothes that aren't always unusual from a distance but are invariably jaw-dropping upon closer inspection.

Margiela's creations often resemble severely engineered functional sculptures. Unlike many 'conceptual' fashion designers, who apply ideas to the surface of what are essentially unremarkable clothes (like the styling on extravagant but conventionally engineered American cars of the 1950s), in the case of Margiela, the design is revolutionary from the inside. Indeed, the outer styling can, at first glance, seem quite generic. His trench coats are a good example: a seemingly ordinary item of clothing that fashion journalists and Margiela fanatics know will give outstanding performance and always fit just right – while remaining somehow always on trend. Which is of course the final irony for a man whose success is based on avoiding the idea that clothes should be fashionable: 'Never compromise for trends, commercial goals or strategic aims. This is who we are and this is what we do.'

Autumn/Winter 2005–6
Trench coat and scarf with elongated neckline, worn
with a T-shirt with darts, a skirt with a burned hem,
and leather waders.

Every detail, whether functional or ornamental, is *deconstructed* and *reconsidered* from scratch.

Opposite above left
Spring/Summer 2009
Two plastic bags transformed into a wide-shouldered bodysuit, worn with a vintage trench belt and flesh-tone leather mules.

Opposite above centre
Spring/Summer 2009
Oversized short dress-bodysuit in black polyester chiffon on a pink silk lining worn with open-toe high-heeled shoes in flesh-tone leather.

Opposite above right
Spring/Summer 2009
Negative photograph of Margiela's first jacket (from Spring/Summer 1989) printed on silk satin and worn as a short dress, with flesh-tone leather mules.

Opposite below left
Spring/Summer 2009
Re-editon of Margiela's first jacket (from Spring/Summer 1989) in black cotton, painted over in white.

Opposite below centre
Spring/Summer 2009
Oversized dinner jacket and integrated black stretch-cotton leggings, worn with a sleeveless Lycra bodysuit, a shirt-front with black mirror applications, and stilettos in black leather.

Opposite below right
Spring/Summer 2009
Oversized cotton dinner jacket with 'disco-ball' mirror applications, worn with a sleeveless bodysuit in flesh-tone matte stretch cotton, and high-heeled open-toe shoes covered in 'disco-ball' mirrors.

Spring/Summer 2009 collection
Shawl with integrated bag in matte red jersey, worn with a sleeveless bodysuit in flesh-tone matt Lycra and open-toe high-heeled shoes in flesh-tone leather.

34.
tom ford

Genius fashion communicator who has forged
a new branding template for the industry

In less than a decade as creative director, between 1994 and 2004, Tom Ford transformed Gucci from a struggling leather-goods company into the most covetable symbol of glamour and sex on the planet. Under the guidance of this American fashion visionary the Italian label achieved worldwide sales of over a billion euros a year. There are very few people alive today who can be said to have had that kind of impact on the fashion business.

Ford gave luxury to the world. As he put it: 'I think that the democratization of luxury had a huge impact on the industry. We brought the stores to peoples' home cities, the catwalk shows to their internet browsers, and the ad campaigns to their daily newspapers. We made luxury almost commonplace.'

Ford's contribution transcends designing clothes. He is an arch-innovator, not just as a designer but also as a businessman. Above all Ford is *the* great fashion communicator. His genius has been to recognize that fashion brands tell stories and that these stories are present at every point of contact between the brand, its customers and potential customers. And so the perfect manners of the shop assistants and the paper quality of the humble carrier bags are as much part of the Gucci experience as the clothing and accessories. At the brands he

transformed, Ford not only took control of the design of the collections but also of the brand itself. And that means more than advertising images; Ford oversaw everything right down to the choice of the carpet customers walk on and the scent infusing the very air in stores and offices. No detail was too insignificant. During his tenure at Gucci and YSL, Tom Ford forged a sophisticated new branding and communication template that has been taken up right across the industry.

Ford also set the trend for the incorporation of Hollywood into the vernacular of fashion. He created a cocktail of fame, sex and fortune that dressed the boom times and made fashion an indispensable tool for Hollywood stars. He made it possible for actresses to sell clothes and for clothes to sell acting talent. Ford showed actresses the power of fashion: that the right dress could guarantee more column inches for their movie than a good review from an esteemed critic (not to mention the lucrative pay packets for appearing in ads that might follow). The red carpet became fully entrenched in the fashion calendar and a major marketing opportunity for fashion brands.

Once again, Ford set the template and others followed. Uniquely, however, the method by which he hybridized fashion and Hollywood

turned Ford himself into a megastar. He moved on to a hugely successful launch of his own brand of cosmetics and fragrance, which – unusually – preceded rather than followed the launch of his clothing range. At the launch, he was mobbed by hysterical fans. Ford isn't just famous: he *is* fame. Most designers labour for a decade or more before they are judged to have created a sufficient impression in the public consciousness to justify the launch of such lines. Tom Ford the brand needed no such introduction. So it is no surprise that after his departure from the Gucci Group, as well as launching his own much-anticipated label, Ford has landed in Hollywood and is due to release his first motion picture. The great storyteller has found a new canvas.

Gucci, 1995
Photograph by Mario Testino, styling by Carine Roitfeld, featuring model Amber Valletta
Male model, left: black trousers and matching black suit jacket worn with green shirt with oversized collar and white buttons. Female model: long teal mohair overcoat worn with teal silk shirt and black and dark teal trousers with leather and gold Gucci logo belt. Male model, right: Brown cotton shirt with dark brown two-piece suit worn with dark brown leather belt with silver Gucci logo.

Above
Gucci, 1996
Photograph by Mario Testino featuring model
Georgina Grenville
Male model: white cotton shirt with gold cufflinks and
white trousers. Female model: white long body con
dress with circular waist cutout with gold chain detail;
white shoes; triangular ring worn on little finger.

Left
Yves Saint Laurent Opium perfume, 2000
Photograph by Steven Meisel featuring model
Sophie Dahl
Gold sandals, gold jewel-framed bracelet with
matching choker and gold stud earrings.

35.
<u>viktor</u> <u>&</u> <u>rolf</u>

Master-showmen of contemporary fashion: spectacular, daring and utterly compelling

Dutch duo Viktor & Rolf are usually seen together, dressed in identical attire. As they mirror each other, so their work is a mirror carefully staged to reflect the world of fashion.

In recent times the international fashion show circuit has been transformed from a purely industry concern to a multi-media global event. Viktor & Rolf shows have become a highlight of this calendar. They arrived on the scene with a bang. Their first show was staged in 1998 during Paris fashion week as an unauthorized, off-schedule event; but nonetheless a dress in the shape of an atomic mushroom cloud went on to become *Time* magazine's picture of the year.

Fashion is to a large extent about performance, and catwalk shows are the standard method of presenting clothes to press and buyers. But there is nothing much standard about Viktor & Rolf shows since, as they put it, 'We see our shows as the actual work we make. The performance is important to us because it animates our clothes.' They extend their creativity to every aspect of their work; nothing is left to chance or done as others might do. 'It's the idea behind a creation that makes it beautiful. This doesn't mean it always has to be very conceptual, but in our case we want a show to transmit an idea or a feeling first, not just

communicate the (skirt) length of the season.' Viktor & Rolf are master communicators, with themselves as the embodiment of the idea of their brand. One could think of them as Andy Warhols of fashion: they embody their work and are physically connected to it. They even learned to tap dance for a show in 2000.

They're not the only fashion designers to use the medium of their shows to express the message of their brand, but Viktor & Rolf do so with exceptional wit and intelligence, and often with rather small budgets. Their shows are never in-your-face shock and outrage; that would be too simple. Instead they take the idiom of fashion as performance and deliver moments of subtlety and beauty that fall between conceptual/performance art, fashion and entertainment.

Their stunning 2008 exhibition at the Barbican Art Gallery in London showed their prowess to full effect: by framing their collection in one giant dolls' house they managed to invest emotional pull and wonder into a type of display that, like so many costume museums, could easily have felt sterile and dead. 'That is why we needed to give the show a meaning in itself, and not just let it be an illustration of events outside the reality of the exhibition.

We started out in the art world and the Barbican gave us the possibility to go back to these roots.' In the process, and working with what is still a young team, they have sculpted a unique vision of fashion, and created moments that are transcendent in their emotional and intellectual intensity.

'The Pierrot Collection'
Spring/Summer 2008 Ready-To-Wear
White duchesse-satin oversized jacket with Pierrot collar and flower detail with matching oversized trousers and black drop chandelier earrings.

Above
'White' collection
Spring/Summer 2002
White-silk structured shirt with large oversized
bib and bow detail, with matching skirt/trousers
and a headband.

Left
'No' collection
Autumn/Winter 2008
Grey belted wool coat with 3D 'NO' on chest,
worn with black tights and green canvas
over-the-knee concealed wedge boots.

Right and below centre
'Shalom' collection
Spring/Summer 2009 Ready-To-Wear
Right: multi-coloured Swarovski crystal-banded dress
with coloured striped organza frills, worn with
nude strapped sandals. Below centre: pleated crepe
spiral dress seen in silhouette. Shalom Harlow
modelled the entire collection for this exclusively
online show.

Far right
'Stars and Stripes' collection
Spring/Summer 2009 Ready-To-Wear
American-flag print long coat worn with matching
knee-length shift dress with bib ruffle detail,
trousers and shoes, and short white gloves.

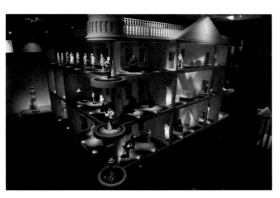

Doll House Collection, Barbican Art Gallery, 2008
A collection of 55 signature pieces from 2002–8
was exhibited in a room-sized dolls' house (above).
The top floor incorporated video projections of the
designers' most iconic shows in which the dolls'
miniature garments could be seen on real-life models.
Top left: Female doll in metallic prom dress and
black shoes. Top right: Male doll in black oversized
structured jacket with grey wash jeans and black
shoes. Far right: female doll in long black dress with
white headscarf and bouquet.

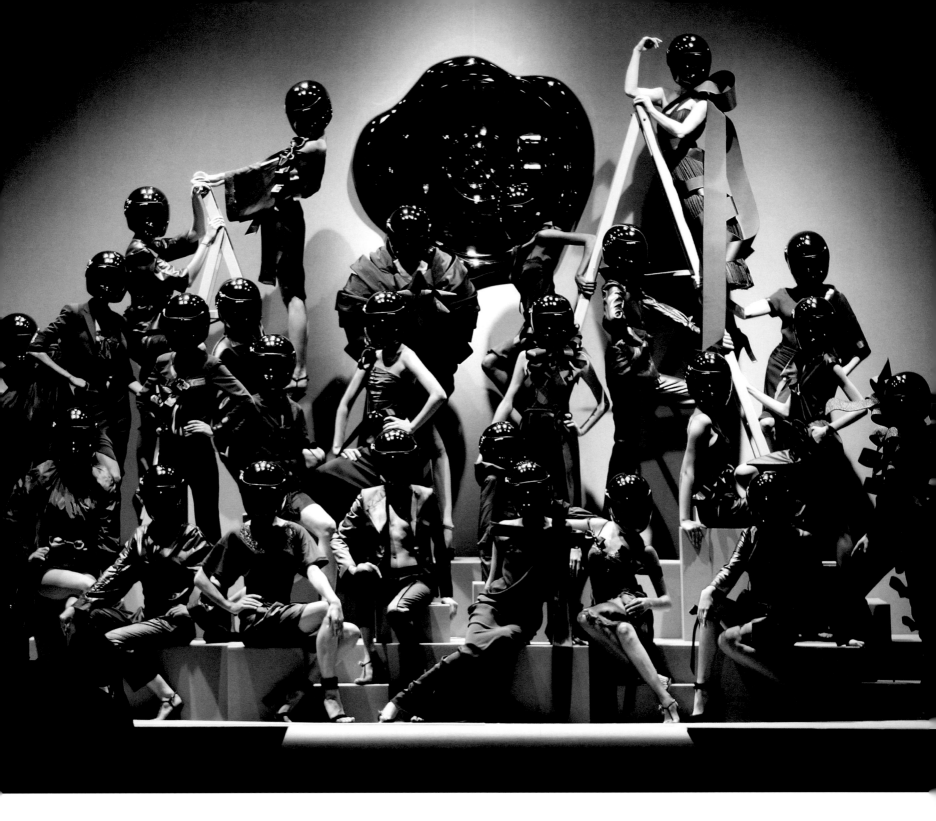

'Flowerbomb' collection
Spring/Summer 2005
This collection marked the surprise launch of the
Flowerbomb fragrance. It opened with an army
of helmet-clad models dressed in black and plum
waisted jackets, rounded blouses and trench coats.

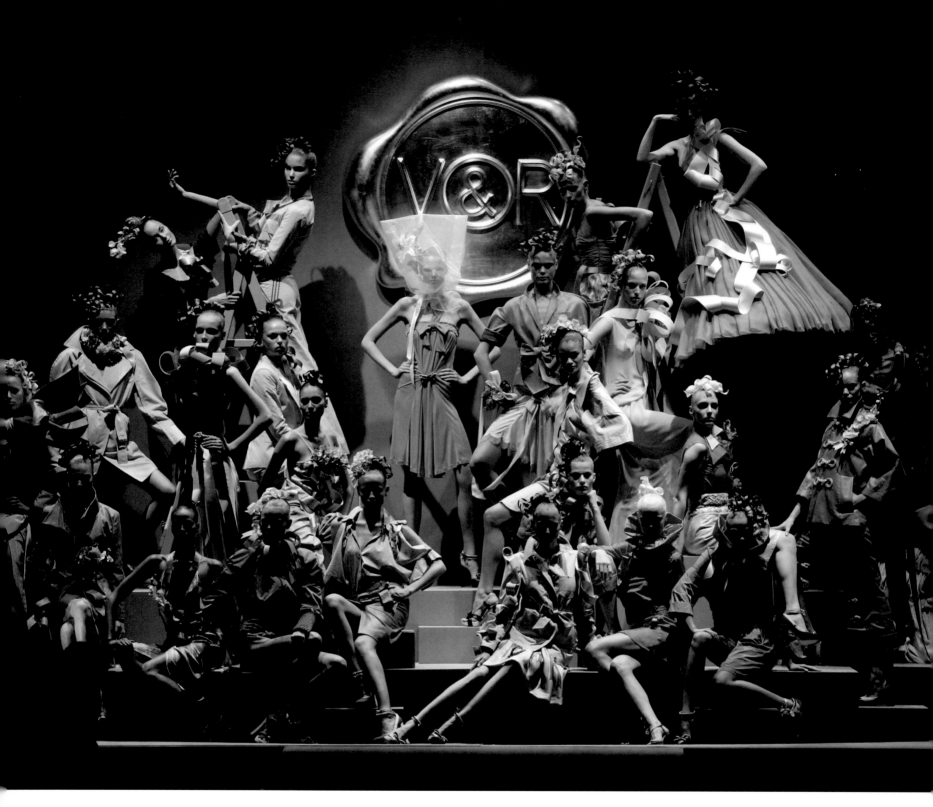

'Flowerbomb' collection
Spring/Summer 2005
Just as the show seemed to be over, the sound of
helicopters and the chant 'flowerbomb, flowerbomb,
flowerbomb' filled the room as the catwalk revolved
to reveal a springtime collection of pinks and reds.
With the air heavily scented with their new fragrance,
Viktor & Rolf took their bows.

36–40.

nick knight

christopher williams

liz deschenes

taryn simon

shannon ebner

photography

charlotte cotton

introduction

charlotte cotton

Creative Director, London Galleries,
the National Media Museum, UK

While the protagonists of any era might describe their historical moment as pivotal, that is unarguably the case right now in the realm of photography. This is in part a consequence of dramatic technological change: the past decade has witnessed a revolutionary overhaul of the available tools for image-making. Since the early 2000s, in both professional and amateur practice, the ongoing development of digital means of capture and dissemination of photographic images has progressively reshaped our understanding of the medium, both in its contemporary expression, and also how we look back upon its past. It is as if the late-nineteenth-century prophecy that everyone would become a photographer is finally being lived out.

As 'citizen photography' becomes a prominent vehicle for breaking news, as well as the carrier of the most undiluted messages of day-to-day intimacy and experience, the role of the professional photographer has shifted. The traditional authored photographic project has to some extent been displaced, along with the role of the photographer in capturing the defining moments of a society's unfolding story. At the same time there has been a decline in financial and editorial support for documentary photography in the pages of picture-driven magazines, and a crisis of confidence in the power of fashion photography and luxury brand advertising to catalyse consumption. As so-called amateur photography has gained greater prominence and kudos via web-based networks and forums, and as the scope of professional assignments and fee structures has declined, the locus of innovation in photographic practice has settled, for reasons both positive and negative, in the realm of contemporary art.

Contemporary art photography, the medium's *vanguard* and *terrain of innovation*, has not only been co-opted into the art market but has taken a central position in the lexicon of contemporary art.

The history of photography is littered with moments in which a small number of radical practitioners reasserted the medium as an arena for individualized, urgent voices that were actively responding to the image-making climate in which they found themselves. What is particular to our time is that contemporary art photography, the medium's vanguard and terrain of innovation, has not only been co-opted into the art market but has taken a central position in the lexicon of contemporary art. This has been truly exciting to witness. Much of the work that has achieved greatest prominence in this period displays very definite signs of the photographers' intentionality and authorship. Such work employs a directorial mode, in which every detail of subject, framing and lighting is pre-conceived and controlled by the photographer both in its process and in its final physical form. The single print (as opposed to the sequence or series), large in size and commanding substantial space on a gallery wall, has become a ubiquitous declaration of photography's art status in museums and galleries across the world.

Associated with this development have been two negative ripple effects. Firstly, as the most high-profile incarnation of 'the photographer' shifted quite definitely away from the industries of journalism, fashion and advertising and into the sphere of art, many more photographers than ever before applied themselves to the gallery context. Luxurious production values and large-scale prints began to be the most prominent signifiers of the photograph as art because these were the most likely to gain commercial success in an inflated art market. Consequently, it became difficult to separate genuinely reflective and innovative artistic practice from the ostentation of some rather less substantial photographic

The five photographers presented here are not only highly attuned to the *rapidly changing technological context*, but they each tread a creative path that opens up *dynamic new avenues* for future practitioners.

propositions. Secondly, the preference for very controlled and authored photographs pushed to the margins some of the inherent possibilities of the medium. The opportunities that photography allows for observation, for the distillation and abstraction of lived experience, for being open to chance and the intervention of the unexpected, and even of mistakes that may happen at any step of the photographic process: these have taken time to become acknowledged as a legitimate part of photography as contemporary art.

The five photographers presented here all stand out as innovators as they navigate this territory, creating departures and proposing future directions for the medium and its genres. They are not only highly attuned to the rapidly changing technological context and the shifts this creates in photographic language and meaning, but they each tread a creative path that opens up dynamic new avenues for future practitioners. Innovation here is defined as an act of finding an authentic, personal and novel route through the given conditions of photographic practice at this juncture in the medium's history. These five practitioners are not a collection of the most celebrated photographers of the late 2000s, and none of them represents the status quo of any of the various industries or genres of photography. Some may perhaps be unfamiliar. But that is because the paths they explore are generous ones, related more to expanding the discourses of photography than profiting from the medium's current moment of elevation into institutional and commercial success, which – if history teaches us anything – may in any case prove short-lived. They are innovators because they transcend photography's conventions in order to expand, for all of us, its reach.

Nick Knight's exploration of the potential of new imaging technologies and web-based platforms cuts radically through the tired formats of commercial image-making to set new standards and aesthetic potential for that genre. Knight independently got the ball rolling back in the early 2000s, at a time when the industry of fashion had yet to envisage how the web would become a vehicle for its messages, and pointedly after 9/11, which sparked a crisis of belief in the efficacy of commercial photography and its narratives. It is of lasting significance that it was an image-maker, rather than a business manager or advertising agency, who staked out the parameters of the fashion industry's visual communication in the digital era, and injected the creative potential of video, sound and interactivity into the first wave of commercial image-making for the web.

Taryn Simon's *An American Index of the Hidden and Unfamiliar* sets a high bar for a documentary photographic project, taking investigation to the very limits of possibility. At a time when there has been a profound drop in the level of traditional support for in-depth photographic journalism from conventional outlets – magazine and book publishers – and in a climate in which the self-awareness of the United States has been globally questioned, Simon's project has great resonance.

The other three photographers highlighted in this chapter operate more specifically within the currently central arena of photography as contemporary art. Each follows a distinct line of investigation, and all three stand out for creatively fusing the visual culture within which they work (including how their audience reads and registers their photographs) with the particular questions, messages and lines of enquiry that shape their art. These artists – Christopher Williams, Liz Deschenes and Shannon Ebner – each create work that distils layers of meaning and investigation into resolved and resonant images. Their styles and strategies are all highly distinct, but they do have in common one notable quality: their work is not contingent upon the Romantic idea of a work of art carrying the 'voice' or 'authorship' of the photographer. Rather than apply a signature aesthetic, each artist deploys multiple strategies in order to communicate and explore the potency and meaning of photographic images today.

Christopher Williams' photographs can be hard work for the viewer – even at times baffling. His recent images carry the prosaic style of commercial product shots and catalogue and promotional images prior to retouching. Each one presents an industrially produced object such as a camera, a car tyre or a plastic corn cob from a shop window

display. Williams' captions meticulously record the words on the manufactured goods and packaging that he pictures, maintaining an air of scrupulous objectivity and detachment. Yet what makes Williams' photographs so abidingly resonant is that one intuits that every detail is pointedly intentional, even while struggling to unravel the back-story of each piece. In an era in which it has been almost a prerequisite of the aspiring contemporary art photographer to confirm absolutely his or her intentionality, Williams' photographs are quietly incendiary. His highly authored photographs pose a conundrum in the viewer's mind that could be said to expose the shallow showmanship and stylish trickery of some of his most high-profile contemporaries.

Liz Deschenes' projects focus upon an increasing awareness of how the very medium of photography shaped twentieth-century experience. At this juncture in its history, when analogue photographic processes such as gelatin-silver (black-and-white) and dye transfer are becoming increasingly marginalized in both professional and amateur practice, the intrinsic qualities of those processes are attracting artists' attention as subjects in their own right. Deschenes' work foregrounds the physicality of photography, the language of its history, and the once-defining qualities of the medium that are about to slip out of common currency.

Shannon Ebner's oeuvre represents a retort to a conspicuously depoliticized epoch in art photography. Her photographs consciously recall much more radical times in the late 1960s and 1970s, when conceptually driven photography was a vehicle for gestures of personal politics and protest, and sought to expose the unseen, often insidious military, governmental and consumer forces that were reshaping Western society. She is one of very few artists of the 2000s to have made that decade's wars both a subject and also a sublimated ingredient in her art, all the while interrogating what it means in political terms to make contemporary art.

Originally associated with the Pictures
Generation in the early 1980s in New York,
James Welling has worked at the intersection
of photography and photographic technology
for three decades.

on innovation

james welling

Photography has always depended on technological change, but where is digital technology going to take us? This moment is exciting because all the capabilities of image-making – traditional or otherwise – have been boosted. Apart from producing *sharper, crisper* and *more accurately coloured photographs*, digital technology has ushered in different ways of thinking about image-making. I wonder, for example, whether it will lessen photography's connection to what some call the 'indexical', in other words its condition as a trace of light on a sensitized surface.

What interests me as an artist is that the various digital modalities of image-making create multiple pathways for me to work with a photograph. The clearest example of this is the way that digital colour affects how all of us see and use colour. My own sense

of colour has been profoundly affected by working with an inkjet printer, for example, which allows my eyes to see a wider range of colours than before. Photography's heightened ability to replicate and visualize colour has produced *a shift in our awareness of colour.* As more vibrant and more subtle colours are capable of being reproduced, I suspect that the world will be coloured differently in architecture, fashion and art.

There's a truism that nothing good comes out of art about art, and that a photographer should only look at 'real stuff' in the 'real world'. But for me, it's all intermixed: our opinions about the world create the world. And this is what is exciting about digital technologies of image-making. They are as much about people's opinions of events as a static recording of the 'outside' visual world.

36.
nick knight

*Creative pioneer who has reinvented
the field of fashion image-making*

Since the moment in the mid-1990s when fashion photography took its first steps into its digital future, Nick Knight has been its pre-eminent innovator. As an image-maker who always rejected the notion of photography as a simulation of human vision, he was destined to make digital generation and production fundamental to his practice. Already in 1993, Knight was beginning to explore the earliest post-production and computer-generated image programs. Digital photography shifted working practices, pulling attention away from the reflective surface of the photographic print or wet proof to the phosphorescent glow of the computer screen. For Knight, whose challenge was always to construct the image he conceived in his imagination, putting whatever technical platform he employed at the service of that vision, digital post-production offered a host of new possibilities and stages at which to intercept and reshape an image's form.

In 1999, Knight began experimenting with the process and aesthetics of three-dimensional imaging technologies that were being developed for the film and animation industries. Three-dimensional processes in those days started with a still photograph onto which information from a rotating scanner was applied – a basic, fault-ridden process that Knight experimented

with by, for instance, varying the amount of light that reflected off the surfaces of the clothing in order to confuse the scanner's registration of depth of field. This same principle of creative engagement with the glitches thrown up by new technologies has also underpinned Knight's exploration of 360-degree imaging in the 2000s. In collaboration with 3D laser scanning pioneer Kevin Stenning, Knight has begun to create sculptural renderings of 360-degree imaging data, reversing the usual derivation of a photographic image from physical objects. Working with plaster, bronze, glass and minerals, Knight has been experimenting with how photography and sculpture can intersect.

Knight was the only major fashion image-maker to perceive the potential of the web. In late 2000, he launched the independent website SHOWstudio.com and issued an international invitation to the fashion photography community to experiment within this new arena. From the outset, Knight enabled users to interact with and mould the content of the site's projects. SHOWstudio anticipated and began to define the new medium of fashion film, bringing sound and motion to a field previously overwhelmingly dominated by the still image. Through the 2000s, with editor Penny Martin and art director Paul

Hetherington, SHOWstudio has captured every possible experience of fashion from camera phone footage of international fashion weeks and website-audience-directed shoots to revealing glimpses into the creative processes of designers, photographers and stylists.

SHOWstudio remains the most substantial demonstration of how fashion can be explored and narrated through the aesthetics and interactivity of the web. This pioneering online project has not only created a bridge between the creative process of fashion photography and its audience, but also spawned new working methods for Knight. Rather than the authorial, even sometimes authoritarian stance of the fashion photographer on set, Knight has found new directions for his own image-making in the greater openness to chance and spontaneity permitted by video and performance.

Sweet, 2008
Still from 3D animation
Stylist Jane How used sweet papers, cupcake wrappers, dolls and Christmas present trimmings to recreate her favourite looks by Comme des Garçons, Yohji Yamamoto, Hussein Chalayan and Thierry Mugler. Nick Knight recorded the result on a 3D scanner and set it to a music-box soundtrack by Fridge.

Men in Tights, 2008
Stills from short film
Bernhard Willhelm collaborated with Nick Knight
to produce this promotional film for his Autumn/
Winter 2008 collection. Willhelm built a name on
his colourful geometric prints, outlandish men's tights
influenced by wrestling wear, and a love of mixing
absurdity with high fashion.

37.
christopher williams

Rigorous and compelling commentator upon our material world

To walk into a gallery displaying Christopher Williams' photographs is to immediately experience a conflicting set of emotional responses. Williams' technically precise photography showcases a range of mundane, industrially produced objects. Other images represent the uncropped and unretouched results of an advertising shoot. There may even be a doubt in your mind as to whether Williams took these photographs himself or whether they were perhaps the work of an anonymous professional photographer recruited to bring a conventional style into the service of this artist's agenda.

Yet at the same time, in the equally considered installation of his photographs, Williams creates a physical and mental rhythm within the gallery space that quite brilliantly invites the viewer to try to unlock the code of each photograph and the relationships that they form with each other. The effect of his photographic installations is contradictory: every step of his process, including the positioning of each individual print, is a seductive invitation to our scrutiny and investigation. Williams consciously presents his photographs like essentially Modernist works of art – each photograph is a locked code, and one that we intuit as being of a tantalizingly weighty significance.

In interviews and his writing, Christopher Williams is as ostensibly transparent about the lines of enquiry that shape his work as the resulting photographs. His choice of industrially manufactured objects and products is determined by their embodiment of the forces of modern political history and its traces within consumer and artistic culture. For example, embedded within Williams' seemingly banal and upbeat presentation of plastic display cobs of corn is the history of the exploitation of an archetypal symbol of American values. From the cultivation of a wild grass in Mesoamerica, to the saving of the first settlers from starvation, to contemporary GM agriculture, American corn is a loaded subject. When you add into the equation the production of the biofuel ethanol from corn in the late twentieth century as a cheaper and more sustainable alternative to petrochemicals, and its use in turn to produce the plastic that is the base material of the shop display corn cobs pictured in the photograph, and also of the photographic paper on which the image is reproduced, you begin to grasp the full power of the web of references that Williams' work invokes.

Williams' approach slices through the intellectual laziness, visual seduction and conventional language of so much photography that proposed itself as contemporary art in the past decade. He not only fully realizes his ideas in physical form but bestows upon them an enduringly potent visual charge that draws the viewer into unravelling their multi-layered meanings. When we look back on photography in the 2000s, we will see that Williams' approach showed us how rigorous, socially engaged and commanding contemporary art photography could be.

Pacific Sea Nettle, Chrysaora Melanaster, Long Beach Aquarium of the Pacific, 100 Aquarium Way, Long Beach, California, September 5, 2007, 2008
Gelatin silver print, 50.8 x 61 cm (20 x 24 in.)

Above

Cutaway model Nikon EM. Shutter: Electronically governed Seiko metal blade shutter, vertical travel with speeds from 1/1000 to 1 second, with a manual speed of 1/90th. Meter: Centerweighted Silicon Photo Diode, ASA 25 -1600, EV 2-18 (with ASA film and 1.8 lens). Aperture Priority automatic exposure. Lens Mount: Nikon F mount, AI coupling (and later) only. Flash: Synchronization at 1/90 via hot shoe. Flash automation with Nikon SB-E or SB-10 flash units. Focusing: K type focusing screen, not user interchangeable, with 3mm diagonal split image rangefinder. Batteries: Two PX-76 or equivalent. Dimensions: 5.3" x 3.38" x 2.13" (135 mm x 86 mm x 54 mm), 16.2 oz (460 g). Douglas M. Parker Studio, Glendale, California, September 9, 2007–September 13, 2007, 2008
C-print, 50.8 x 61 cm (20 x 24 in.)

Opposite

Linhof Technika V fabricated in Munich, Germany. Salon Studio Stand fabricated in Florence, Italy. Dual cable release. Prontor shutter. Symars lens 150 mm/f 5.6 Schneider kreuznach. Sinar fresnel lens placed with black tape on the ground glass. (Yellow) Dirk Sharper Studio, Berlin, June 19, 2007, 2008
C-print, 40.6 x 50.8 cm (16 x 20 in.)

Untitled (Study in Yellow and Red/Berlin) Dirk Sharper
Studio, Berlin, June 21st, 2007 (No. 1), 2008
C-print, 48.3 x 37.8 cm (19 x 14.88 in.)

38.
liz deschenes

Artist who focuses on the medium of photography itself at a moment of unprecedented transition

There are few artists who analyse and narrate the current juncture of photography's history so intelligently as Liz Deschenes. For the past ten years, this American artist-photographer has explored the phenomenological experience of art and its intersection with the technologies and experiences of photography and film. We have entered a period in which analogue capture and representation of photographic images are not only being replaced by digital technologies, but are under threat of becoming defunct as the necessary materials and equipment cease to be manufactured. The processes and production values of independent art photography and film have long remained relatively independent of those of commercial image-making. However, the increasing gap between new dominant technologies and those that defined the medium of photography in the twentieth century is reshaping the way that we perceive, for example, a gelatin-silver print or the use of a 10" x 8" negative film camera.

Every independent art photographer who established their practice in the late twentieth century has of necessity undergone a process of re-evaluation of their work in light of the waning use of analogue techniques. Even if they remain wedded to working with film and light-sensitive chemicals, the growing nostalgia inherent in these increasingly historicized processes has to be factored in to how the viewer will experience their work. Liz Deschenes neither romanticizes nor mourns analogue processes but makes them her subject. As such, there is a timeliness to her practice, which rests upon an awareness that it is only now, at a moment of great technological transition, that the media of photography have become a subject in their own right and a vehicle for conceptual exploration.

In her *Blue Screen Process* of 2001, Deschenes made her subject the behind-the-scenes technique of filming an actor against a pure blue, green or red backdrop (with a second background film then superimposed behind the figure of the actor). This interest in the mechanics of how imagery is made is carried over into her subsequent work. Her *Moiré* series has obvious allusions to Bridget Riley's Op Art paintings, but equally refers to the moiré effect of the interference of pixels and raster lines across digital television screens. The *Moiré* series was created with an analogue camera. Deschenes photographed a perforated piece of paper with a 10" x 8" camera, producing two copies of the negative which she then misaligned in the enlarger to create a pulsating optical illusion.

Such use of analogue processes to simulate digital effects is another example of her continued investigation into the nature and phenomena of image-making. The *Black & White* series of 2003 is a set of monochrome analogue prints that bear the frame dimensions of defunct film stock. For the viewer they are a reminder that these ratios were until recently embedded in our experience of film; they were the invisible framework of this quintessential twentieth-century medium. This attention to the essence of photographic media also underlies Deschenes' *Transfer* series – a suite of bold, pure sheets of colour made using the now almost-defunct dye transfer process. Deschenes used a fourth printing matrix (the dye transfer process typically uses three matrices) to emphasize the richness of this luxurious printing process and the poignancy of its imminent extinction since the Eastman Kodak Company ceased to make the materials in the mid-1990s.

Moiré #19, 2007
UV-laminated chromogenic print,
137.2 x 101.6 cm (54 x 40 in.)

Liz Deschenes *neither romanticizes* nor *mourns* analogue processes but makes them her *subject.*

Left/Right, 2008
UV-laminated chromogenic print mounted
on aluminium, 50.2 x 90 cm (19¾ x 35 in.)

Black & White 1–5 (installation view), 2003
Chromogenic and silver gelatin photograms,
each 76.2 x 101.6 cm (30 x 40 in.)

Elevation 1–7, 1997–2003
Dye transfer prints, 50.2 x 41 cm (19 x 15½ in.)

39.
taryn simon

Intrepid investigator whose work defines the future of documentary photography

The American photographer Taryn Simon gained prominence with her 2003 project *The Innocents*, which included portrayals of former prisoners who had been wrongfully convicted in the US and subsequently freed from Death Row. She photographed each of her subjects in the location where their supposed crime was committed, their alibi location or where they were arrested, and recorded their personal testimonies. The project fused the social commitment and research processes of traditional documentary photography with the aesthetics and staging characteristic of much contemporary art photography at that moment. It was one of a number of important propositions by documentary photographers in the early 2000s showing how social and political issues – traditionally the focus of magazine commissions – could engage the burgeoning audience for contemporary art photography.

Simon soon after began the intense research and production that would lead to the 2007 launch of her book and travelling exhibition *An American Index of the Hidden and Unfamiliar.* This remarkable and ambitious project maps a wide range of off-limits ventures and sites within the borders of the United States. Working with three producers over a four-year period, Simon photographed seventy subjects ranging through government, religion, science and nature, from a nuclear waste storage facility, US military training sites and border controls, to research centres and grassroots political activists. These locations, individuals and phenomena represent the unseen underpinnings of contemporary America and its enduring mythologies.

Some of the photographs' impact stems from the sheer inaccessibility of what they depict: the Church of Scientology Celebrity Center in Hollywood, a cornucopia of contraband confiscated at JFK airport, or a black bear and her cubs hibernating in an underground den. Human subjects include Maryland Ku Klux Klan members, the president of the 'Republic of Texas' interim government, representatives of the International Fellowship of Christians and Jews, and a spokesman for a group promoting the legalization of assisted suicide. But the majority of the photographs in *An American Index of the Hidden and Unfamiliar* focus on governmental and military hidden activities. The project also counterpoints twenty-first-century initiatives such as a digitally simulated urban environment used in military training with now historic examples, such as the Cold War aesthetics of the CIA's original headquarters in Virginia.

Each photograph in *An American Index of the Hidden and Unfamiliar* is accompanied by a precisely factual text documenting its subject with clarity and neutrality. This same neutrality is manifest in Simon's photographic style: using a large-format camera (except where this was not technically possible), she captured each subject with maximum control and objectivity and without an obvious flourish of 'signature' style or commentary. The effect is powerfully compelling. For its scope and ambition, and also its lack of hyperbole, *An American Index of the Hidden and Unfamiliar* is a defining project for the future of documentary photography.

The Innocents, 2003
Troy Webb, 2002. Scene of the crime, the Pines,
Virginia Beach, Virginia. Served seven years of
a 47-year sentence for rape, kidnapping and robbery.

The National Center for Natural Products Research (NCNPR) is the only facility in the United States that is federally licensed to cultivate cannabis for scientific research. In addition to cultivating cannabis, NCNPR is responsible for analyzing seized marijuana for potency trends, herbicide residuals and fingerprint identification. Licensed by the National Institute on Drug Abuse, NCNPR researches and develops chemicals derived from plants, marine organisms, and other natural products.

While eleven states have legalized the medical use of marijuana, a 2005 US Supreme Court decision allows for the arrest of any individual caught using it for this purpose. Nearly half of the annual arrests for drug violations involve marijuana possession or trafficking.

An American Index of the Hidden and Unfamiliar, 2007
Research Marijuana Crop Grow Room,
National Center for Natural Products Research,
Oxford, Mississippi

In 2004 the Monterey Bay Aquarium (MBA) became the first aquarium in the world to place a great white shark in long-term captivity. It was held there for 198 days. In that time it grew from 1.5 m (5 feet) and 26 kg (62 lbs) to 2 m (6 feet, 4½ in.) and 73.5 kg (162 lbs). It developed visible nose injuries from bumping into the glass walls of the Outer Bay and killed two other sharks. As part of its White Shark Research Project, scientists brought the shark into the MBA after it was caught in a nearby fishing net. The goal of the MBA's White Shark Research Program is to better protect white sharks by gaining insight into their biology, behavior, and involvement in the marine ecosystem. In 2004 the World Wildlife Fund placed Great Whites on the WWF 10 Most Wanted list, a list of the world's most sought-after species for marketable souvenirs and food.

An American Index of the Hidden and Unfamiliar, 2007
Great White Shark in Captivity, Million-Gallon
Outer Bay, Monterey Bay Aquarium, Monterey,
California

40.
shannon ebner

Poet-photographer who re-injects political protest into the arena of contemporary art photography

The first decade of the new century has been an era of commercial success and seduction for American contemporary art photography. The most heralded art photographers and their heirs apparent created a new level of spectacle for the medium through large-format prints with gorgeous production values, and narratives of nostalgia for the (principally) American vernacular and the postmodern iconography of advanced capitalism. While documentary photography made some inroads into the museum and gallery arena, there have been few artists in the past decade to have taken their cues from the personally politicized stance adopted by a body of conceptual artists since the mid-1960s.

Shannon Ebner trained as both a photographer and a poet (in distinct phases) in the 1990s and her understanding and passion for both pursuits have permeated her work in the 2000s. Against a backdrop of American military engagement in Afghanistan and the second Gulf War, Ebner has created some of the most expressive realizations of how language – both verbal and photographic – can challenge the politics of our time within the artistic arena.

For the *Dead Democracy Letters* series, begun in 2002, Ebner made an alphabet of wooden letters in the distinctive typeface of the 'Hollywood' sign. Positioning her chosen words in the stark terrain of the Californian landscape, Ebner reclaimed and subverted the language of the George Bush administration. The photographs are black and white, modestly sized. They reference the combined scale and visual economy of Land Art documents created in an earlier era of public activism in the 1960s, as well as the first generation of photographers in the 1970s to explicitly reveal and critique the effects of human exploitation of the American landscape, including Lewis Baltz and Robert Adams. Through her choice of a cool, anti-operatic photographic style, the defiant message of her word sculptures comes to the fore.

Shannon Ebner's 2005 public art project *Dead on the Inside*, made from rough cement blocks, carried especial symbolic weight in its context alongside the imposing grandeur of New York's Rockefeller Center. The work intentionally invoked the use of such cement blocks in conflict zones across the world to create partitions, barricades and borders. The enclosed circular sculpture spelled out 'de/ad/inside', referring both to its inaccessible interior and to a current crisis state of psychological emptiness and absence of meaning.

STRIKE (2007) is a commanding mosaic of small black-and-white photographs that spell out eighteen palindromes consisting of words and fragments of poetry. Each letter of the poem is an individual photograph of cement blocks suspended on a grid of pegs. The blocks' weight and rough finish echo the ominous word play that the letters spell out. The title refers to the syntactical strike that breaks up the lines of the poem as well as the military strikes currently being waged. This description somewhat belies the cumulative and oblique experience of the work, which makes an innovative proposition for how politics, poetry and photography might be combined in the arena of contemporary art.

STRIKE, 2007
540 chromogenic prints, aluminium, wood, each print 19 x 14.6 cm (7½ x 5¾ in.), 381 x 393.7 cm (150 x 155¼ in.) overall

Landscape Incarceration, 2003
C-print, 81.3 x 103.9 cm (32 x 40½ in.)

41–45.

0100010101110101101.o

the yes men

miigam'agan &

gkisedtanamoogk

natalie jeremijenko

wendy seltzer

new media

joline blais & jon ippolito

introduction
joline blais & jon ippolito

Joline Blais is Associate Professor of New Media at the University of Maine. Jon Ippolito is an artist, writer and curator who also teaches at the University of Maine

It is difficult to think of any field in which innovation occurred in the last decade where new media – whether wielded by artists or architects, developers or dressmakers – did not play an essential role. But what of innovation within the field of new media itself? Who offers vision to the next generation of visionaries?

The first wave of new media practitioners in the 1980s and 1990s fashioned the tools that have networked the globe. As this network spread, it ramified – from a data packet sent from UCLA to Stanford, to a tangle of web pages joined via hyperlinks, to a community-edited constellation of images, sounds and news, to a swarm of satellite-enabled hand-helds capable of mapping environmental destruction and coordinating political movements. As virtual reality gave way to augmented reality, the archetypal new media user changed from a white male 'data cowboy' with no social life to a Japanese teenage girl with too much social life. Gawky virtual reality helmets have given way to Treos and iPhones, and people use these stylish wireless devices not to escape bodies, but to find them.

The latest wave takes this networked community and extends it further into the real world and its denizens, both human and non-human. These innovators think quite literally outside the box, recognizing that new media are about communicating with other beings, not with machines. But something has changed. In the first wave, the 'new' in new media placed undue emphasis on the ephemeral – exemplified by the accelerating cycle of obsolescence of hardware, software and everything built with them. The latest wave, on the other hand, sees nothing new in newness. Change is everywhere: in energy

descent, climate change, corporate overreach and constantly mutating technologies. The challenge for this generation is how to accommodate change – how to grow the agility and robustness of networks, developing them from a proof of concept into a long-term strategy for survival.

For networks are the arena in which these creators wage war. Networks offer a level playing field that favours the innovative, whether that field is made of bits, sod or kin. Just ten dollars will buy you a domain name – be it GWBush.com, GATT.org, or TheWorstDomainName.net. It is this egalitarian ethic that empowers the Yes Men to impersonate presidential candidates, multinational corporations and influential NGOs. The artists of 0100101110101101 faced down a 78,000 euro lawsuit from Nike, thanks in part to the anonymity of the internet. By networking a dozen law students across the US, Wendy Seltzer can protect inventors from the chilling effects of intellectual property law by exposing the overreaching tactics of corporate lawyers. Natalie Jeremijenko lays soil on sidewalks and invites geese to a human lunch, reminding us that our food webs include the flora and fauna in driveways and on rooftops. And Miigam'agan and gkisedtanamoogk are rebuilding the longhouse, one of the most successful networks of the past 10,000 years, starting with little more than their own convictions and good will.

Playing on a level field, however, does not mean your opponent won't have the upper hand. The innovators described here aren't designing a funky-looking house or a cool iPhone app; they are designing a world to which the established players are adamantly opposed. Ordinary citizens don't have the cash to fight cease-and-desist letters from Fortune 500 companies directly, and you have to be pretty clever to construct a viral publicity campaign that beats Madison Avenue at corporate public relations. New Yorkers are accustomed to fighting each other over parking spaces, and are scarcely inclined to make room for greenery where there used to be a stretch of unoccupied kerb. Rules set down by the US Department of Transportation, and myriad other government, financial and social hierarchies, control how citizens interact on sidewalks and street corners. Yet, at the onset of the third millennium CE, we are finally beginning to see the dire costs, economic and ecological, of abdicating our responsibility for those decisions to captains of industry and government.

Of course, hierarchies have ruled society for as long as most of us can remember – which is why we should be listening to those who have longer memories. Like many indigenous activists, Wabanaki elders Miigam'agan and gkisedtanamoogk seek to re-forge the bonds that

The internet is less a *technology* for wiring routers via packet-switching than a technology for *social intelligence*… precisely what Euro-ethnic culture lacks.

normally exist between people and the land and between people and each other – bonds broken by hierarchical structures that have consumed those social energies and relationships. They challenge people of all colours to decolonize and re-tribalize, and the internet offers one of many arenas in which to explore this process. While planting his feet firmly in the longhouse tradition of America's northeast coast, gkisedtanamoogk nevertheless looks to the horizon, where he has experimented with global rituals such as microtreaties, the 'distant neighbour protocol' and remote ceremony. He recognizes that the people who are going to lead the future will be children of the internet.

That said, the internet is less a technology for wiring routers via packet-switching than a technology for social intelligence. So perhaps we shouldn't be surprised that the internet built by white male engineers is a barely sustainable system beset by viruses, spam and vitriol. It is precisely social intelligence that Euro-ethnic culture lacks, and that the Wabanaki remember: the longhouse is *their* internet. In place of flamewars, indigenous people had talking circles; instead of money, they had trust. Rather than entrust care of their networks to top-down organizations like ICANN and Verizon, the Wabanaki created an inverse hierarchy, where decisions by the highest inter-tribal council could always be overruled by local communities. Their vision is broad, their communities dense. They recognize that the real doomsday invention of the twentieth century was not the nuclear bomb, but the nuclear family.

Nevertheless, the digital media newly birthed by Euro-ethnic culture offer many practical strategies that innovators from all networked cultures gladly exploit. These creators don't fashion rarities for the white

cube or its elite gatekeepers, but unleash their executable creations on the email inboxes and street corners of ordinary folks. Junkyards and e-commerce sites aren't subjects they paint or sculpt, but sites where they act. As we argue in the book *At the Edge of Art*, the internet has enabled creative people to make and distribute work far outside art's traditional confines. To be sure, there is no gallery to fund high-tech installations, and the lack of a 'dot-art' domain to go with 'dot-com' and 'dot-org' means viewers have to decide for themselves what is or is not art. But these constraints have also freed new media artists from the art world's narrow purview and dependence on the market, helping them learn to survive in a world much bigger than its cloistered hothouse. While art world cognoscenti find titillation in a set of handcuffs or a Barbie doll on a gallery floor, new media artists aim to do more than retrieve a new readymade for the Duchampian frame. The 'readymade' of new media producers is usually their society's rules rather than its products. Like open-source programmers, these innovators start from existing codes – legal, technical or cultural – and recombine, reuse or misuse them. So Jeremijenko rewires toy robots into pollution detectors, and Wendy Seltzer ports the concept of partnership from business law into international relations. They recognize technologies not as collections of diodes and do-loops but as patterns of relationships. They take these relationships and make them visible – and, where possible, change them for the better.

Like many in the first wave of new media innovators, these code-crackers are not CEOs of companies or directors of research labs; they command no minions, yet they are good collaborators. Their work exemplifies new media's seemingly paradoxical aesthetic of 'DIY collaboration'. In the broadcast paradigm of Time Warner and Microsoft, a creator in an entry-level job can communicate with her direct superiors but no higher up the food chain; this arboriform structure of communication is the defining protocol of hierarchies. DIY collaboration, however, requires two radically different assumptions: first, that each node has sufficient autonomy to contribute to the process; and second, that any node can communicate with any other. DIY technologies provide the requisite autonomy, and the distributed architecture of today's electronic networks makes point-to-point contact possible.

If DIY collaboration empowers individuals, it scares the hell out of institutions. The first introduction of email into corporations played havoc with their organizational charts, when suddenly every employee

could email the boss directly. Email twisted the logic of firms still further when bosses realized that answering their own correspondence was more efficient than instructing a secretary to do it. Even the US military, which first sponsored distributed networks to enforce its own command-and-control efforts, now finds itself struggling to cope with the subversive consequences of its investment. On 11 September 2001, mobile phone calls to family and friends enabled a random assortment of passengers to thwart an Al-Qaeda takeover of United Airlines flight 93, while F-15s and F-16s failed to defend the Pentagon itself from attack. Two years later, the embarrassing circulation of Abu Ghraib photos on the internet revealed the army's inability to control the communications of its own troops.

In his 1946 essay 'As We May Think', pioneering engineer Vannevar Bush pinned the cause for the last century's two world wars on the fact that human intelligence had become separated socially and geographically. His vision of the 'memex', an electronic device that would give people access to large library of research material structured by 'links', heralded a global network of distributed information. The cyberspace of the twentieth century was a first draft of this vision, but today's real innovators in new media are taking that vision back down to the earth and all its beings. That cross-species intelligence is our past – and our future.

Pioneer of the cyberpunk movement in science
fiction and founder of the Dead Media Project
and Viridian Design Movement, Bruce Sterling
is one of the most influential and outspoken
voices of the digital age.

on innovation
bruce sterling

New media are so metaphorical. People struggle for words to describe the eruptions. Commonly our struggle is falsely framed as one single clean transition. There, *Old Media*, reeking of ink and celluloid – here, *New Media*, fast, clean, interactive.

Analog and digital. Old atoms just sat there inert. Bits are fast, flashy, weightless.

Spaces. Out here, actual space, where our meat survives. Through the desktop mirror there, noospheric immaterial cyberspaces.

One mighty heave. That'll hurt some, yes, but after that vast effort, surely we can rest. Scan the paper: text. Digitize the film: files. Art becomes graphics,

while music is soundfiles… We seem to be done now, but wait! A newer upheaval! The computers are a network! Transform the works into network-friendly formats! License and contain all that, so it doesn't ooze out like molten lava… Oh no, it got away! Flames are bursting from the previous business models! Musicians, filmmakers and journalists flee in all directions… No place is safe! *The Information Superhighway, the Net, the Web, is a pulverized Cloud…* There in our purses and pockets, tiny screens belch particulated metamedia, maps, snaps, links, tags, tweets and plug-ins…

Aren't we done yet? Can't we stop?

41.
0100101110101101.org

*Artist-provocateurs who mercilessly expose
the failings of public institutions*

Eva and Franco Mattes are here to remind us that some of the most shameful messes are perpetrated by seemingly upstanding cultural icons. Renowned for their masterful subversion of public media, the Italian artist-provocateurs behind the infamous 0100101110101101.org website have twisted satellite surveillance, internet technologies, feature films and street advertising to reveal truths concealed by contemporary society.

The young Barcelona-based duo describe themselves as 'reality hackers' – an apt moniker for these creators of media façades believable enough to provoke embarrassing reactions from governments, the public and the press. 0100101110101101.org first gained notoriety by registering the domain name Vaticano.org in order to undermine the 'official' website for the Catholic Church in 1998. When it took an entire year for the Vatican to notice, Eva and Franco Mattes realized that guerrilla marketing was a potent tool for drawing venal politicians, gullible journalists and sensation-seeking curators out into public view.

The Mattes are masters at exposing the private failures of public institutions. Having hijacked the Pope's home page, they went on a cloning spree of other 'closed' websites. These included Hell.com, an online experiment by artists keen to replicate the exclusivity of the offline art world by offering a 'private, parallel web'. An invitation to one of Hell's private openings, where artists displayed their works on terminals, was hard to come by – but the leap from the Vatican to Hell turned out not to be as hard as it might seem. Hell's gatekeepers periodically emailed exclusive passwords for temporary access to select guests, and one fell into the Mattes' hands. In a matter of hours they had downloaded most of the Hell.com site onto their own, public server. The gates of Hell were thrown open for all viewers; the artists of 0100101110101101.org had turned private art into public art, from exclusive property into common culture.

Over time the Mattes have turned from virtual to physical space for their subversion of public media. 0100101110101101.org caught the mainstream art world with its pants down with the case of Darko Maver, a reclusive Serbo-Slovenian artist who left gruesomely realistic puppets of murder victims in abandoned buildings and hotel rooms and died mysteriously in a Montenegrin penitentiary in 1999. Despite a string of posthumous shows culminating at the forty-eighth Venice Biennale, Maver turned out to be a fiction orchestrated by 0100101110101101.org. Their ersatz press releases fooled sensationalist curators into thinking the atrocities depicted in his photographs were sculptures. In actual fact, Darko Maver was a fictional creation, whereas the corpses were real. It was a shameful reminder that while artists are making 'shocking' artwork absorbed by the market, real violence is being perpetrated and ignored by a media-anaesthetized world.

In their most daring contestation of public space to date, the Mattes produced an ad campaign in 2003–4 for a giant Nike swoosh sculpture in the Karlsplatz public square in Vienna, proposing that the newly sponsored square be renamed Nikeplatz. With the help of Vienna's Public Netbase culture initiative, the Mattes erected an elaborate 'infobox' in the square, beckoning visitors inside to examine 3D models of the sculpture and a custom-designed sneaker, and to debate whether the city should accept the shoe company's Faustian sponsorship. Nike sued for 78,000 euros in damages, but the artists stared down the corporation and a court threw out the charges. In the meantime, scores of letters and emails appeared in the inboxes Austrian newspapers, prompting both Nike and the city government to declare the proposal a farce – and engage in a vigorous dialogue about the role of commerce in shaping public life.

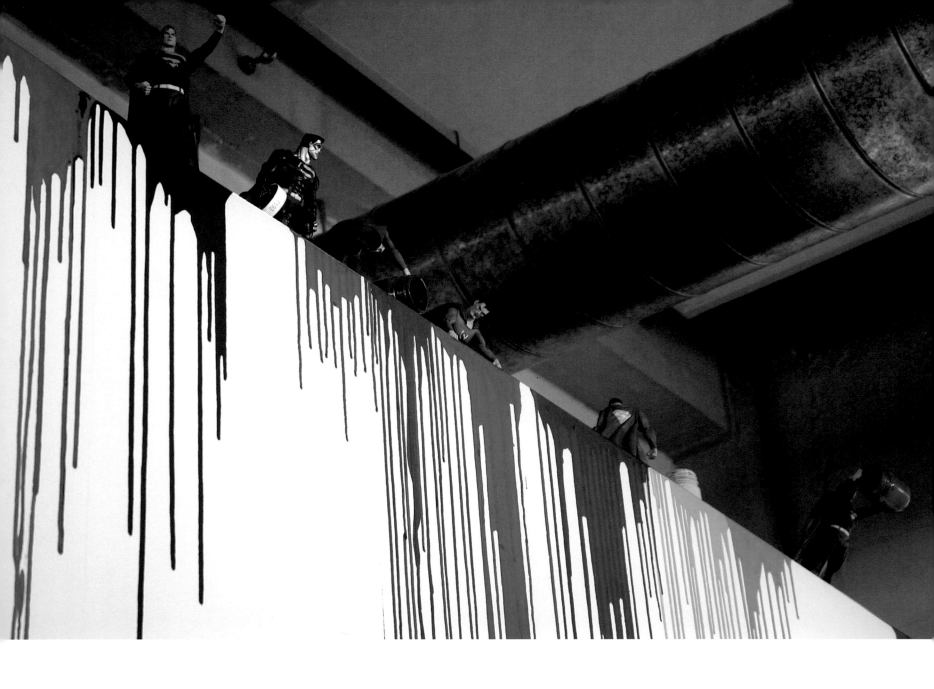

'It's Always Six O'Clock', MU Eindhoven,
the Netherlands, 2008
Installation with ready-made toys. Figures
from popular culture invade the high culture
space of an art museum.

This page (centre row and right) and opposite left
'It's Always Six O'Clock', MU Eindhoven,
the Netherlands, 2008
Familiar figures in an unfamiliar context.

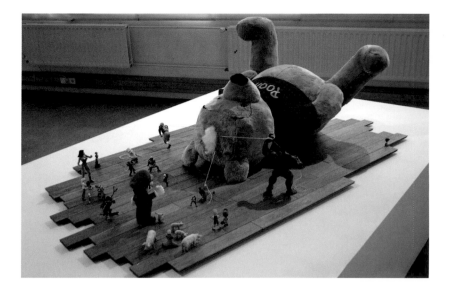

United We Stand, 2005
This poster was on view in cities throughout Europe,
the US and India. The marketing campaign for an
imaginary action movie, based on a heroic vision of
the European Union, produced a flurry of interest
despite the fact that the movie never existed.

An Ordinary Building, 2006
Plaque installed in Viterbo, Italy. In a country whose
economy depends on exploiting its history to attract
tourists, this unauthorized site-specific installation
drew attention to a building with no significant claim
to cultural importance.

Nike Ground, 2003
Unauthorized proposal and site-specific installation
for rebranding Karlsplatz, Vienna's most famous
public space, with corporate sponsorship, including
a rendering of the proposed 'swoosh' sculpture that
would occupy the centre of the square. Nike's attempt
to sue the artists was thrown out of court.

Augustinerstraße Karlsgasse Technische Universität

←— Karlsplatz —→ Otto Wagner Pavillon —→

42.
the yes men

Satirical pranksters who lay bare corporate and political hypocrisy at the highest level

The collapse of the global economy in 2008 showed how the 'free' licence given to multinational corporations in the previous decades had been anything but. Maybe we should have been paying more attention to the Yes Men, new media pranksters who create websites such as DowEthics.com and gatt.org to attract the attention of the business community and mass media, and then drop public relations bombshells when invited to comment on current news stories.

You can't tackle a global behemoth by exhibiting at MoMA, so the Yes Men manipulate internet publicity to hijack mass media. This lever was sufficient to get the attention of then-presidential candidate George W. Bush when he overreacted publicly to the Yes Men's veiled satire GWBush.com, commenting that 'there ought to be limits to freedom'. Four years later, during Bush's second candidacy, the Yes Men went on a tour posing as the group 'Yes, Bush Can!', encouraging supporters to sign a 'Patriot Pledge' to keep nuclear waste in their back yard and send their children to the Iraq war.

In the meantime, the Yes Men secured the domain name gatt.org and posted what purported to be the World Trade Organization's official site dedicated to the controversial GATT trade legislation. When an unsuspecting association of international lawyers invited a spokesman from gatt.org to speak at their conference, that spokesman declared that commerce had superseded democracy and voting was obsolete – an extremist agenda, but one that was nevertheless an extrapolation of the WTO's own policies. This high-level masquerade was remarkably simple to pull off: a straightforward domain registration created a credible, if illegitimate, pretext for a degree of public attention normally only accorded to government officials.

The Yes Men went further, announcing the dissolution of the WTO on gatt.org, and the repercussions were felt everywhere from BBC News to the floor of the Canadian Parliament. When their press release on DowEthics.com declared that Dow Chemical apologized for the Bhopal gas disaster, the company's stock share fell 4 per cent in just 23 minutes. The $2 billion loss in value was an artistic victory – a revelation of Dow's tenuous standing given its history of unethical and unsustainable business practices.

The Yes Men also collaborated on a fake edition of the *New York Times* that appeared on 12 November 2008 on the subways and streets of New York and Los Angeles. Each of the million copies was dated six months in the future, 4 July 2009, and trumpeted headlines such as 'Iraq War Ends' and 'Nation Sets its Sights on Building a Sane Economy' under the slogan, 'All the news we hope to print'.

Reactionary impulses are inclined to see these conjurings as rather dangerous – not because they threaten life and limb, but because they lift the ideological veil that screens current and unjust structures of power and wealth. When Bush declared in reaction to this innovative form of identity theft that 'there ought to be limits to freedom', he had been drawn into revealing an agenda that wasn't obvious from his official website. The Yes Men call their work 'identity correction'; in their words, 'Honest people impersonate big-time criminals in order to publicly humiliate them. Targets are leaders and big corporations who put profits ahead of everything else.'

'Yes, Bush Can', 2004
A spoof tour across the US promoting the presidential
campaign and jingoistic politics of George W. Bush.

THE USA PATRIOT PLEDGE ★ THE USA PATRIOT PLEDGE

YES. BUSH CAN '04

President George W. Bush

The Environment

Liberals whine endlessly about global warming and other so-called dangers. But they never mention that while scientists forecast global warming catastrophes for Europe, Japan and China — *our main economic competitors* — North America is projected to emerge *relatively unscathed*. Only George W. Bush has had the political courage to **embrace global warming as a useful weapon in the trade wars** that will define our future economic well-being, and that of our children.

THE USA PATRIOT PLEDGE

❏ I volunteer to live with the relatively minor consequences of global warming if it will mean increased competitiveness for American industry.

❏ I volunteer to help generate *more* greenhouse gases if it results in a competitive edge for my country.

Family Values

The bedrock of everything that is great about our great country is Christian family values. Liberals cannot accept this fundamental truth, as they are dependent on the votes of homosexuals, adulterers, socialists, and the like. We invite you to let Washington know your commitment to the values we share.

THE USA PATRIOT PLEDGE

❏ I vow to never divorce, and to stay with my spouse until death do us part, no matter how incompatible we may be.

❏ I vow to remain celibate unless married.

❏ I vow to never have an abortion, even if I am raped, am the victim of sexual abuse or incest, or if medical tests show my unborn child to have serious congenital disease or deformities. *[Please skip this item if you are not a woman.]*

❏ I vow to never use drugs developed from stem cell research, and to not allow my dependents to do so, even if they are suffering from a life-threatening illness for which there is no alternative cure.

The Economy

In economic matters, President Bush has shown his leadership by taking necessary — but sometimes unpopular — steps. It would have been *easy* to invest the budget surplus left over by Clinton in Social Security or national health care. President George W. Bush chose the more difficult path of running a *"profit-smart deficit."* Tax cuts favoring the poor would have been *easy*; President Bush took the hard road of tax cuts favoring the elite, because it is the elite who drive our economy. On economic issues more than any others, Washington needs to hear that **USA patriots stand behind President Bush!**

THE USA PATRIOT PLEDGE

❏ I support tax cuts favoring the elite, and I volunteer to pay more than my share of taxes to allow the elite to invest their money in our country's economy. *[Please skip this item if your annual income exceeds $400,000.]*

❏ I commit my children to pay for the wars America is fighting to guarantee their security.

Child's Name: Social Security Number:

❏ I volunteer to forfeit my social security checks when I retire in order to pay down the debt America is accruing.

Name: Social Security Number:

On behalf of **President George W. Bush** and **Attorney General John Ashcroft**, we thank you for your time, your patriotism, and your commitment to a great country and a great president.

Filling out this form in no way substitutes for nor guarantees against present or future obligations toward parties public or private, including the United States government.

TAKE THE USA PATRIOT PLEDGE

An online version of this Pledge is available at **www.YesBushCan.com/pledge/**

Please mail completed Pledge to Yes, Bush Can! PO Box 6245, Arlington, VA 22206

Top left
CNBC newscast, 2004
The Yes Men announced the dissolution of the World Trade Organization on CNBC.

Top right
Gilda, 2005
A mascot symbolizing the 'acceptable risks' in human welfare taken by corporations.

Above
'Yes, Bush Can', 2004
On online invitation to take the USA Patriot Pledge.

THE

YES MEN

HIJINKS BLOGS PRESS MOVIES BOOK LINKS FAQ CONTACT US

Update: Film to close True/False Film Festival, March 1

Identity Correction

Impersonating big-time criminals in order to publicly humiliate them. Targets are leaders and big corporations who put profits ahead of everything else.

Correcting identities...

✓ At conferences
✓ On television
✓ On the street

Latest Hijinks

VIVOLEUM

Exxon's Climate-Victim Candles
June, 2007 | Imposters posing as ExxonMobil and National Petroleum Council (NPC) representatives delivered an outrageous keynote speech to 300 oilmen at GO-EXPO, Canada's largest oil conference, held at Stampede Park in Calgary, Alberta, today.

WHARTON

WTO Proposes Slavery for Africa
November, 2006 | At a Wharton Business School conference on business in Africa, World Trade Organization representative Hanniford Schmidt announced the creation of a WTO initiative for "full private stewardry of labor" for the parts of Africa that have been hardest hit by the 500 years of Africa's free trade with the West.

HUD

HUD Secretary Jackson Announces New Direction for Agency
August, 2006 | Mayor Ray Nagin and Governor Kathleen Blanco speak. After pitching his administration's policies in the usual way, Nagin tells a long story in which truth and lie go skinny-dipping; lie steals truth's clothes, and truth chases after. "What you have is truth running naked after well-clothed lie."

SURVIVABALL

Halliburton solves global warming!
May, 2006 | "The SurvivaBall is designed to protect the corporate manager no matter what Mother Nature throws his or her way," said Fred Wolf, a Halliburton representative who spoke today at the Catastrophic Loss conference held at the Ritz-Carlton hotel in Amelia Island, Florida. "This technology is the only rational response to abrupt climate change," he said to an attentive and appreciative audience.

DOW ANNUAL MEETING

Politely requesting remedy
May, 2005 | Dow wasn't taking any chances at this year's Annual General Meeting (AGM). For the first time in Dow's existence, each and every shareholder was being searched on entry. A phalanx of guards had been hired, and a battery of eight metal detectors were set up at the entrance to the Midland, Michigan Center for the Arts. Every one of the two thousand shareholders who would show up had to empty pockets, check cellphones, get wanded. Old ladies had to let guards rifle through their purses.

more

Sign up for alerts!
Your e-mail:

[] GO!

Search

[] GO!

MORE INFO

The (first) Yes Men Movie

MORE INFO

The Yes Men Book
Disinformation Press

Booking Information
Bring the Yes Men to your school! Contact Liz Cole
(215) 888-1756.

Take what you want! We live in the **Creative Commons.**
Website by **Quilted.coop.**

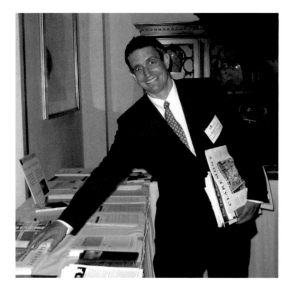

Yesmen.com
Their website in 2009.

At the Heritage Foundation, 2004
The Yes Men insinuated themselves into the Heritage Foundation, a conservative think-tank, to discuss policy with rising stars of the American right.

43.
miigam'agan & gkisedtanamoogk

Re-weaving community out of ancient tradition and twenty-first-century technology

Most new media innovations are speculative, offering a glimpse of a potential future; ingenuity and courage are then required to realize them. The innovations of Miigam'agan and gkisedtanamoogk also require ingenuity and courage, but are oriented in the opposite direction – they seek to recuperate the past in a practice that is not speculative, but lived.

One of the most persistent themes in new media art and activism over the past decade has been the re-weaving of community. By conjuring communities out of code, artists such as Alexei Shulgin, Heath Bunting and Ingo Günther have imagined societies free from the constraints of bodies and national boundaries. Perhaps the most radical is Natalie Bookchin's AgoraXchange, a 'serious game' based on four dramatic departures from traditional European laws: citizenship by choice; no inheritance; no state marriage; and no private land rights.

Bookchin's project is only the initial stirring in virtual space of the millennia-old tradition that Miigam'agan and gkisedtanamoogk are helping their people to revive. Citizenship by choice – the idea that state borders cannot restrict the movement of people or goods – means something different in real life, where Canadian border guards stopped gkisedtanamoogk from joining his Mi'kmaq wife and young children in

Burnt Church, New Brunswick, for six months because he insisted on a Wampanoag passport. No inheritance is a familiar notion in the communities in which Miigam'agan works; they have long recognized the corrupting energy that money brings. Miigam'agan's Mi'kmaq marriage is not recognized by either Canada or the US, and the home she and gkisedtanamoogk built has no private ownership status. However, one need only count the number of people coming and going from Miigam'agan's house in a single day to see how diminished a nuclear family is by comparison. Miigam'agan cares for her community as part of a dense trust network of other women, reviving the role traditionally played by a clan mother.

gkisedtanamoogk and Miigam'agan are survivors of genocide, living amidst their enemy's descendants. gkisedtanamoogk is a descendant of the Wampanoag people, who brought food to the Pilgrims, inviting them to the longhouse and its tradition of respect for all living beings, only to be massacred by them. He still employs Wampanoag technologies of trust-building, including giving *wampum*, traditional beads that he weaves by hand. As founders of the Anikwom Whole Life Center and Miingignoti-Keteaoag – a support organization and partnership of indigenous and Canadian

peoples – gkisedtanamoogk and Miigam'agan continue to share the traditions of their culture with neighbours and allies. Most recently they have launched LongGreenHouse, a partnering between their kin/clan-based networks (the longhouse), and practitioners of sustainable permaculture (the greenhouse).

gkisedtanamoogk has also begun to develop electronic networks. He has worked with fellow innovator Wendy Seltzer to craft the Cross-Cultural Partnership, has helped to devise a 'distant neighbor protocol' that establishes trust among disparate indigenous and colonial peoples, and has conducted a remote ceremony over video link between a lake in Maine and anthropologists at Cambridge University when the US government blocked his travel to England. Holding a 'remote ceremony' sounds like a contradiction to some Native ears; yet for gkisedtanamoogk, it was worth extending his ceremonial practice into this unfamiliar digital territory for the chance it provided to offer *wampum* to the English once again, in the hope that this time they might accept it in peace.

Untitled, 2008, ink on paper
gkisedtanamoogk says that 'in many traditions of indigenous nations of this land, Manitou, the Great Creator, is often depicted in such forms'.

The
Cross-Cultural Partnership

goals framework contexts contributors

What do electronic and indigenous networks have in common?

What is "responsible re-use"?

What does sovereignty mean outside of nation-states?

How can we build networks of trust in the 21st century?

Can democratic access to information be reconciled with the right to privacy?

The Cross-Cultural Partnership working group has brought together artists, scholars, and activists from over a dozen indigenous and developed nations for the purpose of answering questions like these. Its ongoing mission is to envision a legal and cultural framework for sharing connected knowledge in a way that is responsible and sustainable.

Top left and opposite below left
Cross-Cultural Partnership, 2006
In 2006, Miigam'agan and gkisedtanamoogk helped to found the Cross-Cultural Partnership, a protocol for sharing knowledge that respects its connections to people and to the land.

Top right
Wampum
Shell beadwork that is a traditional form of currency, used for securing treaties between nations.

Above
Connected Knowledge conference, 2006
Lucerne-in-Maine, location of the 2006 Connected Knowledge conference, where Miigam'agan and gkisedtanamoogk contributed to the launch of the Cross-Cultural Partnership.

Miingignoti-Keteaoag
The logo for the Miingignoti-Keteaoag, a support organization and partnership between indigenous and Canadian peoples centred on the misapplication of immigration laws to Wabanaki nationals. The symbol depicts the Spirit of Life.

Miigam'agan and gkisedtanamoogk, 2000
Miigam'agan and gkisedtanamoogk during Treaty Day observance in Miigam'agan's community.

Bioneers conference, 2008
The 2008 Bioneers conference at the University of Southern Maine. gkisedtanamoogk's ceremony at this international gathering reminded ecological activists not to ignore indigenous people's time-tested ways of living close to the land.

44.
natalie jeremijenko

Urban shaman working to reconnect the human and non-human inhabitants of the modern city

Natalie Jeremijenko is a shaman, which is to say she treats public health not as a matter of individual afflictions, but as an imbalance in the relationship between nature and culture. Shamans often live on the edge of a village, with a foot in each world. Jeremijenko holds office hours on a raft made of disposable bottles on the Hudson River, literally straddling the roles of New York artist, naturalist and community activist. She gave up a post in Yale's engineering department to design contraptions that refocus our attention on the sunlight, air, water and creatures that surround and sustain us.

Jeremijenko often appropriates the high-tech tools of our imbalanced society for her shaman's dilly bag, as when she highlights wiki edits to expose corporate whitewashing (in the online resource 'How Stuff is Made') or deploys sensors to track suicide jumps from the Golden Gate Bridge (the 'Despondency Index'). But her latest work looks beyond the interpersonal intelligence of the web to the interspecies intelligence of the web of life: a shaman's 'peer-to-peer' network includes bugs, beasts and buds.

Jeremijenko's Environmental Health Clinic looks to re-forge lost connections between humans and their environs, while her *OOZ* projects (zoo spelled backwards) extend the concept of the zoo to unexpected settings and species, and seek to create new models for interaction between humans and their fellow creatures. Considering a mousetrap, like any good engineer, she tried to design a better version – in her case, by imagining one suited to a rodent exquisitely adapted to our physical and chemical habitat. Instead of cheese, the mice were lured by the same antidepressants that help palliate the misery of humans eking out cramped lives: jelly beans, alcohol, Zoloft and Prozac. (The mice preferred vodka to gin.) If they really needed help, the mice could trip a switch on a mobile phone to dial the health clinic. Her cross-species cookbook, meanwhile, exploits the fact that people and geese share many tastes in common – an unexpected sensory connection between the two species.

Equally sensory, if less appetizing, are Jeremijenko's face masks, equipped with a greyscale measure of elemental carbon in nearby air, or the operation of her feral robotic dogs. Jeremijenko shows schoolchildren and college students how to rewire these mechanical canines to sniff out toxins in landfills and other neighbourhoods. Jeremijenko's mechanical mutts are more than entertaining toys. They roam across a landscape populated by animals real and invented, contributing to a healthier planet.

Perhaps Jeremijenko's best fieldwork takes place not in remote jungles or even in landfills, but on the sidewalks of New York, where her 'No Parks' reclaim spaces that cars aren't allowed to park in by transforming them into autonomous green zones. City dwellers rarely see the non-human citizens of the neighbourhoods they live in; but, if they encourage soil and shrubbery instead of hot concrete, they'll see butterflies again.

Jeremijenko envisages the island of Manhattan as an immense zoo, populated with bats, pigeons, squirrels and many other creatures that cohabit with humans. She invites ordinary citizens to become park rangers of this 'Decentral Park'. Indoors, meanwhile, Jeremijenko suspends plants below light fixtures powered by a solar awning, growing indoor plants via external light. It's one thing to install a solar panel just to run shiny gizmos, but another to trade electricity for the oxygen generated by bringing other species into your home. For Jeremijenko, nature isn't 'out there' in a rainforest in Brazil or behind bars in Central Park, but always in our midst, waiting for us to recognize and rejoin its ecosystem.

OOZ, Inc. (… for the birds), 2006
A high-density bird cohabitation on the roof of
Postmasters Gallery, New York. This experimental
interaction with the birds of New York City includes
multi-family bird dwellings, water systems and a live
webcam to the human gallery space.

WHOOZ, 2008
Jeremijenko and Jeffrey Warren's WHOOZ project
brochure asks New Yorkers to take on the duties of
'Deputy Park Rangers' and report on ubiquitous
urban creatures such as squirrels and pigeons across
Manhattan, or 'Decentral Park', via SMS.

WHOOZ.org • Manhattan National Wildlife Refuge

☐ Wilderness area

☐ Outside park territory

Stay back from edge

Waterfowl

North ↑

Sleeping shelter

OUTSIDE PARK BOUNDARIES

Partially submerged wreck

Trash dumpster

Ranger station

Bat Interface

Strollers

Fishing pier

Scenic viewpoint

0 ——— 2 Kilometers
0 ——— 2 Miles

Shared territory

The variety of wildlife on Manhattan shares both space and resources with human populations. The WHOOZ mapping project aims to identify zones of overlapping usage between human and animal populations.

The WHOOZ map does not attempt to accurately map animal populations, but rather the sites and spaces in which humans interact with animals. In a sense the mappers are mapping themselves as they interact with animals.

Ultimately we hope the project will increase awareness among humans of the other inhabitants of this beautiful park.

> START A TOUR:
> ## SAFARI
> St. Marks
> Place

Safari Tours

As mapping data is collected, it will be made available to park visitors as SAFARI TOURS. To begin a safari, follow the directions above. You will receive either recent wildlife sightings near your current location, or nearby locations where wildlife is likely to be based on past sightings.

This feature will be activated as soon as there is sufficient data in the system.

WHOOZ Park

The island of Manhattan has been declared a National Wildlife Habitat (Decentral Park), and its flora and fauna are now being studied by citizen park rangers, including you.

All citizens are empowered with the rights and responsibilities of official Deputy Park Rangers, and are invited to participate in gathering information about the ecosystems which make up this beautiful park.

As you conduct your investigations, use the badge and ID card below to identify yourself as a Park Ranger to others. Feel free to deputize anyone you meet.

Wildlife Mapping

WHOOZ is actively engaged in mapping animal populations in Manhattan, and anyone with a cellphone can participate in mapping. WHOOZ is particularly interested in **BATS**, **INSECTS**, **RATS**, and **PIGEONS** Use these four keywords to submit sightings to WHOOZ. Learn more at WHOOZ.ORG

SIGNUP:

> USE SMS TO TEXT
> ## FOLLOW
> WHOOZ
> TO
> # 40404

START MAPPING:

> SEE BATS?
> ## BATS 8th Ave
> & 28th St.
> Manhattan
>
> PIGEONS?
> ## PIGEONS
> Union Square

WHOOZ - Jeffrey Warren in collaboration with Natalie Jeremijenko's OOZ project

Jeremijenko's latest work looks beyond the *interpersonal* intelligence of the web to the *interspecies* intelligence of the *web of life*: a shaman's 'peer-to-peer' network includes *bugs*, *beasts* and *buds*.

Top left and centre
Environmental Health Clinic, Ghent, Belgium, 2009
Jeremijenko held consultations with passers-by anxious about environmental issues.

Top right and above left
Facemask, San Francisco, 2004
Cyclists wear a mask with a greyscale measure that indicates the presence of pollution.

Above left and right
Environmental Health Clinic, New York, 2008
This clinic was conducted by Jeremijenko from a raft made of recycled cans and outfitted with a water distiller and solar panel for a laptop.

OOZ

The ongoing *OOZ* project seeks to create new models for interaction and cooperation between humans and other species, while raising awareness of pollution and climate change.

Other Nutrition FAQs #11
Why are there 350 industrials chemicals in my breast milk? How did they get there?

Other Nutrition FAQs #7
Why are the Hudson River Fish and Frogs on Antidepressants?

what would a fallout **shelter** for the **climate** crisis look like **?**

No Park, New York, 2008
Micro-parks of mosses and grasses planted in 'no parking zones', Jeremijenko's *No Parks* absorb storm water run-off, stabilize soil, capture water for nearby trees and dilute dog urine.

45.
wendy seltzer

Fashioning new legal frameworks for creative collaboration in the digital age

By its very nature, law is rarely the subject of innovation; more often, law struggles to catch up with the changing times. This lag is especially obvious in intellectual property litigation, where lawyers judge, for example, file-sharing networks according to an eighteenth-century yardstick (copyright) and gene manipulation according to a fifteenth-century one (patents).

Wendy Seltzer, by contrast, is a lawyer of the twenty-first century. One of the legal eagles behind Creative Commons, the Electronic Frontier Foundation (EFF) and Harvard's Berkman Center for the Internet and Society, Seltzer began her graduate work as a disciple of cyber-law guru Larry Lessig and has gone on to blaze new trails of legal innovation. For example, she has worked on the EFF's Endangered Gizmos campaign, a kind of endangered species list for everything from file-sharing software to digital-to-analogue converters – all either threatened or already killed off by industry lawyers keen on stifling innovation at odds with their business models.

Borrowing a well-known legal term for smothering creativity without ever going to court, Seltzer's Chilling Effects website catalogues DMCA (Digital Millennium Copyright Act) cease-and-desist letters received by creators and critics of all kinds, from writers of *Harry Potter* fan fiction to critics of Scientology to programmers trying to make their Sony robotic dogs dance. Originally conceived by Seltzer, the project is now supported by half a dozen law clinics across the US, and includes 'weather reports' on the shifting legal status of 'Fair Use', as well as practical tools such as a 'DMCA counter-notification' generator.

Creative initiatives like the Endangered Gizmos campaign and chillingeffects.org tend to reinforce the battle lines already staked out between the copyright maximalists of old media and the 'information wants to be free' advocates of the digital age. Seltzer, however, has moved beyond this stale dichotomy to ask how the free access to information required for a democratic society can be reconciled with the privacy rights of electronic citizens – a question that looms large in a world of gene patenting, global positioning satellites and warrantless wiretaps. For solutions she has looked to two very different sources. First, to indigenous peoples, who share medicines, songs and stories in ways that are neither fully open nor closed, but that reinforce the social fabric of their communities. And second, to the concept of 'partnership' from business law, and its implication of responsibilities beyond the letter of the law. Working with anthropologist James Leach and other members of the Connected Knowledge working group, Seltzer drew from these sources to devise the Cross-Cultural Partnership, which injects the ethics of partnership law into the debate over intellectual property to encourage responsible reuse and, in the best practices, to generate trust that can lead to ongoing cooperation and new forms of creative kinship.

The Cross-Cultural Partnership can help organizations, businesses and individuals to build bridges of ethical behaviour across the cultural clashes that increasingly divide our globalized society: between drug companies and rainforest shamans over medicinal herbs; between artists and technologists in art and science collaborations; and between libertarians and communitarians over control of software.

By finding novel ways to protect the legality of innovation and nourish the collaborations it requires, Seltzer acts as a meta-innovator, ensuring a healthy legal and cultural climate for innovation at large.

Chilling Effects
A chart showing the number of copyright-related cease-and-desist letters issued by country. Using data from the Chilling Effects repository (approximately 2001–9) and created with IBM's Many Eyes software.

Russia

Switzerl...

Australia
123

USA
7,149

Spain
58

Italy

China

France
137

Netherla...
59

Japan
364

Argentina
131

Eur...

Belg...

So...

Uk...

Germany
416

India

Sing...

Brazil
96

Den...

UK
1,251

Canada
198

Opus (Radio Medicine) by Radio Healer, 2003.
Album cover design by mac n. zie and Randy Kemp
The performance duo Radio Healer, consisting of
Latino electronic musician Cristóbal Martinez and
Choctaw/Yuchi Creek flautist Randy Kemp, are
working with Seltzer as part of her Cross-Cultural
Partnership project.

Endangered Gizmos
The Electronic Frontier Foundation's 'Endangered
Gizmos' list in 2009. The list details everything from
file-sharing software to digital-to-analogue converters
that is under threat or or has already been killed off
by legal action.

Chilling Effects
Statistically common phrases found in
cease-and-desist letters, from the Chilling
Effects online repository.

Chilling Effects

Visualizations of the relative frequency over time of copyright infringement notices sent to blogs versus websites (top and bottom); and those sent to websites as a whole (centre).

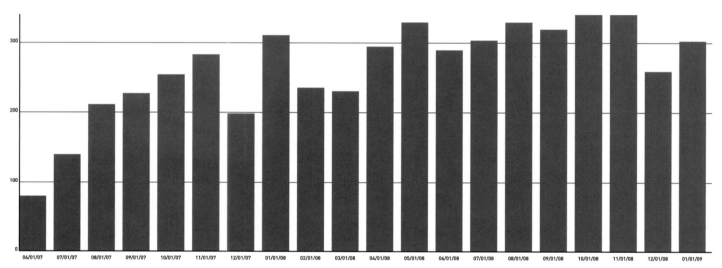

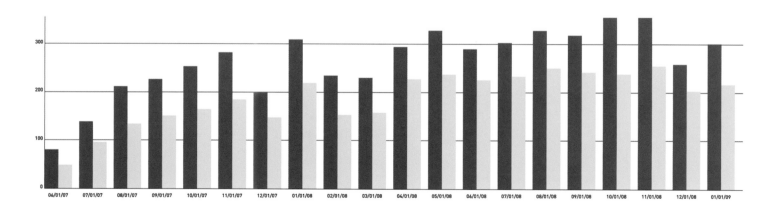

46–50.

josephine mecksepe

nicole eisenman

lindsay seers

delaine le bas

michael patterson-carver

visual arts

emma dexter

introduction

emma dexter

Director of Exhibitions at Timothy Taylor
Gallery, London

Over a decade ago, cultural practitioners wondered whether the internet would herald a new democratic landscape for both maker and consumer: as dematerialized art arrived at last, a screen-based electronic art would be consumed at home, interacted with via user groups and forums, finally sounding the death knell for the unique object. This scenario raised the spectre of redundant and deserted museums and galleries, as visitors stayed home privately consuming art on screen, or moved around the city with art directly streamed to their new mobile telephones. Interactivity became the new buzz concept – the point where technology, audiences, museums and art could coalesce: online groups could create shared projects, while visitors pressed buttons to change random electronic elements in displays, thereby 'altering' the artwork.

With hindsight, we know that new technological developments do not necessarily replace other forms, media or indeed technologies. The advent of photography failed to make painting or drawing obsolete; in fact, by satisfying the impulse for realism it prepared the ground for avant-garde developments at the turn of the twentieth century. Ironically, while the internet was becoming ubiquitous in our own time, the period also witnessed a resurgence of interest from critics, collectors and curators in traditional media such as painting, drawing, ceramics and plinth-based sculpture. Internet art *per se* has thus far failed to make its mark: audiences still prefer direct encounters in museums, galleries and homes. Rather than becoming a ubiquitous gallery, the internet has become a universal library.

The use of the internet as a marketing, educational and access tool, as well as an organizing structure for art production and consumption,

has been promoted: it supplies information about artists, venues and exhibitions; it hosts video and virtual tours; and it delivers free art-historical information on collections and individual works. It has not materially changed the nature of selling: internet art sales companies failed during the dotcom slide, while commercial galleries mushroomed globally over the same period. Visitors and collectors use the internet to research artists, plan visits to galleries and museums, and track auction and sales records, but it can never replace the object.

Today, the dominant narrative of the globalized contemporary art world, fuelled economically by hypercapitalism and speculation, is characterized by a small group of nomadic curators presenting a similar group of internationally validated artists in museum exhibitions and biennales, whose works are bought at international art fairs by an ever-increasing elite of collectors. However, recent economic turmoil has slowed the market, and questions are gathering about the sustainability of the system if both financial and climatic changes are forced. If oil prices rise steeply and governments take draconian measures to reduce harmful emissions, if commodity shortages lead to oil and water wars, what will the effects be on the art market? Art fairs and biennales have become dependent on international exhibitors and visitors for their success. Will we see instead the rise in status of local exhibitions and events, as only the super-rich are able to travel regularly? As the art world has grown, it has attracted celebrities, billionaires and speculators; exhibition openings have become part of the international party circuit, offering amidst the glitz and glamour proximity to high-status cultural objects. The art world is unlikely to react by shrinking back to what it was in the 1970s: too many people have been touched by contemporary art for that to happen. What this new landscape can offer is a chance for reflection and rebalancing after the volatility of the past few years.

The legacies of Joseph Beuys and Andy Warhol have dominated art discourse and production over the last forty years. Recently, as the art market has boomed, Warhol's influence has been predominant, with its celebration/ironic embrace of the tropes of advanced capitalism and industrialization, its zenith represented by Damien Hirst's triumphant Sotheby's sale in September 2008. In the future, as the world adapts to changes in behaviour, business, travel and consumption, the art world may see a resurgence of Beuys's influence: political art, performance and process-based practice are currently on the rise, while art fairs have evidenced a move away from jewel-encrusted 'bling' art on display.

Perhaps *visual arts practice* in the twenty-first century will *hybridize* aspects of modernism, post-modernism and *digimodernism*, and combine in works that are both global and local, *nomadic and rooted*, sustainable and in some loose sense *democratic*.

The cultural critic Alan Kirby has dubbed the present condition digimodernism: a user-centred, text-based, electronic world, which gives the user a sense of power and agency as they author their own unique, customized path through a global internet, play live video games with fellow users on the other side of the world, or affect television-show outcomes. Alternatively, the manifesto accompanying Nicolas Bourriaud's 2009 Tate Britain exhibition 'Altermodern' defined altermodernism as a set of terms describing digital-age culture, characterized by mediumlessness, nomadism, precariousness, mapping, clustering, sustainability and globalism. As such, the key characteristics of post-modernism – such as site-specificity, appropriation, hybridity, impermanence and referentiality – are swept away. However, what Bourriaud is really describing is not the artwork itself, but instead the prevailing conditions/mechanisms surrounding it – how criticism is marshalled, how art is marketed, publicized, researched and sold, how art and exhibitions are organized and produced, and how the research systems and networks set up by artists function. In fact many of the works selected by Bourriaud reflect a keen sense of history, place, subjectivity, specific political, cultural and historic conditions and narratives – as well as employing diverse and hybrid voices and materials.

Perhaps a time-lag exists between a key technological breakthrough and the art made with and in response to it. Or, rather, perhaps art practice will react to the current disparity between the sophistication of digital communication and the vacuity of much of the content by becoming a locus for philosophical layering and complexity, as well as providing authenticity and primary sensual, somatic, emotive and

intellectual experiences. Perhaps, in an authorless, Wikipedia world, visual arts practice will hybridize aspects of modernism, post-modernism and digimodernism, so that authenticity, materiality, spirituality, history, appropriation and creolization will combine in works that will necessarily be both global and local, nomadic yet specifically rooted, sustainable and in some loose sense democratic.

Demand for primary encounters with visual art shows no sign of abating. Both virtual and real visits to museums and their websites have soared. As the century progresses, however, museums will need to adapt to changing demographics. Major cities will face an ever-increasing diversity of languages and ethnicities; large metropolitan museums in the West are already working hard to increase their holdings of Chinese and Indian contemporary art, reflecting these locations' coming global economic dominance. In line with current segmentation of markets and interest groups, museums may also start to create sections designed to address distinct visitor groups – zones for younger or older visitors, label-free zones, zones with the addition of music – or alternatively they might simply become havens of contemplation, freed as much as possible from the digital realm. Perhaps in line with the flattening of culture stimulated by de-hierarchized, internet-based information, museums may introduce greater transparency about display or acquisition choices. They may also find ways of integrating the work of non-professionals, outsiders or children with those of the currently accepted canon, creating displays that reflect the complex nature of both audience and art practice.

Privatization of the cultural realm is also likely to grow exponentially. While many collections overseas are open only by appointment, some private galleries in the UK are intriguingly following a public-sector-style model, embracing community access and educational events. New private ventures such as 176 and the David Roberts Foundation often feature curatorial programmes that eschew the product-based presentations normally expected of galleries rooted in private collections, and instead mount projects that espouse the very latest in collaborative and performance-based practice.

The 1990s were characterized, with London taking the lead, as a dynamic period for artist-run spaces, colonizing the run-down warehouses that were relics of former industrial times. Now high property prices have driven artist-run ventures from city centres, and private museums and commercial galleries have taken their place. Artists have instead focused on time-based projects, putting on performance club nights and screenings, and piggy-backing on other projects to present multi-layered,

multi-authored programming. This and other manifestations of hybridity between public and private sector will continue unabated. The art world, in all its diverse manifestations, will continue to grow, becoming ever more complex as access and information about contemporary practice, as well as art history, continue to spread; as audiences become more segmented; and as sites catering for specific-interest groups proliferate.

Nevertheless public museums and art spaces will continue to be at the forefront of museological developments: their role as cultural barometers interfacing with public policy remains key. Arts centres such as the Pompidou in France, Montehermoso in Spain and the Whitechapel in the UK have current and future programmes that heavily feature women artists. The process of re-writing history will continue, as museums attempt to shore up holdings of works by 'minority' artists that they failed to acquire earlier. Many private collectors have led the way here, creating collections focused specifically on women artists or black artists.

Innovators will come in many forms. As digital culture creates mobile, ephemeral flows and drifts of information, visual arts practice will undoubtedly mirror and feed off it, but it will also provide an alternative, becoming an important locus for connection with stasis, materiality, permanence, tradition and history. Throughout the twentieth century, the accepted canon has centred on traditional media, despite huge technological developments: Francis Bacon's work is rightly hailed as a pre-eminent expression of post-war existential angst, but it does not specifically reference the white heat of technology, the space race or Cold War science.

Humble materials, simplicity of means, connection with lived experience will continue to draw audiences. The inherent humanity of the drawn line, the painted canvas, the hand-carved figure, the unique finger-printed ceramic: these long-established media that act as a distillation of creative human history will flourish alongside film, photography and other electronic media that reflect the flux of the contemporary scene. Disaffection with mainstream political processes and a loss of faith in institutions suggest that art can remain a place for dialogue and discussion, as audiences seek honesty and authenticity from artists impelled to critique society. As a result, art about art, or art about commerce, will have less influence, while work springing from genuine fervour will be in the ascendant. The practitioners who make such work, its awkward poetics combined with a fierce engagement, will bring us sharply back to confront what is most engaging in art – an encounter with a unique and passionate voice that helps us to reconnect with our own humanity, and in future we will need that more than ever.

on innovation

hans ulrich obrist

Alteration? Change? Novelty? Introduction? Departure? Variation? *Innovation means a new way or practice or process of doing something.*

Innovation requires specific rules, which brings me to Oulipo, a literary group that functions like a permanent research laboratory for innovation by inventing new sets of rules for the production of literature. These games of language draw upon the arithmetical ideas of Raymond Roussel and produce what Oulipo protagonist Harry Mathews calls 'absolutely unimaginable incidents of fiction'.

François Le Lionnais, co-founder of Oulipo, emphasized the term 'potentiality' – which he preferred to experimental – meaning the attempt to find something that has not yet been done and which could yet be realized. Potentiality leads us to

Unbuilt Roads, my own project which arose out my obsession with unrealized artists' projects. This has to do with innovation not only in the future and present, but also the past as a possible tool box for innovation.

For every project that is carried out, hundreds of other proposals by artists, architects, designers, scientists and other practitioners around the world remain unrealized and invisible. Unlike unbuilt architectural models and competition submissions, which are frequently published and discussed, *public endeavours in the visual arts that are planned but not carried out ordinarily remain little known. But I see unrealized projects as the most important unreported stories in the art world.* As Henri Bergson showed, realization is only one possibility which is surrounded by many other possibilities that are worth knowing about. There are many amazing unrealized projects out there, <u>forgotten projects</u>, <u>misunderstood projects</u>, <u>lost projects</u>, <u>desk-drawer projects</u>, <u>realizable projects</u>, partially <u>realized projects</u>, <u>poetic-utopian dream constructs</u>, <u>censored projects</u>. It is important that certain roads are taken in an active and dynamic way, not in a nostalgic way, in order to transform some of them into propositions or possibilities for the future.

46.
josephine meckseper

Anti-capitalist, anti-consumerist visionary with a sharp eye on power and the people

Josephine Meckseper collapses the visual and aesthetic codes of consumerism and high fashion with the symbols and insignia of the political realm in works that implicitly critique the Western capitalist system. She uses film, video, photography, painting, graphic design, sculpture and installation to ape the seductive power of shop windows, display cases, posters and advertisements. 'I'm trying to create a new and contemporary vocabulary, one in which politics, equal rights and readiness to change have a place.'

Growing up in a leftist artistic family and community, Meckseper excoriates both her native Germany as well as her adopted home in the US. In *CDU-CSU* (2001), she creates a fashion-shoot allegory of contemporary Germany under Angela Merkel, raising issues of nationalism, feminism and consumerism: perfect Aryan blondes, sporting CDU-CSU necklaces (after Germany's two conservative sister parties), lounge in conspicuous luxury, while a working-class maid stands in the background. Meanwhile, *USA* (2007) satirizes the contemporary US predicament: a tottering tower of display furniture presents the cheap tools of oblivion – martini glass, disco ball and necklace mounted above a newspaper reporting the bloody after-effects of the Iraq War.

The way in which genuine political protest has been co-opted by fashion, advertising and the culture industry in order to convey youth, energy and authenticity is another issue raised by Meckseper in numerous photographs, videos and installations. *Untitled Berlin Demonstration* (2002) reveals the theatricality of demonstrations: the staging, the orchestration, and the costume and dress codes of police and protesters alike. In a similar vein, *Pyromaniac 2* (2003) cheekily styles the pouting poster girl for radical political action and revolt. In *March for Peace and Justice* (2007), Meckseper's overriding aesthetic treatment of the subject suggests the manipulation and control of people power, and its reduction to merely decorative and lifestyle elements.

In *Blow Up (Tamara)* (2006), Meckseper uses her glittering, reflective vitrine of discordant objects and images to expose the contradictions and absurdities of consumerism. Beautiful women model frumpy GDR-style underwear, signifying a utilitarian dead-end for fashion; nearby pan scourers and orthopaedic supports are treated with the reverence normally reserved for handbags or jewels. Meckseper uses the Situationist technique of *détournement* to achieve her ends, adopting and then twisting the aesthetic tools and codes of unbridled consumerism to undermine its power.

Meckseper suggests her methodology demonstrates Martha Rosler's observation that consumer society objectifies the person and personifies the object. Recently, her targets have included the car industry and petrochemicals lobby, exposing once again how codes of power are used by advertising to sell the dream. Meckseper regularly uses large mirrored plinths – the minimalist aesthetic updated to reveal the effect of an endless commodity surplus, created by any reflective surface.

Since the end of the Bush era, and the arrival of global financial turmoil, Meckseper's work appears not just relevant but prescient. Her naked dummies, empty signs, cheap goods and utilitarian clothing worked as satires on rampant consumerism, but they now suggest the flip-side: a future of enforced thrift, self-sufficiency, commodity shortages and food riots. Indeed, they depict the very fragility of our entire economic and political system.

USA, 2007
Mixed media sculpture on Plexiglas cube,
74.6 x 21.8 x 21.6 cm (29⅜ x 8⅝ x 8½ in.)

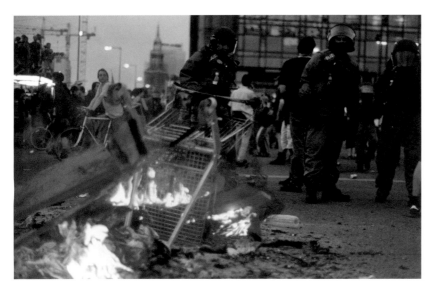

Top left
Untitled (Berlin Demonstration, Fire, Cops), 2002
C-print, 76.2 x 101.6 cm (30 x 40 in.)

Top right
CDU-CSU, 2001
C-print, 106.6 x 165.5 cm (42 x 65 in.)

Above
Untitled (Berlin Demonstration, Smoke), 2002
C-print, 76.2 x 101.6 cm (30 x 40 in.)

Right
Pyromaniac 2, 2003
C-print, 101.6 x 76.2 cm (40 x 30 in.)

Meckseper uses her *discordant* objects and images to expose the *contradictions* and *absurdities* of consumerism.

Blow Up (Tamara), 2006
Mixed media in vitrine (installation view),
208.3 x 243.8 x 68.6 cm (82 x 96 x 27 in.)

Bottom
Installation view featuring, left, *Ten High*, 2008, Plexiglas platform, chrome mannequins, walker, cane, bottle of whisky, Bible, ashtray with cigarettes, broken mirror on wooden panel, poster mounted to aluminium, mixed media on canvas, aluminium sign, T-shirt, tie and artificial vomit on Plexiglas, 350.5 x 350.5 x 350.5 cm (138 x 138 x 138 in.)

Below
Installation view featuring, left, *Fall of the Empire*, 2008, mannequin head in plastic, metal bottle rack, feather duster, metal display stand, flag, bath mats, mounted poster, chrome angel sculpture, vase, 123.2 x 243.8 x 68.6 cm (48½ x 96 x 27 in.) and, centre, *0% Down*, 2008, black-and-white video, sound, transferred to DVD, 6 mins

Below
Installation view featuring, front, *Negative Horizon*, 2008, chrome car rims on mirrored display case, 129 x 240 x 120 cm (50¾ x 94½ x 47¼ in.)

Above
Untitled (Hammer and Sickle), 2005
Chrome-painted tools, mirror on wood,
78.7 x 121.9 x 121.9 cm (31 x 48 x 48 in.)

Above
*March for Peace, Justice and Democracy, 04/29/06,
New York City*, 2006
Black-and-white and colour 16 mm film transferred
to DVD, sound, 7:20 mins

47.
nicole eisenman

Satirical painter of biting allegories that critique contemporary society

Nicole Eisenman is a devastating satirist who uses paint to eviscerate contemporary society and its ills. She is not ashamed of the old-fashioned medium of painting, and even less of the notion of allegorical painting. Previously known for her large-scale murals and cartoon-style works on paper depicting all-female communities of lesbian amazons, replete with diverse erotic and scatological details, in her more recent work Eisenman has taken a more universal and existential focus.

Within the context of American contemporary painting, often obsessed with popular culture and slackerish aesthetics, Eisenman has a distinctly European outlook, modelled on the grand trajectory of European history painting. Her work critiques contemporary society, but in paintings that combine the dream-like, visionary qualities of Edvard Munch or Pierre Puvis de Chavannes with the satirical observational narratives of Pieter Bruegel the Elder or William Hogarth.

This dyspeptic world view relates to the artist's personal and professional mid-life crisis: she has commented that 'it is healthy to look at sadness in the world, and in yourself, and to dwell on it for a little while'. In a disarmingly frank hand-drawn diagram from 2007, entitled *This Explains Everything*, she reveals the influence

on her work of a mixture of intersecting influences and anxieties, from German Jewish culture and history, to fear regarding age, parenthood, her career and global warming.

As in all good allegorical painting, every detail exists for a reason. In *Captain Awesome* (2004), a muscled, hirsute male stands in his backyard brandishing a corn-cob bat and a phallic upraised thumb, signalling that all is well. This painting can't be about anywhere but America – the picket fence, the baseball cap, the wooden barn and weathervane, the grain silo. This is Eisenman's parodic view of life outside the big cities. But this happy symbol of alpha masculinity seems unaware of the fact that he is standing up to his ankles in mud or worse, and the single leaf hanging from the tree sounds an ominous note. Eisenman presents us with an allegory of the current state of the USA – lacking self-awareness, dumbly optimistic, sinking unwittingly into the mire, in a 'perfect' yet doomed world.

Eisenman's recent works mix contemporary and historical references to achieve a generalized rather than specific point of reference. In *Beasley Street* (2007), inspired by the verse of the same name by punk poet John Cooper Clark, Eisenman depicts a Montmartre-style street scene of urban decay and degradation,

conflating Dickens's Oliver begging in the foreground, with rows of prostitutes and drug dealers, and less predictably Hollywood matrons in wheelchairs. In *Coping* (2008), she presents a European-style town centre, in fact based on her hometown of Scarsdale, New York, in which the inhabitants doggedly go about their daily business, oblivious to the fact that they are up to their waists in excrement. Again, the figures are disparate and disconnected – absorbed in their own thoughts, isolated in their predicament.

Eisenman creates a form of post-history painting, one that exists beyond historical specificity. She strives to achieve a simultaneity of disparate influences and traditions, and thus makes memorable and melancholy metaphors for the state we are in.

Captain Awesome, 2004
Oil on canvas, 129.5 x 101.6 cm (51 x 40 in.)

Beasley Street, 2007
Oil on canvas, 165 x 208.5 cm (65 x 82 in.)

Coping, 2008
Oil on canvas, 165 x 208.5 cm (65 x 82 in.)

48.
lindsay seers

Autobiographical practitioner who becomes a camera and projector to explore the role of the artist

Narrative, the nature of the self, the role and persona of the artist, photography and its relationship to truth, imagination, memory and history are the subjects of Lindsay Seers' practice, which uses photography, film, installation, text, performance and drawing to create inconclusive and oblique narratives and allegories.

Seers' entire œuvre is one continuous autobiographical narrative – starting with using her own mouth as a camera. This act, which joins the body of the photographer directly with the photographic object, suggests the ingestion of the world, and becomes the starting point of Seers' journey as an artist. In *Vampire Camera (Auto-cannibal Series)* (1999), we observe her in the act of being a camera, creating a self-portrait with the aid of a mirror. She uses her lips as the shutter, controlling the play of light on the photographic paper held in her mouth. These auto-camera images literally embody the allegory of the artist's relationship to photography and the self, reflecting back on each other in a solipsistic loop. This notion of auto-cannibalism (hence the fangs) grew from the eerie blood-red hue of the resultant photographs, caused by the passage of light through the cheeks.

Gothic 2 (Optogram Series) (2002) reads like the scene of a crime. The camera/artist lies on the ground like a corpse, watching a gloomy gothic house, while the looming figure of a man blocks out the sky. As the artist herself has acknowledged, this act of becoming a camera is the source from which all her work springs: 'the vampire, the ventriloquist, the possessed, all refer in some senses to the problematic relationship between subject and object, the fusion and confusion of them.'

Developing further the notion of mouth as receptor, Seers has become a ventriloquist, using her mouth to emit another's voice and thoughts, and continuing the metaphor of throwing the voice or the image. This necessitated the creation of various dummies/alter egos, most notably Madame Kwok – as in *Madame Kwok Performance Marseille 1* (2004) – a Siamese twin fortune-teller of Chinese-Mauritian origin, whose dire predictions are heard in *Extramission 6 (Black Maria)* (2009).

As in other works, *Extramission 6 (Black Maria)* employs a documentary mode, with an apparently factual voiceover, but this leads into mysterious and fantastical territory. Based on testimony from her mother and a psychologist, it tells how Seers did not speak until she was eight years old, due to her eidetic memory – which vanished once she acquired the power of speech. This provides the justification for

Seers becoming a camera – a role that she later transmutes into that of projector, literally embodying the Platonic vision theory of the active, ray-emitting eye, as in her video *Still 7, Extramission 6* (2009). This work is viewed in a structure modelled on Thomas Edison's Black Maria, the first-ever film production studio built in 1893 (installation view: *Extramission 6 (Black Maria)*, 2009).

Seers' recent work *It has to be this way* (2009) uses sculpture, installation and video to weave a narrative concerning her vanished stepsister. Her sister's research on Queen Christina of Sweden is explored, along with the fascinating historical figure herself – she often dressed as a man, and reflected Seers' sister's interest in Neoplatonism, androgyny and the Renaissance concept of theatre of the world.

In contradistinction to much contemporary photography, video and installation, which is so often concerned solely with the incidental, offhand and immediate, Seers' works embody complex philosophical ideas, and employ elusive and atmospheric doublings that expose a multilayered analysis of the nature of art, artifice and the role of the artist.

Vampire Camera (Auto-cannibal Series), 1999

Opposite
Still 7, Extramission 6, 2009
DVD still

Top
Madame Kwok Performance Marseille 1, 2004

Above
Gothic 2 (Optogram Series), 2002

Above left and right
It has to be this way, 2009
Installation views

Centre right
Darkroom, 2004

Extramission 6 (Black Maria), 2009
Installation view

Still 10, Extramission 6, 2009
DVD still

Swallowing Black Maria, 2009

49.
delaine le bas

Installation artist whose Roma heritage informs her disquieting look at identity

Delaine Le Bas's work is a form of sculptural and autobiographical assemblage. Using the language of installation art, she fashions shelters, settlements and evocations of lives lived, from found objects discovered at car-boot sales and charity shops – dolls, ornaments, knick-knacks, furniture, photographs, clothes, textiles and jewelry. Her work emanates explicitly from her experience of being born into and living within the Roma community, and the position that community holds within the wider society.

In her work, Le Bas explores the racism and xenophobia experienced by the Roma, the dominant UK national identity from which the Roma are excluded or distanced, and the traditions and culture of the Roma themselves. The viewer, presented simultaneously with these intertwined positions and power structures, experiences the work as a form of visual thought process or storytelling: no explicit position is articulated, rather a series of suggestions through the layering of materials and textures, the juxtaposition of contradictory and disparate elements, symbols and texts.

Infusing contemporary art practice with folk and Roma aesthetics, surrealism and a critique of consumer culture, Le Bas's work possesses a disturbing and disquieting atmosphere. Spidery handwriting and aggressive graffiti express hostility, veiled threats or child-like fears. The voice or figure of the child – lonely, isolated and insecure – haunts the work. Mutilated figures and reworked dolls jostle among icons of rural innocence, rabbits and horses, as well as patches, badges and union flags which speak of dominant cultural discourses, groups and tribes.

Le Bas establishes a visual register for the old order: a 1950s middle-class world of chocolate-box cottages and handsome equestrians, from which she strips away the veneer of gentility to expose the raw, ingrained xenophobia, fear and hatred lurking beneath. The words of the old skipping rhyme 'My mother said/I never should/play with the gypsies in the wood' recur regularly as the suppressed voice of the majority rising to the surface.

The bright fabrics and sequins of Le Bas's detailed embroideries also expose cultural positioning and layering. She juxtaposes the kitsch insignia of national identity and patriarchy, and popular cultural motifs from Disney to nursery rhymes, alongside autobiographical texts and photographs.

For Le Bas there is no separation between art, work and life. Her installations generally incorporate studio space, allowing visitors to understand and watch the process of making. This process requires time and patience, like the prescribed housewifely skills traditionally prized in Roma women – and critiqued by Le Bas. Beneath the sparkle, darker existential messages ring out: 'eat, drink, fuck and die'.

Le Bas speaks openly of her own personal rebellion from early marriage and quiet domesticity, which allowed her to pursue a career and public persona as an artist. In *The House of the Ju Ju Queen* (2007–8), a child-like bride kneels before an altar-like dressing table, set with insignia and symbols both of Roma life and the wider culture, signifying a critical moment of barred choices and freedoms. The web of wool and string criss-crossing and binding the scene, often employed by Le Bas, expresses the limited horizons and claustrophobia of the traditional way of life for Roma women. Le Bas's achievement is that her multilayered environments express simultaneous views and histories, prejudices and tensions, with a disarming and uncanny combination of aggression, exuberance, vulgarity and delicacy.

The House of the Ju Ju Queen, 2007–8
Mixed media installation, variable dimensions

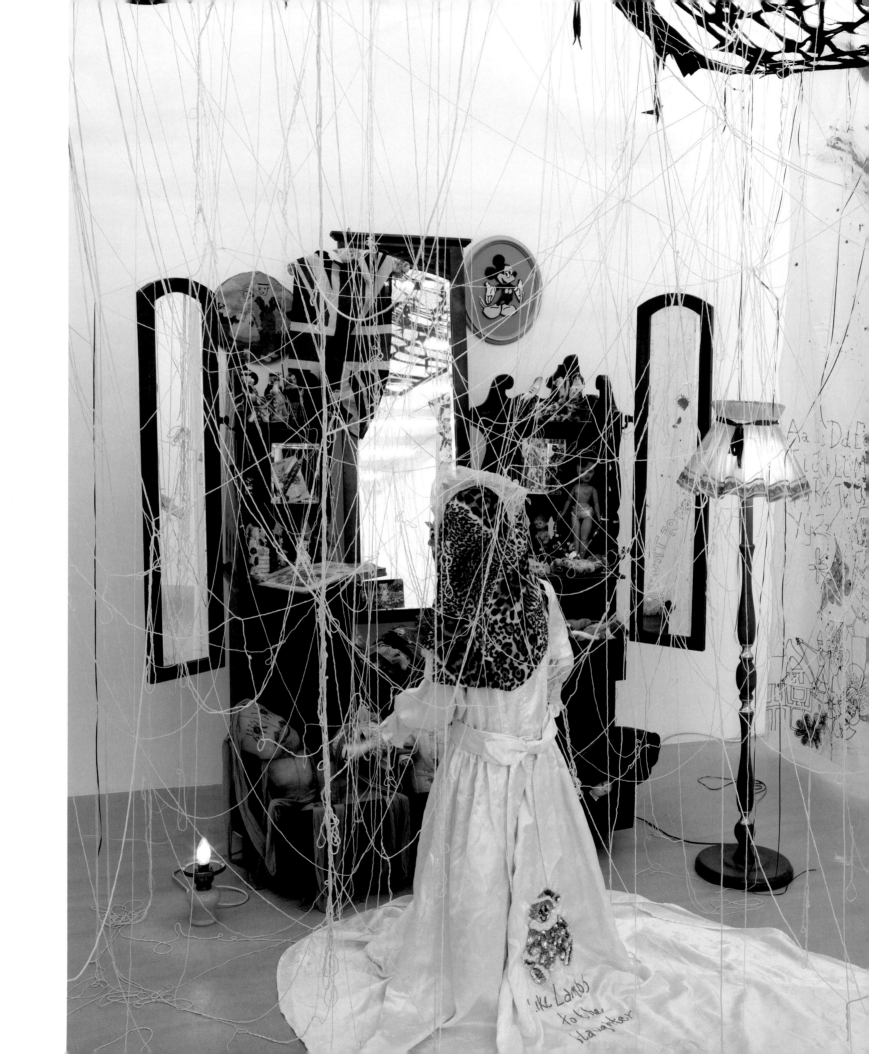

The Walls Can Be Invisible, 2008–9
Mixed media site-specific installation

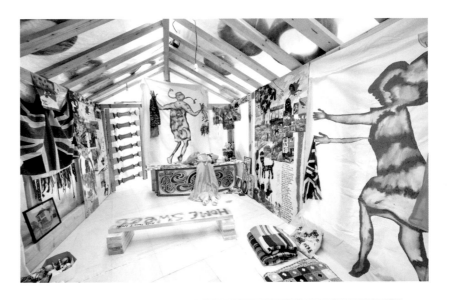

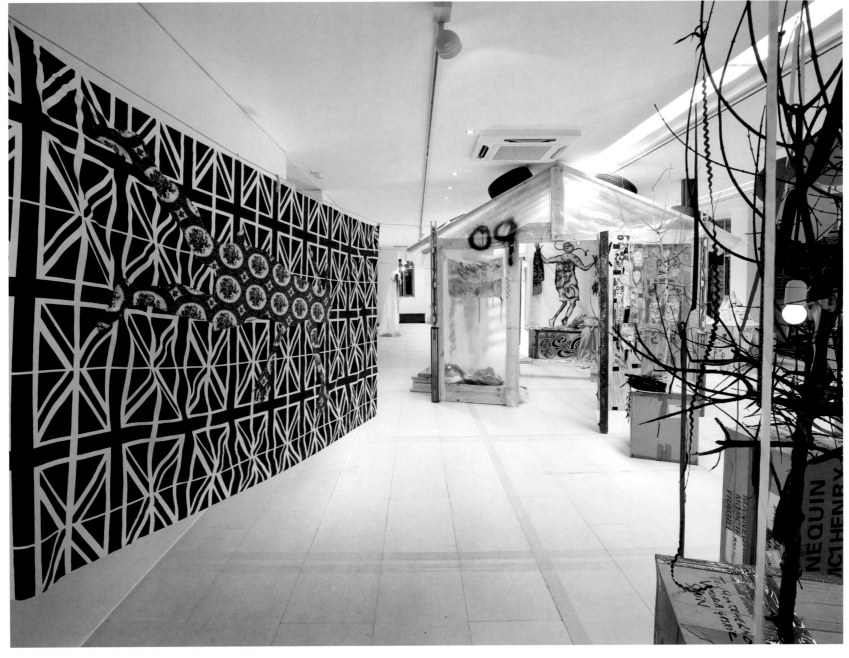

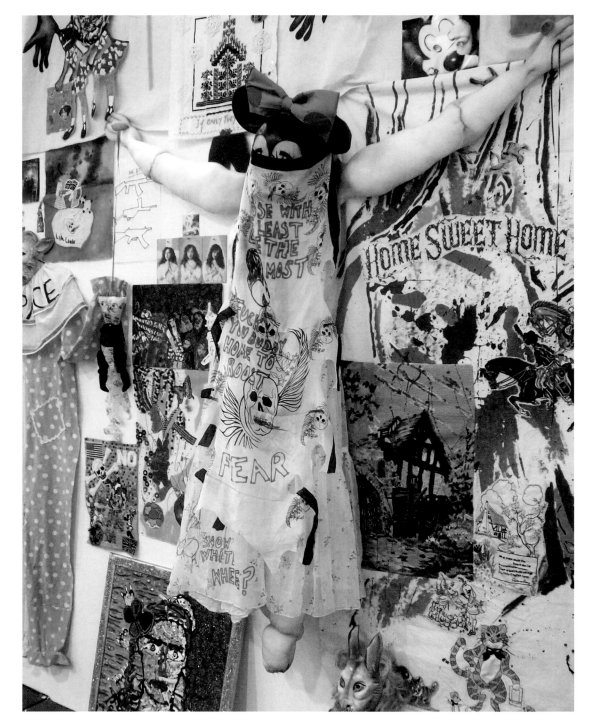

The Altar of Life, 1992–2008
Mixed media installation, complete dimensions
510 x 40 x 330 cm (16 ft 7 in. x 15¾ in. x 10 ft 8 in.)

Dark Energy, 1998–2008
Mixed media painting (detail), complete dimensions
92 x 122 cm (3 ft x 4 ft)

50.
michael patterson-carver

Political activist/artist, whose ink and pencil drawings champion the common man

Michael Patterson-Carver's drawings are a refreshingly frank look at the political realm, dividing into two distinct genres: those that represent well-known world leaders and powermongers, and those that represent ordinary men and women in their desire for change through direct action and demonstrations. The latter, as in *Save Darfur '06* (2007), are always depicted gently smiling, standing shoulder to shoulder, their collective mass filling the picture plane, topped by placards voicing their demands, hopes and desires. They smile because, according to Patterson-Carver, they know they will overcome. (Patterson-Carver's own life and career were shaped by his exposure as a young child to the US civil rights movement. His art and life are now inseparable: his work as an artist and as a political activist are one.)

Drawing denotes authenticity, due to the directness and immediacy of its production; with its innate informality, it somehow embodies certain primal and basic aspects of the human. For this reason it is the most natural means by which Patterson-Carver can expose brutality, greed, lies and manipulation in the service of a collective expression of hope and solidarity. By balancing his depictions of the rich and powerful with images of collective yet individuated

humanity, such as *Roadblock* (2008), Patterson-Carver effectively brings everyone to the same level. The powermongers are mocked through caricature, while ordinary folk are depicted with grace and respect. By giving form to – and poking fun at – the failure of world leadership and the disastrous effects of hypercapitalism, his drawings are a form of sympathetic magic, channelling the desire or power to confront these terrible threats and fears. As Picasso noted, art, from the time of our earliest ancestors, has existed as 'a form of magic … a way of seizing the power by giving form to our terrors as well as our desires'.

Many of Patterson-Carver's drawings are allegories of well-known conspiracy theories. In *OOPS, No WMD's in There, Heh Heh* (2008), George W. Bush holds open a door marked 'Bush Family Skeleton Closet' to reveal Osama Bin Laden, Adolf Hitler and Henry Kissinger, while the room is carefully searched by Secret Service personnel. In *Pay No Attention to the Men Behind the Curtain* (2008), Patterson-Carver shows Bush, Donald Rumsfeld, Bin Laden, a Klansman, a Christian, a skinhead and others as diminutive puppets manipulated by those with the real power – George Bush, Sr. flanked by figures representing global and big-business interests such as oil, munitions and farming.

The vexed relationship between art and politics is nowhere more starkly illustrated than in *Guernica: Incident at the UN* (2007), in which Patterson-Carver depicts the 2003 decision to cover the UN's *Guernica* tapestry because, as the world's most famous anti-war artwork, it was an inappropriate backdrop for the Iraq War press conference hosted by Colin Powell.

Patterson-Carver's work expresses – both through its mode of address and what it reveals – an essential challenge to the dominant culture. It embodies the very notion of the power of the individual's conscience and witness-bearing, and the continuing belief in art as a means of effecting change. In a world beset with apathy, ignorance and self-interest, art needs Patterson-Carver, and others like him, desperately.

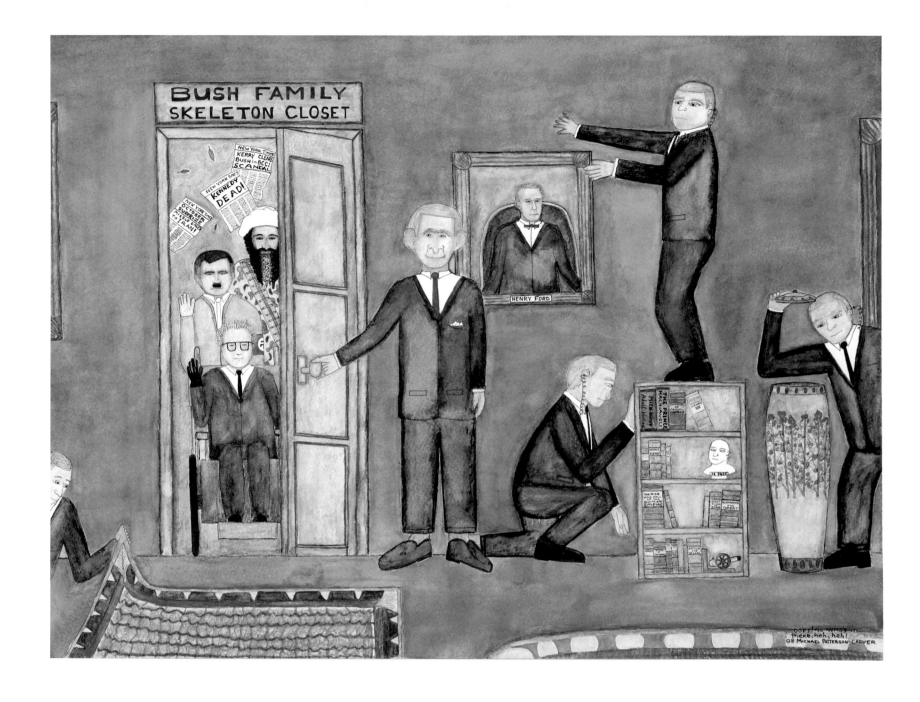

OOPS, No WMD's in There, Heh Heh, 2008
Ink and pencil on paper, 38 x 50 cm (15 x 20 in.)

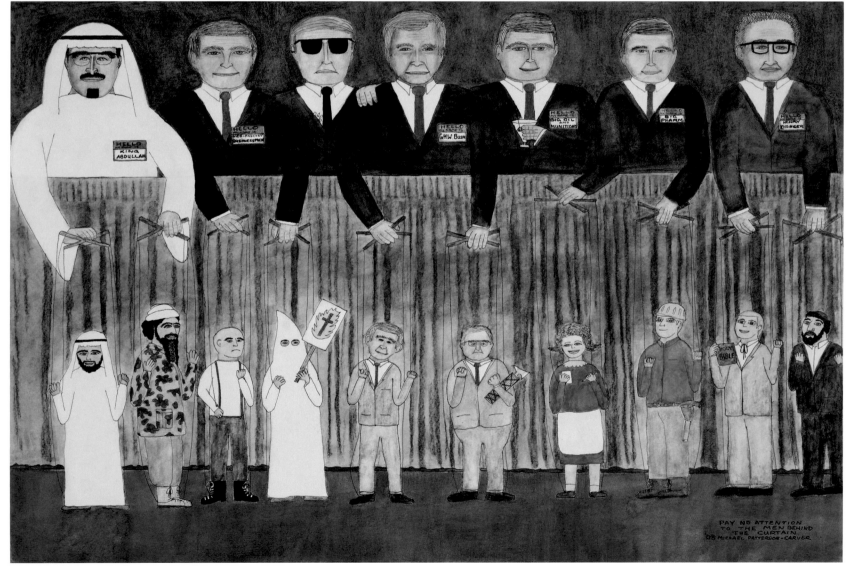

Top left
Guernica: Incident at the UN, 2007
Ink and pencil on paper, 38 x 50 cm (15 x 20 in.)

Above
The Grim Reaper: Stop the Fascists, 2008
Ink and pencil on paper, 38 x 50 cm (15 x 20 in.)

Top right
Save Darfur '06, 2007
Ink and pencil on paper, 22.9 x 30.5 cm (9 x 12 in.)

51-55.

tokujin yoshioka

pieke bergmans

moritz waldemeyer

matthias pliessnig

martino gamper

applied arts
& materials

laura houseley

introduction
laura houseley

Design consultant and author

Distinguishing between craft and mass-produced products was once simple. We could be quite sure of the differences in manufacture, motivation and aesthetic between the two. Today, things aren't so straightforward. The dictionary definition of craft is the same as it ever was (hand-made production requiring specialist skilled labour) but the old assumed parameters of 'craft' have fallen away to leave something altogether more elastic – and relevant. This new craft is no longer practised only by craftsmen and -women, neither is it a twee pastoral pursuit nostalgically remembered, or a collection of skills preserved for posterity rather than purpose. It provides inspirations and templates to mass-production. It might be a method of production in and of itself, or it may be happily partnered with the latest materials, processes and technologies. Contemporary craft is as comfortable when matched with the punk designer, plastics, electronics or flatpack as it is in the hands of the traditional basket weaver. Similarly, 'applied materials' is no longer just a term to describe appliqué or beading. Today, craft production has been liberated from the extraneous position in which it had found itself. In the hands of talented and inventive designers, the disciplines of applied arts and materials are not only relevant but progressive. Issues of perceived value, of the artisan versus the machine, of nostalgia, individuality (of maker, product and consumer), sustainability and art are what currently bother contemporary creatives. Solutions to all of these can be found in craft techniques, materials and psychology. Innovators across a spectrum of disciplines have contributed to making applied arts a newly potent creative practice.

Although less familiar in its modern manifestation, craft's time-honoured associations with skilled and careful production remain its most valuable USP. In the face of mass-produced uniformity comes an inevitable desire for small-scale production and individuality. Time-intensive, bespoke production has a higher currency in our culture than ever before. And so the manufacturing and consumption of just about everything is revisited: fashion, food, design, art, even music. From bags to birthday cards, sandwiches to sandals, hand-made, labour-intensive and small-scale production is worth more, both culturally and commercially. We pay more for it, project additional meaning onto it, and we extol its virtues. The consumer's thirst for the individual product (in the face of mass-produced uniformity) has created an eager market for designer-makers and their wares. The designer-maker method is often born of the necessity of circumstance: it allows energetic young creators to work independently of manufacturers and to avoid large production costs. It is a lovely contemporary irony that high-tech, swift and revolutionary methods of industrial manufacture, as well as marvellous new materials with ever more extraordinary properties, should share their place in the creative hierarchy with humble craft.

Innovation comes from combining craft's labour-intensive, hand-made ethos with a palette of contemporary materials and a concept-driven approach. Among the innovators featured in this chapter is Martino Gamper. His method of production is that of a cabinet-maker, an age-old craft, and yet his choice of material, found furniture, is wholly unexpected. Similarly, Matthias Pliessnig subverts the traditional craft of carpentry and the traditional material of wood by producing work with an unmistakably computer-generated aesthetic. Tokujin Yoshioka goes a step further: Yoshioka is a craftsman who invents his own materials and methods of production. Much of his work replicates the construction processes that occur in the natural world and Yoshioka's designs put the material at the fore. Pieke Bergmans is concerned less with craft production than with the idea of craft. Her ambition is to achieve unique products within the parameters of factory-based construction. Moritz Waldemeyer's complex electronic work represents the very apex of new material application. Craftsman, engineer, scientist and designer, Waldemeyer borrows from each discipline (and collaborates with practitioners in others) to create high-tech, interactive products. And while the results are technologically advanced, Waldemeyer seeks to create objects that inspire an emotional connection, and his studious application to his intensive process is pure craft.

Innovation comes from combining craft's labour-intensive, *hand-made ethos* with a palette of *contemporary materials* and a *concept-driven* approach.

The juncture where new material innovation meets a craft sensibility is an interesting place. Here some designers match traditional materials with the latest methods of production, such as computer-controlled machining tools and rapid-prototyping (see, for example, the work in wood and metal by furniture and product designer Paul Loebach). Others, conversely, use new materials in traditional hand-made manufacture (such as the *Volume* chairs by Raw Edges studio, in which individual paper templates are folded and filled with expanded polyurethane foam).

At the same time, there has been a revival of traditional techniques of applied decoration. This shift is due, in some part, to a renewed appreciation of the function of the decorative arts and a new interest in ornamentation. The recent popularity of an aesthetic that is not minimalist or modernist but expressive and decorative (albeit often ironic) has allowed a host of old skills to flourish again: hand-printed wallpapers, ornamental ceramics, knitting and needlepoint and so many more examples have all been brought in from the cold. This has afforded a new perspective on traditional materials, which are often able to be manipulated and manufactured in new ways, and prompted a renaissance in crafts working with materials such as wood, metals and ceramics.

At the other end of the scale, seemingly far removed from the world of craft, is the dynamic field of material invention. Wonderful new material applications include super-strength plastics used to make bridges, CO_2-absorbing concrete, self-generating (growing) plastics, even invisibility materials. These materials are no longer out of reach

of designer-makers; indeed the most innovative not only use such novel materials but invent their own.

Lastly, craft production – in its guise as a manufacturing method chosen by young designers because of its freedom from industrial constraints – has widely championed another ingredient: the found object. The fashion for using discarded products, furniture or materials has had considerable impact on the contemporary visual landscape. This scavenged material is advantageous to craft producers because it is cheap and readily available, comes complete with inherent associations and sentiment, and it means that in most cases each final product will be unique.

Designer-makers are immersed in the day-to-day process of making. But for many designers, craft is a single note within their wider repertoire. A designer might present a collection based around the rare and ancient art of Japanese enamelling (Hella Jongerius) or employ the skill of traditional British upholsterers (Tom Dixon). He or she might develop new products using historic methods of Taiwanese wicker weaving (Konstantin Grcic) or embroidery (Kiki van Eijk). In these cases the designer works in partnership with a skilled craftsperson: their designs articulate and reinterpret the craft, but they do not seek to master it themselves (a process that can take years). Such is the evolution of contemporary design practices that the hand of the maker does not necessarily have to be that of the designer: craft still provides the narrative and inspiration for such work, and the making process remains vital in communicating providence and value. It is no coincidence that performance design, in which designers create works live in front of an audience, has become such a prolific means of communication for the craft-based designer. The practice is, in fact, charmingly old-fashioned: the final product might be highly untraditional but the showing-off of a craft, a skilled trade, is a time-honoured practice reminiscent of the carpentry workshop or blacksmith's yard of old.

This is not the first time there has been an attempt to recover the values of traditional crafts in the face of industrial modernity. The Arts and Crafts Movement of the late nineteenth century was founded in opposition to the machine-made production of the Industrial Revolution. Despite the floral motifs and cottage-industry products we associate with it now, the Arts and Crafts Movement was in fact both subversive and militant. There are clear parallels between today's flourishing of applied arts and craft and this particularly creative era. Craft is increasingly used today as a point of difference from industrial production and a means to combat the anonymity and aesthetic uniformity of factory-made

products. Craft still powerfully invokes authenticity, integrity and other virtues unobtainable in factory production, and can highlight the near-extinction of skills, traditions and livelihoods.

Adherents of the Arts and Crafts Movement expressed their nostalgic preoccupations through a visual language that was romantic and sentimental. Their products stuck to the traditional craft palette and employed decorative motifs drawn from myth, legend and the natural world. (Though in practice, some Arts and Crafts products were mass-produced to meet demand and not hand-crafted at all, a telling irony that reveals the strength of the idea, over the reality, of craft. This idea remains just as powerful today.) Contemporary innovators generally forego the floral. Indeed, the most significant wielding of craft and material application today is not in opposition to an industrial aesthetic but alongside it. True innovators have found a means to integrate elements of traditional craft into all manner of contemporary products for all purposes, forging as they do an evolution in their path. Craft has become an open and hybrid discipline, retaining or abandoning its traditional associations at will. What's more, this method of production hasn't played such a vital role in the modern landscape since … well, since before it was 'craft' and when it was just 'making things'.

Tom Dixon's continual experimentation
with materials, manufacturing techniques
and everyday objects has made him one of
the most unorthodox and inventive designers
of the past two decades.

on innovation
tom dixon

Innovation doesn't come from nowhere: it can arise out of confronting a problem, from an opportunity offered by a new material or a process just learned or through the transfer of one experience onto another. Many of my own ideas come from *re-contextualizing objects or sensibilities*, or from *making unlikely combinations or associations:* between, say, a factory machine and a sculpture show or installation.

I always get tired of what I have done and believe I could have done better – could have had another shot at it, or thrown it all away and tried something different. My work is most effective when I approach a subject about which I know very little; I am at my best when still naive. My biggest struggle – a challenge to the design industry in general – is to maintain innocence and an outsider's perspective

on problems and opportunities. It's so easy to become institutionalized.

I can't imagine what a *world without innovation* would look like or what a future without innovation could be. For progress, for improvement or even only for survival, striving to better our lives and world should be at the core of human behaviour. We live in a world that needs so much progress, and that will only happen with the engagement of minds that experiment and that are open to taking risks and to the possibility of positive change. Creativity and innovation must be inseparable.

51.
<u>tokujin yoshioka</u>

Renowned as scientist, artist and craftsman for his inspired experiments with process and materials

Whether developing a product design for one of the many manufacturers he regularly works with, an experimental design piece or one of the dramatic installations, dense with ideas, for which he has become famous, Japanese designer Tokujin Yoshioka is always inventive, original and (as is the most common description of his work) poetic. And although he is most often classified as a designer, and experiments with methods of construction and the nature of construction materials are the crux of his work, his particular kind of creative expression has ambitions beyond the functional and towards the emotional. 'I prefer a design that enriches our mind rather than building up a rational society,' he says. The multiple dimensions of his work have earned him a reputation as a scientist, artist and craftsman combined.

Yoshioka looks beyond readily available production techniques and materials for a language that is his own. He is particularly adept at working with the most humble of everyday materials:'I find the beauty that people overlook in their life.' His alchemist approach has seen him produce the award-winning chair *Honey Pop* from 120 sheets of pleated paper; an extraordinary installation, *Remembrance*, using plastic drinking straws (550,000 of them) to build a huge, enveloping cloudscape; and another, at

the Moroso showroom in New York, using tissues. His famous *Pane* (bread) chair is created by packing a semi-cylindrical block of plastic fibres into a paper tube and then baking it in a kiln.

Yoshioka's collaborations with manufacturers such as Driade, Swarovski and Moroso stand out in the world of industrial design for their striking creativity. Of this area of his work Yoshioka says: 'Perhaps when I work with companies, I see the most appealing feature of the client objectively and try to express that charm in the most effective single phrase.' This strategy is clear in the *Eternal* stool Yoshioka produced for crystal manufacturer Swarovski in 2008. This simple stool consists of a suspended crystal captured within a transparent acrylic block. It is a surprisingly reductionist design for the exuberant crystal company.

In his exploratory method of working, Yoshioka is particular and controlling. His studio is a hotbed of experimentation and Yoshioka has been accurately described as technologically unorthodox. But although technology and science, along with innovation of his own devising, are at the heart of many of his designs, Yoshioka argues that design should not depend on technology as a principal motivator: 'I used to believe that technology is what creates the future. However, now I have a sense that there is a hint of the future of design hidden

in nature.' Many of Yoshioka's works reveal the inspiration of natural forms and processes (particularly his recurring method of organizing small structural elements, fibres or materials into a spectacular whole). Yet Yoshioka seeks not to produce semblances to nature or necessarily to use natural materials but instead to re-evoke the wonder of natural creation. Recent works have seen Yoshioka push the language of construction to new limits. The crystalline *Venus* chair made for the 2008 'Second Nature' exhibition at 21_21 Design Sight in Tokyo, was 'grown' rather than made in any conventional sense. Theirs is a 'beauty born of coincidence', says Yoshioka.

'Today, a rapid development of technology, particularly the use of computer renderings, has ensured and made various things real. I want to believe, however, there is something in nature that defies all human imagination. I wonder whether we can make a proposal through design, where we can once again think about the earth and feel the beauty and the power of nature.'

Eternal acrylic and crystal stool, 2008
The glittering, unapologetically minimalist stool was designed in a limited edition of forty-one for the Swarovski Crystal Palace exhibition in Milan. It consists only of a single enormous Swarovski crystal suspended in an acrylic block, intended to evoke a star floating in the heavens.

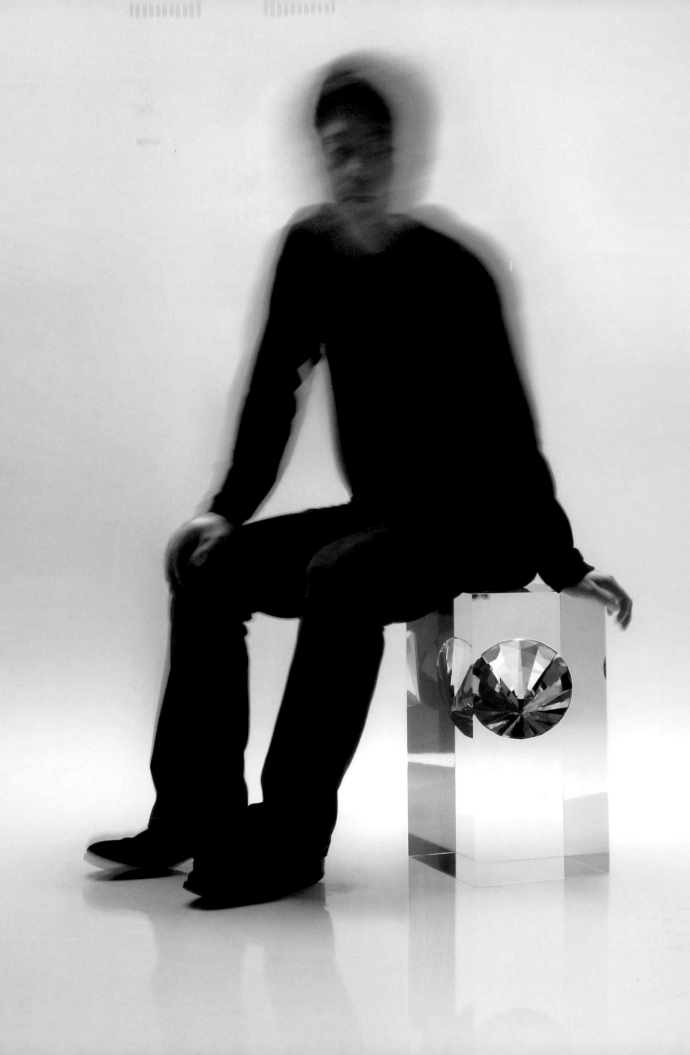

Kimono chair, 2007
A kimono-shaped piece of lacerated plastic fabric, a material similar to the plastic sleeves used to protect wine bottles, becomes a chair when draped over a steel frame. Yoshioka was inspired by stories of magical metamorphosis in the manga comics of his childhood.

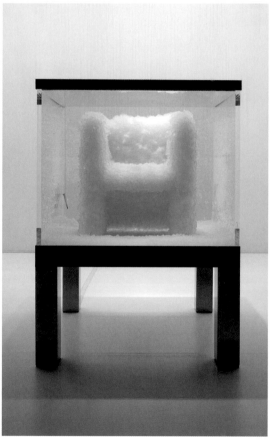

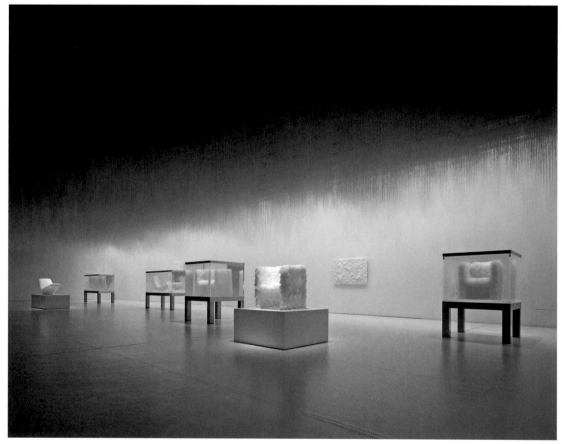

Top row and above
Venus natural crystal chair, 2008
Crystalline chairs were grown over approximately
a month on blocks of polyester fibre submerged in
a tank filled with a mineral solution. Beethoven's
Symphony No. 5, Piano Sonata No. 14 and
Schubert's Symphony No. 7 were piped into the
tanks to influence the formation of the crystal.
The result, said Yoshioka, embodied 'beauty born
of coincidence.'

Above
Clouds, 2008
Venus chairs and crystal chaises-longues were
incorporated in this room-sized installation for the
2008 exhibition 'Second Nature', curated by Yoshioka
and held at 21_21 Design Sight in Tokyo. Thousands
of transparent fibres hanging from the ceiling
resembled low-hanging clouds, creating a space that
evoked powerful natural associations.

52.
pieke bergmans

Dedicated to the pursuit of individual designs within the parameters of mass-production

When a bulb of molten crystal is blown onto a piece of furniture an unexpected impression is made in the liquid material. Conversely, the crystal 'infects' the furniture it meets, melting and burning so that the two objects, now intrinsically connected, form a new whole. This process has been devised by Pieke Bergmans to capture the fluidity and impressionability of crystal. Through it, the designer becomes facilitator; she allows the crystal to follow its most natural and organic inclinations. 'I let the glass do the designing.'

The *Crystal Virus* is recurrent and evolving. 'The nature of the *Crystal Virus* series is that it spreads and changes over time.' Bergmans is intent on developing methods of making that use established techniques of mass-production to produce designs with unique individual character. She studied the process of crystal manufacture at the Royal Leerdam Crystal factory in the Netherlands. 'Liquid crystal is like water, it has a life of its own. But when it is put into a mould all of those qualities are lost, they disappear. It seemed unnatural to me.' And therein lies Bergmans' ambition for her work with crystal. Skilled blowers are instructed to use Bergmans' found furniture in place of traditional moulds. 'The glass reacts to them in a wholly natural way,' she explains. By the time of her 2007 *Vitra Virus* collection, classic modern

furniture designs had taken the place of the anonymous objects Bergmans had previously used: 'the brutal invasion of the crystal onto these design icons creates a dramatic tension.' Another recent manifestation of *Crystal Virus* saw Bergmans commissioned by the Al Sabah Art & Design Collection to 'infect' traditional Middle Eastern furniture.

Few contemporary designers persist with a single method of expression. Bergmans' perseverance with this now signature technique could be compared to the patient labours of the craftsman. Equally, the search for product individuality is something that only craft has traditionally offered. But she is quick to dispel the comparison: 'I'm interested in something else, not in the handmade, but in the techniques and practices used to make mass-produced goods. I'm breaking free of the physical connections to craft.' For Bergmans the goal is to achieve the kind of individuality cherished in craft production within the parameters of mass-production.

The 2008 *Melted Collection*, produced in collaboration with Peter van der Jagt, is a series of furniture built from polystyrene foam that has been baked and melted. 'With careful timing,' says Bergmans, 'each object finds its own way in the oven and comes out slightly different from all the others. It is much more interesting

to design the making-process of a product then just to design its final form.' The vases from this collection are made using an extrusion machine and the form of each is dependent on the natural way that it falls from the machine.

Bergmans' *Lightblubs* and *Chandeliers* (2008) are derivatives of the *Crystal Virus* series. The free-formed crystal *Lightblubs* are lamps which have been 'infected by the design virus'. These bulbs are hand-blown and appear as melted conventional bulbs hanging from traditional light sources. Both they and the *Chandeliers*, formed of hanging clusters of hand-blown bulbs (and produced using a new 'swinging' technique developed by Bergmans), are again produced in collaboration with the master blowers of Royal Crystal Leerdam.

Bergmans looks to the rhythm of natural production for inspiration, including that of our own species: 'The process [of making] is the same but it is our differences that make us interesting. Products and objects can be the same and can have personal beauty too.'

Unlimited Edition, 2007
Pieke Bergmans and Madieke Fleuren
Clay tube vases
These vases are created from tubes of clay emitted by an extrusion machine. Each one is unique, yet the vases can be mass-produced.

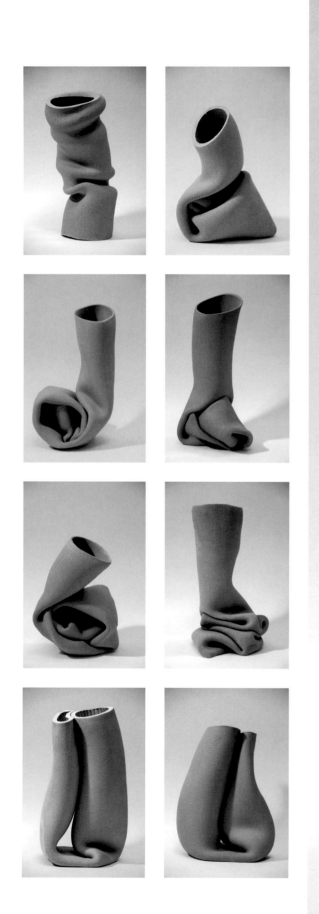

Crystal Virus, 2005–8
Crystal vases embedded in and on wooden furniture
Molten crystal bubbles are dropped onto a piece of
furniture. As the hot glass burns into the wood, some
of the wood's texture is integrated into the vase. Vase
and furniture are permanently fused into a new form.

53.
moritz waldemeyer

Fusing technology with art, fashion and design to open up spectacular new worlds of possibility

Moritz Waldemeyer believes that engineering should be seen as a tool to aid and inspire contemporary creative practice; indeed that it has a rightful place as a creative discipline beside art, architecture, fashion and design. He has done much to push such innovation in disciplines that traditionally did not work with the electronics industry, both as an independent designer and also in collaboration with other creatives. Waldemeyer does not necessarily apply engineering to objects, products or installations according to the classic criteria of need or specific requirements; rather he searches for the point of difference that electronics can offer and uses it as an expressive, creative tool. This approach encourages new ideas 'where the traditionalists run the risk of repeating themselves.' His most frequently employed technology is the micro-controller: tiny chips with a huge programming capacity that he has incorporated into furniture, lighting and clothing to permit interaction between user and object.

East German-born Waldemeyer came to the attention of a wide audience with *Electric Kid* in 2006, his first series as an independent designer. Each of the simple, elegant furniture designs that comprised the collection offered something beyond its usual function. The *Pong* table incorporated the vintage arcade game below a smooth, touch-sensitive surface of translucent DuPont Corian illuminated by 2,500 hidden LEDs. A roulette table showed a similar fusion of clean furniture design with hidden function. A mirror projected a pixelated image of the viewer gathered by an in-built camera. While the *Electric Kid* collection clearly showcased Waldemeyer's technical ability and was a great success, it also communicated much about his attitude towards his craft. He believes in electronics as an inclusive, recreational, entertaining and, importantly, tangible tool.

Waldemeyer had produced similarly impressive works before 2006, but typically in collaboration with other creatives, with his contribution remaining relatively anonymous. It was his inventive technical skill that, in part, enabled the realization of the convention-shattering *Z. Island* kitchen with Zaha Hadid; and the *Lolita* and *Miss Haze* chandeliers for Swarovski with Ron Arad, for which Waldemeyer embedded LEDs within the crystals, enabling *Lolita* to display text messages sent via SMS and *Miss Haze* to display an image created on a PalmPilot.

Of Waldemeyer's recent collaborations, his work with fashion designer Hussein Chalayan is perhaps the most engaging. Waldemeyer has turned Hussein's designs into kinetic, functioning pieces: dresses that transform by unravelling or opening with fluid movements, or unfolding like the petals of a mechanized flower. These designs were achieved after six months experimenting with servo-driven motors, pulleys and wires that were fed through hollow tubes sewn into the dresses. The real challenge, says Waldemeyer, lay in keeping the integrated technology lightweight and hidden, yet strong enough to manoeuvre fabrics. He has also collaborated with Chalayan to create video dresses that display moving images across a surface embedded with thousands of tiny LEDs, blurred and distorted beneath a loose white semi-transparent fabric.

'In a conventional design studio the processes are much more visible; in my work the path from first sketch to prototyping to final project is a lot more abstract. A circuit looks just like any other piece of electronics until it is brought to life,' says Waldemeyer. Although his chosen set of tools may differ widely from those used by the craftsmen, artists and designers who have gone before, Waldemeyer's overriding goal is a familiar contemporary creative pursuit, namely to rejuvenate the process of making in order to forge fresh connections between audience and object: 'With technology you can breathe some life into inanimate objects and it allows people to start a very different relationship with an object, evoking a completely new emotion.'

Dress and hat with lasers and servo motors,
'Readings' collection, Spring/Summer 2008
Hussein Chalayan with Moritz Waldemeyer,
designed in collaboration with Swarovski
This collection explored the dual themes of ancient
sun-worship and modern celebrity-worship. Dresses
incorporated crystals that either focused or diffused
embedded lasers, making the wearer radiate beams
of light or glow like a dying ember.

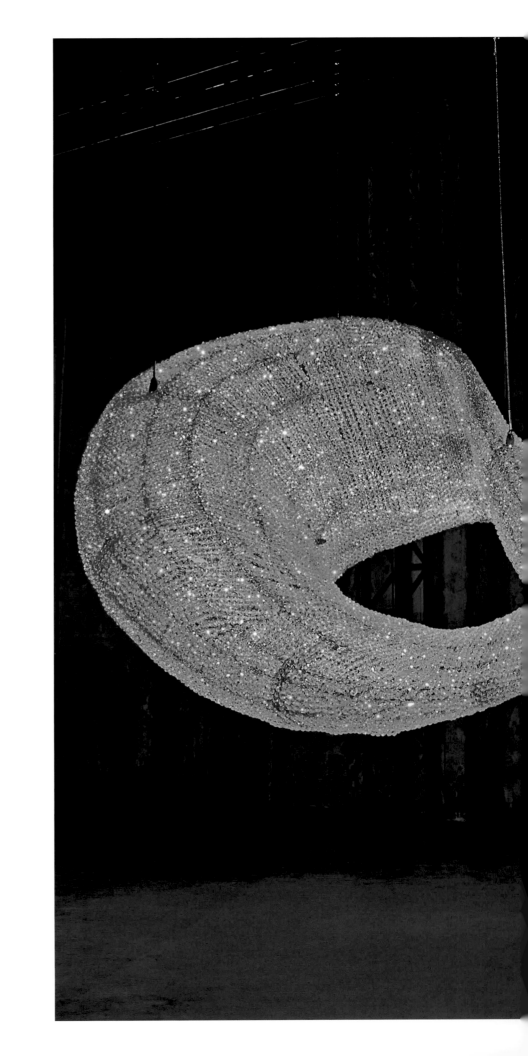

Voyage, 2005
**Yves Béhar and Moritz Waldemeyer for
Swarovski Crystal Palace**
Incorporating 2,000 LEDs and over 50,000 crystals,
this illuminated sculpture, which weighs in excess
of a tonne, displays 'waves' of light washing across
its surface, evoking the motion of the sea or clouds
passing across the sun.

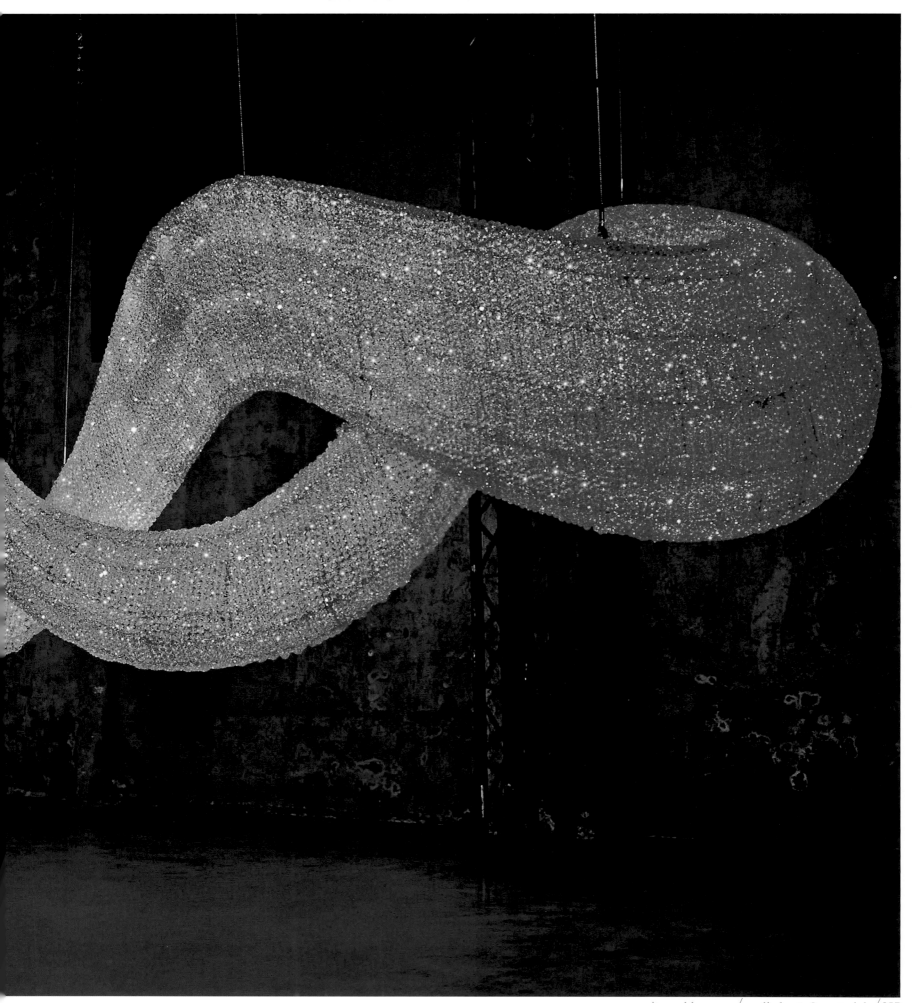

Lolita chandelier, 2004
Rod Arad and Moritz Waldemeyer for Swarovski
Crystal Palace, Swarovski crystal, wires, LEDs
LEDs embedded within the crystals display viewers'
text messages on the chandelier.

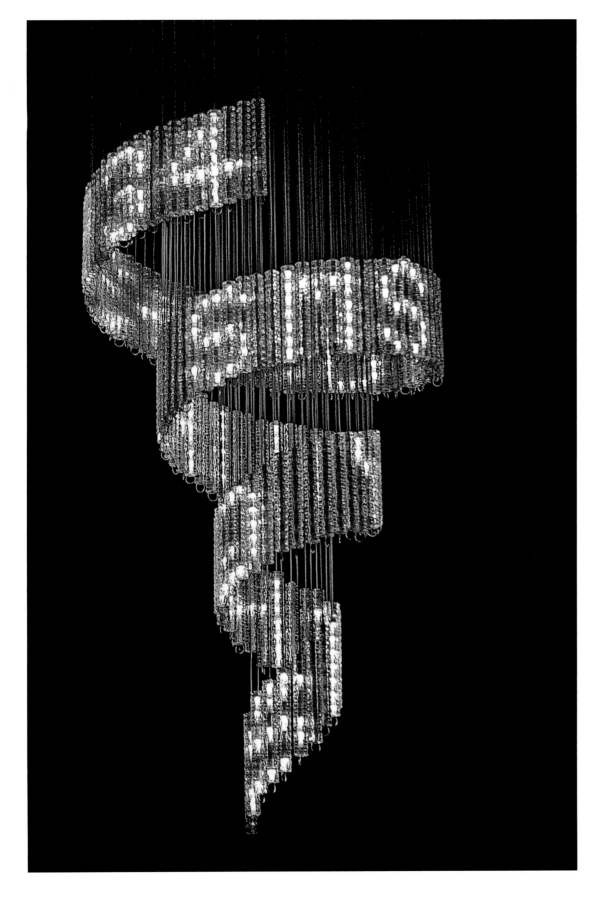

Above
Pandora chandelier, 2007
Fredrikson Stallard and Moritz Waldemeyer
Swarovski crystal, wires, servo motors
1,990 Swarovski crystals suspended from motorized
wires form the shape of a traditional chandelier,
which slowly dissolves into fragments and then
reforms. Its constant movement accentuates the
sparkle of the crystals.

Below and right
By Royal Appointment chairs
Corian and LEDs
The rear illumination automatically changes colour
to match the clothes of the person sitting on the chair,
creating a personalized halo of light.

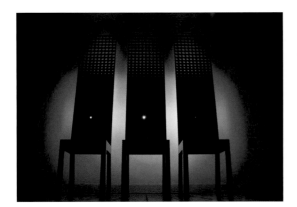

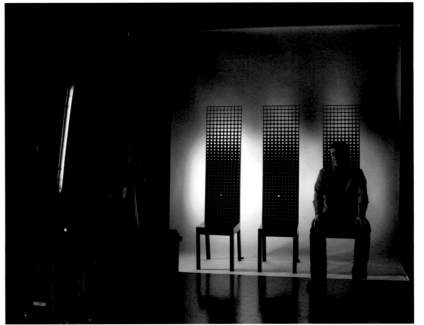

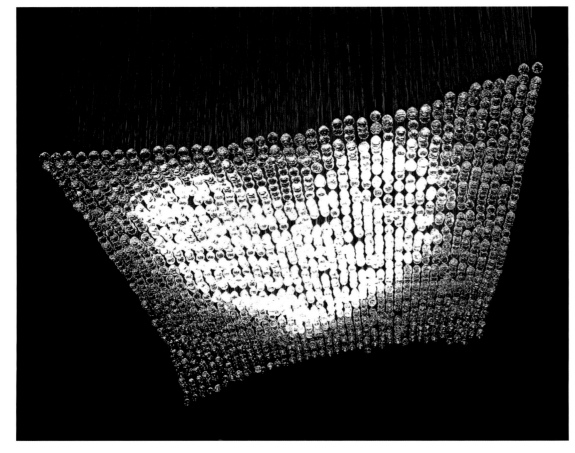

Above
Robotic dress with lasers and servo motors,
'One Hundred and Eleven' collection,
Spring/Summer 2007
Hussein Chalayan with Moritz Waldemeyer
This dress opens like a flower, morphing between a
1940s and a 1960s silhouette. The movement is made
possible by a system of servo-driven motors, pulleys
and wires sewn into the fabric.

Left
Miss Haze chandelier, 2005
**Ron Arad and Moritz Waldemeyer for Swarovski
Crystal Palace**
Swarovski crystal, wires, LEDs
LEDs and microprocessors embedded within
the crystals display an image transmitted from
a PalmPilot using Bluetooth technology.

54.
matthias pliessnig

Pairing time-honoured techniques with digital-age aesthetics

Craft skills and computer technology meet in the furniture created by American designer Matthias Pliessnig. Working predominantly in a single material, steam-bent oak, Pliessnig constructs sinuous and kinetic forms that clearly express the design language we have come to recognize as computer-based, a language more commonly associated with modern materials such as plastics or carbon fibre. 'This combination of new technology and ancient materials fits perfectly into today's stratum,' Pliessnig believes. And indeed it does, for Pliessnig's methods of working are entirely contemporary, even in their assents to nostalgia.

The reference to tradition, to past generations of craft and the values and qualities attached to it, is common in the world of contemporary design. By choosing to work in wood over other, more fashionable, materials Pliessnig makes his work a new chapter in the evolution of traditional design practices. For him it is the physical properties of wood and its huge potential for manipulation that most fascinate. He reveals those qualities with the aid of technology, as illustrated in ambitious and engaging forms such as the undulating *Dilapidated Flow* or the complex geometry of *Ebb*.

Pliessnig had previously worked in wood and had also used the computer as an aid to his designs, but it was a project to build a boat in 2006 that suggested a synergy between the two. The construction process used cross-section planes as supports for pieces of steam-bent wood and concluded with the removal of the supports, leaving the skeletal form of the strips. This principle has influenced much of Pliessnig's subsequent work. He first sketches out his designs on a computer ('I've become comfortable enough with the software that it has become as innate as a sketchbook') and from there allows the work to grow organically. Not only does this marriage of craft and technology forge a new process of hand-manufacture, it also, vitally, allows Pliessnig to explore a visual language that is of key importance to his work.

The linear forms of the bent-wood strips offer more than simple structure, they also suggest a sense of dynamism: 'The movements of hydrodynamic/aerodynamic paths, organic growth, and various structure systems influence my forms.' The ambition to visualize energy and fluidity is a mission to visualize a kind of modernity. The dialogue with the viewer is instantly identifiable as a dialogue of the digital age. Pliessnig acknowledges the work of other great creatives with whom he shares a similar visual language, if not dialect, such as Zaha Hadid and Ron Arad. Though Pliessnig is proud to offer his choice of material as a point of difference. He is especially drawn to the associations of permanence and integrity suggested by wood. Through embracing the natural laws of wood he has changed his own perceptions too, and aims to challenge those of his audiences: 'The material I once thought to be rigid, flat, and unforgiving can actually be fluid and elastic.'

The sculptural qualities of recent work such as *Providence* and *Evolution* are clear. 'Each piece I make provokes a feeling of speed although it is a static form.' The tension between opposing forces – movement and stillness, calmness and unrestrained, natural energy – are at the heart of Pliessnig's work. So too is the supposed conflict between traditional materials and technological languages – though in Pliessnig's hands, these are successfully proven not to be in competition at all.

Occupo Orbis, 2007
Oxidized steam-bent white oak
244 x 183 x 165 cm (96 x 72 x 65 in.)
His sculptural work permits Pliessnig the fullest expression of his innovative creative process.

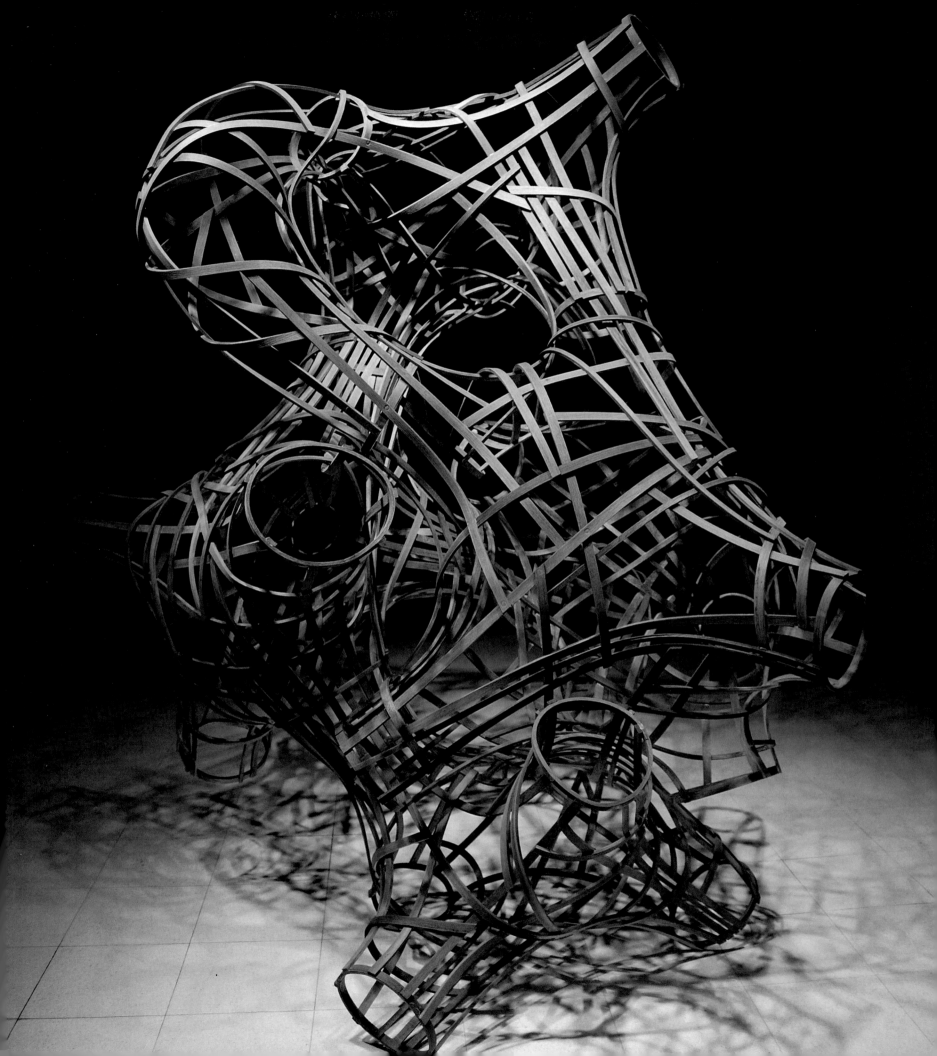

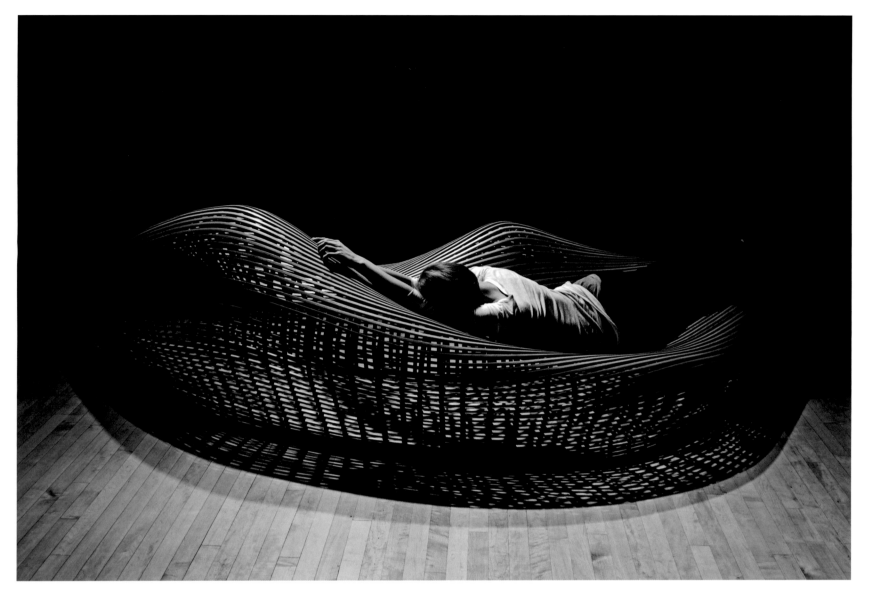

Working predominantly in steam-bent oak, Pliessnig constructs *sinuous* and *kinetic* forms that clearly express the design language we recognize as *computer-based*.

Opposite and this page top and right
Providence, 2008
Steam-bent white oak, series of five
335 x 203 x 91 cm (132 x 80 x 36 in.)
The fluid contours of Pliessnig's steam-bent oak furniture are perfectly suited to the curves of the human form.

Above
Dilapidated Flow, 2007
Steam-bent white oak
223 x 112 x 81 cm (87 x 44 x 32 in.)
Pliessnig uses 3D computer modelling to create the initial concept for his pieces, which he then allows to develop organically in the studio.

55.
martino gamper

Furniture-maker who points to the future
by boldly reinventing the past

Martino Gamper trained as a cabinet-maker in his native Italy before becoming the design protagonist that he is today. This centuries-old craft might seem a long way from the cutting edge of contemporary furniture design, but in fact it is the skills of carpentry and the values of craft production that underpin Gamper's very avant-garde style of making. The combination of this classic process with an irreverent choice of material and unprecedented forms makes Gamper's work especially significant.

As his raw material, Gamper uses existing, foraged furniture. Making use of his considerable construction skills, he dissects and reconstitutes 'found' objects into new designs. The resulting hybrid works, 'Frankenstein designs' perhaps, are each therefore unique. They invoke many of the major themes currently debated in the design world: sustainability, nostalgia, the role of the independent designer-maker and the resurgence of craft techniques. Gamper's method of working and style are not his alone, but he is widely considered the master of them.

When, in 2007, Gamper exhibited a collection of works called *100 Chairs in 100 Days* he captured the spirit of the design times. The exhibition comprised 100 individual chairs, each made from parts of discarded furniture and objects scavenged from the streets and skips of Hackney, East London. Each chair is a sum of strange and unexpected parts, and the resulting accumulative aesthetic is both unprecedented and challenging. This exhibition was a turning point, legitimizing an unconventional method of design production as well as announcing Gamper's own ambitions and motivations.

Found or scrap materials are commonly used in the design world in order to comment on the topic of consumerism and waste, and to promote sustainable production. But for Gamper, such materials offer him the ability to construct quickly, without specialist processes or external aids. This allows Gamper complete control and permits a gratifying immediacy and pace to his work. It bypasses the constraints, as he sees them, placed on creativity by the demands of industrial production: 'I've created a freedom for myself.'

Gamper's work is freed from the categorization that also goes with a more conventional design process. His approach to making is certainly closer to craft than to industrialized design. 'Craft has an element of unpredictability. There is more narrative, more emotion, craft expresses the emotion of the maker. And there is a potential for failure which you don't have with design. In design there is no margin for error.' But Gamper also acknowledges that the explorations and experimental character of his work are rooted in design: 'Craft is purist whilst design is about playing with things.' Gamper finds the thrill of immediate production exhilarating. He is one of a group of designer-makers who have taken to producing designs on demand for audiences, a process billed as 'design performance'. Such live design theatre is a celebration of craft production, albeit a wholly contemporary interpretation of it, in which originality, skill and the designer's individual identity are increasingly valued creative commodities.

Gamper has also applied his method of making to less anonymous materials. In the performance *If Only Gio Knew*, he destroyed and reinvented furniture designed by Gio Ponti for the Hotel Parco dei Principi, Sorrento; in *Martino with Carlo Mollino*, he did the same with a series of Mollino's key designs. His somewhat brave reappropriation of iconic works normally considered sacred indicates Gamper's confidence in this new design language. At the same time, his ambitions also encompass mass manufacture: 'I would like to bastardize what industry can do.' A collection of chairs using parts from the Thonet factory is currently in small-scale production and he is also experimenting with glassware, ceramics and stained glass – areas in which Gamper is, as ever, 'rethinking the formula'.

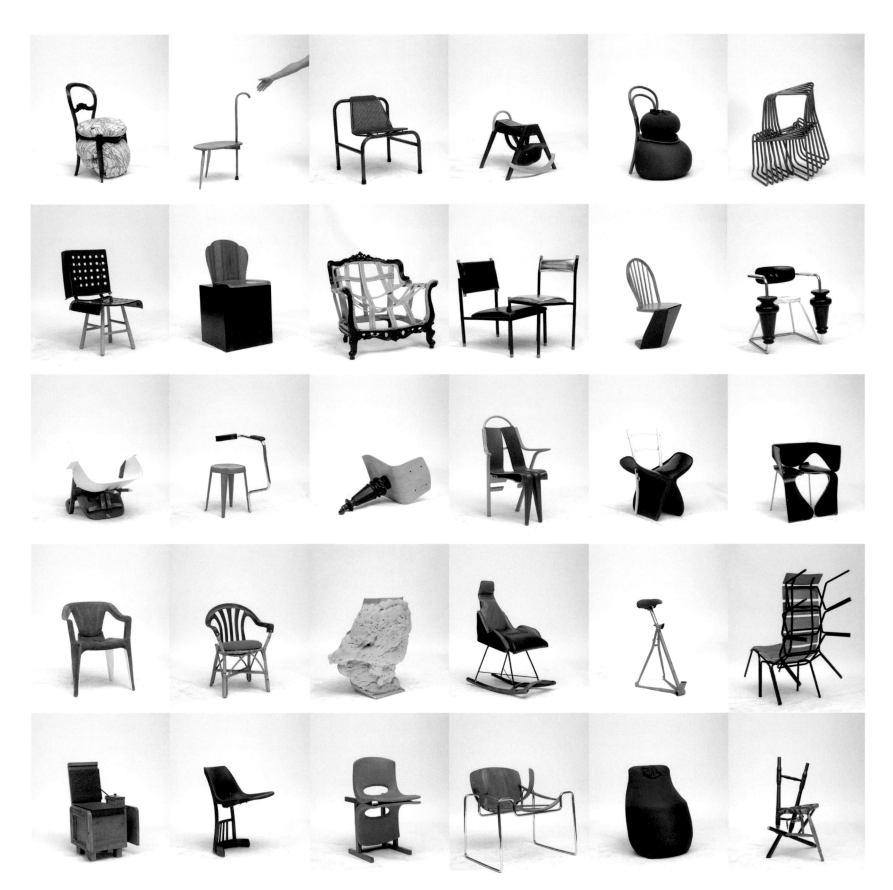

100 Chairs in 100 Days, 2005–7
Gamper created 100 chairs out of objects and
furniture found on the streets of East London.
As he dismantled each piece, he carefully studied
its construction and materials to find inspiration
for the new design, an approach he described as
'sketching in three dimensions'.

Left
Collective, 2008
An installation of reclaimed and remade drawers and boxes stacked on chairs for the exhibition 'Undiszipliniert/ Undisciplined', held at the Kunsthalle Exnergasse, Vienna, in October 2008.

Below
Console, 2007
Gamper created these one-off console tables during the performance *If Only Gio Knew* at Design Basel, for which he destroyed and repurposed furniture originally designed by Gio Ponti in 1960 for the Hotel Parco dei Principi in Sorrento.

56–60.

dunne & raby
gatts & zurr
area/code
hilary cottam
the people

beyond design

paola antonelli

introduction
paola antonelli

Senior Curator of Architecture and Design,
Museum of Modern Art, New York

The dramatic evolution of the tools and scope of design in the past few decades has spawned a new culture that is both material and immaterial. It is complex, constantly changing and adapting, agile in its pursuit of new modes of expression and eager to embrace new social attitudes – a widespread respect for the environment, for instance, or scalability and upgradability. The tools are drawn from every field of scientific and technological study and range from software applications (think of the disrupting effects of HTML and Flash, and then of more complex modelling programs like Rhino, CATIA and UML, all the way to the new age of Processing) to hardware and material innovation (new materials that are more malleable and inspiring for designers are invented every day) and production and manufacturing technologies (from sophisticated 2D laser printers to their versions in three dimensions). The new design culture is global and supported by the speed of information dissemination and by an international market of informed customers. It is animated by the visions of internationally trained designers and based on customization and variety. It is nourished by the vitality of team ingenuity, encouraged by industry, and aimed at designing more new customized materials.

This maelstrom of terms and definitions is not meant to shock, awe and fatigue the reader, but rather to give a sense of the extraordinary pluralism and dynamism that govern contemporary design. Let us count the ways a designer can flex her muscles today: visualization design, information architecture, nanodesign, collective design, interaction design, interface design, web design, computational design, design for debate, critical design, slow design, haptic design, design for the bottom

of the pyramid, democratic design, environmental design, social design and ecodesign are only a few of the possible areas of practice. There are even some methodological studies, such as management theory's so-called 'Design Thinking' (not to be confused with 'intelligent design'). All this, of course, is in addition to good old-fashioned product, furniture and graphic design.

Some of these design tangents are well exposed in this book and represented by such champions as Ben Fry and Natalie Jeremijenko. In this final chapter, we present five examples of innovators who do not fit into any of the previous categories – and, for this reason, might be the most innovative of all. Featured here are examples of mutants, new archetypes of designer, to describe whose work any old-fashioned design cliché – from 'form follows function' to 'design is problem solving' – is desperately inadequate. Their fields of action are: anxiety, paranoia and the malaise of technology (Dunne & Raby); the world of the semi-living (Oron Catts and Ionat Zurr); the twilight zone between the physical and the virtual dimensions (Area/Code); real persons in real need (Hilary Cottam); and the common good (the people). They do not have much in common, except one fundamental characteristic: they focus on the traits that define a human being, whether feeling and emotion, or the need for safety, dignity and responsibility. They study and use the most advanced processes to make sure that progress can suit people's real needs and habits.

Anthony Dunne of Dunne & Raby is the head of the Design Interactions department at the Royal College of Art in London. The programme description at the school reads: 'Designers often refer to people as "users", or sometimes as "consumers". In Design Interactions, we prefer to think of both users and designers as, first and foremost, people. That is, we see ourselves as complex individuals moving through an equally complex, technologically mediated, consumer landscape. Interaction may be our medium in this department, but people are our primary subject, and people cannot be neatly defined and labelled. We are contradictory, volatile and always surprising. To remember this is to engage fully with the complexities and challenges of both people and the field of interaction design.' The final goal of the design quest could not be clearer, and the same applies to the particular type of design that Dunne & Raby have pioneered: 'critical design', also called 'design for debate'. This new type of practice does not always lead to 'useful' objects but rather to generous servings of food for thought – elegantly disguised inside lavishly produced videos, photographs and performances whose

Featured in this chapter are examples of mutants, *new archetypes* of designer, to describe whose work any old-fashioned *design cliché* – from 'form follows function' to 'design is problem solving' – is desperately inadequate.

narrative sparks from original, designed objects – whose usefulness is revealed by their capacity to help us ponder how we really want our things to fit into our lives.

Oron Catts and Ionat Zurr aim at the same target, striving to create beneficial products, yet pummelling doubts into people's minds about life, death and even religion. They design things made of live cells and call them 'semi-living'. Using methods – installations, videos – traditionally of the visual arts trade, Dunne & Raby and Catts & Zurr highlight obstacles and possible wrong turns along the way for other designers and educators, as well as for manufacturers and policy makers. As consciousness of the finite resources at our disposal discourages the over-production of things, several designers are turning to immaterial applications of their skills, ranging from interfaces to services. Some propose themselves as consultants – many design experts of course line up to teach big corporations, but not enough bother to educate politicians, policy-makers and everyday people about the power of design.

A head-on engagement with policy and politics is routine for Hilary Cottam, a designer and social entrepreneur based in London. The concept of social design is not new. In an ideal world, social responsibility would be a prerequisite for design; designers would take a version of the Hippocratic oath and vow to produce beautiful, useful, positive, responsible, functional and economical things that are meaningful additions to the world. But the world is far from perfect and designers are pulled in many different directions, not all of them altruistic or responsible. Many strong personalities in the history of design have thundered against dissolution and waste, sometimes with the vehemence

and moralism of preachers. Victor Papanek was among the first to put this in contemporary terms, addressing issues not only of class and income difference, but also of environmental responsibility. He always had in mind the biggest picture possible, working with UNESCO and the World Health Organization on poverty, disabilities and economic development in the Third World. Many designers practising today have read his seminal book *Design for the Real World: Human Ecology and Social Change*, published in 1971, and through it have learned to think in a completely new way. Cottam represents a pack of younger teams of designers, entrepreneurs, anthropologists and consultants that labour all over the world to bring beauty, grace and common sense not only to design practice, but also to policy-making, management in the private and public sectors and, very simply, to life.

It has been almost thirty years since we gained access to the internet. Slowly but surely we have settled down and, software glitches aside, now freely journey through virtual-world platforms on the web. In fact, for the youngest users there is almost no difference between the world contained in the computer screen and real life, to the point that some digital metaphors, such as video games, can travel backwards into the physical world. Now that we have comfortably ensconced ourselves in the virtual world and learned to modulate our corporeal and online existence, there is a new space in between these two dimensions that is completely open for exploration. It is the space of augmented reality where computers, MMS, SMS, Bluetooth and other digital media meet with the physical environment. That is the space in which Area/Code operates. In the examples of Area/Code games illustrated in these pages, people are in one place, but often feel as though they are in another. Immersed in the screens of their computers or mobile devices while moving in the physical world, they overlap the different dimensions and move and act in groundbreaking, peculiar ways.

One way for designers to make users feel comfortable with advanced technology is to incorporate instinctive human traits, for example in interfaces that can be commanded by moving items around with hands and fingers, by blowing onto them, or even by shaking the computer. Although technologies of this kind have already found commercial applications, most famously in the Nintendo Wii, the Apple iPhone and the game *Guitar Hero*, designers keep staging ingenious new demonstrations. One of the most researched areas of interaction design focuses on objects that respond to our needs and stimuli rather than awaiting our instructions. For the past twenty years, engineers, scientists,

architects and designers have been working towards transforming objects from tools into companions and buildings from containers into open environments, using ever more sophisticated movement- and voice-recognition software.

There was a time, not so long ago, when design felt itself more important than people and couldn't be bothered with worldly concerns. Not any more. Design today is pervaded by humanism. Sociologists and anthropologists have convinced us that collective wisdom is not the lowest but rather the highest common denominator. For this reason, we assign to this collective wisdom the very last spreads in the book. We are all involved in designing the world, but not in the polemic vein of 1970s radical architects, who screamed 'Everybody is a designer!' in an attempt to annihilate any totalitarian imposition from the establishment. It is instead a very constructive attitude based on the principle of open source and supported by the internet, and it has educated manufacturers to expect immediate feedback, even competition, from the grassroots. While the education and dedication that are required to become a professional designer – and the talent and sensitivity that are required to become an excellent designer – should never be underestimated, still design has opened its doors to the world with abandonment. It is difficult to think of a more fertile and promising moment.

Designer of the $100 'XO' laptop for the 'One Laptop Per Child' campaign, Béhar is one of the world's leading creatives, whose work humanizes design by engaging with social agendas as well as technological advances.

on innovation

yves béhar

The word 'innovation' has become annoying: everyone from standard-issue business magazines, stodgy management-consulting firms, engineering giants trying to earn design caché, marketing and PR honchos who transform caché into cliché … all are trying to own it, so that they can bank it. Many years ago, one of my heroes said: 'Innovate as a last resort. More horrors are done in the name of innovation than any other.' If only we had taken Charles Eames' advice and invoked the word 'innovation' more sparingly.

There is nothing wrong with the word 'innovation' in itself, but unfortunately it has become one of those whose true meaning has been sucked out of it. Other terms have encountered a similar fate: 'genius', 'revolutionary' and 'style' are among those that just don't mean what they used to.

Behind an overhyped word, though, there are still some true creators, *people who change the face of business or science or technology or design, people who in the face of stiff competition reinvent an industry or a market. This does not happen often, but when it does, we know about it:* Nicholas Hayek and Swatch, or Elon Musk and Tesla, to cite two examples. <u>True</u> <u>innovation</u> <u>today</u> <u>is</u> <u>more</u> <u>likely</u> <u>to</u> <u>happen</u> at <u>the</u> <u>intersection</u> <u>of</u> <u>several</u> <u>fields</u>, mid-way between technology, design, science and business. It often takes a cross-pollinating creator, or team, to do something that takes us all by surprise – dare I say, something 'new'. For there is really no other way to prove that there is 'another way' than to take the shortcut to innovation.

56.
dunne & raby

Design duo who create hypothetical products to open up present debate and future possibilities

Anthony Dunne and Fiona Raby's outstanding design work is intended to spark debate on the social, cultural and ethical implications of emerging technologies. For many years, they have worked within a new form of design practice that some call 'critical design', others 'design for debate'. Dunne has described it as 'a way of using design as a medium to challenge narrow assumptions, preconceptions and givens about the role products play in everyday life.' Their projects focus on our neuroses (such as 'Designs for Fragile Personalities in Anxious Times', 2004–5, with Michael Anastassiades), on our misguided expectations regarding the power of technology (for instance 'Technological Dreams Series: No. 1, Robots', 2007), on the future of energy ('Is This Your Future?', 2004), or on the subtle new daily needs that human beings could develop in the future ('Do You Want to Replace the Existing Normal?', 2007–8). Their projects' titles often end with a question mark.

In an interview in early 2008, Dunne explained, 'Usually, designers would make technology more user-friendly, easier to use, more attractive. But as technology is becoming more complex, and the impact it might have on our lives becomes more dramatic, designers are starting to use imaginary design products to debate and discuss future possibilities. Design in that way can facilitate a debate about whether we want these futures or not.' Design for debate does not seek to produce immediately 'useful' objects, but rather meditative, harrowing, always beautiful object-based scenarios.

Take 'Robots', for instance. Four mysterious, compelling objects and a video (by Noam Toran) explain that as technology advances and robotic experiments abound – ranging from the pragmatic to the exquisitely absurd – designers are taking a closer philosophical look at our future interaction with robots. Will they be subservient, intimate, dependent, equal? Will they take care of us or will we take care of them? Dunne & Raby look at robots as individuals with their own distinctive personalities and quirks, imagining that robotic devices of the future might not be designed for specific tasks but instead might be given jobs based on behaviours and qualities that emerge over time.

As educators, Dunne & Raby are both involved with the Royal College of Art, London, where Dunne is head of the Design Interactions department and Raby a tutor. The Design Interactions students explore the impact of the most advanced technologies on our daily routines, in particular the design potential of biotechnology and nanotechnology, both of which are now moving out of the research laboratory and into daily life. In 2007, Dunne presented the students with Oron Catts and Ionat Zurr's Tissue Culture & Art Project (TC&A) and their research on tissue design. He launched them into a bio-design and ethics exercise, asking them to design the 'Meat of Tomorrow', based on the first in-vitro patty that TC&A had developed. One of the students, James King, designed a beautiful steak based on a cow's MRI scans. 'We're not just talking about new forms of media,' Dunne said, 'but redesigning parts of people, redesigning animals using tissue as a component in a product. I think what design can do is fast-forward and imagine what happens when those technologies enter everyday life and what kind of new products might emerge.'

Risk Watch, from the series 'Do You Want to Replace the Existing Normal?', 2007–8
This exhibition featured objects designed for a time when we will have more complex and subtle needs than we do today. Place the *Risk Watch* to your ear to hear a number that indicates the level of political stability of the country you are in at that time.

Huggable Atomic Mushroom, from the series 'Designs for Fragile Personalities in Anxious Times', 2004–5
Dunne & Raby redefine the consumer as 'a complete existential being' and in this project explore our irrational but real anxieties. Hug the *Atomic Mushroom* to confront and eventually conquer your fear of nuclear annihilation.

Low Table with Hygienic Paper Roll; *Steps and Tissue Box*;
Bench, from the series 'Park Interactives', 2000
A collection of adult furniture for the Medici Gardens
in Rome. For Dunne & Raby, parks are spaces in
which 'happy families play out idealized scenarios
of modern life' during the day, while at night, they
become sites for activities that are somewhat more
illicit. As a critique of modern design that makes
public furniture nice, user-friendly and efficient, these
objects imagine a society in which local councils
provide amenities for adults to meet and play.

'… using design as a medium to *challenge* narrow *assumptions*, *preconceptions* and *givens* about the role *products* play in everyday life'. *Anthony Dunne*

Coat Hooks, from the series 'Park Interactives', 2000
Can the public be encouraged to misbehave
when confronted with furniture designed to support
illicit activities?

All the Robots 2, from 'Technological Dreams Series:
No.1, Robots', 2007
How will we interact with robots when they do
everything for us? Robots might not turn out to be
highly efficient, functional machines, nor pseudo
life forms, but technological fellow inhabitants of
our world. In this series Dunne & Raby imagine
four types of robot, each with a distinctive function
and character. Robot 2 is very nervous. As soon as
someone enters a room it turns to face them and
analyses them with its many eyes. If the person
approaches too closely it becomes extremely agitated,
which could prove useful for home security.

Blood/Meat Energy Future and *Human Poo Energy Future*,
from 'Is This Your Future?', Science Museum,
London, 2004

For this exhibition project aimed at children aged
between seven and fourteen, Dunne & Raby designed
hypothetical products to explore the ethical, cultural
and social impact of different energy futures,
including meat-based microbial fuel cells (below)
and bio-fuel made of human waste (right).

57.
catts & zurr

The stuff of dreams and nightmares: design at the forefront of biotechnology

When the materials of design are not plastics, wood, ceramics or glass, but rather living tissues, the implications of every project reach far beyond the form/function rapport and the ideas of comfort, modernity or progress. Design transcends its traditional boundaries, and some begin to call it art (but what is the difference, anyway?); the implications aim straight at the heart of our moral sphere and play dangerously and revealingly with our most deeply held beliefs.

In 1996, Oron Catts and Ionat Zurr founded the Tissue Culture & Art Project (TC&A), an influential think-tank that gives life to our dreams and our nightmares: autonomous products made of living cells that are not organic replacements of body parts, but rather new designs that use the same tissue-engineering technologies. To describe the tools of their trade – fragments of bodies that are partly grown and partly constructed, and are sustained by artificial means – they have coined the term 'semi-living'.

Catts & Zurr were artists in residence in the School of Anatomy and Human Biology of the University of Western Australia (UWA) from 1996, where they were joined by Guy Ben-Ary in 2000. They were also Research Fellows at the Tissue Engineering and Organ Fabrication Laboratory, Harvard Medical School, in 2000–1. In 2000, they established SymbioticA, a collaborative artistic laboratory dedicated to the study and critique of life sciences, located within the School of Anatomy and Human Biology at UWA. Since then the lab has hosted more than fifty residents, including not only artists, but also scientists and philosophers who together are laying the groundwork for the development of the biological arts.

Catts, who acts as the artistic director of SymbioticA, studied product design before undertaking a more dedicated and nimble exploration of deep ethical issues. The value of this research is immense and flows into worldwide biotechnology efforts, providing much-needed design support for scientists while also stimulating designers' minds. Equally valuable is the debate that the creations of TC&A and SymbioticA incite.

In the 2008 MoMA exhibition 'Design and the Elastic Mind', TC&A presented two projects: *Pig Wings*, a group of three mummified wing-sets that had originally been harvested out of pig mesenchymal cells, and *Victimless Leather*, a small-scale prototype of a 'leather' jacket grown in vitro. Like all in-vitro tissue, it was a living layer supported by a biodegradable polymer matrix, only in this case that matrix was shaped like a miniature coat. The artists started the project in a bioreactor at Columbia University and then brought it to MoMA, where it was installed in the exhibition galleries within its own incubator, fed nutrients and monitored. At some point during the show, *Victimless Leather* started growing too fast and one sleeve almost came apart. It was time to stop it, the artists decided. But did that mean killing it? Was that a transformation from semi-living to undead? Catts & Zurr argue that *Victimless Leather* offers the possibility of wearing leather without directly killing an animal as 'a starting point for cultural debate'. If the things we surround ourselves with every day can be both manufactured and living, growing entities, 'we will begin to take a more responsible attitude toward our environment and curb our destructive consumerism'.

Hamsa, 1998
Figurine: 2 cm x 1 cm x 1 cm
One of a series of early works by Catts & Zurr's Tissue Culture & Art Project in which skin was grown over miniature figurines representing different aspects of human culture. A *hamsa* is a good luck amulet from the Middle East that protects against the evil eye.

Victimless Leather, 2008
By growing living tissue into a leather-like material,
TC&A confronts the issue of our exploitation of other
living or, in this case, 'semi-living' beings; in shaping
the cells as a consumer product, questions are raised
about the moral implications of wearing dead animals
for protection or for aesthetic reasons.

Victimless Leather, 2008
By growing living tissue into a leather-like material,
TC&A confronts the issue of our exploitation of other
living or, in this case, 'semi-living' beings; in shaping
the cells as a consumer product, questions are raised

Pig Wings, 2008
Living pig tissue engineered into wings invites the
viewer to reflect on a future in which semi-living
objects exist and animal organs are transplanted
into humans, opening up a space for the creation of
ambiguous chimeras. What kind of relationships will
we form with such objects? How will we treat animals
with human DNA, and vice versa?

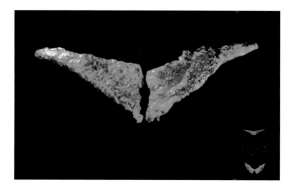

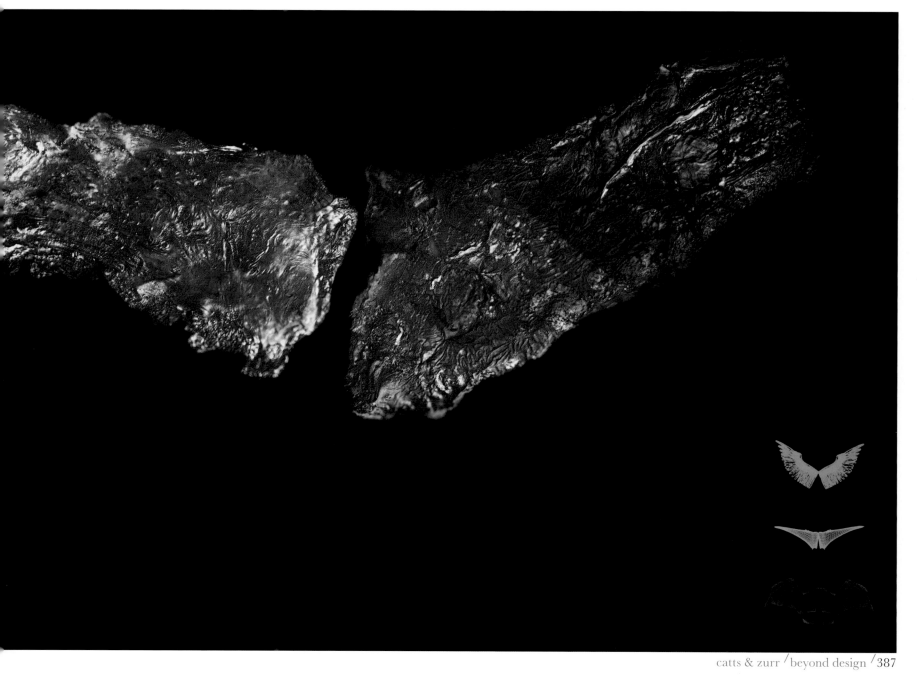

58.
area/code

Gaming at the boundaries of reality, between the virtual and material worlds

Founded in 2005 by Frank Lantz and Kevin Slavin, whose backgrounds are in technology and game design respectively, but whose philosophies demanded a brand new, undefined battlefield, Area/Code has pioneered an innovative and unsettling type of experience in which people inhabit different dimensions at the same time. 'The quickest way to find out what the boundaries of reality are is to figure where they break,' explained Kevin Slavin in a 2008 speech at the MIND08 conference in New York.

Before setting up Area/Code, Lantz and Slavin had been working on *ConQwest*, a promotional game designed for Qwest Wireless in 2003 and first played in Minneapolis in 2004. The game relied on 'semacode' tags, evolved barcodes that can be scanned and read by mobile phone cameras to connect to web addresses. High-school students roamed the city on a mass treasure hunt that mixed cellphone-enabled search-and-capture with gigantic inflatable totems planted to mark conquered territory. The winning team won a $5,000 scholarship for their school. Online, a website showed the players' locations and game progress, turning it into a spectacular audience-facing event.

Plundr, a game from 2006, relies on a piece of software that makes a portable computer traceable in physical space using Wi-Fi Positioning System technologies (WPS). The game is a pirate adventure in which physical space can be renamed, circumscribed and colonized in the virtual world – thus allowing tax-collection, for instance, from other passers-by. Players turn on their Wi-Fi and gain a deeper knowledge of the place they're in (as read in the *Plundr* world). They buy, sell or pillage goods. They explore each other's terrain from Manhattan to Shanghai, from Denver to Eastern Europe, at times suffering the consequences of having entered a rival's territory. They add one more layer of exploration to their physical travels.

Sharkrunners was designed for the occasion of Discovery Channel's twentieth-anniversary 'Shark Week'. After logging in on a computer, each player becomes either a marine biologist or an activist devoted to the protection of sharks, operating in a virtual oceanic vessel from which he or she can monitor and study sharks and gain or lose points in the process. However, the sharks swimming on the computer screen are real live sharks swimming in the ocean, tagged with Global Positioning System (GPS) devices attached to their fins. In Season 1, they were six great white sharks off the coast of California; in Season 2, the game moved to Australia to follow ten tiger sharks and ten grey reef sharks.

Crossroads is a GPS game loosely based on the *Pac-Man* paradigm – move around, eat points, try not to get eaten by the monster that's out to get you. In this two-player game, which lasts thirty minutes, participants capture intersections in downtown Manhattan by moving through them. 'But they must beware the Baron Samedi, an invisible spirit who is in the grid with them,' explains the website. Visible only on the display of the mobile phone and not in the physical world, Baron Samedi still instils anxiety in the players, who behave as if the dangerous enemy were real. They look at the phone, see him approaching, check the street corner, their eyes filled with apprehension, and then run away – from a ghost that does not exist!

The combination of real and virtual opponents creates an uncanny experience, and a new type of play to keep us on our toes as we create a new world.

ConQwest, 2004–5
Designed for Qwest Wireless in 2003, *ConQwest* was
based on the first ever use of 'semacode', optical
codes scanned by phonecams. 'Searchers' were given
special phones with which to collect 'treasure codes',
barcodes that can be digitally scanned and turned
into points.

ConQwest, 2004–5
Teams compete to conquer their city. In a city-wide treasure hunt in Minneapolis designed for high-school students, players went through the city 'shooting treasure' with phonecams and moving their totem pieces to capture territory. Online, a website showed real-time locations and progress.

Sharkrunners, 2007
This is a game of oceanic exploration and high-stakes shark research. Players take on the role of marine biologists tracking great white sharks. They are in control of virtual ships, but the sharks are real animals with GPS units attached to their fins.

Crossroads, 2006
Developed for Boost Mobile handsets, this two-player GPS game invites participants to 'capture' Manhattan intersections simply by moving through them. But they must beware Baron Samedi, a spirit who is in the grid with them. He is invisible in the real world but can be seen on the mobile phone display. The combination of real and virtual opponents creates an uncanny experience and a new type of play.

59.
hilary cottam

Applying design in the real world to improve the lives of those most in need

Hilary Cottam's favourite kind of design is not about making things, but rather about designing ways to make good things happen. The spark is always a very real and urgent issue of great social impact, and the goal is to help other people, whatever their circumstances, to live better. Her partners are city authorities, governmental institutions and private enterprises. Her 'clients' are diabetics, prison convicts, dysfunctional families, at-risk youth, lonesome elderly people and obese individuals. To serve them, in 2007 she founded Participle, an organization that 'creates future services with and for the public', together with an innovation strategist, Charles Leadbeater, and an entrepreneur, Hugo Manassei. With a diverse team of ethnographers, psychologists, social scientists, economists and other experts selected for each task at hand, she studies her subjects and helps them change their behaviour with subtle interventions that are meant to enrich, never disrupt, their daily lives.

Relationships are the focus of the design process, as well as its most powerful tool. The lonely elderly are encouraged to join phone conversations focused on shared interests in a project called MeetUp; diabetic and overweight individuals are steered towards a healthier lifestyle by friendly peer groups

called Activmobs; young people's networking behaviour is redirected to enable them to take part in local activities in Reach Out, a youth project currently under development.

What might seem an idealistic attitude is backed up by Cottam's solid experience in social services. Educated as a social scientist, early on she recognized design's potential to focus purpose and to generate concrete and feasible solutions. Beginning in 1993, she worked as an urban poverty expert for the World Bank in Washington, D.C., for which she led a project in Zambia, among others. In 1999, she co-founded School Works, a London-based experiment to redesign school buildings in the belief that, 'as we live in an increasingly diverse, individualized and less hierarchical society, and new ideas about lifelong learning are emerging, we need our school buildings to open out to their local communities.'

Her attention to the economic soundness of each project has also earned her credibility among politicians. Learning Works (2002), for instance, is an impressive study that proposes a thorough redesign of prisons and diminishes costs while maximizing opportunities for education and constructive activities. By better preparing inmates to re-enter the outside world, this model ultimately reduces the costs to society.

Cottam's philosophy is straightforward: 'The project work I do is collaborative – it's about putting people first and working as part of an inter-disciplinary team; innovative – it's about creative problem-solving and new solutions; delightful – I hope the solutions are covetable and the process is fun; affordable – a promise to deliver something within existing budgets and often saving money; and, most importantly, practical – simple solutions that really work every day.' Participle does not oversimplify the complexity of the design process with a prefab step-by-step recipe, and does not discount the importance of beauty and delight. Its projects are all highly informed, and are uplifting, even when they tackle difficult situations. Cottam is nimble enough often to let others do the designing, and yet forceful enough to know that they need education and guidance. Her projects do not simply work; they give people a renewed sense of hope and strength.

Reach Out
In designing a twenty-first-century youth service, Participle has worked with young people and adults to explore 'what it really means to thrive'; the aim is to help users to identify their capabilities, connect to people, broaden their horizons and 'craft their narrative'.

1 Big Mouth Off

A youth made documentary on youth adult conversations

2 Supersize Us

Activating latent youth adult relationships

3 The Local Ambitions Office

Redefining ambition through neighbourhood alumini

Below and opposite below
Service design concepts
Participle's design starts with the individual and the community. It is a visual, problem-solving process based around four principles: full collaboration with partner organizations; deep involvement of end users and front-line workers; rapid application of ideas to prototypes that are tested and improved; and implementation of a concrete end result, rolling out services that people want and will actually use.

Opposite above
MeetUp
The first enterprise of its type to take on the national challenge of reducing loneliness and social isolation among older people in the UK, MeetUp helps members to develop and maintain new friendships through introductions, phone groups, trips and transportation, and home activity groups. The effects of loneliness and isolation can include memory loss, self-neglect, lower self-esteem and depression.

User Research
Shallow dive

User Research
Deep dive

Opportunities

Co-design

Paper
prorotyping

Experience
prorotyping

Build

60.
<u>the people</u>

A million minds are better than one: we, the people, are the future

Social history oscillates between moments of rampant egocentrism and moments in which pursuit of the common good rises above all other concerns. Granted, these waves often follow economic indicators and the common good becomes more pressing in moments of crisis. Sometimes there is just no choice. But not today – at least, not completely. Even though we are currently facing innumerable urgent global issues, fear and danger are not enough to account for one of the most compelling trends in contemporary society: the concept of open source and collaboration on a global scale.

Explored here only in the field of design – albeit also including the design of systems – the tidal wave that is pushing the world towards a new threshold of collective participation has begun to engulf all aspects of human activity, from music to aid for countries in need, from movies to policy-making. One of the most compelling phenomena in the evolution of society is what has happened to the balance between the individual and the collective. The concept of privacy has mutated to signify not seclusion but a selective way to make contact with other human beings, with the rest of the world, and with ourselves. Our idea of private property has evolved in unexpected ways, opening the door to debates ranging from the value of copyright to the fear of ubiquitous surveillance. Our mobility has increased along with our ability to communicate, and so has our capacity to influence the market with direct feedback, making us all into arbiters and opinion-makers. The most up-to-the-minute design activities are founded on the simple belief that millions of minds are better than one – better even than a traditional design team.

The idea of open source began in the software world and the examples overleaf, *sui generis* design exercises, all rely on the most advanced forms of communication available to create new forms of collective behaviour, from the disruptive power of flash mobs – generated by a rainfall of SMS, these are as sudden and torrential as flash floods – to the brilliant Kiva website, which affords even moderately penny-strapped people the satisfaction of being able to make a constructive impact on somebody's life with a small loan. From systems to software, Ben Fry and Casey Reas's Processing is a manifesto for cooperative experimentation and has had a significant impact as a powerful and inspiring design tool. An open source 'programming language and integrated development environment (IDE) built for the electronic arts and visual design communities', it is simple enough to be picked up by non-programmers yet sophisticated enough to be used for high-level design, architecture, visualization and animation projects. *Make* magazine (now also a website) and instructables.com were both founded in 2005 and represent the last frontier of do-it-yourself. *Make* has a technological slant, while Instructables invites people to share what they do and how they do it, which includes everything from recipes for recycling crayons to how to make your own solar battery charger.

'Everyone is a designer!' proclaimed the true believers of the 1970s Radical Design movement. They meant to challenge what they saw as a class-based system and design culture that not only dictated taste, but also imposed a phoney aspiration of lifestyle on the masses. Today, the same exclamation takes on a completely different weight – positive and constructive. By participating in the design of the world, we will all reach our highest common denominator, the optimal platform from which we can launch experimentation and innovation.

Flash mob, Bucharest, Romania, 2008
Students took part in a mass pillow fight during a flash mob at University Square in Bucharest to commemorate the anti-government demonstration in that square in June 1990. A flash mob is a large group, organized via social media or viral emails, that assembles suddenly in a public place.

Top left
Processing.org
Processing is an open-source programming language, development environment and online community created by Ben Fry and Casey Reas (see page 164). It is now an alternative to licensed creative software.

Above left and right
Visualizations built with Processing
An image based on conical forms (left) and a series of stock data visualizations (right) by Marius Watz.

Top and centre
Rules of Six, 2008
This large wall relief by architects Aranda/Lasch was created using Processing software, high-density foam and a live algorithm for the 2008 MoMA exhibition 'Design and the Elastic Mind'. The piece explores self-assembly and modularity across different scales.

Above left and centre
LED Throwies from Instructables.com, 2009
This website is a forum for people to share what
they do and how they do it, and learn from and
collaborate with others. Developed by the Graffiti
Research Lab, LED Throwies consist of a battery,
LED and magnet which are taped together and
thrown to create light patterns.

Above
Make magazine, Vol. 07, 2006
Devoted entirely to DIY technology projects,
Make magazine 'celebrates your right to tweak,
hack and bend any technology to your own will'.

Top right
Visualization built with Processing
Shape Morph Brush by PostSpectacular.

contributor biographies

Julie Lasky
Based in New York, Lasky is editor of *Change Observer*, an online magazine devoted to design and social innovation affiliated with the popular web publication *Design Observer*. She was formerly editor-in-chief of *i-D* magazine. She is the recipient of a National Arts Journalism Program fellowship and the Richard J. Margolis Award for journalism. She has contributed to numerous publications, including the *New York Times*, the *American Scholar* and *Metropolis*.
www.designobserver.com

Martha Schwartz
Schwartz is a landscape architect and artist with a major interest in urban projects and the exploration of new design expression in the landscape. She has received numerous awards and prizes including the 2006 Cooper-Hewitt Award for her work in landscape architecture, an honorary degree of Doctor of Science from the University of Ulster in Belfast, Northern Ireland, a fellowship from the Urban Design Institute, several design awards from the American Society of Landscape Architects and a recent honorary fellowship from the Royal Institute of British Architects in London. Schwartz is a tenured Professor in Practice of Landscape Architecture at the Harvard University Graduate School of Design and has undertaken residencies at Radcliffe College and at the American Academy in Rome.
www.marthaschwartz.com

Tristan Manco
A freelance art director and writer based in Hove, UK, Manco has been a practising designer and illustrator since 1990, and has written and designed several books published by Thames & Hudson, including *Stencil Graffiti* (2002) and *Street Logos* (2004). He is also the author of *Graffiti Brasil* (2005), along with collaborators Caleb Neelon and Lost Art. Manco's most recently published book is *Street Sketchbook* (2007), the sequel to which is in preparation for publication in 2010. His freelance roles include design consultancy, lecturing and curating.
www.tristanmanco.com

Blek le Rat
Born in Boulogne-Billancourt, Paris, Blek le Rat was one of the first graffiti artists in Europe. He studied painting and architecture, and first experienced graffiti in New York in 1971. Blek broke away from this style in 1981, when he revolutionized street art by using stencils for the first time in graffiti, as part of a project that depicted the silhouette of a rat running along the streets of Paris. The rats became his trademark, followed, later on, by life-sized stencil portraits and figures. Blek's work is now widely recognized, and his iconographic 'guerrilla art' has become an inspiration to artists, including Shepard Fairey and Banksy.

Cecil Balmond
Balmond founded the Advanced Geometry Unit (AGU) in 2000. His work with the AGU includes the Pedro and Ines footbridge in Coimbra, Portugal (2006), the Weave Bridge in Philadelphia (2009), the Taichung Convention Center (2009), the H_edge installation for Artists Space, New York (2006), and for the Graham Foundation, Chicago (2009), the CCTV New Headquarters, Beijing, with OMA (2008), and the Centre Pompidou, Metz, with Shigeru Ban (2009). He was awarded the Gengo Matsui Prize in 2002, and the RIBA Charles Jencks Award for Theory in Practice in 2003. Balmond is the author of *No. 9* (1998), *Informal* (2002) – a prize-winning book on architecture, and *Elemental* (2007). He lectures and teaches across Europe and the USA, and has been visiting Kenzo Tange Professor at the Harvard University Graduate School of Design and Saarinen Professor at Yale University School of Architecture. Balmond is currently the Cret Chair at Penn Design.
www.arup.com/people.cfm?pageid=4373

Greg Lynn
Lynn is an architect whose work advocates increased use of computer-aided design to produce innovative and often complex architectural forms. He was born in 1964 and studied for two degrees at Miami University of Ohio: one in Philosophy (BPhil), and the other in Environmental Design (BED). In 1988 he graduated from Princeton University with an MA in Architecture, and since then he has worked in the architectural office of Antoine Predock, and with Peter Eisenman on the University of Cincinnati School of Design, Architecture, Art and Planning and the Carnegie Mellon Institute. He is currently a Professor at the University of Applied Arts, Vienna, a Studio Professor at UCLA and the Davenport Visiting Professor at Yale University.
www.glform.com

Alastair Fuad-Luke
International sustainable designer, facilitator, consultant educator, writer and activist, Fuad-Luke is author of *The Eco-Design Handbook* (new edition 2009) and *The Eco-Travel Handbook* (2008), both published by Thames & Hudson. Fuad-Luke works with clients across Europe and universities in the UK, Europe, the USA, New Zealand and Australia. As a design activist, he promotes 'slow design' through the work of SLow and slowLab, and encourages participatory design approaches, especially 'co-design', to engage a wider audience in design thinking and practice; his latest book is *Design Activism* (2009). Born in Manchester, UK, and now living in Brixham, Devon, he is a concerned global citizen who is passionate about society-wide engagement with design as a means to living a more fulfilling, sustainable life, while respecting our culturally- and bio-diverse planet.
www.fuad-luke.com

Ezio Manzini
Professor of Industrial Design at the Politecnico di Milano, where he is Director of the Unit of Research Design and Innovation for Sustainability and coordinator of the Doctorate in Design, Manzini is also a visiting lecturer in Japan, Brazil and China; fellow of the Australian Centre for Science, Innovation and Society at the University of Melbourne; member of the Advisory Board of the Technical University of Eindhoven in the Netherlands; as well as Scientific Coordinator of the International Design Research Conference 'Changing the Change' and of the International Summer School 'Designing Connected Places'. Manzini's work is focused on strategic design, service design, design for sustainability and social innovation in everyday life. He has contributed to several recent volumes that focus on design research and sustainable development, and is an Honorary Doctor of Fine Arts at the New School of New York (2006) and Goldsmiths College, University of London (2008), and an Honorary Professor at the Glasgow School of Art (2009).
www.sustainable-everyday.net/manzini

Alice Twemlow
Chair and co-founder of the graduate programme in Design Criticism at the School of Visual Arts in New York, Twemlow is also a PhD candidate in the History of Design programme run by the Victoria and Albert Museum and the Royal College of Art, London. Twemlow, who was born in London and lives in Brooklyn, regularly writes about design for magazines and journals including *Design Observer*, *Architect's Newspaper*, *Eye*, *i-D*, *Design Issues* and *Design and Culture*, and is author of *What is Graphic Design For?* (2006).
www.dcrit.sva.edu

John Maeda
Maeda is a world-renowned graphic designer, artist and computer scientist, who has pioneered the use of the computer for art and redefined the use of electronic media as a tool for expression. In 1999 he was included in *Esquire* magazine's list of the twenty-one most important people for the twenty-first century, and was the recipient of the highest career honours for design in the USA (2001, National Design Award), Japan (2002, Mainichi Design Prize) and Germany (2005, Raymond Loewy Foundation Prize). He earned his PhD in design from Tsukuba University of Art and Design in Japan, and was awarded an Honorary Doctorate of Fine Arts from the Maryland Institute College of Art in 2003. Maeda is the author of four books, including *MAEDA@MEDIA* (2001, published by Thames & Hudson), and *The Laws of Simplicity* (2006). He is currently the President of Rhode Island School of Design.
www.risd.edu/president

Tom Himpe
Himpe is founding partner of Ag8, an independent London-based studio that develops currency for content makers, media platforms and brands. Before this, he worked as a brand strategist in independent, innovative agencies, covering a wide range of European and global brands. Himpe is the best-selling author of *Advertising is Dead, Long Live Advertising!* (2006) and *Advertising Next* (2008), both published by Thames & Hudson.
www.Ag8.com

Bob Greenberg
Chairman, CEO and Global Chief Creative Officer of R/GA, Greenberg has been a pioneer in the advertising industry for over three decades. He leads the vision for R/GA, a digital partner for world-renowned brands such as Hewlett-Packard, L'Oréal Paris, Nike and Nokia. R/GA embodies Greenberg's philosophy of the importance of integrated strategies, creative excellence, and innovative technology. Under his leadership, the agency has received many awards for its creative and technical prowess, including multiple 'Interactive Agency of the Year' honours from *Advertising Age*, *Adweek* and *Creativity*. Greenberg himself has won almost every industry award, including the Academy Award, CLIO, Cannes Lions and the D&AD Black Pencil.
www.rga.com

Masoud Golsorkhi
Born in Iran, Golsorkhi studied photography at the University of Westminster, London. In 1998 he co-founded *TANK* with Andreas Laeufer. Since its inception, *TANK* has been in the vanguard of fashion publishing. Golsorkhi earlier worked with Jean-Paul Gaultier Perfumes, Yves Saint Laurent Beauty, Swarovski, Liberty of London, Braun, British Airways, Christian Lacroix and Dulux, and speaks regularly at Tate Modern, the ICA and the Victoria and Albert Museum.
www.tankmagazine.com

Paul Smith
Smith was born in Nottingham in 1946. In 1967 he met Pauline Denyer, who studied fashion design at the Royal College of Art in London and was to motivate him to become a unique and leading designer. He opened a small shop in Nottingham in 1970 and has subsequently opened shops around the world in cities such as London, New York, Los Angeles, Paris, Milan and Tokyo. Smith's modern and innovative approach to classic cuts and materials has ensured his international success and reputation. In 1995 the Design Museum, London, featured Smith's twenty-five years in the fashion industry in an exhibition titled 'True Brit' as a celebration of his work.
www.paulsmith.co.uk

Charlotte Cotton
Creative Director of the London Galleries, National Media Museum, UK, Cotton was formerly curator and head of the Wallis Annenberg Photography Department at the Los Angeles County Museum of Art, head of programming at the Photographers' Gallery, London, and a curator of photography at London's Victoria and Albert Museum. Cotton has curated a number of exhibitions on contemporary photography and is the author and editor of *Imperfect Beauty* (2000), *Then Things Went Quiet* (2003), *Guy Bourdin* (2003) and *The Photograph of Contemporary Art* (2004 and 2009).
www.nationalmediamuseum.org.uk

James Welling
Welling works at the intersection of photography and photographic technology. Originally associated with the Pictures Generation in the early 1980s in New York, Welling worked and exhibited extensively in Europe in the late 1980s and early 1990s. In 1995, he joined the Department of Art at UCLA. His recent photographs investigate architecture, colour, sculpture and landscape. Welling's *Light Sources* will be published by steidlMACK in autumn 2009.
www.jameswelling.net

Jon Ippolito
Ippolito is one of many foot soldiers in the battle between network and hierarchical cultures: an artist, former Guggenheim curator and co-founder (with Joline Blais) of the Still Water lab at the University of Maine. His current projects – including the Variable Media Network, ThoughtMesh and his 2006 book co-authored with Joline Blais, *At the Edge of Art* – aim to expand the art world beyond its traditional preoccupations.

Joline Blais
Associate Professor of New Media at the University of Maine, Blais previously helped to develop New Media programmes at New York Polytechnic University and at New York University. Her projects include LongGreenHouse, a merging of the Wabanaki longhouse, permaculture gardens and networked collaboration; RFC (Request for Ceremony), a call to invent ceremonies to accompany moments from everyday life; and the Cross-Cultural Partnership, a legal framework for sharing connected knowledge responsibly and sustainably.
stillwaterlab.org

Bruce Sterling
Born in Texas in 1954, Sterling studied journalism at the University of Texas and graduated in 1976, after which he focused on writing, in particular science fiction. Sterling's work has been widely influential: he pioneered the 'cyberpunk' movement in science fiction, and founded the 'Dead Media Project', a catalogue and forum of outdated media technologies. Sterling's 'Viridian Design Movement' focused on developing a green and sustainable design movement. Aside from his fiction, Sterling is the author of two non-fiction books, *Tomorrow Now* (2002) on futurology, and *Shaping Things* (2005) on industrial design. In 2005 he was appointed 'visionary in residence' at the Art Center College of Design in Pasadena, California.
www.wired.com/beyond_the_beyond

Emma Dexter
Dexter is Director of Exhibitions at Timothy Taylor Gallery, London, and in 2009 co-curated 'Living Together, Strategies for Cohabition', commissioned by Montehermoso Cultural Centre, Vittoria, Spain. As Senior Curator at Tate Modern from 2000 to 2007, she curated major solo exhibitions by Pierre Huyghe, Bruce Nauman, Luc Tuymans and Frida Kahlo, and Tate's first photography exhibition, 'Cruel and Tender' (2003). She was Director of Exhibitions at the ICA, London, from 1992 to 2000, curating exhibitions by Steve McQueen, Jake and Dinos Chapman, John Currin and Marlene Dumas. Dexter authored the introductory essay for *Vitamin D* (2005). Dexter was born in London, and studied at Oxford University and the Courtauld Institute of Art.
www.timothytaylorgallery.com

Hans Ulrich Obrist
Born in Zurich in May 1968, Obrist joined the Serpentine Gallery as Co-director of Exhibitions and Programmes and Director of International Projects in April 2006. Before this he was Curator of the Musée d'Art Moderne de la Ville de Paris from 2000, as well as curator of museum in progress, Vienna, from 1993 to 2000. He has curated and co-curated over two hundred solo and group exhibitions internationally since 1991, including: 'Take Me, I'm Yours', 'do it', 'Manifesta 1', 'Cities on the Move', 'Live/Life', 'Nuit Blanche', '1st Berlin Biennale', 'Utopia Station', '2nd Guangzhou Triennale', 'Dakar Biennale', '1st & 2nd Moscow Biennale', 'Uncertain States of America', 'Lyon Biennale' and 'Yokohama Triennale'. In 2007, Obrist co-curated 'Il Tempo del Postino' with Philippe Parreno for the Manchester International Festival. In the same year, the Van Alen Institute awarded him the New York Prize Senior Fellowship for 2007–2008. In 2008 he curated 'Everstill' at the Lorca House in Granada and 'Indian Highway' at the Serpentine Gallery, and was the curator for Artpace residencies in Texas.
www.serpentinegallery.org

Laura Houseley
Housely is a freelance design journalist and editor, and consultant to a number of key international design manufacturers. A former senior editor of architecture and design at *Wallpaper** magazine, she now contributes to a broad range of publications, including *Qvest*, *Icon* and *Pop*. Laura is author of the recently published book *The Independent Design Guide* (Thames & Hudson, 2009) and is based in London.
www.house-31.com

Tom Dixon
Born in Tunisia, Dixon moved to England in 1963. He rose to prominence in the mid-1980s as 'the talented untrained designer with a line in welded salvage furniture'. By the end of the eighties, he was designing chairs for powerhouse Italian brands like Cappellini; by the mid-nineties, he had created his own company, 'Eurolounge', to make and sell his work. Dixon was appointed head of design by Habitat in 1998 and later became Creative Director; he left the company in January 2008. Throughout his career Dixon has held many exhibitions of his work across the globe. Pieces have been acquired by famous museums and are now in permanent collections. Since he set up his eponymous design company in 2002, Dixon's work has entered the international big league through successful shows at major venues such as the Milan Salone. Dixon was awarded the Order of the British Empire in 2001, and was named Designer of the Year 2008 by *Architektur and Wohnen* magazine.
www.tomdixon.net

Paola Antonelli
Antonelli is Senior Curator of Architecture and Design at the Museum of Modern Art in New York, where she has worked since 1994. Before MoMA, she curated design and architecture exhibitions in many countries and worked as contributing editor for *Domus* magazine and as design editor of *Abitare*. She has lectured on design and architecture worldwide and has contributed numerous articles tox publications ranging from *Seed* and *Nest* to the *Harvard Design Review*. Antonelli is author of a number of books, including *Workspheres* (2001), *Objects of Design from the Museum of Modern Art* (2003), *Humble Masterpieces* (2005) and *Design and the Elastic Mind* (2008).
www.moma.org/elasticmind

Yves Béhar
Founder of the San Francisco design studio fuseproject, Béhar is focused on humanistic design and the 'giving' element of his profession, with the goal of creating projects that are deeply in tune with the needs of a sustainable future. Fuseproject designed the world's first $100 'XO' laptop for Nicholas Negroponte's One Laptop Per Child (OLPC) organization, which aims to bring education and technology to the world's poorest children. Other commercial projects include the Herman Miller LEAF Lamp, the Aliph Jawbone and, most recently, Y Water. Béhar's work has been the subject of two solo exhibitions and is featured in the permanent collections of the Museum of Modern Art, New York; the Musée d'Art Moderne/Pompidou Centre, Paris; the Chicago Art Institute; and the Munich Museum of Applied Arts. He is the recipient of numerous awards, including the prestigious National Design Award for Industrial Design and the INDEX: Design to Improve Life, 'Community' award. Béhar also acts as Chairperson of the Industrial Design programme at California College of the Arts (CCA) in San Francisco.
www.fuseproject.com

websites

Interiors & Exteriors
Cao Perrot /caoperrotstudio.com
Petra Blaisse /www.insideoutside.nl
Lang/Baumann /langbaumann.com
Klein Dytham /www.klein-dytham.com
Ab Rogers /www.abrogers.com

Street World
Brad Downey /www.braddowney.com
Leon Reid IV /www.leonthe4th.com
Invader /www.space-invaders.com
Swoon /www.swimmingcities.org
JR /jr-art.net
Blu /www.blublu.org

Built World
Sou Fujimoto /www.sou-fujimoto.com
Alejandro Aravena /www.alejandroaravena.com
UrbanLab /www.urbanlab.com
Carlo Ratti /www.carloratti.com
Turenscape /www.turenscape.com/english

Green World
Justin Francis /www.responsibletravel.com
Cameron Sinclair /www.architectureforhumanity.org
Rob Hopkins /transitionculture.org
William McDonough /www.mcdonoughpartners.com
Janine Benyus /www.biopowersystems.com

Graphic Design
Jonathan Harris /www.number27.org
Metahaven /www.metahaven.net
Ben Fry /www.benfry.com
Manuel Raeder /www.manuelraeder.co.uk
Yuko Nakamura /tha.jp

Advertising
Radiohead /www.radiohead.com
42 Entertainment /www.42entertainment.com
Anomaly /www.anomaly.com
Burger King /www.bk.com
Sid Lee /www.sidlee.com

Fashion
Prada /www.prada.com
Alber Elbaz /www.acnestudios.com/lanvin
Martin Margiela /www.martinmargiela.com
Tom Ford /www.tomford.com
Viktor & Rolf /www.viktor-rolf.com

Photography
Nick Knight /www.nickknight.com
Christopher Williams /www.davidzwirner.com/artists/1
Liz Deschenes /www.miguelabreugallery.com
Taryn Simon /www.tarynsimon.com

New Media
0100101110101101.org /www.0100101110101101.org
The Yes Men /www.theyesmen.org
Miigam'agan & gkisedtanamoogk /newmedia.umaine.
 edu/stillwater/#fellows-miigkis
Natalie Jeremijenko /www.nyu.edu/projects/xdesign
Wendy Seltzer /wendy.seltzer.org

Visual Arts
Nicole Eisenman /www.vielmetter.com
Lindsay Seers /www.mattsgallery.org/artists/
 seers/home.php
Delaine Le Bas /www.soniarosso.com,
 www.nourbakhsch.de
Michael Patterson-Carver /www.smallaprojects.com/
 artists/michaelcarver/main.html

Applied Arts & Materials
Tokujin Yoshioka /www.tokujin.com
Pieke Bergmans /www.piekebergmans.com
Moritz Waldemeyer /www.waldemeyer.com
Matthias Pleissnig /www.matthias-studio.com
Martino Gamper /www.gampermartino.com

Beyond Design
Dunne & Raby /www.dunneandraby.co.uk
Catts & Zurr /www.tca.uwa.edu.au
Area/Code /playareacode.com
Hilary Cottam /www.hilarycottam.com
The People /postspectacular.com (Karsten Schmidt);
 mariuswatz.com (Marius Watz);
 www.reas.com (Casey Reas);
 www.instructables.com; makezine.com

photo credits

a = above, b = below, l = left, r = right,
c = centre, all = all images on page

27, Cloud Chandelier for Kenzo: © cao | perrot studio; 28
(l and bl), L'Allée des Amoureux: © Stephen Jerrome; 28 (r),
Red Box: © Stephen Jerrome; 29, Red Box: © Stephen
Jerrome; 31, Architect OMA, Rotterdam. Photo © Iwan
Baan; 32 (al), Seattle Public Library, Seattle, USA, 2004.
Architect OMA, Rotterdam, 16.3 m × 8.13 m (53 ft. 6 in.
× 26 ft. 8 in.). Photo © Inside Outside; 32 (ar), Real and
translated vegetation across the boundary of the glass
façade, Seattle Public Library, Seattle, USA, 2004.
Architect OMA, Rotterdam. Photo © Iwan Baan; 32 (b),
Garden Carpet #1, 'Living Room', Seattle Public Library,
Seattle, USA, 2004. Architect OMA, Rotterdam. Photo
© Inside Outside; 33 (al), Ector Hoogstad Architects,
Rotterdam. Photo © Inside Outside; 33 (ar), De Architecten
Cie, Amsterdam. Photo © Frits Falkenhagen; 33 (bl),
Architect OMA, Rotterdam, Photo © Inside Outside;
33 (br), Architect OMA, Rotterdam. Photo © Frans
Parthesius; 35, Photo © Lorenzo Pusterla, Zürich; 36,
Photo © FBM Studio; 37 (r), Photo © François Charrière;
38–39 (all), Photo © L/B; 41, Photo Daici Ano; 42 (l and r),
Klein Dytham Architecture; 43 (all), Klein Dytham
Architecture, Photo Nacasa & Partners Inc.; 45, Ab Rogers
Design in collaboration with D.A. Studio and Robson
Jones. Photo Morley von Sternberg; 46 (al, ac and ar),
Ab Rogers Design in collaboration with Shona Kitchen,
D.A. Studio and Robson Jones. Photo Dan Stevens; 46 (b),
Creative Team Leaders Ab Rogers Design; Graphic
Consultants Wolff Olins; Illustrator Sara Fanelli;
Interactive Consultants Robson Jones; Graphics Ab Rogers
Design in collaboration with Praline. Photo Morley von
Sternberg; 47 (al), Ab Rogers Design in collaboration with
Shona Kitchen, D.A. Studio and Robson Jones. Photo
Dan Stevens; 47 (c and b), Creative Team Leaders Rei
Kawakubo and Adrian Joffe (Comme des Garçons),
Ab Rogers (Ab Rogers Design), Shona Kitchen, Takao
Kawasaki (Rei Kawakubo's architectural collaborator in
Tokyo) and Architectures & Associés, Paris. Photo Todd
Eberle; 59, Photo Tod Seelie; 60 (l), Photo Jess Scott
Hunter; 61 (a), Photo Ian Williams; 61 (c), Photo courtesy
the artist; 61 (r), Photo Fahrlaessig; 63–66 (all), © Invader;
67–68 (all), Photo Swoon; 69 (a), Photo Swoon; 69 (b),
Photo Tod Seelie; 71–74 (all), JR, WWW.JR-ART.NET;
77–79 (all), Photo Blu; 91–93 (all), Daici Ano; 95, Photo
© Cristóbal Palma; 96 (b), Photo © Tadeuz Jalocha; 96
(l and r), Photo © Tadeuz Jalocha and Cristóbal Palma; 97
(all), Photo © Alejandro Aravena; 99–100 (all), UrbanLab /
Sarah Dunn & Martin Felson; 101 (l), UrbanLab / Sarah
Dunn & Martin Felson. Photo © Michelle Litvin; 101 (r),
UrbanLab / Sarah Dunn & Martin Felson; 103–104,
© Senseable City Laboratory, MIT. Assaf Biderman
associate director, Mauro Martino interaction designer,
Carlo Ratti director, Andrea Vaccari project leader. Special
thanks to Jon Reades, Francisca Rojas. AT&T Labs:

index